SPANISH PAINTINGS

OF THE FIFTEENTH

THROUGH NINETEENTH CENTURIES

D0086950

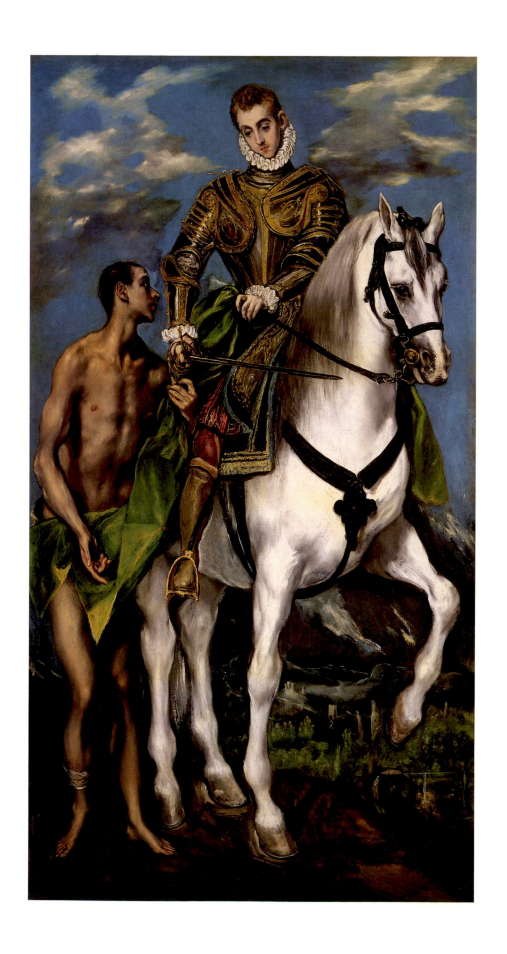

THE COLLECTIONS OF THE

NATIONAL GALLERY OF ART

SYSTEMATIC CATALOGUE

SPANISH PAINTINGS

of the Fifteenth through Nineteenth Centuries

Jonathan Brown

Richard G. Mann

NATIONAL GALLERY OF ART · WASHINGTON

CAMBRIDGE UNIVERSITY PRESS

Edited by Barbara Anderman
Designed by Klaus Gemming, New Haven, Connecticut
Typeset in Galliard
by Finn Typographic Service, Inc., Stamford, Connecticut
Printed and bound by Amilcare Pizzi, S.p.A., Milan, Italy

COVER: Francisco de Goya, *The Marquesa de Pontejos*, 1937.1.85
FRONTISPIECE: El Greco, *Saint Martin and the Beggar*, 1942.9.25

LIBRARY OF CONGRESS CATALOGING-IN-PUBLICATION DATA
National Gallery of Art (U.S.)
Spanish paintings of the fifteenth through nineteenth centuries /
Jonathan Brown, Richard G. Mann.
p. cm. – (The Collections of the National Gallery of Art:
systematic catalogue)
1. Paintings, Spanish – Catalogs. 2. Painting – Washington (D.C.) –
Catalogs. 3. National Gallery of Art (U.S.) – Catalogs. I. Brown,
Jonathan, 1939– . II. Mann, Richard G., 1949– III. Title. IV. Series:
National Gallery of Art (U.S.). Collections of the National Gallery
of Art.
ND804.N38 1990
759.6'074'753 – dc20 90-5640
ISBN 0-89468-149-4 (paper)
ISBN 0-521-40107-0 (cloth)

CONTENTS

Spanish Paintings of the Fifteenth through Nineteenth Centuries is the second publication in a series of systematic catalogues of the National Gallery of Art's holdings in paintings, sculpture, and decorative arts. The more than two dozen volumes of *The Collections of the National Gallery of Art* will fulfill our responsibility to provide a complete description and interpretation of our extraordinary collections to both the inquiring general visitor and to the specialized scholar in art history. The books in the series are written by Gallery curators and leading outside authorities, thus taking into account the issues and methodologies unique to each field.

We are fortunate that this important project has been informed by the knowledge and expertise of two leading authorities on Spanish painting, Jonathan Brown and Richard Mann. Professor Brown's books on Velázquez, Murillo, and Zurbarán, on other Spanish artists, and on the history of Spanish patronage are among the most respected in the field. Professor Mann has contributed his specialized knowledge of El Greco and Goya and their patrons.

The Spanish paintings in the National Gallery, though restricted in number, are an important part of the old master collection. Here it is possible to see early and late examples of El Greco's painting, Velázquez' work on an intimate scale, Murillo addressing both the sacred and the profane, and Goya's incisive portraits of Spain's aristocratic and intellectual society.

Only those Spanish paintings in the Kress collection have been catalogued extensively before, by Colin Eisler in 1977. Since that date, heightened interest in Spanish art among the public and among scholars has spurred monographic exhibitions and innovative research on the artists represented in the National Gallery's collection. Careful examination in the conservation laboratories, using new diagnostic methods, has extended our understanding of painters' working methods and brought new focus to questions of workshop practice and the distinctions among modelli, finished works, and replicas. By setting forth comprehensively the results of scholarly discoveries about the Gallery's holdings, we hope to further a more general understanding of the development of Spanish painting and the context in which it evolved.

J. Carter Brown
Director

ACKNOWLEDGMENTS

The authors commenced work on this catalogue in 1984, and during the period of research and writing were helped by many people in many ways. Naturally, our greatest debt is to Suzannah Fabing, who coordinated the project for the National Gallery of Art with exemplary professionalism and efficacy. An early draft of the manuscript was read by Marcus B. Burke and William B. Jordan, who corrected errors and freely shared their knowledge of the field. Dr. Jordan made a special trip to Washington to help us thrash out some of the trickier problems of attribution and date. Beverly Brown and Sydney Freedberg also read the draft and offered useful suggestions.

Members of the Gallery's conservation department prepared condition reports and were always available to examine and re-examine technical questions as they arose. For their help, we are very grateful to Paula DeCristofaro, Sarah Fisher, Catherine Metzger, and Susanna Pauli.

Another member of the Gallery staff, Susan Davis, reviewed and often expanded the sections on provenance. Charles M. Ritchie very kindly made the drawings of El Greco's signatures in Greek. Randi Nordeen ably typed the manuscript and carefully executed the many revisions, including those occasioned by the painful transition from one kind of software to another partway through the process. And Barbara Anderman, our editor, did a masterful job in putting the manuscript into final shape.

Separately, Richard Mann acknowledges the assistance of James Carmin and Sheila Klos, art reference librarians at the Library of the School of Architecture and Allied Arts, University of Oregon, for assistance in locating sources and obtaining material on interlibrary loan. Christine Sundt, slide curator, University of Oregon, helped with the comparative illustrations. Richard Mann also thanks the librarians of The Frick Art Reference Library and the Hispanic Society of America for their gracious assistance with many matters.

Jonathan Brown wishes to acknowledge the contributions made by members of his seminar at the Institute of Fine Arts, New York University, which studied the Gallery's collection of Spanish paintings in 1985. Some of the results of this seminar are incorporated, with due acknowledgment, into the entries. And, as always, he thanks the staff of Marquand Library, Princeton University, for their courtesy and assistance.

INTRODUCTION

The Spanish painting collection at the National Gallery of Art, though small in size, is distinguished by important works of many of Spain's greatest painters. Ranking first are seven paintings by El Greco, the quality and variety of which are not surpassed by any other collection in the world. The Gallery owns representative works from every period of the artist's activity in Italy and Spain, and, except for portraiture, the range of his thematic repertory is complete. In addition to characteristic religious works, including two from a major church commission, the National Gallery possesses his only surviving mythological scene, which is a picture with an extensive landscape background. The collection also affords an opportunity to see the artist's production in large and small format alike.

The second important group is comprised of no less than seven portraits by Goya, spanning all but the last period of his activity (1814–1828). This emphasis on portraits rather than on the artist's narrative or genre paintings is typical of North American collections as a whole.

Of the leading seventeenth-century painters, Murillo is seen at his best as an interpreter of both religious and secular works in *The Return of the Prodigal Son* and *Two Women at a Window,* one of two genre paintings by the master in the United States. The one picture surely attributable to Velázquez is *The Needlewoman*, a rare informal study that, despite its small size, displays his incomparable technique. The *Still Life* by van der Hamen y León and *The Assumption of the Virgin* by Valdés Leal are superb examples of these important Golden-Age painters. (Zurbarán is less well served; the execution of the large painting of *Saint Jerome with Saint Paula and Saint Eustochium* is here assigned partly to the workshop, while *Saint Lucy* is a minor work.)

Works of the fifteenth and earlier sixteenth century are few but notable in quality and historical importance. The two panels by the Master of the Catholic Kings represent Hispano-Flemish painting of the late fifteenth century at its best. The companion pieces once owned by the Kress Foundation are now in other North American museum collections. The only picture of the early sixteenth century is the one here attributed for the first time to Fernando Yáñez de la Almedina, datable to his Italian period. This discovery was made by David Alan Brown, the Gallery's curator of early Italian painting, and is of far-reaching significance for understanding the introduction of the Italian High Renaissance into Spain. This not only is the first known work from the artist's Italian period, but also provides a firm basis for revising the canon of works attributed to Yáñez and his collaborator, Fernando de Llanos. The catalogue entry for this work is fittingly authored by Dr. Brown.

Like the majority of paintings in the Gallery, the Spanish works were acquired as gifts, mostly from the founding benefactors, who donated twenty-four of the thirty-three pictures catalogued here. Numerically, the list is topped by Andrew W. Mellon and Samuel H. Kress, each of whom gave nine. Other important but smaller gifts came from the Widener family and Mr. and Mrs. P. H. B. Frelinghuysen.

The collection as it exists today was largely acquired between 1937, the date of the Mellon gift, and 1956, when the last of the Kress pictures entered the Gallery. The private collectors who generously donated their pictures to the nation were understandably attracted by the most renowned Spanish painters, a circumstance that has inevitably created gaps in the collection. But despite the lack of breadth, the Gallery's collection of works by the great Spanish masters is one of the best in North America.

Jonathan Brown
February 1990

The four-panel screen by a Portuguese artist follows the entries for Spanish paintings. All other entries are arranged alphabetically by artist. For each artist, there is a short biography and bibliography, followed by individual entries on paintings arranged according to accession numbers. Paintings assigned to an artist's workshop are discussed after paintings by him. A list of changes of attribution and of title is included at the end of the volume.

The following attribution terms have been used:

Attributed to: Probably by the named artist according to available evidence, although some degree of doubt exists.

Studio/Workshop of: Produced in the named artist's studio/workshop by assistants, possibly with some participation of the named artist. It is important that the named artist was responsible for the creative concept and that the work was meant to leave the studio as his.

Follower of: An unknown artist working specifically in the style of the named artist, who may or may not have been trained by the named artist. Some chronological continuity is implied.

After: A copy of any date.

School: Indicates a geographical distinction, used only when it is impossible to identify a specific artist, his studio or followers.

The following conventions are used for dates:

1603	Executed in 1603
c. 1603	Executed sometime around 1603
1603–1614	Begun in 1603, finished in 1614
1603/1614	Executed sometime between 1603 and 1614
c. 1603/1614	Executed sometime around the period 1603–1614

Dimensions are given in centimeters, height preceding width, followed by dimensions in inches in parentheses.

The technical notes summarize the contents of the examination reports prepared by members of the Gallery's conservation department for the Systematic Catalogue. In writing the technical notes, the authors collaborated closely with the conservators responsible for preparing the reports, and they studied all the paintings jointly with the conservators. The notes describe the condition of the paintings as of September 1989. The dates of major treatments have been indicated when known.

Each painting was examined unframed front and back under visible light with the naked eye and with the assistance of a binocular microscope having a magnifying power of up to 40x. All the paintings subsequently were studied under ultraviolet light. All significant areas of retouch and repaint revealed through the examination process are discussed in the notes. Although x-radiographs are available for most of the Spanish paintings, they are mentioned in the technical notes only when the information they provide was considered germane to the elucidation of the painting, for instance when they showed reworking of the original composition. Infrared reflectography was utilized to reveal underdrawing and changes in composition where these were suspected to exist. When useful information was discovered, reflectograms were prepared, although only those considered essential to the interpretation of the work are discussed in the technical notes. The pigments of the painting by Lucas Villamil and of several paintings by El Greco were analyzed by the National Gallery conservation and science departments. Results of these analyses are summarized in the notes.

The majority of paintings were executed on plain-weave fabric supports, which are referred to in the headings by the conventional term "canvas," and in the technical notes by the generic term "fabric." The fabric is assumed to be linen, but only if fiber analysis was undertaken do the technical notes specify "linen." Similarly, wooden supports are described under the term "panel" in the headings; where the wood has been analyzed scientifically, it is identified in the technical notes. All the paintings on fabric have been lined with an aqueous lining adhesive such as glue or paste to auxiliary fabric supports, assumed to be linen. The original tacking margins generally were removed as part of the lining treatment, and the paintings were mounted on non-original stretchers.

Provenance information has been stated as concisely as possible. Dealers' names are given in parentheses to distinguish them from collectors. A semicolon indicates that the work passed directly from one owner to the next. A period indicates either that we have been unable to establish whether it did so or that there is a break in the chain of ownership. The year in which a painting entered the National Gallery is recorded in the accession number. We checked provenance information from original sources in nearly all cases, and we have been able to modify existing knowledge of the provenance of several works. Endnotes indicate sources not obvious from context and provide additional information needed to supplement accounts of ownership.

The exhibition history is complete as far as it is known. Information has been checked from the original catalogues of nearly all relevant exhibitions.

In the main text of the entries, related works have been discussed, but they are illustrated only insofar as the budget has allowed. Information that is not essential to the interpretation of the Gallery's paintings is kept to a minimum. Left and right refer to the viewer's left and right, except in the cases of figures or persons represented.

All early references are given, even if they are trivial in nature. Otherwise, only the principal literature is included. The titles of works cited in the endnotes are abbreviated if the full titles are given in the references to that entry, the bibliography following the artist's biography, or the list of sources at the beginning of this volume. References and exhibition histories are complete as of 6 October 1989.

Richard G. Mann

Abbreviations for Frequently Cited Periodicals

AB	The Art Bulletin
AEA	Archivo Español de Arte
AEAA	Archivo Español de Arte y Arqueología
ArtN	Art News
AQ	The Art Quarterly
BCMA	Bulletin of the Cleveland Museum of Art
BMMA	Bulletin of The Metropolitan Museum of Art
BSAA	Boletín del Seminario de Estudios de Arte y Arqueología, Universidad de Valladolid
BSee	Boletín de la Sociedad Española de Excursiones
BurlM	The Burlington Magazine
Conn	The Connoisseur
GBA	Gazette des Beaux-Arts
IntSt	International Studio
JbBerlin	Jahrbuch der Königlich Preussischen Kunstsammlungen; Jahrbuch der Preussischen Kunstsammlungen; Jahrbuch der Berliner Museen
JbWien	Jahrbuch der Kunsthistorischen Sammlungen des allerhöchsten Kaiserhauses; Jahrbuch der Kunsthistorischen Sammlungen in Wien
MagArt	Magazine of Art
MunchJb	Münchner Jahrbuch der bildenden Kunst
RAAM	Revue de l'Art Ancien et Moderne
RArt	La Revue de l'Art
RfK	Repertorium für Kunstwissenschaft
RLouvre	La Revue du Louvre et des Musées de France
StHist	Studies in the History of Art
ZfbK	Zeitschrift für Bildende Kunst
ZfK	Zeitschrift für Kunstgeschichte

Cairns and Walker 1944	Cairns, Huntington, and John Walker, eds. *Masterpieces of Painting from the National Gallery of Art*. Washington, 1944.
Cairns and Walker 1952	Cairns, Huntington, and John Walker, eds. *Great Paintings from the National Gallery of Art*. New York, 1952.
Cairns and Walker 1962	Cairns, Huntington, and John Walker, eds. *Treasures from the National Gallery of Art*. New York, 1962.
Cairns and Walker 1966	Cairns, Huntington, and John Walker, eds. *A Pageant of Painting from the National Gallery of Art*. 2 vols. New York, 1966.
Cook, "Spanish Paintings"	Cook, Walter S. "Spanish Paintings in the National Gallery of Art; I: El Greco to Goya. II: Portraits by Goya." *GBA* 28 (August, September 1945), 65–86, 151–162.
Eisler 1977	Eisler, Colin. *Paintings from the Samuel H. Kress Collection: European Schools Excluding Italian*. Oxford, 1977.
Gaya Nuño, *La pintura española*	Gaya Nuño, Juan A. *La pintura española fuera de España*. Madrid, 1958.
Kress 1945	National Gallery of Art. *Paintings and Sculpture from the Kress Collection*. Washington, 1945.
Kress 1956	National Gallery of Art. *Paintings and Sculpture from the Kress Collection Acquired by the Samuel H. Kress Foundation 1951–1956*. Intro. by John Walker, text by William E. Suida and Fern Rusk Shapley. Washington, 1956.
Kress 1959	National Gallery of Art. *Paintings and Sculpture from the Samuel H. Kress Collection*. Washington, 1959.
Mellon 1949	National Gallery of Art. *Paintings and Sculpture from the Mellon Collection*. Washington, 1949. Reprinted 1953 and 1958.
NGA 1941	National Gallery of Art. *Preliminary Catalogue of Paintings and Sculpture*. Washington, 1941.
NGA 1942	National Gallery of Art. *Book of Illustrations*. Washington, 1942.
NGA 1965	National Gallery of Art. *Summary Catalogue of European Paintings and Sculpture*. Washington, 1965.
NGA 1968	National Gallery of Art. *European Paintings and Sculpture, Illustrations*. Washington, 1968. (Companion to NGA 1965, which was published without illustrations.)
NGA 1985	National Gallery of Art. *European Paintings: An Illustrated Catalogue*. Washington, 1985.

Shapley 1968	Shapley, Fern Rusk. *Paintings from the Samuel H. Kress Collection – Italian Schools*. 3 vols. London, 1966–1973. Vol. 2, *XV–XVI Century*, 1968.
Shapley 1979	Shapley, Fern Rusk. *Catalogue of the Italian Paintings, National Gallery of Art*. 2 vols. Washington, 1979.
Thieme-Becker	Thieme, Ulrich, and Felix Becker. *Allgemeines Lexikon der bildenden Künstler von der Antike bis zur Gegenwart*. Leipzig, 1907–1950. Continuation by Hans Vollmer. *Allgemeines Lexikon der bildenden Künstler des xx. Jahrhunderts*. Leipzig, 1953–1962.
Walker 1956	Walker, John. *National Gallery of Art, Washington*. New York, 1956.
Walker 1963	Walker, John. *National Gallery of Art, Washington*. New York, 1963.
Walker 1976	Walker, John. *National Gallery of Art, Washington*. New York, 1976.
Widener 1885–1900	*Catalogue of Paintings Forming the Collection of P.A.B. Widener, Ashbourne, near Philadelphia*. 2 vols. Paris, 1885–1900. Vol. 1, *Modern Paintings*. Vol. 2, *Early English and Ancient Paintings*.
Widener 1913–1916	*Pictures in the Collection of P.A.B. Widener at Lynnewood Hall, Elkins Park, Pennsylvania*. 3 vols. Philadelphia, 1913–1916. *Early German, Dutch and Flemish Schools*, notes by W.R. Valentiner and C. Hofstede de Groot, 1913. *British and Modern French Schools*. Notes by William Roberts, 1915. *Early Italian and Spanish Schools*. Notes by Bernard Berenson and William Roberts, 1916.
Widener 1923	*Paintings in the Collection of Joseph Widener at Lynnewood Hall*. Intro. by Wilhelm R. Valentiner. Elkins Park, Pennsylvania, 1923. Also 1931 ed.
Widener 1935	*Inventory of the Objets d'Art at Lynnewood Hall, Elkins Park, Pennsylvania, The Estate of the Late P.A.B. Widener*. Philadelphia, 1935.
Widener 1942	National Galley of Art. *Works of Art from the Widener Collection*. Foreword by David Finley and John Walker. Washington, 1942.
Widener 1948	National Gallery of Art. *Paintings and Sculpture from the Widener Collection*. Washington, 1948.

CATALOGUE

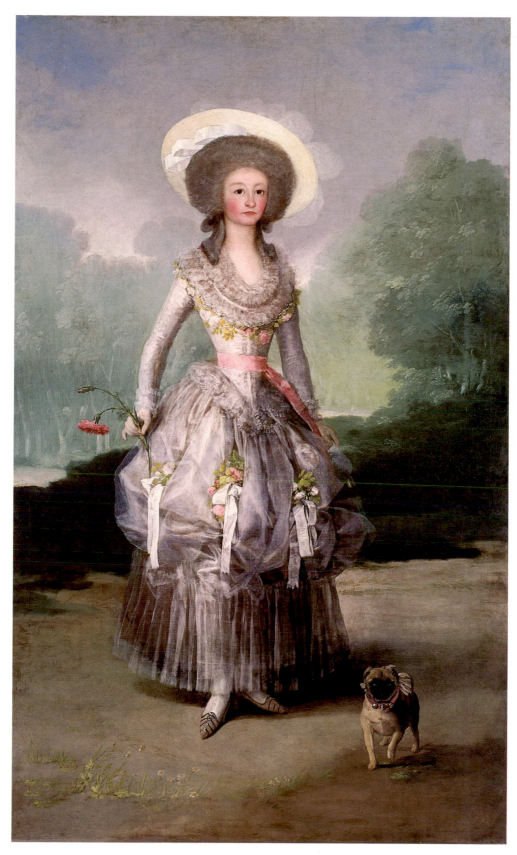

Francisco de Goya, *The Marquesa de Pontejos*, 1937.1.85

rational explanation. *Goya and Doctor García Arrieta* (Minneapolis Institute of Arts), 1820, one of the few portraits executed by the artist during his years at Quinto del Sordo, is comparable in style and mood to the Black Paintings.

In 1824 Goya emigrated to Bordeaux, France, where he lived until his death on 16 April 1828, except for visits to Paris (summer 1824) and to Madrid (spring 1826 and summer 1827). In 1825 he published *Bulls of Bordeaux,* a suite for four lithographs which show mastery of the new print medium. The radiant, tender *Milkmaid of Bordeaux* (Prado, Madrid), one of his final paintings, expresses renewed optimism; the juxtaposition of broken strokes of unmixed colors seems a prefiguration of impressionist techniques.

Goya has been recognized as one of the greatest artists of all times and as a pivotal figure in the development of modern art. His exploitation of the textural qualities of paint and the emotional intensity of much of his imagery greatly influenced later painters. Romantics, realists, impressionists, symbolists, and surrealists have all regarded him as their spiritual ancestor. His oeuvre, which has been thought to include from 688 (Gassier and Wilson) to 772 (Gudiol) paintings, is as diverse as it is large.

R.G.M.

Notes

1. "En q.ᵉ he logrado haces observacioˢ. a q.ᵉ regularmente no dan lugar las obras encargadas, y en que el capricho y la invencion no tienen ensanches." Gassier and Wilson 1971, 382 (transcription), 108 (translation).

Bibliography

Viñaza, Conde de la (Cipriano Muñoz y Manzano). *Goya: su tiempo, su vida, sus obras.* Madrid, 1887.

Beruete y Moret, Aureliano de. *Goya, pintor de retratos.* Madrid, 1915. Translated by Selwyn Brinton. London, 1922.

Mayer, August L. *Francisco de Goya.* Munich, 1923. Translated by Robert West [pseud.]. London, 1924.

Desparmet Fitz-Gerald, Xavier. *L'oeuvre peint de Goya.* 4 vols. Paris, 1928–1950.

Sánchez Cantón, Francisco Javier. *Vida y obras de Goya.* Madrid, 1951. Translated by Paul Burns. Madrid, 1964.

Trapier, Elizabeth du Gué. *Goya and His Sitters.* New York, 1964.

Gassier, Pierre, and Juliet Wilson. *Vie et oeuvre de Francisco Goya.* Paris, 1970. Translated by Christine Hauch and Juliet Wilson. New York, 1971.

Gudiol y Ricart, José. *Goya: 1746–1828; Biography, Analytical Study and Catalogue of His Paintings.* Translated by Kenneth Lyons. 4 vols. New York, 1971.

Pérez-Sánchez, Alfonso E., and Eleanor A. Sayre, eds. *Goya and the Spirit of Enlightment.* Exh. cat., Prado, Madrid; Museum of Fine Arts, Boston; The Metropolitan Museum of Art, New York. Boston, 1988.

1937.1.85 (85)

The Marquesa de Pontejos

c. 1786
Oil on canvas, 210.3 x 127 (82¾ x 50)
Andrew W. Mellon Collection

Technical Notes: The support is a medium-weight plain-weave fabric, lined with wax resin and mounted on a new stretcher in 1968. The tacking margins of the original fabric have been cropped.

The red ground is visible where the paint is thinly applied or abraded. Goya applied oil paint in a variety of techniques ranging from thin glazes to opaque layers in light-colored areas. Contour adjustments are visible on the left side of the waist and the hem of the dress. The position of the feet has been shifted.

The painting is structurally secure. There is scattered abrasion throughout the figure and in the background.

Provenance: The painting remained in the possession of the Pontejos family until it was purchased by Mellon.[1] The sitter, the Marquesa de Pontejos; Joaquín Pérez Vizcaino y Moles, her third husband, Casa Pontejos, Madrid.[2] Don Manuel de Pandro y Fernández, Marqués de Miraflores, Vizcaino's son-in-law, Casa Pontejos, by 1867.[3] Genoveva de Sanmiego y Pando, Marquesa Viuda [widow] de Martorell, Marquesa de Miraflores and Marquesa de Pontejos, Don Manuel's granddaughter, Casa Pontejos, by 1900.[4] Don Manuel Alvarez de Toledo, Marqués de Miraflores and Marqués de Pontejos, her son, Casa Pontejos, by 1928.[5] Sold July 1931 by Don Manuel Alvarez through Mrs. Walter H. (Anna) Schoellkopf, Madrid, and (M. Knoedler & Co., Inc., New York and Paris), to Andrew W. Mellon, Pittsburgh and Washington;[6] deeded December 1934 to The A. W. Mellon Educational and Charitable Trust, Pittsburgh.

Exhibitions: *Obras de Goya,* Ministerio de Instruccíon Pública y Bellas Artes, Madrid, 1910, 32, no. 92. *Retratos de mujeres españolas por artistas españoles anteriores á 1850,* Sociedad Española de Amigos de Arte, Madrid, 1918, 37, no. 33. *Pinturas de Goya,* Prado, Madrid, 1928, 23, no. 18. *Spanish Painting,* Toledo [Ohio] Museum of Art, 1941, no. 84. *L'art européen à la cour d'Espagne au XVIIIᵉ siècle,* Galerie des Beaux-Arts, Bordeaux; Grand Palais, Paris; Prado, Madrid,

definition of the figures primarily in terms of large, flat planes of intense color were unprecedented in church decorative schemes.

On 31 October 1799, Goya was appointed first court painter, the highest position available to an artist at the Madrid court. He executed several individual portraits of the king and queen between 1799 and 1801, as well as the famous *Family of Charles IV* (Prado, Madrid), in which he represented himself at an easel in imitation of Velázquez' self-portrait in *Las Meninas* (Prado, Madrid). Goya's royal sitters expressed great satisfaction with his penetrating realism, but many commentators maintain that he intended to satirize the family. After 1801 Goya was seldom given royal commissions, although he continued to receive his large annual salary.

In the early years of the nineteenth century, Goya continued to produce images of government officials such as *Don Antonio Noriega* (1961.9.74), in which the sitter's rank is clearly indicated. He also began to create intimate, psychologically profound portraits such as *Bartolomé Sureda y Miserol* (1941.10.1) and *Señora Sabasa Garcia* (1937.1.88), in which the subjects are depicted simply and directly without attributes of rank against neutral backgrounds. In the works of this period, heavily textured impasto enlivens a generally thin, fluid application of paint.

Scholars have long debated whether the oath of loyalty that Goya swore on 23 December 1808 to Joseph Bonaparte as king of Spain signified genuine support for the Napoleonic regime, which had been established earlier that year in Madrid. Goya sympathetically portrayed many leaders of the French community in Madrid, but he later painted the duke of Wellington (c. 1812/1814, National Gallery of Art, London) and others who worked for the liberation of Spain. The violence that Goya witnessed during the Spanish War of Independence (1808-1814) inspired him to execute the *Disasters of War,* a series of eighty-two etchings done between 1810 and 1820, eighty of which were first published in 1863. The prints constitute one of the most powerful indictments of war ever made. Through innovative techniques, Goya created violent effects that enhance the brutality of his images.

Beginning in about 1808 Goya painted a significant number of genre scenes. In paintings such as *The Knife Grinder* (Magyar Nemzeti Galéria [Hungarian National Gallery], Budapest) and *The Forge* (The Frick Collection, New York), he heroized workers and emphasized the harsh force of their movements through rough handling of paint. Goya dealt with similar subjects in many drawings about the period 1810 to 1823.

In 1814 Goya commemorated the heroism of Spaniards who had fought against the French invaders in two large paintings, *Second of May in the Puerta del Sol* and *Executions of the Third of May* (both Prado, Madrid). Attempting to regain royal favor, he did six portraits of Ferdinand VII, between 1814 and 1815. Ferdinand restored Goya's salary, which had been discontinued during the Napoleonic occupation, but he did not give the artist any commissions. Goya's postwar portraits, such as *Miguel de Ladrizábal* (Národni Galeri v Praze [National Gallery], Prague) and *Francisco del Mazo* (Musée Goya-Jaurès, Castres), are distinguished by their intensity, austerity, and vigorous brushwork.

In 1816 Goya published *Tauromaquia*, a series of thirty-three prints illustrating the historical development of bullfighting and the feats of famous contemporary bullfighters. The bold, dramatic style of these prints is comparable to that of the *Disasters*. He created, from 1815 to 1824, the *Disparates,* a series of etchings related in mood to the *Caprichos* but larger in scale and more difficult to interpret; eighteen of the twenty-two plates in this series were published for the first time in 1864.

In 1819 Goya suffered a relapse of his illness and almost died. This traumatic experience is probably reflected in the fourteen Black Paintings (Prado, Madrid) which he executed about 1820/1823 in oil directly on the walls of two rooms in the country house on the outskirts of Madrid, popularly called Quinto del Sordo (house of the deaf man), that he had purchased in February 1819. His rough handling of paint and expressionistic distortions intensify the violence of such images as *Saturn Devouring His Son.* Numerous attempts have been made to interpret the program, but these highly personal paintings defy

Francisco José de Goya y Lucientes

1746 — 1828

GOYA was born on 30 March 1746 in the small town of Fuendetodos near Saragossa to José Francisco de Paula, a gilder, and Gracia Lucientes, a member of an impoverished noble family. At the age of fourteen, Goya began a four-year apprenticeship in Saragossa to José Luzán, an undistinguished painter who had studied in Naples. In 1763 and 1766 Goya unsuccessfully participated in competitions sponsored by the Real Academia de San Fernando, Madrid. Sometime after 1766 he traveled to Italy, where he is documented from 1770 to 1771. An honorable mention in a competition held at the Academia de Parma helped him obtain religious commissions in Saragossa, where he settled by June 1771.

On 25 July 1773, Goya married in Madrid Josefa Bayeu, the sister of Francisco Bayeu, the leading Spanish artist at court. Bayeu greatly assisted Goya's career by obtaining for him a position at the royal tapestry factory, for which Goya executed sixty-three cartoons by 1792 (thirty-nine of them before 1780). Vivid colors and intense luminosity distinguish such cartoons as *The Parasol* (Prado, Madrid) from those of his competitors. Goya published in July 1778 his first serious group of prints: nine etchings after paintings by Velázquez in the royal collection. He was unanimously elected to the Academia in Madrid in May 1780, on the basis of *Christ on the Cross* (Prado, Madrid), a conventional neoclassical painting; he was appointed deputy director of the Academia in March 1785.

Goya's contemporaries esteemed him most highly as a portraitist. He received his first important portrait commissions in 1783 from the Conde de la Floridablanca and the Infante Don Luis. The works which Goya executed for the Infante include the portrait of his daughter, *María Teresa de Borbón y Vallabriga, later Condesa de Chinchón* (NGA 1970.17.123). Goya quickly became established as a portraitist of the leading members of Madrid society. Influenced by portraits of Velázquez and of contemporary French and English artists, he developed a dignified, elegant style of portraiture, which is exemplified by

The Marquesa de Pontejos (1937.1.85). Delicate pastel tones predominate in many of the early portraits. In 1786 Charles III appointed Goya painter to the king; shortly after his coronation in 1789, Charles IV made him court painter.

Near the end of 1792 Goya fell victim to a mysterious illness that incapacitated him for much of the following year, left him permanently deaf, and caused him to reevaluate his goals as an artist. In January 1794 Goya sent Don Bernardo de Iriate, Vice-Protector of the Academia, *Yard with Lunatics* (Meadows Museum and Gallery, Southern Methodist University, Dallas) and eleven other small paintings "in which I have managed to make observations for which there is normally no opportunity in commissioned works which give no scope for fantasy and invention."[1] Goya subsequently developed fantasy and invention into powerful social commentary in the *Caprichos,* a series of eighty etchings offered for sale early in 1799. The combination of realistic observation and brutal distortion gives extraordinary power to the scenes drawn both from daily life and from his imagination. Their sardonic criticisms of the existing social order made the prints controversial, and Goya quickly withdrew them from sale.

Between 1797 and 1799 Goya portrayed Gaspar Melchor de Jovellanos (Prado, Madrid) and other important liberal intellectuals, some of whose ideas probably are illustrated in the *Caprichos.* In his portrait of Jovellanos, Goya interpreted the statesman's melancholy expression with a depth of feeling rare in his earlier portraits but increasingly common in his later works. Dark backgrounds enhance the somber mood of many of the portraits of the late 1790s.

Jovellanos, Minister of Grace and Justice from November 1797 to August 1799, helped Goya to obtain the commission for the frescoes in the hermitage church of San Antonio de la Florida, Madrid, executed between 1797 and 1798. Goya reversed the usual baroque arrangement by depicting angels below the dome in which he represented Saint Anthony performing a miracle. The vigorous brushwork and the

1979–1980, 67–68, no. 18. On loan to the National Gallery, London, 1982–1983. On loan to the State Hermitage Museum, Leningrad, 1986. *Goya: The Condesa de Chinchón and Other Paintings, Drawings, and Prints from Spanish and American Private Collections and the National Gallery of Art,* National Gallery of Art, Washington, 1986–1987, brochure, not paginated. *Goya and the Spirit of Enlightenment,* Prado, Madrid; Museum of Fine Arts, Boston; The Metropolitan Museum of Art, New York, 1988–1989, no.9.

BORN ON 11 September 1762, Doña María Ana de Pontejos y Sandoval was the only child of Don Antonio Bruno de Pontejos y Rodriguez and María Vicenta de Sandoval.[7] The Pontejos family was very wealthy and had residences in Madrid, Cádiz, Santander, and Torrejón de Ardoz. Doña María Ana became the fourth Marquesa de Pontejos upon the death of her father in 1807.[8]

She was married three times, first in 1786 to Francisco de Monino y Redondo, Spanish ambassador to Portugal and brother of the Conde de la Floridablanca, first minister to the king between 1777 and 1792. At the time of Doña María Ana's marriage to Monino, Floridablanca was at the height of his political influence;[9] as his sister-in-law, Doña María Ana moved in the highest court circles. In 1787 she was made an honorary member of the Real Sociedad Económica (Royal Society of Economics). Following Floridablanca's dismissal from the government in 1792, Monino and Doña María Ana were exiled to Murcia for a brief period.

Shortly after Monino's death, Doña María Ana married Don Fernando de Silva y Meneses, a royal bodyguard from a distinguished Sevillan family. Widowed again in January 1817, she married in September of the same year her most famous husband, Joaquín Pérez Vizcaino y Moles (1790–1840), with whom she shared her titles.[10] In 1820 Vizcaino joined the national militia, which opposed King Ferdinand VII. He and his wife were forced to flee Spain in 1822 as a result of his outspoken support of liberal reforms.[11] During their long exile, the marqués and marquesa traveled throughout Europe. They were able to return to Spain in 1833 after Francisco Tadeo Calomarde and other conservative government ministers were removed from office. After Doña María Ana's death on 18 July 1834, Vizcaino used her estate to help finance business ventures such as the foundation of the important bank Caja de Ahorros and charitable projects such as construction of housing for the homeless. Vizcaino was active in politics and served as mayor of Madrid.

In Goya's painting, the marquesa, accompanied by a pug dog, stands before a vaguely defined bluish-green setting. In her right hand she holds a pink carnation; in her left, a closed fan. Her silvery gray tulle dress with a skirt *à panier* is decorated with pink roses and pink ribbons. The dress, the straw hat, and the elaborate powdered hairstyle imitate the fashions promoted by Marie-Antoinette.[12] In the second half of the eighteenth century Spanish noblewomen preferred French fashions but only wore them on their private estates because many Spaniards found the adoption of foreign styles offensive and unpatriotic.[13] The extreme narrowness of the marquesa's waist has been described as deliberately satirical.[14] However, the narrow waist corresponds with the heavy corseting fashionable among Spanish noblewomen throughout the eighteenth century;[15] extremely narrow waists are shown in many other contemporary portraits of Spanish court ladies.[16]

It is likely that Goya executed the portrait on the occasion of the marquesa's first marriage in 1786. This date accords with her probable age, the character of the costume, and the evolution of the artist's style.[17] The warm silvery tones, accented by pinks, help to create a sensuous mood appropriate for a wedding portrait. It seems probable that the flowers were intended to allude to the marquesa's marriage. Roses are well-known symbols of both sensual and spiritual love.[18] A carnation has often been considered to be an ideal image of pure love, untainted by carnal lust,[19] and it might therefore be an especially suitable flower for a young bride to carry.

It has often been supposed that Goya's representation of the lavishly dressed marquesa before a park setting was influenced by the work of such prominent French and British artists as Boucher, Fragonard, Reynolds, and Gainsborough.[20] However, it is very difficult to identify a specific borrowing from any of these artists. Goya seems to have utilized formulae that were common throughout Europe, including Spain. The park setting and the detailed rendering of the elaborate costume are typical of Spanish court portraits of women throughout the eighteenth century.[21]

The vague, painterly treatment of the background differs from the precisely rendered settings of earlier eighteenth-century Spanish court portraits and might seem to follow Gainsborough's methods. The setting, however, which has been virtually reduced to a stylized flat backdrop, is considerably more simplified than the landscapes in Gainsborough's portraits.[22]

The influence of Velázquez can be noted in Goya's presentation of Doña María Ana. The firmly erect

posture, the stiffness of the outstretched arms, and the direct but aloof gaze correspond to Velázquez' royal portraits.[23] In these respects, the depiction of the marquesa differs significantly from earlier eighteenth-century portraits of Spanish noblewomen, who were generally shown with a strongly pronounced smile and in a dancelike stance based on diagonals.[24]

The contrast between the emotional aloofness of the marquesa and the emphasis on her physical presence helps to endow the painting with a sense of tension that enhances its impact. By representing the marquesa dressed in a French costume and posed in a way that vividly recalls Velázquez' portraits, Goya mirrored the situation of the marquesa and other members of Floridablanca's circle, who strove to reconcile French ideas with Spanish beliefs and traditions.[25]

The portrait seems to glisten and shimmer because of the light tones and the greatly varied brushwork, which was probably influenced by Velázquez. The paint is applied most freely in the background, where large, thin, fluid strokes are used and where marks of the brush are evident. At the opposite extreme, the smooth handling of paint in the face of the marquesa contributes to her sense of aloofness. Goya was able to convey the appearance of the dress accurately, even though he boldly juxtaposed dense and thin strokes throughout the costume.

Near the beginning of this century, Beruete saw a version of this portrait in the possession of an art dealer in Madrid,[26] but no further trace of it has been found. A drawing of the marquesa by or after Goya was owned in 1945 by José Lázaro, Madrid; its present whereabouts are unknown.[27]

R.G.M.

Notes

1. Cook, "Spanish Paintings," 152, n. 2.
2. On Vizcaino's life and career and on his inheritance of his wife's estate, see Eduardo C. Puga, "El Marqués de Pontejos," *La ilustración española y americana* 39 (8 May 1895), 286–287.
3. Yriarte 1867, 139. Basic biographical information about the members of the house of Pontejos is given by Alberto and Arturo García Carraffa, *Diccionario heráldico y genealógico de apellidos españoles y americanos,* 88 vols. (Madrid, 1919–1963), 71: 137–140; Juan Moreno de Guerra y Alonso, *Guía de la grandeza* (Madrid, 1917), 228–229.
4. Exh. cat. Madrid 1900, no. 92. The painting was also recorded in her possession by Benusan 1901, 156; Calvert 1908, no. 215; Lafond 1910, 6; Stokes 1914, 338, no. 251; Beruete 1915, 39; Loga 1921, 200, no. 307; *Colección de Goya* 1924, no. 58.
5. Exh. cat. Madrid 1928, 23, no. 18.
6. Lively accounts of the negotiations involved in this

sale are given by Finley 1973, 21–22; Walker 1974, 125.
7. Information about Doña María Ana's life is based on Beruete 1915, 39; Cook, "Spanish Paintings," 152–153; García Carraffa 1919–1963, 71: 139; exh. cat. Bordeaux-Paris-Madrid 1979–1980, 67–68; Nigel Glendinning in exh. cat. Madrid-Boston-New York 1988–1989, 9–12, no. 9. Glendinning now provides the most comprehensive treatment of Doña María Ana's life.
8. Doña María Ana had previously inherited the title of Condesa de la Ventosa upon the death of her mother in 1801. On the origins of her titles, see especially exh. cat. Madrid-Boston-New York 1988–1989, 9–12, no. 9.
9. On Floridablanca's ministry, see Richard Herr, *The Eighteenth-Century Revolution in Spain* (Princeton, 1958), 22, 27–28, 33–36, 50–51, 78, 115–117, 131, 133, 173, 220–221, 232, 234, 240–244, 256–266.
10. On Vizcaino, see Puga 1895, 286–287; *Enciclopedia universal ilustrada europeo-americana,* vol. 79 (Bilbao, 1930), 814–815.
11. They were recorded in Paris in November 1822. See exh. cat. Madrid-Boston-New York 1988–1989, 10–12, no. 9.
12. On the fashions promoted by Marie-Antoinette, see André Blum, *Les modes au XVIIe et au XVIIIe siècles* (Paris, 1928), 77–85.
13. Fernando Diaz Plaja, *La vida española en el siglo XVIII* (Barcelona, 1946), 186–205.
14. See, for example, Licht 1979, 224–225.
15. Diaz Plaja 1946, 196.
16. For instance, in the portrait of Doña María Amalia de Sajonia (wife of Charles III) by Louis Silvestre le jeune (Prado, Madrid; Francisco Javier Sánchez Cantón and José Pita Andrade, *Los retratos de los reyes de España* [Barcelona, 1948], pl. 151).
17. Sánchez Cantón 1951, 35–36, 153–154. The deliberate artificiality and the harmonious pale tones of the background can be compared to Goya's treatment of the settings in such approximately contemporary tapestry cartoons as *The Swing* (1787, collection of duque de Montellano, Madrid). The handling of paint, the stiffness of the pose, and the direct concentration on the figure can be compared to other portraits by Goya in the late 1780s, such as that of the family of the duque de Osuna (1789, Prado, Madrid).
18. Rosemary Cotes, *Dante's Garden with Legends of the Flowers* (London, 1899), 17–20; Elizabeth Haig, *The Floral Symbolism of the Great Masters* (London, 1913), 71–82.
19. Haig 1913, 84–85.
20. Benusan 1901, 156; Mayer 1923 (see Biography), 58–59; Constable 1928, 307; Sánchez Cantón 1930, 97; Cook, "Spanish Painting," 153; Walker 1963, 232; Trapier 1964, 4; exh. cat. Bordeaux-Paris-Madrid 1979–1980, 68.
21. For instance, Jean Ranc's portrait of Doña María Bárbara de Braganza, wife of Fernando VI (Prado, Madrid; Sánchez Cantón and Pita Andrade 1948, pl. 148); and Anton Rafael Mengs' portraits of the Marquesa de Llano (Real Academia de Bellas Artes de San Fernando, Madrid; Max Osborn, *Die Kunst des Rokoko* [Berlin, 1929], pl. 421); of María Luisa de Borbón (*Angelika Kauffmann und ihre Zeitgenossen* [exh. cat., Vorarlberger Landesmuseum and Österreichisches Museum für Angewandte Kunst] [Bregenz and Vienna, 1968–1969], pl. 176), and of the Marquesa de los Glanos (Prado, Madrid; repro. at The Frick Art Reference Library, New York).
22. In this regard, Goya's portrait could be compared to Gainsborough's portrait of Mrs. Grace Dalrymple Elliott

(1778, The Metropolitan Museum of Art, New York; Ellis Waterhouse, *Gainsborough* [London, 1958], pl. 184). Because Goya probably knew Gainsborough's portraits only through prints, it is unlikely that he would have been able to appreciate fully the painterly qualities of their landscape settings.

23. These qualities can be noted in such paintings as Velázquez' portrait of Queen Mariana, now in the Prado (Jonathan Brown, *Velázquez: Painter and Courtier* [New Haven, 1986], fig. 259 [color]).

24. This is true of the paintings cited in notes 16 and 21 and of numerous other portraits as well, such as Jean Ranc's portrait of Doña Isabel Farnesi (Prado, Madrid; Sánchez Cantón and Pita Andrade 1948, pl. 140).

25. On their attempt to synthesize French and Spanish culture, see Herr 1958, especially 37–85, 154–168, 181–200, 229–230.

26. Beruete 1915, 173, no. 95.

27. Cook, "Spanish Painting," 153, fig. 1. Compare Gassier and Wilson 1971, 78, no. 221.

References

1867. Yriarte, Charles. *Goya, sa biographie et le catalogue de l'oeuvre.* Paris: 139.

1887. Viñaza (see Biography): 271, no. 158.

1901. Benusan, Samuel Levey. "A Note upon the Paintings of Francisco José Goya." *The Studio* 24: 156, repro. 158.

1902. Benusan, Samuel·Levey. "Goya: His Times and Portraits." *Conn* 4: 123.

1907. Oertel, Richard. *Francisco de Goya.* Leipzig: 86, fig. 61.

1908. Calvert, Albert F. *Goya: An Account of His Life and Works.* London: 139, no. 215, pl. 88.

1910. Lafond, Paul. *Goya.* Paris: 6, pl. 43.

1914. Stokes, Hugh. *Francisco Goya.* London: 168, 338, no. 251.

1915. Beruete (see Biography): 39, 173, no. 94, pl. 9 (also English ed. 1922: 47–48, 207, no. 101, pl. 9).

1921. Loga, Valerian von. *Francisco de Goya.* Munich: 58–59, 70, 199, no. 388, fig. 64.

1924. *Colección de cuatrocientos y nueve reproducciones de cuadros, dibujos, y aquafuertes de Don Francisco de Goya precididas de un epistolario del gran pintor y noticias biográficas por Don Francisco Zapatar (1860).* Madrid: no. 58.

1928. Constable, William George. "The Goya Exhibition at Madrid." *BurlM* 52: 307.

1928–1950. Desparmet Fitz-Gerald (see Biography). 2: 49, no. 330; vol. 1 of plates: pl. 257.

1930. Sánchez Cantón, Francisco Javier. *Goya.* Paris: 37, 70, 96–97, pl. 15.

1937. Cortissoz, Royal. *An Introduction to the Mellon Collection.* Boston: 43.

1937. Frankfurt, Alfred. "The Mellon Gift to the Nation." *ArtN* 35 (January): 13.

1941. Ritchie, Andrew Carnduff. "The Eighteenth Century in the National Gallery: Italian, English, French, and Spanish Masters." *ArtN* 40 (June): 39, repro. 20.

1944. Cairns and Walker: 128, color repro. 129.

1945. Cook, "Spanish Paintings:" 151–153, fig. 2.

1949. Mellon: 50, no. 85, repro.

1951. Sánchez Cantón (see Biography): 35–36, 38, 153–154, pl. 17.

1955. Gassier, Pierre. *Goya.* Paris: 32, 96.

1958. Gaya Nuño, *La pintura española*: 159, no. 897, pl. 253.

1961. Havemeyer, Louisine B. *Sixteen to Sixty: Memoirs of a Collector.* New York: 167.

1963. Walker: 232, color repro. 233.

1964. Trapier (see Biography): 4, 52, no. 5, figs. 5–6.

1966. Cairns and Walker. 2: 342, color repro. 343.

1971. Gassier and Wilson (see Biography): 30, 61–62, 78, no. 221, color repro. 62, repro. 94 (also 1981 ed.: 30, 62–63, 78, no. 221, color repro. 62, repro. 94).

1971. Gudiol (see Biography). 1: 76–77, 258, no. 266; 2: fig. 382, color fig. 383.

1973. Finley, David Edward. *A Standard of Excellence: Andrew W. Mellon Founds the National Gallery in Washington.* Washington: 21–22, repro. 20.

1974. de Angelis, Rita. *L'opera pittorica completa di Goya.* Milan: 101, no. 185, color pl. 10.

1974. Walker, John. *Self-Portrait with Donors.* Boston: 125, repro. 126.

1979. Baticle, Jeannine, "L'art européen à la cour d'Espagne au XVIIIᵉ siècle." *RLouvre* 29: 320, fig. 3.

1979. Conisbee, Philip. "Art from Spain at the Grand Palais." *BurlM* 121: 821.

1979. Descargues, Pierre. *Goya.* London: 77.

1979. Licht, Fred. *Goya: The Origins of the Modern Temper in Art.* New York: 144, 224–225, fig. 105.

1979. Salas, Xavier de. *Goya.* Translated by G. T. Culverwell. London: 177, no. 156, color repro. 36.

1980. López-Rey, José. "Chronique des arts: Espagne." *GBA* 115: 14.

1981. Glendinning, Nigel. "Goya's Patrons." *Apollo* 114: 241.

1983. Gállego, Julián. "Los retratos de Goya." *Goya en las colecciones madrileñas.* Exh. cat., Prado. Madrid: 55, fig. 24.

1984. Camón Aznar, José. *Francisco de Goya.* 4 vols. Saragossa, 2: 47–50, color repro. 29.

1937.1.88 (88)

Señora Sabasa Garcia

c. 1806/1811
Oil on canvas, 71 x 58 (28 x 22⅞)
Andrew W. Mellon Collection

Technical Notes: The support is a medium-weight plain-weave fabric, probably linen, lined to another fabric of the same type. The tacking margins have been removed, and there is cusping along the edges. The grayish white ground and the paint layers are of moderate thickness. Small lumps scattered in the background are probably caused by slubs in the canvas weave. Areas of old repaint in the face and hands have turned white.

Provenance: Remained in the possession of the sitter until her death;[1] by descent to Mariana García Soler, her goddaughter, Madrid;[2] sold by Dr. Sota, her husband, to Don José Joaquín Herrero, Madrid;[3] Dr. James Simon, Berlin, by 1908;[4] Count Paalen, Berlin; Heinrich Sklarz, Berlin, by

1923;[5] (Duveen Brothers, New York);[6] purchased 21 February 1930 by Andrew W. Mellon, Pittsburgh and Washington;[7] deeded 28 December 1934 to The A. W. Mellon Educational and Charitable Trust, Pittsburgh.

Exhibitions: *Porträtaustellung,* Kaiser Friedrich Museens Verein, Berlin, 1908–1909, no. 91, as *Junge Mädchen. A Century of Progress Exhibition of Paintings and Sculpture,* The Art Institute of Chicago, 1934, 12, no. 68. *A Loan Exhibition of Paintings by Goya,* M. Knoedler & Co., New York, 1934, no. 8. *Bilder vom Menschen in der Kunst des Abendlandes,* Nationalgalerie, Berlin, 1980, 187, no. 42. *Goya: The Condesa de Chinchón and Other Paintings, Drawings, and Prints from Spanish and American Private Collections and the National Gallery of Art,* National Gallery of Art, Washington, 1986–1987, brochure, not paginated.

THE SUBJECT of this portrait was first identified as Sabasa Garcia by Juan Allende Salazar.[8] His proposal has been accepted by most subsequent scholars, although Harris and Camón-Aznar have questioned it.[9] Full documentation for this painting is lacking, but the identification of the sitter seems reasonable on the basis of its provenance.

Before 1806 Goya had represented Sabasa Garcia's uncle, Evaristo Pérez de Castro, in a portrait now in the Louvre.[10] According to Allende Salazar, Goya first saw Sabasa Garcia at Pérez' house and asked permission to paint her because he was fascinated by her beauty.[11] Whether or not this is true, it seems likely that the artist's association with Pérez helped him secure the opportunity to paint Sabasa. She was close to her uncle, whom she appointed executor of her estate in all her wills dated prior to his death in 1848.[12]

Sabasa Garcia was the name by which Maria Garcia Pérez de Castro was known to her close friends.[13] She was born in 1790 in Madrid to José Joaquín Garcia Noriega and his wife, Nicasia Pérez de Castro. In 1820 she married Juan Peñuelas (1790–1850), who owned large estates in Iruegas but lived in Madrid. The provisions of several wills made by the couple between 1823 and 1850 indicate that their country estates provided them with a substantial income. During the 1840s, Peñuelas was awarded the Order of Isabel la Católica and made a knight of the Order of Carlos III. The last documentary reference to Sabasa Garcia is her will of 14 May 1850, but the exact date of her death in uncertain.

Judging by Sabasa Garcia's appearance in the National Gallery's painting, it seems likely that Goya portrayed her sometime between 1806 and 1811. Before Valverde Madrid had established her birthdate, scholars had assigned the painting on stylistic grounds to these years.[14] The depiction of the figure against a neutral background without any attributes of rank corresponds with the format of many other portraits of the early nineteenth century, such as *Young Lady Wearing a Mantilla and a Basquiña* (1963.4.2) and *Eugenio de Guzmán Palafox y Porto-carrero, Count of Teba* (The Frick Collection, New York).[15] During this period, Goya increasingly treated portraits as intense psychological studies.

The directness and simplicity of Goya's representation of Sabasa Garcia create a sense of immediacy. The half-length figure, clad in a shawl with bright yellow stripes, stands out vividly against the dark background. The thick, roughly applied paint in the shawl and the bold white impasto highlights in the transparent veil help to set off the smooth handling of paint in the face. The seriousness of Sabasa's demeanor enhances the impact of her large brown eyes, which seem to stare directly and forcefully out at the viewer. The portrait is a moving evocation of a recurring theme of Romantic literature: the unexpected power and fascination of a young woman, arising from her beauty, freshness, and intense awareness of life.[16]

R.G.M.

Notes

1. Valverde Madrid 1983, 109.

2. Valverde Madrid 1983, 108–109.

3. Trapier 1964, 55, no. 59; Valverde Madrid 1983, 108–109.

4. Hadeln 1908, 203.

5. Mayer 1923, 206, no. 499.

6. *Duveen* 1941, no. 235.

7. Photocopy of David Finley's notebook, in NGA curatorial files.

8. G. H. McCall, librarian of Duveen Brothers, Inc., to John Walker, 19 March 1940; F. J. Sánchez-Cantón to John Walker, 20 April 1940, both in NGA curatorial files. Allende Salazar identified the subject while it was at Duveen's New York galleries. Cook, "Spanish Paintings," 161, was the first publication of Allende Salazar's proposal.

9. Harris 1969, 87, no. 26; Camón Aznar 1984, 3: 156, point out that no documents establish the identity of the sitter.

10. Gudiol 1971, 4: figs. 835, 836. The reasons for dating the portrait of Pérez before 1806 are summarized by Valverde Madrid 1983, 108.

11. Cook, "Spanish Paintings," 161.

12. Valverde Madrid 1983, 108.

13. Valverde Madrid 1983, 108–109, is the source of the biography outlined here. Before Valverde's publication of his investigations concerning Sabasa Garcia, very little was known about her.

14. See, for example, Cook, "Spanish Paintings," 161. Valverde Madrid 1983, 108, suggests that Goya's representation of Sabasa Garcia without jewelry indicates that the portrait must be dated before her marriage.

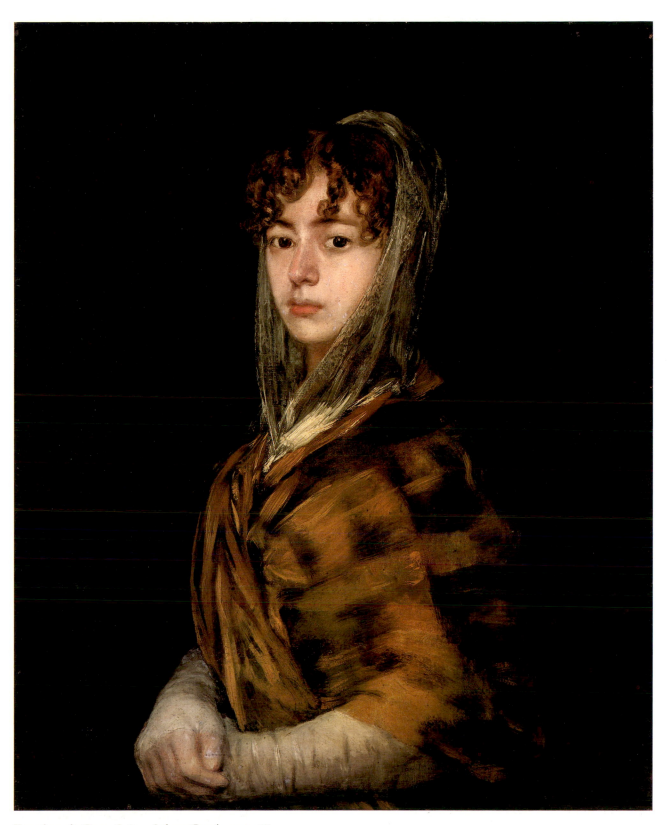

Francisco de Goya, *Señora Sabasa García*, 1937.1.88

15. Trapier 1964, figs. 46–47.

16. Among the many fictional characters who illustrate this theme are Julie in Rousseau's *Nouvelle Héloïse* and Lotte in Goethe's *Sorrows of Young Werther*. Natasha in Tolstoy's *War and Peace* brings this theme to a culmination.

References

1908–1909. Hadeln, Detlev Freiherrn von. "Die Porträtausstellung des Kaiser Friedrich Museens Verein." *ZfK* 44: 203, repro. 197.

1915. Beruete (see Biography): 120, 179, no. 220 (also English ed. 1922: 123, 213, no. 228).

1923. Mayer (see Biography): 80, 206, no. 499.

1928. Pantorba, Bernardino de [José López Jiminez]. *Goya*. Madrid: 96.

1930. Sánchez Cantón, Francisco Javier. *Goya*. Paris: 70, pl. 46.

1930. Valentiner, Wilhelm R. *Die unbekannte Meisterwerke in öffentlichen und privaten Sammlungen*. Berlin: no. 91, repro.

1934. Siple, Ella S. "A Goya Exhibition in America." *BurlM* 64: 228, fig. B.

1937. Cortissoz, Royal. *An Introduction to the Mellon Collection*. Boston: 43.

1937. Croninshield, Frank. "The Singular Case of Andrew W. Mellon." *Vogue* (1 April): 74, 142–143, color repro. 75.

1941. *Duveen Pictures in Public Collections of America*. New York: no. 235, repro.

1941. NGA: 90, no. 88.

1945. Cook, "Spanish Paintings:" 160–161, fig. 7.

1949. Mellon: 47, no. 88, repro.

1951. Sánchez Cantón (see Biography): 104, pl. 59.

1952. Cairns and Walker: 130, color repro. 131.

1958. Gaya Nuño, *La pintura española*: 171, no. 1021.

1964. Trapier (see Biography): 33, 55, no. 59, pl. 59.

1966. Cairns and Walker. 2: 344, color repro. 345.

1969. Harris, Enriqueta. *Goya*. London: 9, 87, no. 26, color pl. 26.

1971. Gassier and Wilson (see Biography): 158, 167, 198, no. 816, color repro. 155 (also 1981 ed.: 158, 167, 198, no. 816, color repro. 155).

1971. Gudiol (see Biography). 1: 132, 309, no. 527; 4: color fig. 832.

1974. de Angelis, Rita. *L'opera pittorica completa di Goya*. Milan: 119, no. 447, color pl. 33.

1979. Licht, Fred. *Goya: The Origins of the Modern Temper in Art*. New York: 247–248, 257, fig. 123.

1979. Salas, Xavier de. *Goya*. Translated by G. T. Culverwell. London: 102, 190, no. 381, repro. 96.

1983. Valverde Madrid, José. "El Retrato de doña Sabasa Garcia por Goya." *Goya* 177: 108–109, repro. 169.

1984. Camón Aznar, José. *Francisco de Goya*. 4 vols, Saragossa, 3: 156–157.

1941.10.1 (548)

Bartolomé Sureda y Miserol

c. 1803/1804
Oil on canvas, 119.7 x 79.3 (47⅛ x 31¼)
Gift of Mr. and Mrs. P. H. B. Frelinghuysen in memory of her father and mother, Mr. and Mrs. H. O. Havemeyer

Technical Notes: The painting is executed over a reddish brown ground of average thickness and is in very good condition except for small discolored retouches in the jacket and face and in the background. The paint is applied in a quick and assured manner; in many areas, the application is thin, allowing the ground color to show through the brushstrokes. The impastoed highlights still retain a good deal of the texture and were not flattened by the relining. The painting is close to its original size, having lost only the tacking edges.

Provenance: Possibly Pedro Escat, Palma de Mallorca.[1] Sureda family, Madrid, before 1907.[2] Louisine W. Havemeyer [1855–1929], New York.[3] By descent to her daughter, Mrs. P. H. B. Frelinghuysen [née Adaline Havemeyer, 1884–1963], Morristown, New Jersey.

Exhibitions: *Loan Exhibition of Paintings by El Greco and Goya*, M. Knoedler & Co., New York, 1915, no. 9. *Francisco Goya, His Paintings, Drawings and Prints*, The Metropolitan Museum of Art, New York, 1936, no. 8. *Goya: The Condesa de Chinchón and Other Paintings, Drawings, and Prints from Spanish and American Private Collections and the National Gallery of Art*, National Gallery of Art, Washington, 1986–1987, brochure, not paginated. *Goya and the Spirit of Enlightenment*, Prado, Madrid; Museum of Fine Arts, Boston; The Metropolitan Museum of Art, New York, 1988–1989, no. 65.

BARTOLOMÉ SUREDA (1769–1850) was born in Palma de Mallorca.[4] After beginning the study of art in Palma, he moved to Madrid to continue his training at the Real Academia de San Fernando, in which he enrolled on 2 November 1792.[5] There he met Agustín de Betancourt, the great Spanish engineer and mechnical designer, who discovered Sureda's potential as an industrial draftsman and administrator. Sureda accompanied Betancourt to England in 1793 to study manufacturing techniques, returning to Spain in 1796.

While in England, Sureda learned a new method of aquatint, an example of which was shown by Betancourt to the Real Academia on 5 March 1797.[6] His son Alejandro later reported that Sureda had taught a new graphic technique to Goya, which is usually assumed to have been mezzotint, but was almost

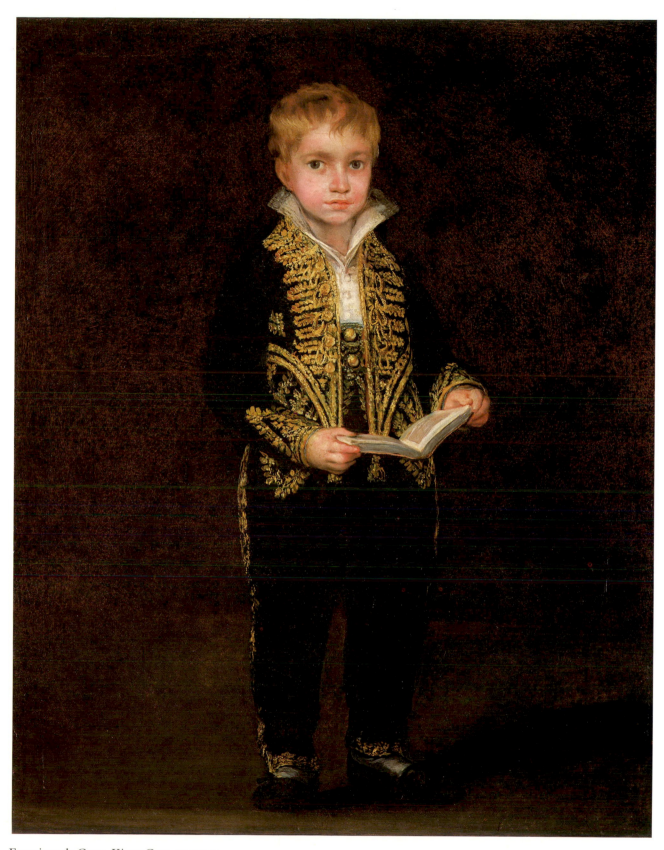

Francisco de Goya, *Victor Guye*, 1956.11.1

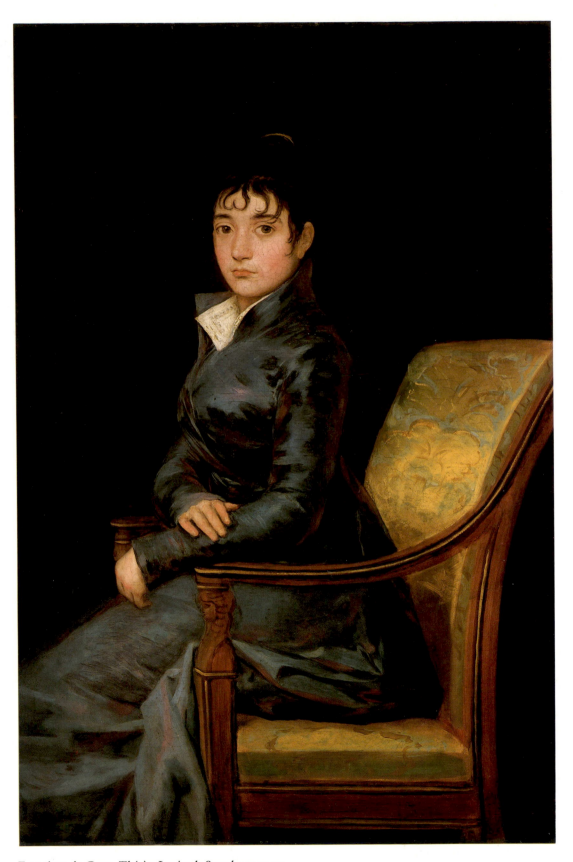

Francisco de Goya, *Thérèse Louise de Sureda*, 1942.3.1

1942.3.1 (549)

Thérèse Louise de Sureda

c. 1803/1804
Oil on canvas, 119.7 x 79.4 (47⅛ x 31¼)
Gift of Mr. and Mrs. P. H. B. Frelinghuysen in memory of her father and mother, Mr. and Mrs. H. O. Havemeyer.

Technical Notes: The support is a medium-weight, plain-weave fabric, lined to an auxiliary fabric. A smooth, light colored ground has been applied overall. The paint surface is in good condition except along the right edge, where there is a series of fairly regular horizontal cracks, suggesting that the painting may have been rolled up at one time. Some flattening of the paint surface occurred during the relining. The varnish, which is slightly pigmented, is dull and disfigured by bloom. The original tacking margins have been removed.

Provenance: same as 1941.10.1

Exhibitions: *Loan Exhibition of Paintings by El Greco and Goya,* M. Knoedler & Co., New York, 1915, no. 10. *Francisco Goya, His Paintings, Drawings and Prints,* The Metropolitan Museum of Art, New York, 1936, no. 9. *Goya: The Condesa de Chinchón and Other Paintings, Drawings, and Prints from Spanish and American Private Collections and the National Gallery of Art,* National Gallery of Art, Washington, 1986–1987, brochure, not paginated.

LITTLE IS KNOWN of the sitter, who was born as Thérèse Louise Chapronde Saint Amand in France.[1] She was a friend from childhood of the renowned horologist and designer of scientific instruments, Abraham-Louis Bréguet. Bréguet, in turn, was a friend of Bartolomé Sureda's protector, Agustín de Betancourt, and it is probably through this friendship that Sureda met his future wife.

The Bréguet archive preserves fourteen letters from Thérèse Louise (who signed as "Louise") to the Bréguet family in Paris; the earliest is dated 1803, the latest 1831, after the Suredas had retired to Mallorca.[2] The letters written between 1803 and 1808 often touch on the affairs of Betancourt and his French wife, who was thoroughly disliked by Señora Sureda for her extravagant ways, but especially because Señora de Betancourt considered the Suredas to be socially inferior and excluded them from her circle of friends. Thérèse Sureda's occasionally scathing assessments of Señora de Betancourt's conduct fit well with her character as represented in Goya's picture, which ranks among his masterpieces of portraits of female subjects.

The sitter's costume, a tunic of changing blue silk over a white chemise, is influenced by the short-waisted fashions of the empire style.[3] Her hair is oiled and arranged in curls low on the forehead, or in the "antique" manner current in French fashion around 1800. The armchair with caryatid support and sloping back is also in the French empire style.[4] Here, as in the companion portrait, Goya shows the sitter as a follower of the current French fashions.[5]

J.B.

Notes

1. For what is known of the sitter's biography, see José García Diego, "Huellas de Agustín de Betancourt en los Archivos Bréguet," *Anuario de estudios atlánticos* 21 (1975), 12–16, 29–35; Antonio Rumeu de Armas, *Ciencia y tecnología en la España ilustrada: La escuela de Caminos y Canales* (Madrid, 1980), 325–326, 334.
2. García Diego 1975, 29–35.
3. For the costume, see Millia Davenport, *The Book of Costume,* 2 vols. (New York, 1948), 2: 808, no. 2259, repro.
4. For the chair, see Madeleine Jarry, *Le siège français* (Fribourg, 1973), 284–286, fig. 286.
5. For the date of the portrait, see the discussion of 1941.10.1.

References

1867. Yriarte, Charles. *Goya, sa biographie et le catalogue de l'oeuvre.* Paris: 148.
1887. Viñaza (see Biography): 263, no. 121.
1902. Lafond, Paul. *Goya.* Paris: 138, no. 215.
1903. von Loga, Valerian. *Francisco de Goya.* Berlin: 204.
1908. Calvert, Albert. *Goya: An Account of His Life and Works.* London: 140, no. 238.
1915. Beruete (see Biography): 179, no. 214.
1924. Mayer (see Biography): 166, no. 428.
1928–1950. Desparmet Fitz-Gerald (see Biography). 2:221, nos. 5, 10, pl. 424.
1931. *H. O. Havemeyer Collection: Catalogue of Paintings, Prints, Sculpture and Objects of Art.* Portland, Maine: 314, repro. 315.
1945. Cook, "Spanish Paintings:" 156–160, fig. 6.
1961. Havemeyer, Louisine W. *Sixteen to Sixty: Memoirs of a Collector.* New York: 136.
1964. Trapier (see Biography): 31–33, Figs. 57–58.
1970. Gassier and Wilson (see Biography): 198, no. 814, repro. (also 1971 ed: 198).
1971. Gudiol (see Biography). 1: 311, no. 534, fig. 840.
1974. de Angelis, Rita. *L'opera pittorica completa di Goya.* Milan: 119, no. 446, color pl. 31.
1979. Salas, Xavier de. *Goya.* Translated by G. T. Culverwell. London: 95, 102, no. 379, repro.
1984. Camón Aznar, José. *Francisco de Goya.* 4 vols. Saragossa, 3:159.

Notes

1. The ownership by Escat is first mentioned by Yriarte 1867, 148, and is noted in Viñaza 1887 (see Biography), 263, nos. 120–121.

2. Although Calvert 1908, 140, states that the paintings were then still in the Sureda family, Havemeyer 1961, 136, implies that the portraits were purchased before her husband's death in 1907. Mrs. Havemeyer also implies that the Sureda portraits were purchased in Spain by quoting the price of acquisition in pesetas, which casts doubt on the ownership by Durand-Ruel, Paris, cited by Desparmet-Fitzgerald 1928–1950: 2, 220.

3. In exh. cat. New York 1912, nos. 9–10, the portraits are erroneously listed as being "previously in the collection of D. Sureda, Seville."

4. The most complete, reliable account of Sureda's career is found in Antonio Rumeu de Armas, *Ciencia y tecnología en la España ilustrada: La escuela de Caminos y Canales* (Madrid, 1980), much of which comes from the "Expediente personal de B. Sureda," Archivo de Palacio, Madrid, case 1019/24. The additional information from published and archival sources used in this entry was generously provided by Professor Ernest Lluch.

5. See Enrique Pardo Canalis, *Registros de matrícula de la Academia de San Fernando, de 1752 a 1815* (Madrid, 1967), 208.

6. For a transcription of the minutes of the session, see Pedro García Ormaechea y Casanovas, "Betancourt y la Academia de Bellas Artes; III: La actividad de Betancourt hasta 1800," *Revista de Obras Públicas* 112 (1964), 943. For the technique see *Descripción de las máquinas de más general utilidad que hay en el Real Gabinete de ellas establecido en el Buen Retiro hecha de órden de S. M. Número II, Máquina para hacer clavos* (Madrid, 1798), 19. According to Ernest Lluch the author is Juan López de Peñalver.

7. The anecdote is recorded in the manuscript notes of the Conde de Valencia de Don Juan, who spoke with Alejandro Sureda (1815–1889) after his father's death. The information is reported by Manuel Pérez-Villamil, *Arte e industrias del Buen Retiro* (Madrid, 1904), 47–48, n. 1. As is pointed out by Eleanor Sayre, *The Changing Image: Prints by Francisco Goya* [exh. cat., Museum of Fine Arts] (Boston, 1974), 281, none of Goya's surviving prints is executed in mezzotint, which in any case was invented in the seventeenth century. The description of Sureda's print shown at the Academia in 1797 (cited by García Ormaechea 1964, 943) corresponds to the use of aquatint in the *Caprichos*: "una estampa grabada por don Bartolomé Sureda de un modo que imita perfectamente el labado de la tinta china, que es de la mayor utilidad para los planos de Arquitectura" (a print engraved by don Bartolomé Sureda that imitates perfectly the wash of china ink, and is of the greatest utility for architectural plans); see also *Descripción de las máquinas* 1798. For further information on the introduction of aquatint into Spain, see Reva Wolf, "Francisco Goya and the Interest in British Art and Aesthetics in Late Eighteenth-Century Spain" (Ph.D. diss., New York University, 1987), 110–123.

8. See 1942.3.1 for further discussion.

9. For Sureda's activities at the Buen Retiro porcelain factory from 1803 to 1808, see Pérez Villamil 1904, 45–64; Rumeu de Armas 1980, 355.

10. Archivo General de Simancas, Consejo Supremo de Hacienda, Junta General de Comercio y Moneda, leg. 328, c. 35. This lengthy document contains information on Sureda's activities in Paris during the war years and confirms the high esteem in which he was held by the Spanish government.

11. For Sureda's directorship of the Moncloa factory (successor to the Buen Retiro), see Pérez Villamil 1904, 94–98.

12. For the retirement years of Sureda, and a reproduction of one of his genre scenes, see Gabriel Llabrés, untitled article on Sureda, *Boletín de la Sociedad Luliana* (Palma de Mallorca) 24 (1885), 5–7.

13. Sureda's date of death is documented in Rumeu de Armas 1980, 412.

14. The portraits of Sureda and his wife have been dated as follows: Mayer 1924 (see Biography), 1801–1824; Desparmet Fitz-Gerald 1928–1950 (see Biography), 1820; Trapier 1964 (see Biography), 1807–1808; Gassier and Wilson 1970 (see Biography), 1804–1806; Gudiol 1971 (see Biography), 1803–1806; Salas 1979, c. 1804; Camón Aznar 1984, "poco antes de 1808;" Moreno in exh. cat. Madrid-Boston-New York 1988–1989, 1804–1806.

15. For the costume, see Jules E. J. Quichérat, *Histoire du costume en France depuis les temps les plus reculés jusqu'à la fin du XVIIIe siècle* (Paris, 1877), 637. Sureda's interest in fashion is confirmed in three of the lithographs made in Paris in 1811, which depict current women's costumes (Félix Boix, "La litografía y sus origenes en España," *Arte español* 6 [1925], 280–282.)

16. Trapier 1964, 32, fig. 56.

17. For the Batoni portrait and further discussion of Goya's use of English portraits, see Wolf 1987, 74–75.

References

1867. Yriarte, Charles. *Goya, sa biographie et le catalogue de l'oeuvre.* Paris: 148.

1887. Viñaza (see Biography): 263, no. 120.

1902. Lafond, Paul. *Goya.* Paris: 138, no. 214.

1903. von Loga, Valerian. *Francisco de Goya.* Berlin: 204.

1908. Calvert, Albert. *Goya: An Account of His Life and Works.* London: 140, no. 237.

1915. Beruete (see Biography): 174 (also English ed. 1922, 208).

1924. Mayer (see Biography): 166, no. 427.

1928–1950. Desparmet Fitz-Gerald (see Biography). 2:220, no. 509, pl. 423.

1931. *H. O. Havemeyer Collection: Catalogue of Paintings, Prints, Sculpture and Objects of Art.* Portland, Maine: 313, repro. 312.

1945. Cook, "Spanish Paintings:" 156–160, fig. 5.

1961. Havemeyer, Louisine W. *Sixteen to Sixty: Memoirs of a Collector.* New York: 136.

1964. Trapier (see Biography): 31–33, fig. 55.

1970. Gassier and Wilson (see Biography): 158, repro. 198, no. 813.

1971. Gudiol (see Biography). 1:311, no. 533, fig. 839.

1974. de Angelis, Rita. *L'opera pittorica completa di Goya.* Milan: 119, no. 445, repro. in reverse; color pl. 30.

1979. Salas, Xavier de. *Goya.* London: color repro. 95; 102, no. 378, repro.

1984. Camón Aznar, José. *Francisco de Goya.* 4 vols. Saragossa, 3: 159, color repro. 161.

certainly aquatint.[7] This would explain Goya's masterful tonal effects in the *Caprichos,* published in 1799, unlike his hesitant use of the medium in the prints after paintings by Velázquez of 1778 to 1779.

In 1800 Sureda was sent by the Spanish government to France to study the manufacture of textiles and porcelain; he returned to Spain in September 1803, having married Thérèse Louise Chapronde Saint Amand, the subject of the pendant portrait in the National Gallery of Art.[8] On 18 October 1803, Sureda entered the Real Fábrica de Porcelana del Buen Retiro, and on 8 August 1804 was appointed *director de labores* of this famous porcelain factory.[9] Under Sureda's guidance a new type of hard-paste porcelain was invented, which restored the quality and finances of the operation. In September 1807 Sureda became director, but the French invasion of the following year and subsequent destruction of the factory caused him to emigrate to France, where he and his wife lived from 1809 until the final months of 1814.

Upon his return, Sureda settled in Mallorca and founded a factory for worsted cloth. However, in February 1817 he was called to Madrid to direct the Real Fábrica de Paños in Guadalajara.[10] On 26 March 1821, he became acting director of the Real Fábrica de Loza de la Moncloa, and then, in 1822, permanent director.[11] Four years later he was also made director of the Real Fábrica de Cristales de La Granja. He retired from royal service on 13 November 1829 and went back to his native Mallorca, where he devoted time to painting, a lifelong avocation. He painted landscapes, religious subjects, and genre scenes in the manner of Goya.[12] His death occurred on 10 May 1850.[13]

The portraits of Súreda and his wife are usually dated in the period 1801–1808, although Desparmet thought they were done as late as 1820.[14] As Salas notes, the logical moment for the execution of the portraits would be after Sureda's arrival from Paris. Bartolomé was recalled on 2 September 1803 and is documented as at work in the Buen Retiro factory on 18 October.

This suggestion is confirmed by the costume, which conforms to Parisian fashion from about 1799.[15] It features a close-fitting redingote with deep lapels and high collar in a dark color, a striped waistcoat, a cravat wound several times around the neck, and a high-crowned hat. His hair is worn in a short style known variously as "à la Brutus" or "à la Titus." If the portrait was indeed done shortly after his return from France, the sitter would have been about thirty-five years old.

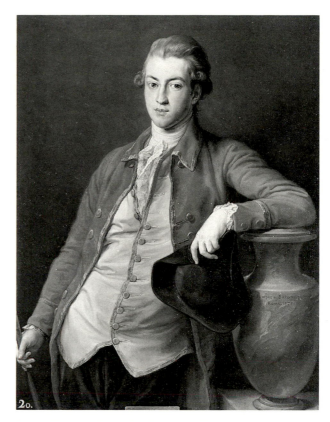

Fig. 1. Pompeo Batoni, *Charles Cecil Roberts,* 1778, oil on canvas, Museo de la Real, Academia de Bellas Artes de San Fernando, Madrid, 708

As Trapier has noted, the pose is almost identical to that in Goya's portrait of his friend Evaristo Pérez de Castro (Louvre).[16] However, its origins are to be found in English portraiture of the eighteenth century, where the pose of a standing figure leaning on an arm, hat in hand, is conventional (see Thomas Gainsborough's *Colonel John Bullock,* Needwood House, Burton collection). This format was adopted by the Italian painter Pompeo Batoni and used in a work that would have been known to Goya. This is the portrait of *Charles Cecil Roberts,* executed in 1778, and given by Charles III to the Real Academia de San Fernando in 1784 (fig. 1).[17] Goya was admitted to membership in the Academia in 1780. The mood and subdued technical brilliance of this work are in keeping with the intimate portraits that Goya began to produce at this time and continued to paint until the end of his life.

J.B.

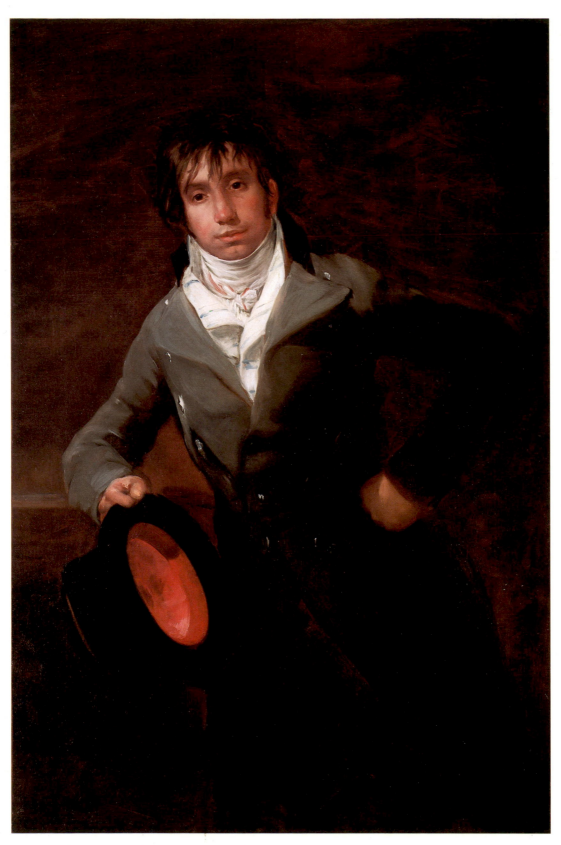

Francisco de Goya, *Bartolomé Sureda y Miserol*, 1941.10.1

1956.11.1 (1471)

Victor Guye

1810
Oil on canvas, 103.5 x 84.5 (40¾ x 33¼)
Gift of William Nelson Cromwell

Inscriptions:
On the back of the original fabric:[1] *Ce Portrait de mon Fils a été peint par Goya pour faire le pendant de celui de mon Frère le Général. Vt Guye.* (This portrait of my son was painted by Goya as a pendant to that of my brother the General. V[incen]t Guye.)

Technical Notes: The support is a lightweight, tightly woven fabric, probably linen, lined to a medium-weight, plain-weave fabric. The shallow cusping pattern at the edges of the fabric is visible through the surface paint. The thin, red ground has a pronounced pebbly texture; brushmarks in the ground form a concentric pattern around the figure. X-radiographs do not reveal any pentimenti. The painting is in secure structural condition. The lining has slightly flattened the impasto. Abraded areas of brown paint in the background have been retouched.

Provenance: Vincent Guye, father of the sitter, who transported the painting from Madrid to Saint-Dié, the Jura, France, in 1813;[2] Guye family, Saint-Dié (Trotti et Cie., Paris, by 1913);[3] (M. Knoedler & Co., Paris, London, New York by 1915);[4] J. Horace Harding [1863–1929], New York, by 1916 (sale, Parke-Bernet, New York, 1 March 1941, 36, no. 59); Harding's children, Charles B. Harding, Catherine Tailer, and Laura Harding;[5] purchased 1957 by the NGA from funds derived from the bequest of William Nelson Cromwell.

Exhibitions: *Loan Exhibition of Paintings by El Greco and Goya for the Benefit of the American Women's War Relief Fund and the Belgian War Relief Fund,* M. Knoedler & Co., New York, 1915, 28, no. 25. *Fiftieth Anniversary Exhibition,* The

Fig. 1. Francisco de Goya, *Portrait of General Nicholas Guye,* 1810, oil on canvas, Virginia Museum of Fine Arts, Richmond, Gift of John Lee Pratt, 1971.1.26

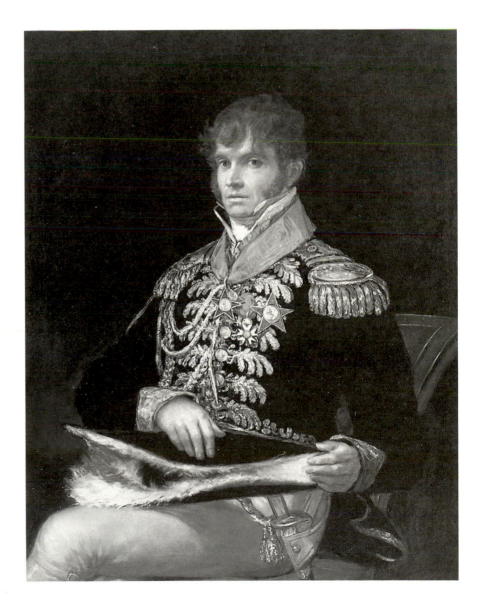

Metropolitan Museum of Art, New York, 1920, 9 (unnumbered). *Spanish Paintings from El Greco to Goya*, The Metropolitan Museum of Art, New York, 1928, 3, no. 16. *Loan Exhibition of Paintings by Goya*, M. Knoedler & Co., New York, 1934, no. 6. *Spanish Paintings*, Philadelphia Museum of Art, 1937, no cat. *Exhibition of Paintings, Drawings, and Prints by Francisco Goya (1746–1828)*, California Palace of the Legion of Honor, San Francisco, 1937, 32, no. 24. *The Collection of the Late J. Horace Harding*, James St. L. O'Toole Galleries, New York, 1939, 28 (unnumbered). *Portraits by Masters of the XVI, XVII, XVIII Centuries*, James St. L. O'Toole Galleries, New York, 1939, no. 15. *Paintings, Drawings, and Prints: The Art of Goya*, The Art Institute of Chicago, 1941, 54, no. 82. *An Exhibition of Paintings by Living Masters of the Past*, Baltimore Museum of Art, 1943, 26–27 (unnumbered). On loan to the National Gallery of Art, Washington, 1946–1956. *Goya: A Loan Exhibition for the Benefit of the Institute of Fine Arts*, Wildenstein, New York, 1950, 19, no. 36. *The Art of Francisco Goya*, The Virginia Museum of Fine Arts, Richmond, not paginated (unnumbered). *Vystatka kartin iz Museez Soedinennyk Shatatov Ameriki* [Exhibition of Paintings from Museums of the United States of America], State Hermitage Museum, Leningrad; State Pushkin Museum, Moscow; State Museum of Ukranian Art, Kiev; State Museum of the Belorussian SSR, Minsk, 1976, 8 (unnumbered). *Goya: The Condesa de Chinchón and Other Paintings, Drawings, and Prints from Spanish and American Private Collections and the National Gallery of Art*, National Gallery of Art, Washington, 1986–1987, brochure, not paginated.

NICOLAS GUYE commissioned this portrait of his nephew as a pendant to the portrait that Goya painted of him (fig. 1); Guye intended both portraits as presents for Vincent, Victor's father. It has been assumed that Goya painted the portrait of Victor in 1810, the same year in which he painted Nicolas Guye.[6]

Nicolas Guye was one of the most important Napoleonic generals in Spain.[7] In 1810 Guye organized in Madrid the first infantry regiment of Joseph Bonaparte's government and was appointed governor of Seville. Among his many military victories was the defeat in 1812 of the unofficial army of General Juan Martin Díaz, an important leader of the Spanish resistance. The apparent sympathy with which Goya depicted Nicolas Guye and his nephew has been cited in support of the theory that the artist favored the Napoleonic regime.[8] However, Goya created equally sympathetic portraits of such leaders of the Spanish resistance as Juan Martín Díaz (Robert Neuberger collection, Cologne)[9] and Panteleón Pérez de Nenín, major general of the defense junta of Bilbao (Banco Exterior, Madrid).[10] It thus seems wise not to attempt to deduce the artist's political beliefs from commissioned works.

Goya portrayed Victor Guye when he was six or seven years old.[11] Victor is shown wearing the gold-embroidered uniform of the Order of Pages to Joseph Bonaparte, King of Spain.[12] The boy studied at the prestigious College of Nobles, which the young Victor Hugo attended during his stay in Madrid from 1811 to 1812.[13] Nothing is known of Victor Guye's life after he returned from Madrid to the Jura with his father in 1813.

Goya has shown Victor standing before a neutral grayish brown background that helps to set off the blue of his uniform. Victor's large blue eyes gaze directly out at the spectator, and he seems to ignore the open book which he holds with both hands. Goya depicted the gold embroidery with heavy impasto, but otherwise used thin, fluid strokes through which the red ground can be seen in several places. The viewer's attention is focused on the head partly because Goya's careful definition of it contrasts with his loose, summary handling of the hands and the rest of the body.

As in his other portraits of children, including the National Gallery's *María Teresa de Borbón y Vallabriga* (1970.17.123), Goya has represented his youthful subject without sentimentality. Victor's upright stance, the directness of his gaze, his slightly furrowed brow, and the serious expression on his lips all contribute to the sober mood, which is enhanced by the neutral background.

R.G.M.

Notes

1. Beruete 1913, 4, recorded the inscription, which is now concealed by the lining that was attached to the original fabric before the painting entered the NGA collection.

2. Muller 1971, 29, 51; Muller 1972, 11.

3. Beruete 1913, 2.

4. Desparmet Fitz-Gerald 1928-1950 (see Biography), 2: 292, no. 551s. Knoedler's ownership in 1915 is established by the exhibition catalogue of that year.

5. Annotated copies of the Harding sale catalogue at The Frick Art Reference Library, New York, and at the National Portrait Gallery, Washington, D.C., have the purchase price indicated in the margin. It appears probable that the painting was purchased by Harding's children rather than bought in. On the sale see Comstock 1941, 204.

6. Beruete 1913, 4. The inscription on the back of the portrait of General Guye indicates that it was presented to Vincent on 1 October 1810. It seems likely that the Gallery's painting was given to Vincent at the same time. Both portraits have the same dimensions.

7. Hosotte 1927, 56-75, presents a full analysis of Guye's military career.

8. See, for example, Muller 1971, 29.

9. Gudiol 1971 (see Biography), 4: color fig. 1071.

10. Gudiol 1971 (see Biography), 4: fig. 885, color fig. 887.

11. According to Beruete 1913, 4, Victor was four or five years older than a brother born in 1808. This information corresponds with his apparent age in the portrait.

12. The uniform was first identified by Beruete 1913, 4. On Victor's membership in the corps, see also Hosotte 1927, 67; Gassier 1981, 249. Muller 1972, 11, argues that Victor was probably too young to have been admitted to this group. It seems possible, however, that Victor, even if not a page, might have been given permission to wear the uniform through the influence of his uncle.

13. Lipschutz 1972, 12; Gassier 1981, 249.

References

1898–1899. Bardy, Henri. "Le général Guye, maire de la ville de Saint-Dié du septembre 1829 au 30 octobre 1830." *Bulletin de la société philomatique vosgienne* 25: 132.

1913. Beruete y Moret, Aureliano de. "Deux portraits inédits de Goya." *Les arts* 136 (April): 2–4, repro. 3.

1914–1915. Pène du Bois, Guy. "Greco, Goya, and Velasquez: Three Pillars of Spanish Art." *Arts and Decoration* 5: 183, repro.

1915. Beruete (see Biography): 120, 180, no. 241, pl. 44 (also English ed. 1922: 143, 214, no. 250, pl. 46).

1917. Candee, Helen Churchill. "Certain Goyas in America." *Scribner's Magazine* 62: 430, 438, repro. 432.

1923. Mayer (see Biography): 86, 195, no. 319, pl. 205.

1927. Comstock, Helen. "Children's Portraits in European Art." *IntSt* 86 (February): 40, repro. 42.

1927. Hosotte, Louis. "Un général comtois du Premier Empire, Nicolas Philippe Guye (1773–1845)." *Académie des sciences, belles lettres, et arts de besançon; bulletin*: 67.

1928. Pantorba, Bernardino de [José López Jiminez]. *Goya*. Madrid: 98.

1928–1950. Desparmet Fitz-Gerald (see Biography). 2: 291, 292, no. 550s, under 551s.

1934. Comstock, Helen. "Loan Exhibition of Goya's Portraits." *Conn* 93: 332–333.

1934. Siple, Ella S. "A Goya Exhibition in America." *BurlM* 64: 287.

1937. Clifford, Henry. "Great Spanish Painters: A Timely Show." *ArtN* 35 (17 April): 11.

1941. Comstock, Helen. "Auction Sales." *Conn* 108: 204, repro. 201.

1951. Sánchez Cantón (see Biography): 103, 171.

1955. Gassier, Pierre. *Goya*. Paris: 95.

1958. Gaya Nuño, *La pintura española*: 175, no. 1059.

1962. Cairns and Walker: 122, color repro. 123.

1964. Trapier (see Biography): 37, 56, no. 66, figs. 66, 67.

1966. Cairns and Walker. 2: 326, color repro. 347.

1971. Gassier and Wilson (see Biography): 214, 253, 261, no. 884, repro. 208 (also 1981 ed.: 214, 251, 253, 261, no. 884, repro. 208).

1971. Gudiol (see Biography). 1: 142, 315, no. 554; 2: fig. 894, color fig. 895.

1971. Muller, Priscilla. "Goya's Portrait of Gen. Nicolas Guye." *ArtN* 70 (December): 29, 51, repro. 51.

1972. Lipschutz, Ilse Hempel. *Spanish Painting and the French Romantics*. Cambridge, Mass.: 12.

1972. Muller, Priscilla. "Goya's Portrait of Nicolas Guye." *Arts in Virginia* 12 (Winter): 9–11, fig. 14.

1974. de Angelis, Rita, *L'opera pittorica completa di Goya*. Milan: 123, no. 511, repro.

1979. Salas, Xavier de. *Goya*. Translated by G. T. Culverwell. London: 123, 190, no. 381, color repro. 103.

1981. Gassier, Pierre. "Goya and the Hugo Family in Madrid." *Apollo* 114: 249.

1984. Camón Aznar, José. *Francisco de Goya*. 4 vols. Saragossa, 3:184.

1961.9.74 (1626)

Don Antonio Noriega

1801
Oil on canvas, 102.6 x 80.9 (40⅜ x 31⅞)
Samuel H. Kress Collection

Inscriptions:
On paper held in sitter's hand: *El Sor Dn / Antonio / Noriega / Tesorero / General / F. Goya / 1801*
At lower left on tablecloth:[1]

Dn Antonio Noriega de [Ba]da caballero y Regidor de la / Rl y distinguida Orden Espanola de don. C. III; Diputado / en Corte del Principe de Asturias. Director genl de las / Temporalidades de España e Indias y de la Rl Negocia / cion del Giro: Del Consejo de s.m. en el Rl y Supremo del / Hacienda y su Tesorero General &c. &c. (D[o]n Antonio de [Ba]da knight and Councillor of the Royal and distinguished Spanish Order of Don C[arlos] III; Delegate in the Court of the Prince of Asturias. Director general of the Revenues of Spain and the Indies and of the Royal Bank of the Exchange: Of the Council of His Majesty in the Royal and Supreme Ministry of Finance and his High Treasurer, etc. etc.)

Technical Notes: The support is a coarse, plain-weave fabric, lined to a very fine, plain-weave fabric. The left tacking edge was unfolded to form part of the picture surface and covered with paint by a later hand. Coarse particles in the thick red ground that covers the entire painting surface protrude through the thinly applied paint. Goya left the ground color visible in many places, utilizing it, for example, as a middle tone in parts of the flesh. There is scattered retouching in the head, left wrist, jacket, and background.

Provenance: Purchased from a private collector in Madrid by Freiherr Ferdinand Eduard von Stumm [1843–1925], while he was ambassador of the German Empire to the court of Madrid, 1887–1892[2] (sale of his estate, Auktionshaus Dr. Günther Deneke, Berlin, 4 October 1932, 19, no. 87); (Wildenstein, Paris and New York);[3] the Samuel H. Kress Foundation, New York, 1955.[4]

Exhibitions: *Goya*, Bibliothèque Nationale, Paris, 1935, 60, no. 251. *The Art of Goya*, The Art Institute of Chicago, 1941,

45, no. 70. *Goya: A Loan Exhibition for the Benefit of the Institute of Fine Arts*, Wildenstein, New York, 1950, 18, no. 16. *Masterpieces of Painting Through Six Centuries*, Allied Arts Association, Houston, 1952, 12, no. 23. *Goya: The Condesa de Chinchón and Other Paintings, Drawings, and Prints from Spanish and American Private Collections and the National Gallery of Art*, National Gallery of Art, Washington, 1986–1987, brochure, not paginated.

ANTONIO NORIEGA BERMÚDEZ was born in Bada (Asturias) to Manuel Francisco Noriega Pérez de Estrado and his wife, Mauricia Alonso de Riveiro.[5] The date of his birth is uncertain. Noriega held important administrative posts during the reign of Charles IV and was a close friend of Manuel Godoy, first minister of the king, from 1792 to 1798 and from 1801 to 1808.[6] In 1799, Noriega was appointed to the Contaduría General de Propios y Arbitrios del Reyno (General Financial Administration of Public Properties and Tax Revenues of the Kingdom).[7] He was subsequently appointed to the posts listed in the inscription. On 23 July 1801 he was made a knight of the Order of Charles III;[8] he wears the blue and white ribbon of the Order on his jacket in Goya's portrait.[9]

Noriega's most important office was that of *tesorero general* (high treasurer); Goya's inscription indicates that Noriega must have attained this office by 1801. He retained this post until his death in 1808. As *tesorero general*, Noriega was one of the most important officials of the Spanish government.[10] In the Ministry of Finance he ranked second after the *superintendente general* (chief administrator), who was a member of the king's cabinet. The *tesorero general* was responsible for supervising all governmental financial transactions; no accounts could be paid without his authorization.

Noriega's management of government funds between 1801 and 1808 was disastrously inefficient and corrupt.[11] Between these years, the national debt increased from 4,108,052,721 to 7,204,256,831 *reales*. This increase can be explained only partly by the expenses of war; to a large extent it resulted from poor management and theft by all levels of officials involved in supervising and carrying out financial transactions.

Noriega's death in 1808 was extremely brutal. After being seized and imprisoned in Badajoz by French soldiers, he was attacked and set on fire by a mob of Spaniards who believed that he was collaborating with Napoleon.[12] Ironically, Noriega and other government officials had fled to Badajoz in the hope that they would there be able to establish a government free from French influence.

In the portrait, Goya has depicted Noriega as a dedicated and concerned administrator. The representation of the official seated in an armchair at a table covered with papers follows a conventional portrait formula, but it serves to suggest his involvement in his administrative tasks. His furrowed brows indicate worry, but his direct gaze and upright posture suggest his ability to deal with the difficulties that the government faced. The hand inside his jacket was probably intended to emphasize his authority. This gesture occurs in many other contemporary portraits of Spanish leaders; it was certainly not intended to imitate Napoleon, as Eisler has suggested.[13]

The dark neutral background, which is typical of Goya's portraits of the early nineteenth century, helps to establish an appropriately serious mood. Strongly contrasting with the background are the vivid red vest and the glittering gold decorations on the jacket and chair. The bold application of impasto greatly enlivens the painting.

R. G. M.

Notes

1. The inscription is badly abraded and nearly illegible in places.

2. Mayer 1935, 49. The dates of Stumm's appointment as ambassador to Madrid are established by *Almanach de Gotha*, 182 vols. (Gotha and Leipzig, 1764–1959), 127 (1890): 680; 129 (1892): 786.

3. Ay-Whang Hsia, vice-president, Wildenstein, New York, letter, 14 September 1988, in NGA curatorial files.

4. Eisler 1977, 229, no. K2029.

5. Alberto y Arturo García Carraffa, *Diccionario heráldico y genealógico de apellidos españoles y americanos*, 88 vols. (Madrid, 1919–1963), 62: 142–143.

6. Pascual Madoz, *Diccionario geografico-estadistico-historico de España*, 16 vols. (Madrid, 1845–1850), 3: 260.

7. *Gazeta de Madrid*, 19 July 1799, 653.

8. García Carraffa 1919–1963, 62: 143.

9. Trapier 1964 (see Biography), 23.

10. Antonio Ballesteros y Beretta, *Historia de España*, 12 vols. (Madrid, 1918–1941), 6: 193–194.

11. Ballesteros 1918–1941, 6: 207–208.

12. Madoz 1845–1850, 3: 260.

13. Eisler 1977, 229, no. K2029. Because Godoy's government attempted to keep Spain independent of Napoleonic control, a deliberate imitation of the French leader seems unlikely. For a concise review of Godoy's ministry between 1801 and 1808, see Luis Perralt García, *Historia de España*, 5 vols. (Madrid, 1967), 5: 126–138. The same gesture can be seen in Goya's portrait of José Queralto (1802, Alte Pinakothek, Munich; Gudiol 1971 [see Biography], 4: fig 889) and an anonymous portrait of Dionisio Alcalá Galiano (Museo Naval, Madrid).

References

1928–1950. Desparmet Fitz-Gerald (see Biography). 2: 289, no. 547; 2 (of plates), part 2: pl. 481.

1935. Mayer, August L. "The Portrait of Don Antonio Noriega by Goya." *Apollo* 22: 49, color repro. opp. 49.

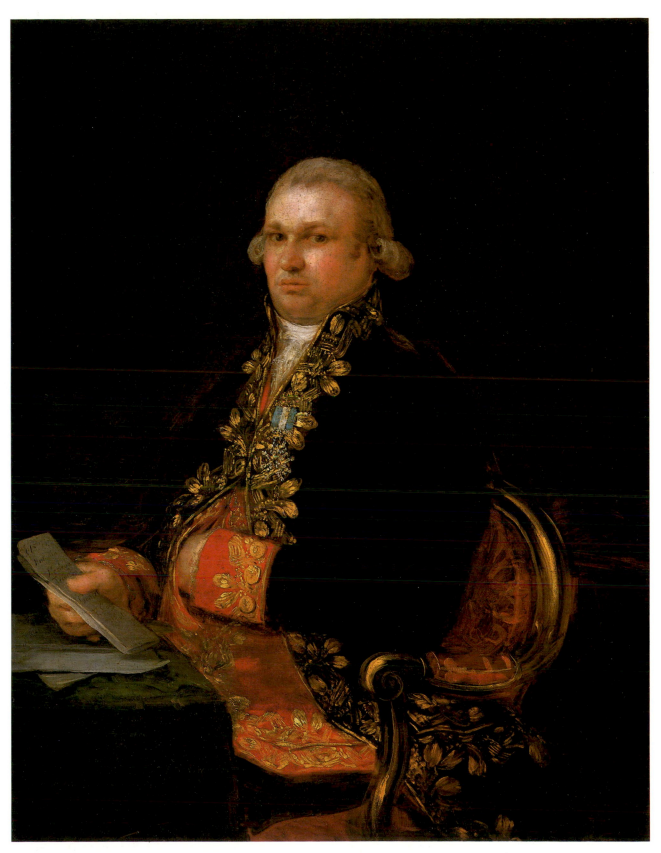

Francisco de Goya, *Don Antonio Noriega,* 1961.9.74

1937. "Notable Works of Art Now on the Market." Advertising Supplement, *BurlM* 71 (December): no. 18, repro.

1951. Sánchez Cantón (see Biography): 170.

1958. Gaya Nuño, "*La pintura española:*" 160, no. 993.

1959. Kress: 90, no. 33, repro.

1964. Trapier (see Biography): 23, 59, no. 39, figs. 39–40.

1971. Gassier and Wilson (see Biography): 167, no. 801, repro. 197 (also 1981 ed: 167, no. 801, repro. 197).

1971. Gudiol (see Biography). 1: 110, 292, no. 436; 3: figs. 703, 704.

1974. de Angelis, Rita. *L'opera pittorica completa di Goya.* Milan: 116, no. 399, repro.

1977. Eisler: 230–231, no. K2029, fig. 221.

1979. Salas, Xavier de. *Goya.* Translated by G. T. Culverwell. London: 190, no. 381, repro.

1984. Camón Aznar, José. *Francisco de Goya.* 4 vols. Saragossa, 3: 135, repro. 327.

1963.4.2 (1903)

Young Lady Wearing a Mantilla and a Basquiña

c. 1800/1805
Oil on canvas, 109.5 x 77.5 (43⅛ x 30½)
Gift of Mrs. P. H. B. Frelinghuysen

Inscriptions:
At lower left: *Goya*

Technical Notes: The support is a medium-weight, plain-weave fabric which has been relined. Triangular additions at all four corners have converted the painting to a rectangle. In the original shape, the corners were diagonally cropped. The lower corner additions, which measure 18 x 18 cm along the side and bottom margins, are larger than the additions in the upper corners (9 x 9 cm).

The ground is a smooth, dull red layer, over which the paint layer is thinly applied. The paint layer is abraded throughout, especially in the background and the sitter's dress. These areas have been extensively retouched, as have the lower part of the face and the left eye.

Provenance: Probably Serafín García de la Huerta [d.1839], Madrid, inventory, 1840. Marqués de Heredia, Madrid, by 1867.[1] Benito Garriga, Madrid, by 1887[2] (sale, Hôtel Drouot, Paris, 24 March 1890, no. 4). Hubert Debrousse (sale, Hôtel Drouot, Paris, 6 April 1900, no. 45); Kraemer, Paris;[3] (Durand-Ruel, Paris, 1906); Henry Osborne Havemeyer [1847–1907], New York;[4] his widow, Louisine W. Havemeyer [née Elder, 1855–1929], New York; their daughter, Mrs. P. H. B. Frelinghuysen [née Adaline Havemeyer, 1884–1963], Morristown, New Jersey.

Exhibitions: *Loan Exhibition of Paintings by El Greco and Goya*, M. Knoedler & Co., New York, 1915, no. 7. *A Loan Exhibition of Goya*, Wildenstein, New York, 1950, no. 15, repro. 28. *Goya; Das Zeitalter der Revolutionen, 1789–1830*, Kunsthalle, Hamburg, 1980–1981, 327, no. 296, color pl. 9. On loan to Rijksmuseum, Amsterdam, 1981–1982. *Goya: The Condesa de Chinchón and Other Paintings, Drawings, and Prints from Spanish and American Private Collections and the National Gallery of Art*, National Gallery of Art, Washington, 1986–1987, brochure, not paginated.

THE traditional identification as a bookseller or a bookseller's wife appears to be mistaken. The painting is probably the one owned by the Madrid collector, Serafín García de la Huerta, who died on 25 August 1839. The inventory of his collection compiled in 1840[5] includes a picture described as follows: "no. 859 – Otro de una señora con mantilla y basquiña, de Goya, de cinco cuartas de alto por tres y media de ancho, en dos mil reales" (Another [canvas] of a lady with mantilla and *basquiña*, by Goya, measuring five cuartas high by three and a half wide, two thousand reales). Although the vertical and horizontal dimensions are about five centimeters smaller each than those of the Gallery's painting, this is an acceptable margin of difference given the correspondence of the subject's attire with the description in the inventory.

A *basquiña* is a traditional item of Spanish feminine apparel which evolved through the centuries. During the reigns of Carlos IV and Fernando VII, it took the form of a short-sleeved overdress that was worn out of doors.[6] The sitter's costume closely corresponds to a contemporary book illustration showing the types of Spanish costume being worn in 1801 (fig. 1).[7] The sitter in Goya's portrait also holds a fan, as does the person in the print. The print's caption, like the entry in the inventory, refers to the lady as a *señora*, a word with social implications that probably would not be appropriate to the wife of a shopkeeper.

The bookseller association began with Yriarte in 1867, who referred to the picture as the "Portrait de 'la Librera.'"[8] Viñaza embellished this description by attaching the name of a Madrid street, calle de las Fuentes, to the title.[9] Some years later, Beruete[10] rechristened the portrait as the "Bookseller of the calle de Carretas," thus anticipating a discovery by Sambricio of documents that, in his view, established the identity of the sitter with certainty.[11]

The documents in question[12] refer to the so-called process of "purification" instituted by the government of Fernando VII, who was restored to the throne of Spain after the defeat of the French in the Peninsular War. The purpose of these investigations was to identify and punish Spaniards who had collaborated with the French. Goya was suspected of

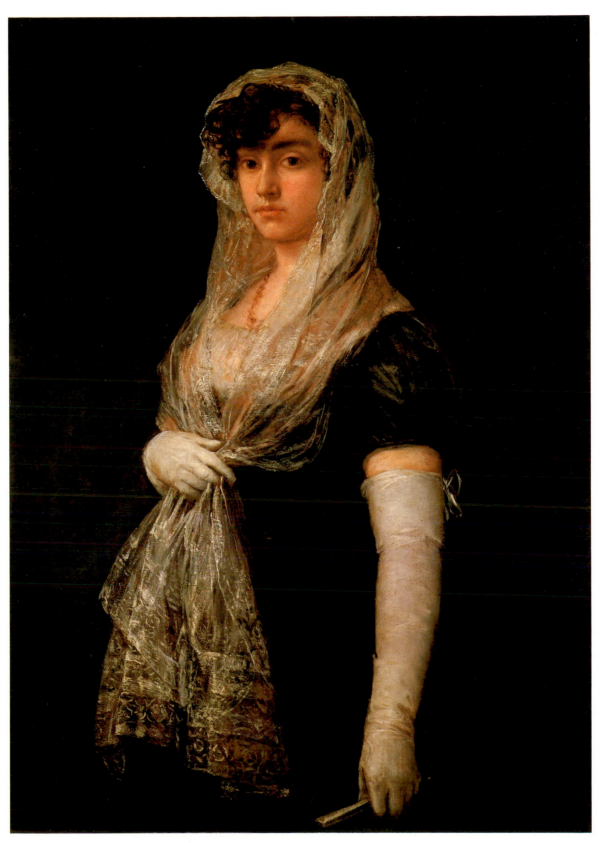

Francisco de Goya, *Young Lady Wearing a Mantilla and a Basquiña*, 1963.4.2

¡ Lo que tarda !

Señora de basquiña con un fleco, y mantilla blanca bordada.

Fig. 1. From *Colección general de los trages que en la actualidad se usan en España* (Madrid, 1801)

having been a collaborator, and accordingly his activities during the occupation were investigated. One of the witnesses who testified to his loyalty was Antonio Bailó, a bookseller with a shop at calle de Carretas, 4. Accepting the traditional identification of the sitter as the wife of a bookseller, Sambricio concluded that she was the spouse of Bailó. This person was later identified by Valverde Madrid as María Mazón, who married Bailó on 1 July 1807 and inherited the bookshop when he died on 9 April 1826.[13] She herself was deceased on 27 February 1829.

Despite the inherent interest of these documents for Goya's biography, there is no reason to relate them to a picture that was known in 1840 simply as "una señora con mantilla y basquiña." It may be that Yriarte, who invented the "bookseller" title, was relating information from the person who then owned the picture, because there is no suggestion in the composition that the sitter has a specific occupation except as a member of the upper class. The inventory of possessions compiled when María Mazón and her husband drafted their wills in 1815 mentions no works of art of any kind.[14]

The painting belongs to the brilliant series of female portraits executed during the years preceding the Peninsular War and is usually dated within the years 1800 to 1807.[15] On the evidence of the costume and the relationship to a work such as the portrait of the *Countess of Chinchón*, executed in 1800 (Duke of Sueca, Madrid), a date of around 1801 to 1805 is plausible.

Desparmet Fitz-Gerald notes the existence of two copies, one of which was offered for sale to Louisine Havemeyer in Madrid by the Marqués de Heredia, who had the copy made when he sold the original.[16]

J.B.

Notes

1. Yriarte 1867, 138.
2. Viñaza 1887 (see Biography), 265, lists Garriga as owner. Desparmet Fitz-Gerald 1928–1950 (see Biography), 2:168, notes without supporting evidence that Garriga acquired the painting in 1868.
3. On the acquisition by Kraemer and the subsequent sale to Durand-Ruel, see Desparmet Fitz-Gerald 1928–1950 (see Biography), 2:168.
4. Havemeyer 1961, 153–154, 158–159, gives an account of this purchase.
5. For the inventory, see Saltillo 1950–1951, 204. The association of García de la Huerta's painting with the one in the National Gallery is made by Desparmet Fitz-Gerald 1928–1950 (see Biography), 2: 168, who mistakenly gives the date of sale as 1850. Desparmet Fitz-Gerald refers only to "Collection Kraemer;" "Kraemer," however, possibly could be Eugene Kraemer, a French collector whose estate, which held a Goya portrait, was sold at the Galerie Georges Petit in 1913 (*Catalogue des tableaux anciens, écoles anglaise et française du XVIIIᵉ siècle*, Galerie Georges Petit, Paris, 28–29 April 1913).
6. For a brief history of the *basquiña*, see *Enciclopedia universal ilustrada europea-americana*, vol. 7 (Barcelona, n.d.), 1078–1079. I am grateful to Elsa S. Upton for bringing to my attention the significance of this garment for the question of the sitter's identification.
7. *Colección general de los trages que en la actualidad se usan en España principiada en el año 1801 a Madrid* (1801), ed. Julián Gállego (Madrid, 1973), pl. 13. The engraver is A. Rodríguez.
8. Yriarte 1867, 138.
9. Viñaza 1887 (see Biography), 267.
10. Beruete 1915 (see Biography), 176, no. 167.
11. Valentín Sambricio, "Goya no fué afrancesado," *Arriba* (daily newspaper, Madrid), 31 March 1946, 12.
12. Published in Valentín Sambricio, *Tapices de Goya* (Madrid, 1946), cl–clii.
13. Valverde Madrid 1979, 278.
14. Valverde Madrid 1979, 278.
15. Another portrait in the series is *Señora Sabasa García*, 1937.1.88. Various proposals for dating *Young Lady Wearing a Mantilla and a Basquiña* are as follows: Desparmet Fitz-

Gerald 1928–1950 (see Biography), c. 1807; Sánchez Cantón 1951 (see Biography), just after 1805; Trapier 1964 (see Biography), 1805–1807; Gassier and Wilson 1970, 1805–1808; Gudiol 1971, 1803–1806; Salas 1979, 1805–1808; Camón Aznar 1984, 1806; Beruete 1915, late 1790s; Mayer 1924, 1800–1805.

16. Desparmet Fitz-Gerald 1928–1950 (see Biography), 2:168. Havemeyer 1961, 158–159.

References

1867. Yriarte, Charles. *Goya, sa biographie et le catalogue de l'oeuvre*. Paris: 138.

1887. Viñaza (see Biography): 267.

1915. Beruete (see Biography): 176, pl. 22 (also English ed. 1922: 85, pl. 24).

1924. Mayer (see Biography): 171, no. 502.

1931. *H. O. Havemeyer Collection. Catalogue of Paintings, Prints, Sculpture and Objects of Art*. Portland, Maine: 317.

1928–1950. Desparmet Fitz-Gerald (see Biography). 2: 168–169, pl. 375.

1931. *H. O. Havemeyer Collection. Catalogue of Paintings, Prints, Sculpture and Objects of Art*. Portland, Maine: 317.

1950–1951. Marqués del Saltillo. "Colecciones madrileñas de pinturas: la de D. Serafín García de la Huerta." *Arte Español* 18: 204, no. 859.

1951. Sánchez Cantón (see Biography): 79–80 (also English ed. 1964: 79).

1961. Havemeyer, Louisine W. *Sixteen to Sixty: Memoirs of a Collector*. New York: 158–159.

1964. Trapier (see Biography): 27, fig. 48.

1970. Gassier and Wilson (see Biography): 199, no. 835, repro.; 374, n. 835 (also English ed. 1971).

1971. Gudiol (see Biography). 1: 308, no. 522, fig. 826.

1974. de Angelis, Rita. *L'opera pittorica completa di Goya*. Milan: 119, no. 449, repro.

1979. Salas, Xavier de. *Goya*. London: 102, 191, no. 399, repro.

1979. Valverde Madrid, José. "La librera de la calle de Carretas." *Goya* 148–150: 278, repro.

1983. Gassier, Pierre. *Goya: témoin de son temps*. Fribourg: 194, color repro. 195 (also English ed. 1983).

1984. Camón Aznar, José. *Francisco de Goya*. 4 vols. Saragossa, 3: 156–157, color repro. 173.

1970.17.123 (2495)

María Teresa de Borbón y Vallabriga, later Condesa de Chinchón

1783
Oil on canvas, 134.5 x 117.5 (53 x 46¼)
Ailsa Mellon Bruce Collection

Inscriptions:
At lower left: *LA S.D. MARIA TERESA / HIXA DEL SER. INFANTE / D. LUIS / DE EDAD DE DOS ANOS Y NUEVE MESES* (The S[enorita] D[oña] Teresa, daughter of the Most Serene Infante, Don Luis, at the age of two years and nine months)

Bears inventory marks from the collection at Boadilla del Monte, probably by nineteenth-century hands:[1]
at lower left: *B*
at the lower right: *15.5*

Technical Notes: The painting is on a coarse, open-weave fabric attached to a lining fabric of heavy plain weave. The thin red ground does not conceal the fabric texture. Goya applied paste-consistency oils directly with a great deal of certainty. Because the dog is the only compositional element that overlaps adjacent areas, it seems possible that Goya had not planned to include the dog when he began the portrait. There is very little evidence of glazing. The painting is in fairly good condition with slight losses and abrasion. There is retouching in the sky at upper left, at the bottom of María Teresa's skirt (between her right shoe and the dog), and in the foliage at bottom left. The red ground may be more prominent in the sky now than at the time of the portrait's completion due to a combination of minor abrasion and increased transparency of the blue-white mix.

Provenance: Commissioned in 1783 by the Infante Don Luis de Borbón [1727–1785], palace of Arenas de San Pedro (Avila); his daughter, the sitter, palace at Boadilla del Monte (near Madrid);[2] her only child, Carlota Luisa de Godoy y Borbón [1800–1886], Condesa de Chinchón, Duquesa de Alcudia y de Sueca, Boadilla del Monte, in whose possession it was recorded in 1867 and 1886;[3] her son, Adolfo Ruspoli [1822–1914], Conde de Chinchón, Duque de Sueca, Boadilla del Monte;[4] his daughter, Maria Teresa Ruspoli y Alvarez de Toledo, wife of Henri-Melchior Cognet Chappuis, Comte de Maubou de la Roue, Paris;[5] her nephew, Don Camilo Carlos Adolfo Ruspoli y Caro [1904–1975], Conde de Chinchón, Duque de Alcudia y de Sueca, Madrid, by 1951.[6] Sold by the family to (Wildenstein, New York, by March 1957);[7] purchased 2 March 1959 by Ailsa Mellon Bruce, New York.[8]

Exhibitions: *Goya: The Condesa de Chinchón and other Paintings, Drawings, and Prints from Spanish and American Private Collections and the National Gallery of Art*, National Gallery of Art, Washington, 1986–1987, brochure, not paginated.

THIS DELIGHTFUL and radiant depiction of the young María Teresa is one of several portraits created by Goya in 1783 for the Infante Don Luis de Borbón, the younger brother of Charles III.[9] It originally formed a pair with Goya's portrait of María Teresa's brother, Luis María de Borbón (fig. 1). The most imposing work that Goya created for the Infante is the group portrait of his family and household, including the young María Teresa de Borbón and the artist himself (Magnani Foundation, Parma).[10]

Don Luis de Borbón (1727–1785) was the first member of the royal family to commission works per-

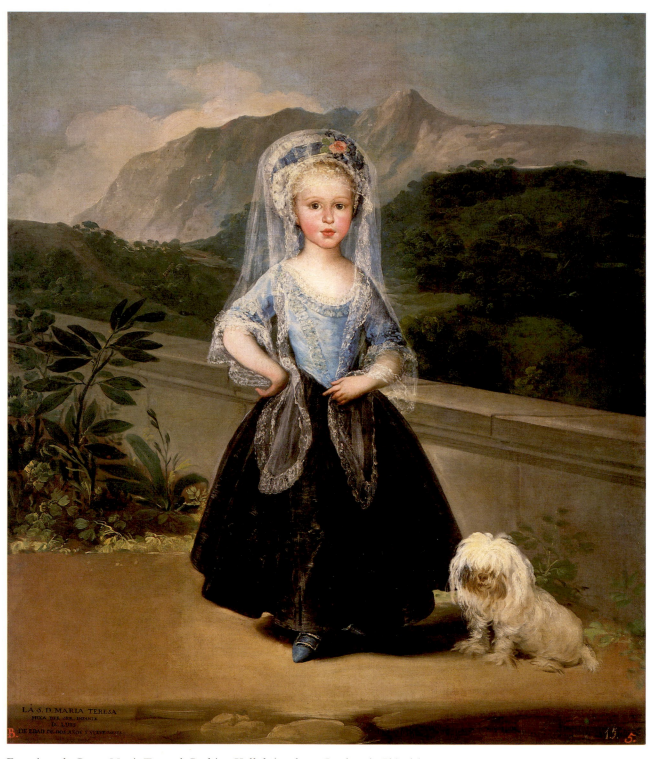

Francisco de Goya, *María Teresa de Borbón y Vallabriga, later Condesa de Chinchón*, 1970.17.123

sonally from Goya.[11] Although Don Luis was not on good terms with Charles, it has been widely supposed that his patronage assisted Goya in his efforts to gain recognition at the court of Madrid. Don Luis had been destined by his family for an ecclesiastical career; he was made cardinal-archbishop of Toledo a few days after his eighth birthday in 1735 and archbishop of Seville in 1741. Because his drunkenness and promiscuity caused many scandals, Don Luis was forced to renounce his ecclesiastical offices at the age of twenty-seven. Against the wishes of his family, he married María Teresa Vallabriga y Rozcas in 1776. She was thirty-one years younger than the Infante and was widely esteemed for her beauty and intelligence. Because the marriage violated laws stipulating that the child of a king could marry only a person of very high noble rank, Don Luis' family was not allowed to visit Madrid.

In an attempt to compensate for their exclusion from the cultural life of Madrid, Don Luis and his wife invited artists to stay for extended periods at their palace at Arenas de San Pedro (Avila) and to live on informal terms with the family. Goya resided with Don Luis and his family at Arenas de San Pedro in August and September 1783. Generally, it has been supposed that during his stay at Arenas Goya completed the National Gallery's painting as well as the individual portraits of the Infante, his wife, and their son.[12]

This theory is supported by a letter of 20 September 1783 to Martín Zapater, in which Goya describes the enthusiasm with which Don Luis received the portraits of members of his family: "Su Alteza me a echo mil onores, he echo su retrato, el de su señora y niño y niña con un aplauso inesperado por aber hido ya otros pintores y no aber acertado a esto." (His Highness gave me a thousand honors. I made his portrait, that of his wife and son and daughter to praise that was unexpected because other painters had already been there but did not meet with this.)[13] However, Gassier argues that Goya's emphasis on the exceptional nature of his achievement suggests that he was referring to the group portrait.[14] Gassier's theory is plausible, but it should be noted that the list of persons mentioned in the letter does not constitute an adequate description of the group portrait,

Fig. 1. Francisco de Goya, *Luis María de Borbón,* 1783, oil on canvas, private collection, Madrid [photo: Ampliaciones MAS]

which includes fourteen members of the household.[15] Although Goya's wording is vague, it seems probable that he intended to refer to individual portraits of family members.

María Teresa de Borbón y Vallabriga was the eldest daughter of the Infante and María Teresa Vallabriga.[16] Born on 7 March 1779, she would have been approximately four-and-a-half years old when Goya was working at Arenas de San Pedro in 1783. This age accords with her appearance in the National Gallery's painting. That being the case, the age recorded in the inscription must be incorrect, even though technical analysis indicates that Goya must have added the inscription shortly after completing the painting.[17] There is no reason to doubt that Goya was responsible for the inscription. The lettering corresponds closely to that of the inscription on Goya's portrait of María Teresa's brother, Luis María de Borbón, which records his age accurately. It is difficult to understand why Goya would have recorded María Teresa's age incorrectly.[18]

After her father's death, María Teresa was placed in a convent in Toledo, where the archbishop supervised her education. In 1797 she married Manuel Godoy, duque de Alcudia y de Sueca, the first minister of Charles IV from 1792 to 1798 and from 1801 to 1808. It was widely supposed at the time that the king and queen pressured María Teresa to accept Godoy as her husband in order to improve his status, because they greatly esteemed his advice. However, María Teresa also benefited from the arrangement. Following the marriage, Charles IV permitted María Teresa and Don Luis' other children to use the family name Borbón and to inherit titles held by their father; both the name and the titles had previously been prohibited to Don Luis' children by royal decree. Queen María Luisa awarded María Teresa the Order of the Queen, the highest award that could be given to a woman at the time. María Teresa became the Condesa de Chinchón in 1803, when her brother voluntarily renounced the title.

María Teresa left her husband in 1808 when he was removed from office by a coup d'état. During the Napoleonic wars, she attained great popularity because of her strong public support for Spanish independence. Between 1822 and her death in 1828 María Teresa lived in Paris, where she devoted herself to a life of sensual pleasure. Goya depicted María Teresa twice as an adult: in a full-length standing portrait (c.1797; Uffizi, Florence) and in a justly famous full-length seated portrait (1800; private collection, Madrid).[19]

In the Gallery's painting, María Teresa is shown

Fig. 2. Diego de Velázquez, *Prince Balthasar Carlos as a Hunter,* 1634/1635, Museo del Prado, Madrid, 1189

standing with a shaggy white dog on a terrace at the palace of Arenas de San Pedro. She wears a lace-trimmed blue bodice, a black skirt, and a white mantilla decorated with a blue ribbon and a pink rose. The mantilla, a distinctive Spanish form of headdress, enjoyed widespread popularity in the second half of the eighteenth century and became virtually a national symbol.[20] Directly behind her are the dark bluish green foothills and the mountains of the Sierra de Gredos, at the base of which the palace was located. The parapet, the foothills, and the mountains are arranged in a zigzag pattern that helps to enliven the portrait.

The painting has frequently been compared to Velázquez' portraits of royal children.[21] In particular, the depiction of María Teresa against the mountain

vista strongly recalls Velázquez' portrait of Prince Balthasar Carlos as a hunter (fig.2). Both Velázquez and Goya avoided sentimentality in their representation of children, and they used similar devices to enhance the dignity of their young subjects. As Velázquez did in his portrait of Balthasar Carlos, Goya has projected the figure of María Teresa from a low viewpoint so that she is endowed with an impressive monumentality that belies her actual height. Both artists represented their youthful subjects with serious expressions and erect poses that help to establish a sense of authority. In the Gallery's painting, only María Teresa's large, wide-open eyes and her pudgy cheeks and arms emphasize the fact that she is a very young child. In general terms, Goya's handling of paint also recalls Velázquez' work. For instance, the combination of long, transparent strokes and flicks of impasto in the mantilla and the exposure of the red ground and the weave of the canvas in several places seem inspired by Velázquez' technique.

Don Luis and his wife probably encouraged Goya to model the portrait of María Teresa on paintings by Velázquez, whose work they admired and collected.[22] The evident borrowings from Velázquez' portraits of royal children may have more than aesthetic significance. It seems possible that Don Luis intended Goya's portrait of María Teresa to affirm his conviction that his children deserved to be accepted at the court of Madrid as members of the royal household. Thus, this seemingly innocent image of a young girl may have been conceived with a message that reflects the tragedy of Don Luis' exile.

R.G.M.

Notes

1. The white *15* at lower right is cracked and abraded, but because the crack pattern does not conform completely to that of the main body of the paint, it must have been added later than the lengthy inscription at lower left, which has cracked in synchrony with the main body of the paint. The red *B* at lower left and the red *5* at lower right have no obvious cracks and must be the most recent additions to the painting. The painting was assigned the number 15 in the inventory compiled in 1886 of the paintings at the palace at Boadilla del Monte. Viñaza examined the inventory, which existed only in manuscript form, but no later scholars have been able to locate it. See Viñaza 1887 (see Biography), 225, no. 29; Gassier 1979, n. 26. According to Wethey 1977, 205, the numbers at the lower right of the Gallery's painting are very similar in form to those found in the same place on other paintings from Boadilla del Monte. A *B* also occurs at lower left of other paintings from the palace, including the portrait of the Infante Don Luis de Borbón, now in Cleveland (Lurie 1967, 6). See note 12 for further discussion of the Cleveland painting.

2. Gassier 1979, 21, n. 24. In reconstructing the provenance of this painting, I benefited greatly from the assistance of Susan Davis, NGA Department of Curatorial Records.

3. Yriarte 1867, 138; Viñaza 1887 (see Biography), 225, no. 29. See also Gassier 1979, 21, n. 26; Arnaiz and Montero 1986, 45. Biographical information on the condesa and her descendants is given by *Almanach de Gotha*, 182 vols. (Gotha and Leipzig, 1764–1959), 176 (1939): 614–615; Juan Moreno de Guerra y Alonso, *Guía de la grandeza* (Madrid, 1917), 52; *World Nobility and Peerage*, vol. 87 (London, 1955), 158, 171; Domingos Araujo Affonso et al., *Le sang de Louis XIV*, 2 vols. (Braga, 1961), 1: 192; 2: 492–497. Alice Sunderland Wethey, letter, 26 September 1988, in NGA curatorial files, graciously provided a genealogical table for the descendants of the condesa and other information on the family.

4. Recorded in his possession by Oertel 1907, 54; Calvert 1908, 124, no. 60. Also noted by Ay-Whang Hsia, vice-president of Wildenstein, New York, letter, 29 November 1988, in NGA curatorial files.

5. Ay-Whang Hsia, letter, 29 November 1988, in NGA curatorial files. Desparmet Fitz-Gerald 1928–1950 (see Biography), 2: 13, no. 292, claims that the painting was in the liquidation sale of the estate of Adolfo Ruspoli, Paris, 7 February 1914. Possibly the painting was bought in or purchased by the family at this sale.

6. Recorded in his possession by Sánchez Cantón 1951 (see Biography), 167.

7. Ay-Whang Hsia, letter, 29 November 1988, in NGA curatorial files.

8. Ay-Whang Hsia, letter, 29 November 1988, in NGA curatorial files. On Ailsa Mellon Bruce's acquisition of the painting, see Walker 1974, 198–200.

9. The most thorough studies of the portraits created by Goya for Don Luis are Gassier 1979, 10–21; Arnaiz and Montero 1986, 45–55.

10. Gassier 1979, color fig. 1.

11. See Ricardo del Arco y Garay, *Temas aragoneses* (Saragossa, 1953), 104–105; Glendinning 1981, 236–238; Arnaiz and Montero 1986, 45–55, on their association. For an overview of Don Luis' life, see Diego Angulo Iñiguez, "La Familia del Infante Don Luis pintada por Goya," *AEA* 14 (1940), 53–58; Affonso et al. 1961, 1: 191; Gassier 1979, 10–12. Arnaiz and Montero 1986, 45–59, demonstrate that Goya was probably introduced into Don Luis' circle by Francisco del Campo, Secretario del Camara, Gentilhombre, y Guadarropa de Doña María Teresa de Vallabriga y Rozcas (secretary of the chamber, gentleman, and valet of Doña María Teresa Vallabriga y Rozcas). Francisco del Campo married the sister of Goya's wife in March 1783.

12. Lafond 1900, 46; Beruete 1915 (see Biography), 24; Mayer 1923 (see Biography), 12–13; Sánchez Cantón 1951 (see Biography), 28; Trapier 1964 (see Biography), 2; Camón Aznar 1984, 1: 150–151. Individual portraits by Goya of the Infante and his wife were recorded in the 1886 inventory of the collection of the palace at Boadilla del Monte. See Viñaza 1887 (see Biography), 225. Finished portraits by Goya of the Infante and his wife cannot be identified today, although bust-length studies of both the Infante (Duque de Sueca, Madrid; Gudiol 1971 [see Biography], 2: fig. 236) and his wife (Zalzo collection, Madrid; Gudiol 1971, 2: fig. 238) are in existence. For a good discussion of the problems involved in interpreting the 1886 inventory and in identifying works created by Goya for Don Luis, see Gassier 1979, 18. It seems possible that the bust-length studies were utilized in making the family portrait. The Cleveland Mu-

seum of Art, *European Paintings of the 16th, 17th, and 18th Centuries* (Cleveland, 1982), 486–489, repro. 487, no. 215, attributes its portrait of Don Luis de Borbón to Goya and suggests that it is one of the paintings that the artist executed in 1783 at Arenas. However, the Cleveland painting differs significantly from other portraits by Goya, and it seems more likely that Anton Rafael Mengs executed the painting now in Cleveland. See Gassier 1979, 18, for a good analysis of the Cleveland painting.

13. Agueda and Salas 1984, 107–108, no. 49.

14. Gassier 1979, 14–15.

15. Agueda and Salas 1984, 107, n. 7, 121, n. 13, suggest that Goya would have preferred to compose the large group portrait in his studio and that he probably only executed sketches for it at Arenas de San Petro.

16. Her life is discussed by Joaquín Ezquera del Bayo and Luis Perez Bueno, *Retratos de mujeres españolas del siglo XIX* (Madrid, 1924), 38; Angel Salcedo Ruiz, *La epoca de Goya* (Madrid, 1924), 211; Affonso et al. 1961, 1: 192; Camón Aznar 1984, 3: 122; Gassier 1986, 16–24.

17. The black paint of the inscription has cracked in synchrony with the main body of the paint. This indicates that it must have been added not long after the completion of the portrait.

18. It is, of course, possible that Goya painted the portrait now in the National Gallery before 1783 and that the sitter was made to look older than she really was. This, however, seems highly unlikely.

19. Reproduced by Gassier 1986, 19 (Uffizi portrait); Gudiol 1971 (see Biography), 3: fig. 676 (Madrid portrait).

20. Fernando Diaz-Plaja, *La vida española en el siglo XVIII* (Barcelona, 1946), 195; Aileen Ribeiro, *Dress in Eighteenth-Century Europe, 1715–1781* (London, 1984), 87.

21. Trapier 1964 (see Biography), 2; Held 1965, 236; Lurie 1967, 5; Gassier and Wilson 1971 (see Biography), 61; Glendinning 1981, 238.

22. According to Arco y Garay 1953, 104, Don Luis owned Velázquez' *Crucifixion of Christ* (Prado, Madrid). According to Glendinning 1981, 238, Don Luis also owned versions of Velázquez' equestrian portrait of Balthasar Carlos and of his portrait of Sebastian del Morra. María Teresa Vallabriga coveted a sketch for *The Maids of Honor* owned by Jovellanos and unsuccessfully tried to persuade him to part with it.

References

1867. Yriarte, Charles. *Goya, sa biographie et le cataloque de l'oeuvre*. Paris: 138.

1869. Lefort, Paul. "Francisco Goya y Lucientes." In Charles Blanc et al. *Histoire des peintres: école espagnole*. Paris: 6, 12.

1887. Viñaza (see Biography): 225, no. 29.

1900. Lafond, Paul. "Goya." *RAAM* 7: 46.

1902. Benusan, Samuel Levey. "Goya: His Times and Portraits." *Conn* 2: 31; 4: 122.

1907. Oertel, Richard. *Francisco de Goya*. Leipzig: 54–55.

1908. Calvert, Albert F. *Goya: An Account of His Life and Works*. London: 124, no. 60.

1914. Sentenach, Narciso. *Los grandes retratistas en España*. Madrid: 112–113.

1915. Beruete (see Biography): 22–23, 171, no. 64. (also English ed. 1922: 26–28, 205, no. 66).

1921. Loga, Valerian von. *Francisco de Goya*. Berlin: 42, 188, no. 153.

1923. Mayer (see Biography): 12–13, 186, no. 184.

1928-1950. Desparmet Fitz-Gerald (see Biography). 1: 15; 2: 13, no 292.

1930. Derwent, Lord George Harcourt Johnstone. *Goya: An Impression of Spain*. London: 32.

1951. Sánchez Cantón (see Biography): 28, 167.

1964. Trapier (see Biography): 2-3, 52, no. 1, figs. 1-2.

1965. Held, Jutta. "Literaturbericht: Francisco de Goya: die Gemlde." *ZfK* 28: 235-236.

1967. Lurie, Ann Tzeutschler. "Francisco Jos de Goya y Lucientes: Portrait of the Infante Don Luis de Borbón." *BCMA* 54: 5, fig. 7.

1971. Gassier and Wilson (see Biography): 17-18, 61, 78, 94, no. 210, color repro. 59 (also 1981 ed.: 17-18, 61, 78, 94, no. 210, color repro. 59).

1971. Gudiol (see Biography). 1: 52, 243, no. 150; 2: figs. 244, 246, color fig. 245.

1974. de Angelis, Rita. *L'opera pittorica completa di Goya*. Milan: 98, no. 158, repro.

1974. Walker, John. *Self-Portrait with Donors*. Boston: 198-200, repro. 199.

1977. Wethey, Harold. "El Greco's 'St. John the Evangelist with St. Francis' at the Uffizi." *Pantheon* 35: 205.

1979. Gassier, Pierre. "Les portraits peints par Goya pour l'Infant Don Luis de Borbón à Arenas de San Pedro." *RArt* 43: 13, 18, fig. 2.

1979. Salas, Xavier de. *Goya*. Translated by G. T. Culverwell. London: 50, 177, no. 145, color repros. 33-35.

1981. Glendinning, Nigel. "Goya's Patrons." *Apollo* 114: 238.

1983. Gassier, Pierre. "Goya, pintor del Infante D. Luis de Borbón." In *Goya en las collecciones madrileñas*. Exh. cat., Prado. Madrid: 18.

1984. Agueda, Mercedes, and Xavier de Salas, eds. *Francisco de Goya: cartas a Martín Zapater*. Madrid: 107-108, no. 49; 109, n. 7; 121, n. 13.

1984. Camón Aznar, Jos. *Francisco de Goya*. 4 vols. Saragossa, 1: 150-151, repro. 274.

1986. Arnaiz, José Manuel, and Angel Montero. "Goya y el Infante Don Luis." *Anticuario* 27: 44-45, repros. 48, 49.

1986. Gassier, Pierre. "La contessa di Chinchon." *Goya nelle collezioni private di Spagna*. Exh. cat., Collezione Thyssen-Bornemisza. Lugano: 18-19, repro. 19.

1988. Symmons, Sarah. *Goya: In Pursuit of Patronage*. London: 98, repro. 99.

Workshop of Francisco de Goya

1937.1.86 (86)

Charles IV of Spain as Huntsman

c. 1799/1800
Oil on canvas, 46.6 x 30 (18⅜ x 11¾)
Andrew W. Mellon Collection

Technical Notes: The original support consists of a medium-weight, plain-weave, single-threaded fabric, loosely woven, which has been lined. The tacking margins have been trimmed. The lowest ground is a thin red layer covered by a gray-brown imprimatura. The paint is applied as fluid pastes and transparent glazes with tiny impasto of medium height in the highlights. There is a pentimento in the hair: the curls to the right side of the face were once lower. The paint is rather badly abraded overall, and there are darkened dabs of inpainting. A darkened, grimy varnish gives the work a dull, flat look.

Provenance: Marquesa de Bermejillo del Rey, Madrid. (Trotti et Cⁱᶜ, Paris); half share sold to (M. Knoedler & Co., New York);[1] purchased 17 October 1928 by Andrew W. Mellon, Pittsburgh and Washington; deeded 28 December 1934 to The A. W. Mellon Educational and Charitable Trust, Pittsburgh.

Exhibitions: *Goya: The Condesa de Chinchón and Other Paintings, Drawings, and Prints from Spanish and American Private Collections and the National Gallery of Art*, National Gallery of Art, Washington, 1986–1987, brochure, not paginated.

(See discussion on page 36.)

1937.1.87 (87)

María Luisa of Spain Wearing a Mantilla

c. 1799/1800
Oil on canvas, 46 x 30 (18⅛ x 11¾)
Andrew W. Mellon Collection

Technical Notes: The painting is on a medium-weight, plain-weave, single-thread fabric, loosely woven, and is lined to a heavier weight fabric. The tacking margins have been cut and removed. Oil paint is rather thinly applied, with some impasto, over a ground layer of deep rose color. A thin layer of gray-brown imprimatura is applied over the ground. There are two scratches, at the top and bottom left corners. The paint is abraded throughout, most evidently in the dress. Scattered retouches have discolored. The varnish is also discolored and milky.

Provenance: same as 1937.1.86

Exhibitions: *Goya: The Condesa de Chinchón and Other Paintings, Drawings, and Prints in Spanish and American Private Collections and the National Gallery of Art*, National Gallery of Art, Washington, 1986–1987, brochure, not paginated.

Fig. 1. Francisco de Goya, *King Carlos IV in Hunting Costume*, 1799, oil on canvas, Patrimonio Nacional, Palacio Real, Madrid

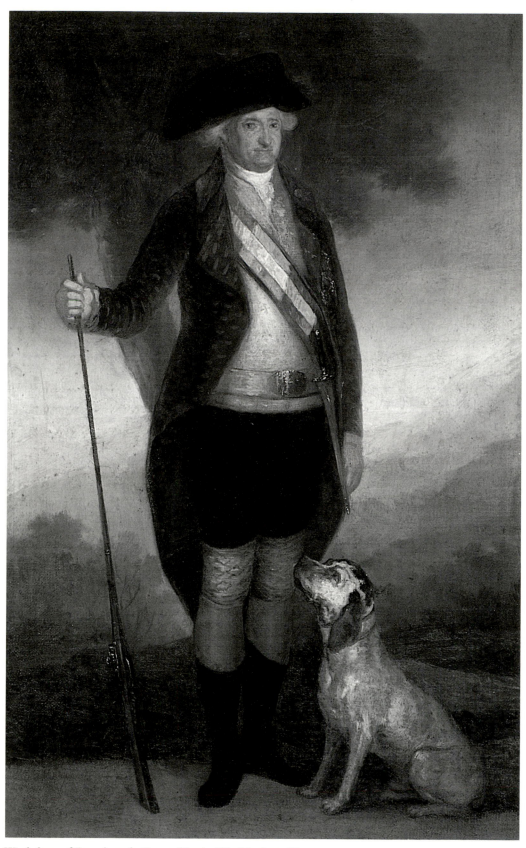

Workshop of Francisco de Goya, *Charles IV of Spain as Huntsman*, 1937.1.86

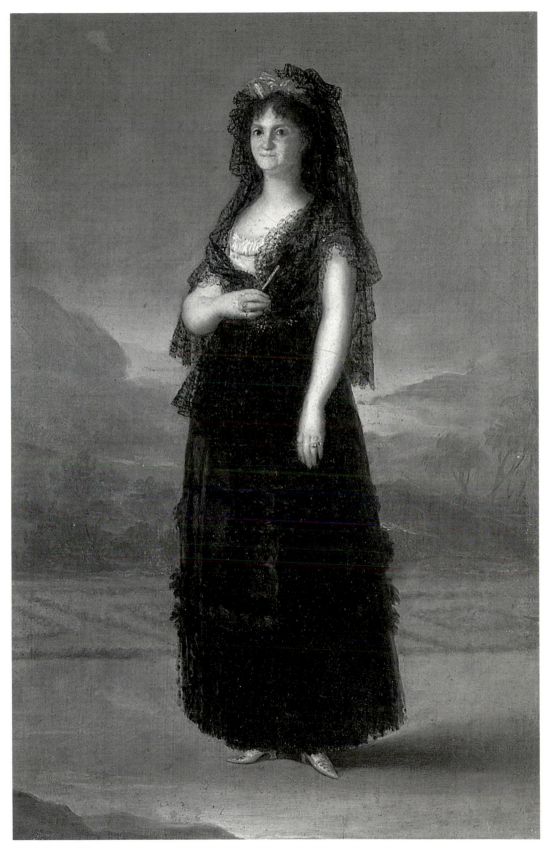

Workshop of Francisco de Goya, *María Luisa of Spain Wearing a Mantilla*, 1937.1.87

CHARLES IV OF SPAIN was born in Naples in 1748. In 1765 he married María Luisa Teresa of Parma (born 1751), daughter of Philip, duke of Parma, and Isabella of France. María Luisa dominated her weak-willed husband after he became king in 1788, and installed Manuel Godoy as favorite, with disastrous consequences for the government of the country. Following the French occupation of Spain in 1808, the king and queen went into exile and never returned. They died in Rome in 1819.

This painting and its pendant, *María Luisa of Spain Wearing a Mantilla*, are reduced versions of full-scale portraits in the Palacio Real, Madrid (figs. 1, 2).[2] The portrait of the queen was in progress on 27 September 1799; presumably that of the king was executed at about the same time, although it is not documented.[3] On 15 October 1799, the queen wrote to Godoy that

Fig. 2. Francisco de Goya, *Queen María Luisa Wearing a Mantilla,* 1799, oil on canvas, Patrimonio Nacional, Palacio Real, Madrid

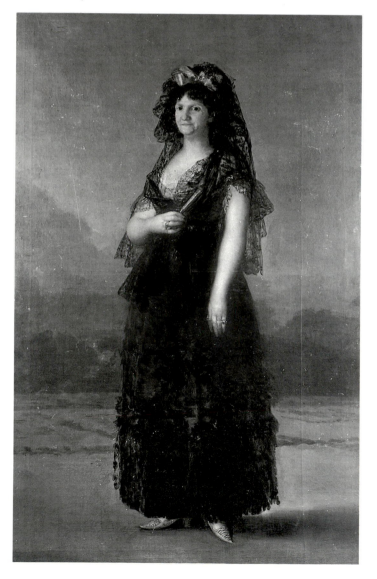

Goya's assistant Agustín Esteve was making a copy of her portrait which she would send to him upon completion (Prado, Madrid).[4] Apparently a copy of the king's portrait was also made, which is now in the Museo di Capodimonte, Naples. They measure 209 x 126 cm, while the originals measure 210 x 130 cm. Another set of copies is recorded in the Palazzo del Governo, Parma.

The National Gallery's portraits have sometimes been considered as preparatory studies by Goya for the full-scale portraits in Madrid or as autograph replicas.[5] However, the authenticity is rejected by Soria, Sambricio, Trapier, Gassier and Wilson, Wagner, and Bottineau.[6]

The quality indicates that the paintings are not by Goya. Except for minor changes in the background, the artist has followed the models virtually without change, thus indicating that they are not preliminary studies. Furthermore, the brushwork is dull and uniform, lacking the varied touches of impasto that distinguish Goya's portraits. In the portrait of the king, the bold pattern of the jacket, realized in the original by the varied and subtly blended application of yellow pigment over the buff coat, becomes a timid, repetitive pattern. The brilliant handling of the sash and the vest beneath are similarly diminished by the perfunctory treatment. Finally, the copyist fails to reproduce the somewhat burly physique of the king and his lively, slightly amused expression. Comparable limitations are readily observable in the queen's portrait.

Goya's workshop frequently produced replicas of his originals, and especially of his portraits of the king and queen.[7] These two paintings appear to be contemporary copies, although—unlike the other copies—they have been considerably reduced in scale. Sambricio attributed them tentatively to Agustín Esteve, Goya's principal assistant in the late 1790s, although he also considered it possible that they were done by another member of the shop such as Felipe Abas, Gil Arranz, or Asensio Juliá.[8] Soria rejected the attribution to Esteve and raised the name of Francisco Lameyer (1825–1877) as a possibility.[9] A reduced version of the queen's portrait by Lameyer, known to me only in a reproduction,[10] does not suggest that he was the author. Until the styles of Goya's assistants are more fully studied, the attribution may be left an open question.

J.B.

Notes
1. This information is included in the notebook of David Finley, in NGA curatorial files.

2. Gudiol 1971 (see Biography), 3: figs. 663, 665.

3. The documentation is cited by Sambricio 1957, 91, which is the standard account of Goya's portraits of Charles IV and Maria Luisa.

4. Sambricio 1957, 94. The portrait of the king in Capodimonte is reproduced on pl. 6; the queen's portrait in the Prado is reproduced in Gudiol 1971 (see Biography), 3: fig. 664.

5. Gudiol 1971 (see Biography), 1:289, nos. 416–417, considers the paintings to be preparatory sketches, while Cook, "Spanish Paintings," 153–156, regards them as autograph replicas.

6. Soria 1943, 240, n. 9; Soria 1957, 36, n. 9, where the companion piece to *Charles IV* is mistakenly identified as *María Luisa in an Oriental Turban*. Sambricio 1957, 112; Elizabeth du Gué Trapier, letter, 12 April 1962, in NGA curatorial file; Gassier and Wilson 1970 (see Biography), 166, nos. 774–775; Wagner 1983, 2:182. Bottineau 1986, 370, n. 124.

7. For this point, see Sambricio 1957, 88.

8. Sambricio 1957, 112. Bottineau 1986, 370, n. 124, also attributed the paintings to Esteve.

9. Soria 1943, 240, n. 9.

10. "Pintura española. Siglos XVIII al XX," *Goya* 98 (1970), advertising supplement of Manuel Gonzàlez.

References

1943. Soria, Martin S. "Agustín Esteve and Goya." *AB* 28: 240, n. 9.

1945. Cook, "Spanish Paintings:" 153–156, figs. 3, 4.

1957. Sambricio, Valentín de. "Los retratos de Carlos IV y María Luisa, por Goya." *AEA* 30: 85–113, pls. 5, 6.

1957. Soria, Martin S. *Agustín Esteve y Goya*. Valencia: 36, n. 9.

1958. Gaya Nuño, *La pintura española*: 78, 169, nos. 995, 977.

1970. Gassier and Wilson (see Biography): 166, nos. 774, 775 (also 1971 ed., 166, nos. 774, 775).

1971. Gudiol (see Biography). 1:289, nos. 416, 417; 3: figs. 659, 660.

1976. Walker: 404, color figs. 582, 584.

1983. Wagner, Isadora-Joan Rose. "Manuel Godoy. Patrón de las artes y coleccionista." 2 vols. Ph.D. diss. Universidad Complutense, Madrid, 2: 182.

1986. Bottineau, Yves. *L'art de cour dans l'Espagne des lumières, 1746–1808*. Paris: 370, n. 124.

1963.4.1 (1902)

The Duke of Wellington

c. 1812
Oil on canvas, 105.5 x 83.7 (41½ x 33)
Gift of Mrs. P. H. B. Frelinghuysen

Inscriptions:
At lower left in another hand: A. W. Terror Gallorum (A[rthur] W[ellesley] Terror of the French)

Technical Notes: The painting is executed on a fabric support and has been lined to two auxiliary fabrics. A red colored ground of average thickness has been applied overall. The paint is applied in opaque layers with raised brushwork and some impasto in the details and highlights of the white shirt and white feather of the hat. The painting is in secure condition. Numerous small overpaints are scattered throughout the composition, notably in the upper left forehead and shadowed cheek. The profile line of the right cheek and the background to the left have also been reinforced with scattered application of overpaint. The varnish is in poor condition.

Provenance: Probably Miguel de Alava [1771–1843], Vitoria, Spain;[1] Ricardo Alava, Madrid; (Joseph Wicht, Madrid, c. 1902); through Mary Cassatt to Henry Osborne Havemeyer [1847–1907], New York, 1902;[2] his widow, Louisine W. Havemeyer [née Elder, 1855–1929], New York; their daughter, Mrs. P. H. B. Frelinghuysen [née Adaline Havemeyer, 1884–1963], Morristown, New Jersey.

Exhibitions: *Loan Exhibition of Paintings by El Greco and Goya*, M. Knoedler & Co., New York, 1912, no. 14, as by Goya. *Paintings, Drawings and Prints: The Art of Goya*, The Art Institute of Chicago, 1941, no. 83, as by Goya. *Goya; Drawings and Prints*, Smithsonian Institution, traveling exhibition, 1955, no. 187, as by Goya (cat. suppl. for The Metropolitan Museum of Art, New York). On loan to the National Gallery of Art, Washington, 1962–1963. *Goya: The Condesa de Chinchón and Other Paintings, Drawings, and Prints from Spanish and American Private Collections and the National Gallery of Art*, National Gallery of Art, Washington, 1986–1987, brochure, not paginated. *La Alianza de Dos Monarquías: Wellington y España*, Museo Municipal, Madrid, 1988, 161, color repro. 162, 376–377, no. 4.1.13.

ARTHUR WELLESLEY, first Duke of Wellington (1769–1852), commanded the British Army during the Peninsular War and at Waterloo. He was made a field-marshal in 1813, and was created duke in May 1814 after the last battle of the Peninsular War, fought at Toulouse on 10 April 1814. Wellington was prime minister from 1828 to 1830, was elected chancellor of Oxford University in 1834, and served as secretary of state for foreign affairs between 1834 and 1835.[3]

Wellington first entered Madrid on 12 August 1812, following his victory over the French at the Battle of Salamanca (22 July), and departed on 1 September to lay siege to Burgos. During this short stay in the capital, Goya executed three portraits of the duke—one drawing, two oils—which are generally acknowledged as authentic.[4] Of these, only one is documented: the *Equestrian Portrait* (Wellington Museum, London), which was completed by the end of August and exhibited in the Real Academia de San

Fernando on 2 September 1812. The bust-length portrait in the National Gallery, London (fig. 1), was also executed at this time, although somewhat altered at a later date – perhaps in 1814, when Wellington returned to Madrid as ambassador to the court of Spain.

The drawing in the British Museum (fig. 2) seems to have been made from life as a preparatory study for the *Equestrian Portrait*.[5] It is possible that Goya then used the drawing as a starting point for the bust-length portrait, adding the outline of a round medal and making what appear to be circular erasures where he intended to place the duke's decorations. Nevertheless, the painted portrait, which is extensively reworked, also was probably made in the presence of the subject.

The close adherence of the Washington picture to the portrait in the National Gallery, London, and certain weaknesses in execution suggest that it was painted by a member of Goya's workshop.[6] In the treatment of the eyes, for example, the intense expression found in the half-length portrait in the National Gallery becomes rigid. The crease to the left side of the mouth and the dimple on the jaw, which help to impart a sense of volume to this part of the face, lie on the surface of the Washington picture like perfunctory accents. A small but telling detail is the confusion of a shadow with the sideburn. In the London painting, Goya clearly indicates the triangular shape of the sideburn. The painter of the Washington portrait misreads this passage and interprets it almost as a wavy lock of hair.[7] Another sign of the hand of an assistant is the even application of paint, in contrast to the nuanced use of impasto modeling in the London version. When the assistant resorts to this technique, as in the streaky white highlight just above the collar, the result is inconclusive and unconvincing, because it does not help to define either the face or the costume.

Nevertheless, the treatment of the body and particularly of the costume does not correspond to any of the known originals. Braham thought that Goya,

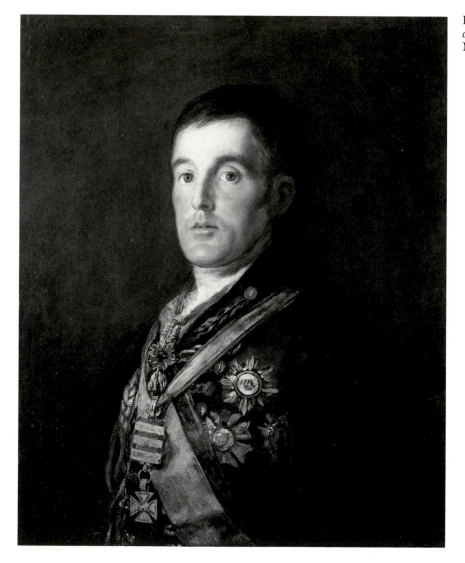

Fig. 1. Francisco de Goya, *The Duke of Wellington*, 1812 – 1814, oil on panel, National Gallery, London, 6322

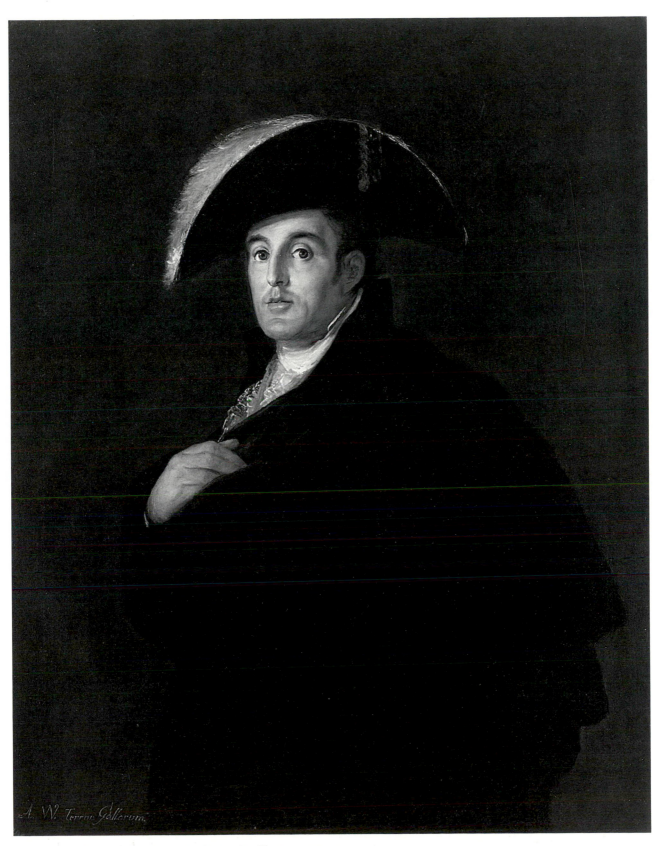

Workshop of Franciso de Goya, *The Duke of Wellington*, 1963.4.1.

Fig. 2. Francisco de Goya, *Portrait of the General the Marquis of Wellington, Later First Duke of Wellington*, 1812, red and black chalk, Trustees of the British Museum, London, 1862.7.12.185

Fig. 3. After Francisco de Goya, *The Duke of Wellington*, 1812, black chalk, Hamburger Kunsthalle, 38547

to whom he ascribed the picture, had clad the figure in the dark blue coat because he did not have access to the painting now in London and could not reproduce the decorations accurately.[8] Another explanation is suggested by the relationship between Wellington and the putative original owner of the portrait, General Miguel de Alava.[9] General de Alava (1777–1843) was Wellington's liaison officer and close friend. The two officers had fought together at Salamanca and entered Madrid in August 1812.[10]

Wellington is known to have had a rather unconventional attitude toward the forms and regulations of military dress. During the Peninsular War, he apparently often wore civilian dress.[11] At Waterloo, fought almost exactly three years after the Battle of Salamanca, he wore a costume that resembled the one worn in the Washington painting: a low cocked hat and a dark blue "surtout" coat covered by a cloak

and cape of the same color.[12] In other words, Wellington is here represented much as he appeared on the battlefield, an image that would have been especially suitable for his Spanish comrade-in-arms.

The date of execution is uncertain. The inclusion of the red ribbon of the Order of the Golden Fleece indicates that the portrait was done after about 20 August 1812, when Wellington heard news of the award, which was bestowed on him by the grateful Cortes of Spain on 7 August. If General de Alava had wanted to have the portrait as soon as possible, Goya might well have assigned its execution to an assistant. Goya was hard pressed for time at this moment in completing the *Equestrian Portrait*; as he wrote to Francisco Durán on 28 August 1812: "No tengo tiempo para nada" (I have no time for anything).[13] However, it is possible that the portrait was done at a somewhat later date. Alava seems to have owned the

of Martin in the workshop replica *Saint Martin and the Beggar* (1937.1.84).

The highly finished state of the National Gallery's version of the altarpiece of Ildefonso and the traces of a signature indicate that El Greco probably executed the work on commission.[20] The careful replication of all the features of the original altarpiece differentiates this painting from *The Holy Family with Saint Anne and the Infant John the Baptist* (1959.9.4), which was probably intended as a *modello* or *ricordo* for the use of the artist and his assistants.

R.G.M.

Notes

1. Pigment analysis in September 1987 detected lead white, iron oxide, and possibly red lead in the red table covering. X-ray fluorescence cannot detect the crimson lake dyes assumed to have been used in the glaze. Red lake pigment, which gives a purplish hue, was mixed with lead white and azurite in the blue robe of the saint, which may also contain blue verditer and ultramarine. The yellow highlights of the hem of the Madonna's robe are probably lead-tin yellow, mixed with yellow ochre and possibly massicot. On El Greco's blue pigments, see Susanna Pauli, "Two Paintings by El Greco: *Saint Martin and the Beggar*. Analysis and Comparison" (forthcoming publication, conservation department papers, National Gallery of Art).

2. The inventory of El Greco's estate made in 1614 includes the following item: "Un S. ilefonso escribiendo" (A Saint Ildefonso writing). San Román 1910 (see Biography), 193. It is probable that this refers to the National Gallery's painting, which is the only known replica of the altarpiece of this subject executed for the Hospital of Charity in Illescas.

3. Listed in the inventory of 1621 as follows: "Un san Ylefonso bestido de cardenal escribiendo, de bara y terzia de alto y casi un bara de ancho, con quadro dorado" (A Saint Ildefonso dressed as a Cardinal writing, a *vara* and a third in height and almost a *vara* in width, with a gilded frame). Francisco de Borja de San Román y Fernández, "De la vida del Greco," *AEAA* 3 (1927), 70, no. 15. A *vara*, a traditional Spanish measurement, equals about 84 cm. Thus, the painting was said to be 112 cm tall and almost 84 cm wide.

4. *Relación del magestuoso recibimiento y entretenido cortejo de una fiesta de toros celebrada en honor de Carlos II y su esposa en Burguillos en una casa de recreación de D. Juan Varela Colima, secretario de S. M. y recaudador de los millones de Toledo y su partido…3 de junio de 1698* (Madrid, 1698). The relevant passage is transcribed in Francisco J. Sánchez Cantón, *Fuentes para la historia del arte español*, 5 vols. (Seville and Madrid, 1923–1941), 5: 509–510. The presentation is described as follows: "A la Reina se ofrecieron doce albanicas de láminas primorísimas y al Rey una pintura de vara y media de alto, original del célebre Dominico Greco, que representaba a San Ildefonso con nuestra Señora, objectos predelictísimos de la devoción de Carlos II" (To the Queen were presented twelve fans with exquisitely decorated blades and to the King a painting a *vara* and one-half in height [that is, about 126 cm tall], an original by the celebrated Dominico Greco, which depicts Saint Ildefonso with Our Lady, favored objects of devotion of Carlos II). The National Gallery painting is the only work by El Greco or his workshop which corresponds to this description.

The painting is listed in the inventory of the collection at the Palacio Real, Madrid, made between 1701 and 1703, as follows: "Ytten otro lienzo de Vara y quartta de altto y bara de Ancho poco mas de Un San Yldefonso escribiendo delantte de Una Ymagen de nuestra Señora y Un Retratto en el mismo lienzo del Griego todo tasado en treinto Doblones" (And another picture one *vara* and a quarter in height [that is, c. 105 cm] and a little more than one *vara* wide [a little more than 84 cm wide] of a Saint Ildefonso writing in front of an image of Our Lady and a portrait in the same picture [frame?] by Greco, all valued at 30 *doblones*. *Inventarios reales: testamentario del Rey Carlos II*, ed. Gloria Fernández Bayton, 6 vols. (Madrid, 1975–), 1: 31, no. 130.

This entry seems to refer to two separate paintings which had been enframed together. Double enframing was not common, but it was sometimes utilized in the collection of paintings at the Palacio Real in Madrid. Among the 1,067 entries in the 1701–1703 inventory of the Madrid palace, there are five additional references to other small works enframed together. (Fernández Bayton 1975–, 1: 20, 23, 42, 49, 91, nos. 24, 48, 250, 322, 731.) All of these entries concern two paintings enframed together, except for no. 48, which consists of fourteen heads by Velázquez in eight frames.

It is impossible to know for certain what portrait was enframed with *Ildefonso*; the portrait might be a now-lost work. Nevertheless, it is tempting to posit that the *Ildefonso* was displayed with El Greco's portrait of a Dominican or Trinitarian monk (33 x 25 cm, Prado, Madrid; Legendre and Hartmann 1937, 52). This is one of the few portraits by El Greco or his school that could be combined with the Ildefonso without significantly exceeding the measurements given in the 1701–1703 inventory. Because the subject of this portrait is a monk, the combination of this painting with the *Ildefonso* would accord with the practice otherwise followed in the royal collection of jointly enframing thematically related works.

5. *Catalogue d'une riche collection de tableaux de l'école espagnole et des écoles d'Italie et de Flandre* (Paris, 1862), 19, no. 64. I am indebted for this reference to Susan Davis of the NGA curatorial records department; she was able to locate a copy of the catalogue with the assistance of Mrs. Harold Wethey and Elizabeth Conran, curator, Bowes Museum, Barnard Castle, County Durham. Cossío 1908 (see Biography), 598–599, no. 299, and Mayer 1926, 46, no. 287, maintain that Zacharie Astruc purchased the painting in Madrid and imported it to France. Because the painting was in the condesa de Quinto's 1862 sale, this is not possible. Astruc made his first trip to Spain in 1864. See Sharon Fleisher, *Zacharie Astruc: Critic, Artist, and Japoniste* (New York, 1978), 305.

6. The price is annotated in the copy of the sale catalogue at the Frick Art Reference Library, New York.

7. See note 6.

8. For an interesting account of Knoedler's purchase of this painting, see Holmes 1936, 335–340.

9. Date of purchase is noted in David Finley's notebook in NGA curatorial files. On Mellon's gift of this painting to the National Gallery and on his methods of collecting, see the entry for 1937.1.84, note 6.

El Greco, *Saint Ildefonso,* 1937.1.83

out, but significant losses of paint are confined to the edges of the original picture surface. The painting was cleaned and treated in 1988.

Provenance: Probably in the artist's possession at the time of his death.[2] His son, Jorge Manuel Theotocópuli, Toledo, by 1621.[3] Presented in 1698 to Carlos II [1661–1700] by Don Juan Varela Colima, the king's secretary and tax collector for the city and province of Toledo.[4] Condesa de Quinto, Paris (sale, Paris, 1862, no. 64,[5] as *Un saint-Evêque écrivant*); Alphonse Oudry (sale, Hôtel Drouot, Paris, 16–17 April 1869, no. 139, as *Prelat écrivant l'histoire de la Vièrge*, for 500 francs[6]); Jean-François Millet [1814–1875], Paris; his widow, Catherine Lemaîre Millet (sale, Hôtel Drouot, Paris, 24–25 April 1894, no. 261, as *L'Evêque*, for 2,000 francs[7]); Edgar Degas [1824–1917], Paris (sale, Galerie Georges Petit, Paris, 26–27 March 1918, no. 3, as *Saint-Dominique*); (M. Knoedler & Co., London);[8] purchased 7 February 1922 by Andrew W. Mellon, Pittsburgh and Washington;[9] deeded December 1934 to The A. W. Mellon Educational and Charitable Trust, Pittsburgh.

Exhibitions: *Paintings by Old Masters from Pittsburgh Collections*, Carnegie Institute, Pittsburgh, 1925, no. 21. *Spanish Paintings from El Greco to Goya*, The Metropolitan Museum of Art, New York, 1928, no. 31. *A Century of Progress Exhibition of Paintings and Sculpture*, The Art Institute of Chicago, 1933, no. 175. *Paintings and Sculpture Owned in Washington*, Phillips Gallery, Washington, 1937, no. 13. *El Greco of Toledo*, The Toledo [Ohio] Museum of Art; Prado, Madrid; National Gallery of Art, Washington; Dallas Museum of Fine Arts, 1982–1983, no. 43, pl. 56.

THIS IS the only extant replica of the large altarpiece of this subject which El Greco created for the Hospital of Charity at Illescas, probably before 1603.[10] The replica has an exceptionally distinguished provenance; the French artist Jean-François Millet, who once owned it, greatly admired its emotional power.[11]

Saint Ildefonso (c. 610–667), patron saint of Toledo, was appointed archbishop of that city in A.D. 657.[12] Although he is recognized as a saint by the entire Church, his cult has effectively been confined to Spain and Spanish territories. Within Spain he has long been venerated for his exemplary chastity, his care for the poor, his theological and devotional writings, and his visions. In the sixteenth century his treatise, *De virginitate sanctae Mariae*, was interpreted as an early defense of the Immaculate Conception.

El Greco's representation of Ildefonso was highly innovative.[13] The saint was most frequently shown receiving the chasuble from the Virgin Mary. He was also commonly depicted as a standing or enthroned figure wearing ornate ecclesiastical robes and holding symbols of his office.[14] In the altarpiece at Illescas and the National Gallery replica, Ildefonso is shown seated at a writing table furnished with costly objects of sixteenth-century design. Holding a quill pen in his hand, the saint pauses in the midst of his writing and gazes devoutly at a small statue of the Virgin. In representing Ildefonso in this way, El Greco utilized iconography previously associated with the doctors of the Church.[15] The statue shown by El Greco closely resembles the one which Ildefonso was supposed to have kept in his oratory and which is still preserved in the main retable that El Greco designed for the church of the Hospital of Charity.[16]

Like many of his other iconographic innovations, El Greco's representation of Ildefonso responded to the ideas of contemporary Toledan churchmen. Salazar de Mendoza and Pisa, Toledan ecclesiastical scholars who were friends of El Greco, claimed that Ildefonso merited veneration especially because of his writings, and that he should be compared in this regard to such doctors of the Church as Saint Jerome.[17] Salazar and Pisa were particularly concerned with establishing Ildefonso's orthodoxy because Cardinal Cesare Baronio and other prestigious non-Spanish scholars maintained that Ildefonso had propounded heretical beliefs.[18] In depicting Ildefonso as an inspired writer, El Greco created visual propaganda in support of the belief that Ildefonso should be revered as a doctor of the Church.

Grime and discolored varnish distorted the appearance of the National Gallery's painting during much of the twentieth century. The poor condition probably caused Wethey to assign this replica to the workshop.[19] The recent cleaning and restoration have made it evident that the painting is an outstanding autograph work.

The lively, varied brushwork is characteristic of El Greco's mature style. Bold, thick slashes of white impasto on the saint's robe and the table covering vividly convey the appearance of light glistening on cloth. Smooth, fluid strokes are used to model the saint's face and hands. The canvas grain is exposed in several parts of the background. Such details of the setting as the glistening silver desk service have been captured with astonishing naturalism.

No artist in El Greco's workshop could have made the saint's longing gaze at the Madonna and Child so convincing. His large, glistening eyes and the tautly pulled muscle of his neck emphasize the intensity of his devotion. One can appreciate the difference between autograph and workshop paintings by comparing the saint's mouth with the wavelike grimace

pushed the distinctive features of his style to an extreme in the works of his final years, such as the stunning *Apocalyptic Vision* for the Hospital of Saint John the Baptist (1608/1614, The Metropolitan Museum of Art, New York). *Diego de Covarrubias* (1600/1605, Museo del Greco, Fundación Vega-Inclán, Toledo) and other late portraits are enlivened by bold brushwork, but they are more naturalistic in conception and more sober in coloring than his religious paintings.

Because El Greco's work was opposed in many respects to the principles of the early baroque style which came to the fore near the beginning of the seventeenth century, it is not surprising that he had no important followers. Later seventeenth-century Spanish commentators praised his skill but criticized his antinaturalistic style and his complex iconography. His reputation had plummeted by the early eighteenth century, when Palomino described his mature work as "contemptible and ridiculous" in his influential history of Spanish art.[2] El Greco continued to be held in low esteem until the third quarter of the nineteenth century, when French Romantic writers praised his work for the "extravagance" and "madness" which had disturbed eighteenth-century viewers. During the 1860s in France, the painter Manet, the critic Astruc, and the scholar Lefort called attention to El Greco's mastery of artistic effects and thus helped to promote a widespread and lasting revival of interest in his work. The first comprehensive catalogue of El Greco's oeuvre was published in 1908 by Cossío, whose interpretation of his style as a response to Spanish mysticism greatly influenced later viewers. During the first half of the twentieth century, commentators cited a wide variety of circumstances to explain his distinctive style, including religious ecstasy, madness, and even defective vision.

The discovery and publication by Marías and Bustamante of comments by El Greco on artistic theory, and the work of other recent scholars have made it possible to evaluate El Greco's achievement more objectively. It is now apparent that his emotionally powerful style was inspired by deeply held aesthetic and intellectual convictions.

R.G.M.

Notes

1. On this painting, see *From Byzantium to El Greco: Greek Frescoes and Icons* [exh. cat., Byzantine Museum of Art, Athens; Royal Academy of Arts] (London, 1987), 190–191, no. 63, color pl. 63. A comprehensive review of what is known of El Greco's Cretan period is provided by Nikolaos M. Panagiotakis, *The Cretan Period of the Life of Domenikos Theotokopoulos* (Athens, 1986).

2. Antonio Palomino de Castro y Velasco, *El museo pictórico y escala óptica* (1715; reprint ed., Madrid, 1947), 841.

Bibliography

Cossío, Manuel B. *El Greco*. Madrid, 1908. Rev. ed., ed. Natalia Cossío Jímenez. Barcelona, 1972.

San Román y Fernández, Francisco de Borja. *El Greco en Toledo*. Madrid, 1910.

Wethey, Harold E. *El Greco and His School*. 2 vols. Princeton, 1962; Madrid, 1967 (Spanish edition).

Marías, Fernando, and Agustín Bustamante García. *Las ideas artísticas de El Greco*. Madrid, 1981.

El Greco of Toledo. Exh. cat., The Toledo [Ohio] Museum of Art; Prado, Madrid; National Gallery of Art, Washington; Dallas Museum of Fine Arts. Boston, 1982–1983.

Mann, Richard G. *El Greco and His Patrons*. Cambridge, 1986.

1937.1.83 (83)

Saint Ildefonso

c. 1603/1614
Oil on canvas, original painted surface and extended tacking margins 112 x 65.8 (44⅛ x 25⅞)
Andrew W. Mellon Collection

Inscriptions:
At lower left: traces of a signature in cursive Greek

Technical Notes: The original support is a coarse, plain-weave fabric. Before 1937 the tacking edges were flattened, and the picture was lined to a larger, medium-weight, plain-weave fabric. The white ground layer and the dark red imprimatura do not conceal the weave texture. X-radiographs reveal that the ground layer is applied roughly; striations indicate that the artist may have used a palette knife or small trowel. The imprimatura was left exposed in several places, notably along the edges of the saint's left arm and hands. The paint was applied in a moderately thick, textured paste with translucent layers in the table covering and the Madonna's robe.[1] The original right and left tacking margins are covered by daubs of paint; those on the right were left exposed after the recent treatment. Small areas of loss are scattered through-

El Greco

1541 – 1614

DOMENIKOS THEOTOKOPOULOS, called El Greco, was born in 1541 in Candia, the capital of Crete. In 1566 he was recorded in Candia as a master painter. The signed *Dormition of the Virgin* (Church of the Koimesis tis Theotokou, Syros, Ermoupolis) was probably created near the end of the artist's Cretan period. This painting combines post-Byzantine and Italian mannerist stylistic and iconographic elements.[1]

El Greco probably went to Italy to master the modern Western Renaissance style. He is documented in August 1568 in Venice, where he remained until the autumn of 1570, when he went to Rome. He was profoundly influenced by the rich colors and the free handling of paint of Venetian painters, but there is no evidence to support the tradition that he was apprenticed to Titian. The awkward handling of figures and the illogical construction of space in *Christ Cleansing the Temple* (1957.14.4) and other early works indicate the difficulties that he experienced in mastering the Western style.

In Rome, El Greco resided at least for a while at the Farnese Palace, where he became acquainted with the Farnese librarian, Fulvio Orsini, whose belief in the compatibility of art and scholarship seems to have profoundly influenced him. In 1572, El Greco was admitted to the Academy of Saint Luke as a miniature painter. The works of his Roman years, such as the *Pietà* (c. 1575, Hispanic Society of America, New York), reveal his increasing mastery of anatomy and coherent compositions.

Unable to obtain major public commissions in Rome, El Greco signed a contract in 1576 in Rome for altarpieces for the important church of Santo Domingo el Antiguo, Toledo. By July 1577 he had arrived in Toledo, and by September 1579 he had completed nine paintings for Santo Domingo, including such masterpieces as *The Trinity* (Prado, Madrid) and *The Assumption of the Virgin* (The Art Institute of Chicago). These works helped to establish his reputation as the most gifted artist in Toledo. The dissatisfaction of Philip II with the *Martyrdom of Saint Maurice*, which El Greco completed in 1582 for the church of El Escorial (now in the Salas Capitulares at El Escorial), effectively ended any hopes of royal patronage that he may have had. It is perhaps for this reason that he decided to remain in Toledo, where he had come in contact with a group of learned churchmen who appreciated his work.

By 1585, El Greco appears to have established a corporate workshop capable of producing altar frames and statues as well as paintings. In 1586 he obtained the commission for *The Burial of the Count of Orgaz* (Santo Tomé, Toledo), an exceptionally large painting (480 x 360 cm), now his best known work. The decade 1597 to 1607 was a period of intense activity for El Greco. During these years, the artist and his workshop created pictorial and sculptural ensembles for a variety of religious institutions, including the College of Doña María de Aragón, Madrid, an Augustinian seminary; the Chapel of Saint Joseph, Toledo, a private chapel with exceptional privileges; and the church of the Hospital of Charity, Illescas, a charitable foundation. Between 1607 and 1608 El Greco was involved in a protracted legal dispute with the authorities of the hospital at Illescas concerning the payment for his work; this dispute greatly strained his financial resources and contributed to the economic difficulties that he experienced until his death in 1614. In 1608 he received his last major altarpiece commission, for the Hospital of Saint John the Baptist, Toledo.

By 1600 El Greco had developed his distinctive, mature style in such religious paintings as the *Incarnation* for the College of Doña María de Aragón (1596–1600, Prado, Madrid). He evolved a style of exceptional emotional power by combining characteristic features of Central Italian mannerism—including elongated proportions, dramatic foreshortenings, serpentine poses, and shallow space—with rich colors and bold, seemingly free handling of paint inspired by Venetian practice. Freed from the necessity of conforming to the mainstream of Italian art and encouraged by his ecclesiastical patrons, he

Hamburg drawing, which subsequently passed to his son and grandson,[14] and thus could have commissioned the portrait after Wellington had returned to England.

<div align="right">J.B.</div>

Notes

1. Beruete 1915 (see Biography), 122–123; Havemeyer 1961, 156-157.

2. Copies of correspondence between Wicht and Mary Cassatt, Havemeyer's agent, in NGA curatorial files.

3. For Wellington's biography, see Elizabeth Longford, *Wellington: The Years of the Sword* (London, 1969); idem, *Wellington: Pillar of State* (London, 1972). See also Philip Guedella, *The Duke* (London, 1971).

4. For Goya's portraits of Wellington, see Allan Braham, "Wellington y Goya," in exh. cat. Madrid 1988, 145–163.

5. The drawing is discussed by Braham in exh. cat. Madrid 1988, 148–153, and by Eleanor A. Sayre, in *Goya and the Spirit of Enlightenment* [exh. cat., Prado, Madrid; Museum of Fine Arts, Boston; The Metropolitan Museum of Art] (New York, 1989), no. 97.

6. The attribution to Goya is accepted without qualification by the following writers: Calvert 1908, 142, no. 253; Mayer 1924 (see Biography), 67, no. 450; Desparmet Fitz-Gerald 1928–1950 (see Biography), 2:190; Sánchez Cantón 1951 (see Biography), 96; Braham 1966, 621; Harris 1969, 87–88; Gassier and Wilson 1970 (see Biography), 254, no. 900; Gudiol 1971 (see Biography), 316, no. 558; Camón Aznar 1984, 3:198 (as located in New York City); Braham in exh. cat. Madrid 1988, 149. The following express reservations about the quality while still accepting Goya's authorship: Beruete 1915 (see Biography), 122–123, no. 243 (the head "is weak, the weakest point of the painting, nor does it seem to be copied from life"); and Trapier 1964 (see Biography), 38 ("it must be confessed that Goya has not given the duke of his best"). The attribution is rejected implicitly by Xavier de Salas, *Goya* (London, 1979), who does not include it in his checklist of authentic works, and explicitly by Eleanor Sayre, verbal communication, 10 August 1979, on record in NGA curatorial files.

7. The author of the Washington portrait may have based his version on a drawing in the Hamburger Kunsthalle (fig. 3), as noted by Hanna Hohl in *Goya: das Zeitalter der Revolutionen, 1789–1830* [exh. cat., Hamburger Kunsthalle] (Hamburg, 1980), 301, no. 267. Although the authenticity of this sheet is accepted both by Hohl and by Pierre Gassier, *The Drawings of Goya: The Sketches, Studies and Individual Drawings* (London, 1975), 48, it has recently and plausibly been challenged by Braham in exh. cat. Ma-

drid 1988, 149, and Sayre in exh. cat. Madrid-Boston-New York 1989, no. 97.

8. Braham 1966, 621.

9. The following line of argument was developed by Carina Fryklund and presented in my seminar at the Institute of Fine Arts, New York University.

10. The great friendship between the two men is described by Pablo de Azcárate y Flórez, *Wellington y España* (Madrid, 1960), 268–275.

11. Testimony of a young Swiss officer reported by Longford 1969, 205. She discusses Wellington's dress during the Peninsular War, 146–147.

12. Contemporary prints depicting Wellington in battle generally show him in a "surtout" coat. See Victor Percival, *The Duke of Wellington: A Pictorial Survey of His Life* (London, 1969). He wears a nearly identical costume in the *Equestrian Portrait* by Sir Thomas Lawrence shown at the Royal Academy in 1818; Ronald S. Gower, *Sir Thomas Lawrence* (Paris and New York, 1900), repro. opp. 60.

13. The text of the letter appears in Angel Canellas López, *Diplomatario de Francisco de Goya* (Saragossa, 1981), 367, no. 236.

14. Gassier 1975, 48.

References

1908. Calvert, Albert. *Goya: An Account of His Life and Works*. London: 142, no. 253.

1915. Beruete (see Biography): 122–123, no. 243, pl. 45 (also English ed. 1922: 148–149, no. 251, pl. 45).

1924. Mayer (see Biography): 67, no. 450, fig. 228.

1928–1950. Desparmet Fitz-Gerald (see Biography). 2: 190, no. 477, pl. 394.

1931. *H. O. Havemeyer Collection. Catalogue of Paintings, Prints, Sculpture and Objects of Art*. Portland, Maine: 318, repro. 319.

1951. Sánchez Cantón (see Biography): 96.

1961. Havemeyer, Louisine W. *Sixteen to Sixty: Memoirs of a Collector*. New York: 156-157.

1963. Brooke, Humphrey, ed. *Goya and His Times*. Exh. cat., Royal Academy of Arts. London: 61 (by Nigel Glendinning).

1964. Trapier (see Biography): 38, no. 68, pls. 68, 70.

1966. Braham, Allan. "Goya's Equestrian Portrait of the Duke of Wellington." *BurlM* 108 (December): 618-621, appendix.

1969. Harris, Enriqueta. *Goya*. London: 87-88.

1970. Gassier and Wilson (see Biography): 254, no. 900, repro. 262 (also English ed., 1971).

1971. Gudiol (see Biography). 1:146, 316, no. 558; 4: fig. 903.

1984. Camón Aznar, José. *Francisco de Goya*. 4 vols. Saragossa: 3: 198.

10. The altarpiece is not mentioned in the artist's contract of 1603 with the Hospital. As Wethey 1962, 2: 18–19, no. 23, has pointed out, it is likely that El Greco executed the altarpiece before 1603. Because of the bitterness of the lawsuit following the completion of the contracted works in 1605, it is unlikely that El Greco would have agreed to undertake any further work for the institution after 1605. On the interpretation of this ensemble, see Sarah J. Barnes, "The Decoration of the Church of the Hospital of Charity, Illescas," *StHist* 11 (1982), 44–55.

11. Tillot 1875, xi, records Millet's reaction to the painting. "Voilà disait-il [Millet] souvent dans sa dernière maladie, en montrant un tableau du Greco accroché auprès de son lit, voilà une peinture qui est peu apprecié, l'auteur en est à peine connu. Eh bien! je connais peu de tableaux qui me touchent, je ne dirait pas d'avantage, mais autant; il fallait avoir bien du coeur pour faire une oeuvre comme celle-là." (Look at that, he [Millet] often said during his final illness, pointing at a picture by El Greco hung near his bed, that's a painting little appreciated, its author barely known. Well! I know of few pictures which touch me, I wouldn't say more, but as much; you'd need lots of heart to make a work like that.)

12. On Ildefonso and his cult, see Francisco de Pisa, *Descripcíon de la imperial ciudad de Toledo, y historia de sus antiquedades, y grandeza, y cosas memorables* (1625; reprint, Madrid, 1974), 100r–109v; Louis Réau, *Iconographie de l'art chrétien*, 3 vols. (Paris, 1955–1959), vol. 2, part 2: 676–678; S. J. McKenna, "St. Ildefonsus of Toledo," *New Catholic Encyclopedia*, 15 vols. (Washington, D.C., 1967), 7: 358.

13. See Barnes 1982, 47–48 (with bibliography). For a review of the usual iconography of the saint, see Réau 1955–1959, vol. 3, part 2: 677–678.

14. El Greco represented Ildefonso in this way in the painting now in the Escorial. (See Wethey 1962 [see Biography], 1: fig. 315; 2: 145, no. 275.) Pedro de Cisneros represented Ildefonso as an enthroned bishop in a panel in the retable in the Mozarabic Chapel in Toledo Cathedral.

15. Barnes 1982, 48 (with previous bibliography).

16. Barnes 1982, 44; Wethey 1962 (see Biography), 1: fig. 376; 2: 14, 16–17.

17. Pisa 1625, 104r–107r; Pedro Salazar de Mendoza, *El glorioso doctor San Ildefonso, arçobispo de Toledo, primado de las Españas* (Toledo, 1618), 239–245.

18. The idea that Ildefonso held unorthodox beliefs can be traced back to the Council of Frankfort of 794. At this council, Bishop Felix of Urgel and Archbishop Elipando of Toledo cited Ildefonso's writings in support of their belief that Christ was not fully divine. Ildefonso nowhere proposed such an idea, but the arguments presented by Felix and Elipando seem to have been accepted by non-Spaniards. For more on this issue, see Mann 1986 (see Biography), 29.

19. Wethey 1962 (see Biography), 2: 239, no. X-361. Cossío 1908 (see Biography), 334, described the replica as a carelessly painted and weak work of little importance ("descuidado en la factura, ennervicido y de poca importancia"). José Gudiol y Ricart, *Domenikos Theotokopolis, El Greco*, trans. Kenneth Lyons (New York, 1973), omits the National Gallery painting from his extensive catalogue of El Greco's works. The National Gallery's painting has been attributed to El Greco by Lafond 1906, 25–26; Mayer 1911, 83; Frappart 1918, 26; Field 1920, 6; Mayer 1926, 46, no. 287; Burroughs 1928, 39; Rutter 1930, 96; Holmes 1936, 340; Cortissoz 1937, 42–43; Legendre and Hartmann 1937, 433; Cook, "Spanish Paintings," 73–74; Camón Aznar 1950, 871, 1381, no. 495; Gaya Nuño, *La pintura española*, 206, no. 1397; William B. Jordan in exh. cat. Toledo-Madrid-Washington-Dallas 1982–1983, 249, no. 43.

20. What we know of El Greco's studio practice suggests that he did not execute works on speculation. Therefore it seems most likely that the Gallery's painting was commissioned. However, if this version remained in the artist's possession at the time of his death as appears to be the case (see Provenance), the individual who commissioned it must not have finalized the purchase.

References

1875. Tillot, Charles S. *Catalogue de la vente qui aura lieu par suite de décès de Jean-François Millet, peintre*. Hôtel Drouot, Paris, 10–11 May: ix.

1906. Lafond, Paul. "Domenikos Theotokopuli dit Le Greco." *Les arts* 58: 25–26.

1908. Cossío (see Biography): 334, 598–599, no. 299 (also 1972 ed.: 194, 383, no. 255).

1911. Mayer, August L. *El Greco*. Munich: 83.

1918. Frappart, A. "Chronique des ventes." *Les arts* 168: 26.

1920. Field, Hamilton Easter. Editorial. *The Arts* 1: 6, repro. 7.

1926. Mayer, August L. *Domenico Theotocopuli, El Greco*. Munich: 46, no. 287, pl. 63.

1928. Burroughs, Bryson. "Spanish Paintings from El Greco to Goya." *BMMA* 23: 39, repro. 40.

1930. Rutter, Frank. *El Greco*. New York: 96, no. 67.

1936. Holmes, Sir Charles J. *Self & Partners (Mostly Self)*. London: 340.

1937. Cortissoz, Royal. *An Introduction to the Mellon Collection*. Boston: 42–43.

1937. Legendre, Maurice and Alfred Hartmann. *Domenikos Theotokopoulos Called El Greco*. Paris: 433, repro.

1938. Goldscheider, Ludwig. *El Greco*. London: pl. 181 (also 1954 rev. ed.: pl. 187).

1945. Cook, "Spanish Paintings:" 73–74, fig. 5.

1949. Mellon: xii, repro.

1950. Camón Aznar, José. *Dominico Greco*. 2 vols. Madrid, 2: 871, 1381, no. 495, fig. 676 (also 1970 rev. ed., 2: 880, 1356, no. 500, fig. 740).

1958. Gaya Nuño, *La pintura española*: 206, no. 1397.

1962. Wethey (see Biography). 1: fig. 113; 2: 19 (under no. 23), 239, no. X-361 (also Spanish ed. 1967, 2 vols., 1: pl. 117; 2: 34 [under no. 23], 254–255, no. X-361).

1969. Manzini, Gianna, and Tiziana Frati. *L'opera completa del Greco*. Milan: no. 125e.

1942.9.25 (621)

Saint Martin and the Beggar

1597/1599
Oil on canvas, wooden strip added at the bottom,
193.5 x 103 (76⅛ x 40½); wooden strip 4.6 x 103 (1⅞ x 40½)
Widener Collection

Inscriptions:

At lower right in cursive Greek: *doménikos theotokópoulos e'poíei* (Domenicos Theotocopoulis made this)

δομήνιγος θεοθκ૭ρυλος
ε'ποιφ

Technical Notes: In structure and condition the painting is almost identical to its companion piece, *Madonna and Child with Saint Martina and Saint Agnes* (1942.9.26). The support is a single piece of linen with an unusual diamond-weave pattern. The tacking edges have been removed, but the original format was retained. The wooden strip attached to the bottom is a later addition. The gypsum ground and the two layers of reddish-brown imprimatura above it do not hide the weave texture. El Greco left the imprimatura exposed in several places: notably, to outline the head and shoulders of the beggar and the upraised leg of the horse.

Analysis of several cross sections by the NGA science and conservation departments reveals a complex layering of colors above the gesso and imprimatura. The artist utilized a variety of techniques, from wet-on-wet to scumbling. Impasto was used for Martin's collar and cuffs. X-radiographs reveal that the raised index finger of the saint's left hand originally was painted lower and that the neckstrap of the horse was placed higher. There are no major losses, except in the area of a one and one-half inch wide tear, located six inches from the bottom edge and twenty inches from the left edge. The painting was taken off a panel stretcher in 1942 and relined.[1]

Provenance: Commissioned for the Capilla de San José, Toledo, 9 November 1597. Sold by the directors of the chapel, in Paris, 1906, to (Boussod Valadon, Paris); purchased later the same year by Peter A. B. Widener, Elkins Park, Pennsylvania.[2] Inheritance from the Estate of Peter A. B. Widener by gift through power of appointment of Joseph E. Widener, Elkins Park.[3]

Exhibitions: *Loan Exhibition of Paintings by El Greco and Goya*, M. Knoedler & Co., New York, 1915, 38, no. 37. *El Greco of Toledo*, The Toledo [Ohio] Museum of Art; Prado, Madrid; National Gallery of Art, Washington; Dallas Museum of Fine Arts, 1982–1983, 168, 241, no. 30, pl. 17.

EL GRECO created this painting for the altar on the Gospel (north) side of the Chapel of Saint Joseph in Toledo. It originally faced the *Madonna and Child with Saint Martina and Saint Agnes* (1942.9.26), which was displayed on the Epistle (south) side of the chapel. Martín Ramírez (d. 1569), who provided for the establishment of the Chapel of Saint Joseph in his will, had intended that it be part of a convent of Carmelite nuns. His heirs delayed construction, however, and transformed the project into a private family burial chapel.[4] The ensemble of paintings for the chapel was one of the most important undertakings

of El Greco's career and included another large painting, *Saint Joseph and the Christ Child*, which is still displayed above the main altar.[5] El Greco signed the first contract for the altarpieces on 9 November 1597. In a document of 13 December 1599, Dr. Martín Ramírez de Zayas agreed to pay the full appraised value of El Greco's completed works.[6]

Saint Martin, clad in gold-damascened armor, sits astride a white Arabian horse as he cuts his bright green cloak in half in order to share it with the beggar who stands at the left. A distant and very freely painted view of Toledo is visible beneath the body of the horse. The bright white of the horse and the shining gold designs on Martin's armor make the horse and its rider stand out vividly from the background. Strong foreshortening helps to create the impression that the horse is projecting into the viewer's space. When the painting was located directly above the altar table, the very low viewpoint from which El Greco represented the horse would have enhanced this effect.

Saint Martin, a bishop of Tours during the fourth century, was the patron saint of Martín Ramírez, founder of the chapel. Saint Martin was widely venerated for his chastity, generosity, and zealous propagation of the Catholic faith.[7] The division of his cloak with a beggar was one of the most frequently represented events of his life.[8] At the time of this incident Martin was a Roman soldier stationed in France. The nearly naked beggar standing outside the gates of Amiens aroused his compassion to such an extent that he shared his only personal possession with the poor man. That night, Christ announced to Martin in a vision that He was the beggar who had been clothed; this vision inspired Martin to be baptized and to pursue an ecclesiastical career. In the context of the chapel, *Saint Martin and the Beggar* would have alluded to the chastity of Martín Ramírez, who was a childless bachelor, and to his generosity, which was demonstrated by the acts of charity recorded in the inscription on his sarcophagus.[9]

The National Gallery's painting was related to *Saint Joseph and the Christ Child* on the main altar of the chapel in several respects. In both paintings El Greco confined the protagonists to a narrow foreground ledge before a distant vista of Toledo. By representing the horse from a low viewpoint, El Greco elevated the figure of Martin above that of the beggar in much the same way that he elongated the figure of Joseph above the Christ Child. Martin was represented with his head inclined toward the beggar at the same angle that Joseph was shown tilting his head as he gazes down at the Christ Child.

El Greco established a dynamic emotional link be-

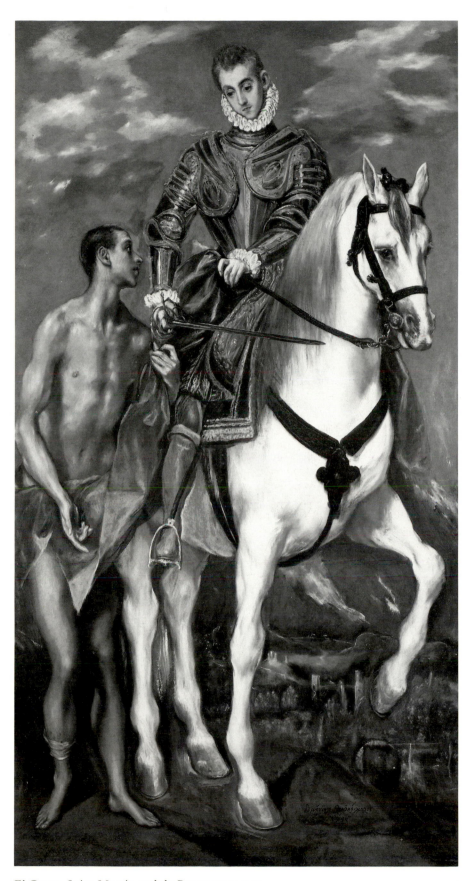

El Greco, *Saint Martin and the Beggar*, 1942.9.25

tween the main altarpiece and the two paintings above the side altars. The Christ Child in the main altarpiece turns his head sharply forward away from Joseph and stares fixedly to the right in the direction of the Epistle altar above which the *Madonna and Child with Saint Martina and Saint Agnes* was originally displayed. The strong diagonal of the Child's upraised arm reinforces the direction of his gaze. While the Child gazes at Mary, Joseph attempts to direct his attention to Martin's act of charity by pointing his staff toward and physically guiding the Child in the direction of the Gospel altar, above which the painting of Saint Martin was placed. Joseph's action visualizes his role in educating the Child about such duties as care for the poor and thus accords with the emphasis placed by adherents of his cult on his significant contribution to the Child's development.[10] Through these devices, El Greco managed to relate the main altarpiece both physically and psychologically to the side altarpieces.[11]

Saint Martin and the Beggar and *Saint Joseph and the Christ Child* were the first two paintings in which El Greco represented the city of Toledo.[12] It seems possible that the vistas were intended to suggest that Martín Ramírez and other Toledans emulated the virtues of Martin and Joseph. Indeed, by dedicating the chapel to Joseph rather than to his name saint, Martín Ramírez and his heirs may have intended to imitate the humility that Joseph demonstrated by caring for the Christ Child, whom he recognized as the Son of God.[13] Because Saint Martin was considered a vigorous defender of the faith, El Greco's representation of him riding out from Toledo could reflect the city's conception of itself as a leader of the Counter-Reformation.[14]

It seems likely that El Greco executed the present painting after he had begun the *Madonna and Child with Saint Martina and Saint Agnes*. Because x-radiography indicates that he introduced no major changes in the course of making the painting, he must have organized it immediately in terms of strongly pronounced diagonals, without experimenting with a more classicizing arrangement as he had done in the painting of the Madonna and saints. In *Saint Martin and the Beggar* he effectively combined such diverse elements as the foreshortened body of the horse, the cloak, and the gestures and glances of the figures to define a zigzag pattern that helps both to direct the viewer's attention and to express the content of the altarpiece.

There are at least five small-scale versions of this painting, including 1937.1.84. Others are in The Art Institute of Chicago; the Galleria Palatina, Palazzo Pitti, Florence; and The John and Mable Ringling Museum of Art, Sarasota. Another version was formerly in the Rumanian Royal Collection, Bucharest.[15]

R.G.M.

Notes

1. The technical notes are based on Susanna Pauli, "Two Paintings by El Greco: *Saint Martin and the Beggar*. Analysis and Comparison" (forthcoming publication, conservation department papers, National Gallery of Art). I am grateful to her for allowing me to discuss some of her findings here.

2. Edith Standen (Widener's curator), notes, in NGA curatorial files.

3. "The Perfect Collection, as Achieved by Mr. Widener of Philadelphia," *Fortune* 6 (September 1932), 66, 69.

4. Soehner 1961, 15–17. Soehner 1961 remains the basic source on the history and purposes of the chapel. The special privileges of the chapel included the right to celebrate Mass daily. Soehner maintains that the chapel was the first in Europe to be dedicated to Saint Joseph.

5. Wethey 1962 (see Biography), 1: fig. 114.

6. The commission also included the *Coronation of the Virgin*, a small painting for the attic of the main retable (Wethey 1962 [see Biography], 1: fig. 110); statues for the main altar (for a view of the main altar, see Wethey 1962 [see Biography], 1: fig. 113); and architectural frames for all the altarpieces. The first contract, of 9 November 1597, was published by San Román 1910 (see Biography), 157–158. The document of 13 December 1599 is discussed by Soehner 1961, 37, n. 22. Dr. Martín Ramírez de Zayas had previously claimed that the evaluation was unjustly high.

7. On the life of Saint Martin see Alban Butler, *The Lives of the Fathers, Martyrs, and Other Principal Saints*, ed. F. C. Husenbeth, 4 vols. (London, 1926), 4: 187–197; Leon Clugnet, "Martin of Tours," *The Catholic Encyclopedia*, 15 vols. (New York, 1907–1912), 9: 732–733; Granger Ryan and Helmut Ripperger, trans., *The Golden Legend of Jacobus Voragine* (1941; reprint, New York, 1969), 663–674.

8. On representations of this event in art, see Mrs. [Anna Murphy] Jameson, *Sacred and Legendary Art*, 4th ed., 2 vols. (London, 1863), 2: 721; Louis Réau, *Iconographie de l'art chrétien*, 3 vols. (Paris, 1955–1959), vol. 3, part 2, 907–909.

9. Soehner 1961, 29, relates the altarpiece to Martín Ramírez's generosity. He transcribes the inscription on the sarcophagus, 35, note 3. The white color of Martin's horse may have been intended to emphasize the saint's purity. For another interpretation of the significance of the white horse, see Georgiana Goddard King, "The Rider of the White Horse," *AB* 5 (1923), 6–7.

10. Joseph's action also serves to point out to the Child an event in which he will be involved directly, as a beggar. On Christ's commitment to the care of the poor see especially Matthew 25:40.

11. On the interrelationship between the paintings of Saint Martin and of the Madonna, Child, and saints, see the entry for 1942.9.26.

12. Soehner 1961, 25.

13. In this regard it is interesting to note that the inscription under the statue of King David on the left side of the

main altarpiece praises Joseph's sacrifice of himself for the glory of God. (The inscription is transcribed by Soehner 1961, 38, n. 38.) In *Saint Joseph and the Christ Child*, the angels holding flowers and wreaths above Joseph's head illustrate the heavenly rewards that will be given to those who, like him, humbly serve God. The theme of the heavenly glorification of the servants of God is highly appropriate for a burial chapel.

14. See, for example, Pedro Salazar de Mendoza, *El Glorioso Doctor, San Ildefonso, Arçobispo de Toledo, Primado de las Españas*, introduction, not paginated. For a modern study of Toledo in El Greco's lifetime, see Richard Kagan, "The Toledo of El Greco," exh. cat. Toledo-Madrid-Washington-Dallas 1982-1983, 35-73.

15. For discussion of these paintings see the entry for 1937.1.84.

References

1845. Amador de los Rios, José. *Toledo pintoresco o descripción de sus más célebres monumentos*. Madrid: 186.

1857. Parro, Sisto Ramón. *Toledo en la mano o descripción histórico-artística de la magnífica catedral y de los demás célebres monumentos*. 2 vols. Toledo, 2: 320.

1890. Palazuelos, El Vizconde de. *Toledo: guía artístico-práctica*. Toledo: 958.

1906. Lafond, Paul. "La Chapelle San José de Tolède et ses peintures du Greco." *GBA* 36: 388, repro. 387.

1907-1950. Thieme-Becker. Vol. 33 (1939): 6.

1908. Cossío (see Biography): 304-308, 340, 588, no. 242, pl. 46 (also 1972 ed.: 174-175, 385-386, no. 282, fig. 53).

1909. Calvert, Albert F., and C. Gasquoine Hartley. *El Greco*. London: 122-123, pl. 94.

1911. Mayer, August L. *El Greco*. Munich: 40, 81.

1913-1916. Widener. 3: not paginated, repro.

1923. Widener: 30, repro. 31 (also 1931 ed.: 30, repro. 31).

1926. Mayer, August L. *Dominico Theotocopuli, El Greco*. Munich: 48, no. 297.

1930. Rutter, Frank. *El Greco*. New York: 51, 62, 97, no. 77.

1931. Mayer, August L. *El Greco*. Berlin: 99, 103-104.

1937. Legendre, Maurice, and Alfred Hartmann. *Domenikos Theotokopoulos Called El Greco*. Paris: 459, repro.

1938. Goldscheider, Ludwig. *El Greco*. London: pl. 116.

1940. Widener, Peter A. B. *Without Drums*. New York: 59-60.

1941. Gudiol y Ricart, José. *Spanish Painting*. Exh. cat., Toledo [Ohio] Museum of Art. Toledo: 66, fig. 42.

1942. Widener: 4, no. 621.

1945. Cook, "Spanish Paintings:" 66-70, fig. 2.

1948. Widener: 30, no. 621, repro.

1950. Camón Aznar, José. *Dominico Greco*. 2 vols. Madrid, 2: 698-703, 1382, no. 522, figs. 533, 538 (also 1970 rev. ed., 2: 708-720, 1367, no. 523, figs. 587-589).

1952. Cairns and Walker: 78, color repro. 79.

1956. Guinard, Paul. *El Greco*. Translated by James Emmons. Cleveland: 26.

1957. Soehner, Halldor. "Ein Hauptwerk Grecos: die Kapelle San José in Toledo." *ZfK* 9: 212-215, figs. 19, 22-23.

1957. Soehner, Halldor. "Greco in Spanien" *MunchJb* 8: 162-164, 167, fig. 39; *MunchJb* 9/10 (1958/1959): 190, under nos. 56-57.

1958. Gaya Nuño, *La pintura española*: 199, no. 1337, fig. 108.

1961. Soehner, Halldor. *Una obra maestra de El Greco: la Capilla de San José de Toledo*. Translated. Madrid: 29-30, pl. 15-16.

1962. Wethey (see Biography). 1: 47, figs. 116-118; 2: 13, no. 18 (also Spanish ed. 1967, 1: 63, pls. 100-102; 2: 28, no. 18).

1966. Cairns and Walker. 1: 200, color repro. 201.

1969. Manzini, Gianna, and Tiziana Frati. *L'opera completa del Greco*. Milan: no. 105-C, color pl. 16.

1973. Gudiol y Ricart, José. *Domenikos Theotokopoulos, El Greco*. Translated by Kenneth Lyons. New York: 176, 349, no. 135, color fig. 162 (also 1983 ed.: 176, 349, no. 135, color fig. 162).

1975. Lafuente Ferrari, Enrique, and José Manuel Pita Andrade. *El Greco: The Expressionism of His Final Years*. Translated by Robert E. Wolf. New York: 158, no. 58, fig. 75.

1976. Davies, David. *El Greco*. London: 14, no. 22, color pl. 22.

1942.9.26 (622)

Madonna and Child with Saint Martina and Saint Agnes

1597/1599
Oil on canvas, wooden strip added at bottom, 193.5 x 103 (76⅛ x 40½); wooden strip 4.6 x 103 (1⅞ x 40½)
Widener Collection

Inscriptions:
On the lion's head in cursive Greek: *dth*

Technical Notes: In structure and condition this painting is almost identical to its companion piece, *Saint Martin and the Beggar* (1942.9.25). The support is a single piece of twill-weave linen with an unusual diamond-weave pattern, lined to a plain-weave fabric. The tacking edges have been removed, but the original format was retained. The wooden strip attached to the bottom is a later addition. The gypsum ground and the two layers of reddish-brown imprimatura do not hide the weave texture. The artist utilized a variety of techniques, from wet-on-wet to scumbling. Exceptionally thick impasto can be noted on the face of Saint Martina and on the draperies of the virgin martyrs and angels. X-radiographs reveal an important change in the head of Saint Martina. A profile view of her head is visible immediately to the right of the upturned countenance in the completed painting (fig. 1). The features of the two faces are the same, but they are projected from different points of view. Originally, Martina's head was upright and her gaze directly focused on Agnes. The painting was taken off a panel stretcher (perhaps original) and relined in 1942.

Provenance: Commissioned 9 November 1597 for the Capilla de San José, Toledo. Sold by the directors of the chapel, in Paris, 1906, to (Boussod Valadon, Paris); pur-

chased later the same year by Peter A. B. Widener, Elkins Park, Pennsylvania.[1] Inheritance from the Estate of Peter A. B. Widener by gift through power of appointment of Joseph E. Widener, Elkins Park.[2]

EL GRECO created this painting for the altar on the Epistle (south) side of the Chapel of Saint Joseph in Toledo. It originally faced *Saint Martin and the Beggar* (1942.9.25), which was displayed above the altar on the Gospel (north) side of the chapel.[3]

The Madonna and Child are enthroned in the heavens and surrounded by angels and seraphim. Below, two virgin martyrs are shown in adoration of the heavenly group. When this painting was located directly on the altar table, the half-length saints would have appeared to be standing immediately behind it; this effect would have illustrated the saints' roles as intercessors for the founder and patrons of the chapel.[4]

On the right stands Saint Agnes, who holds a lamb, her standard attribute.[5] Agnes is venerated as the most important of all the Roman virgin martyrs and as a defender of chastity.[6]

Fig. 1. X-radiograph of head of Saint Martina (lower left)

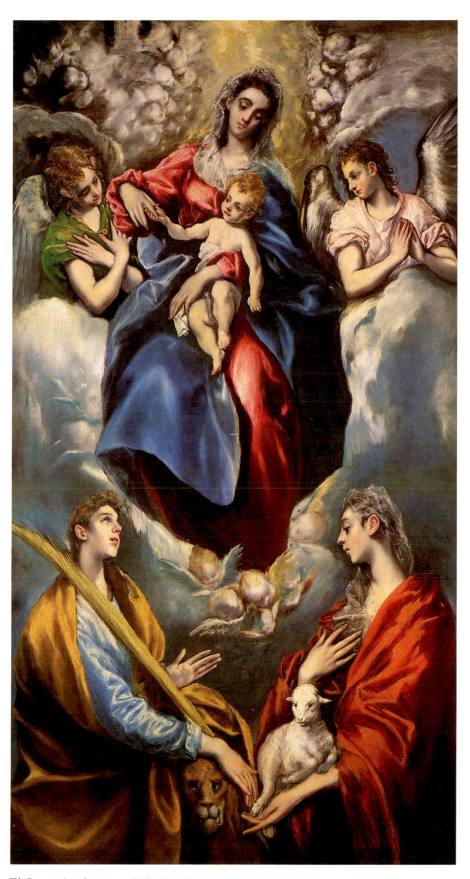

El Greco, *Madonna and Child with Saint Martina and Saint Agnes*, 1942.9.26

Cossío and several subsequent scholars have described the figure on the left as Saint Thecla.[7] However, recent authorities have tended to identify this figure as Saint Martina.[8] The lion and palm branch are the standard attributes of both these virgin martyrs.[9] Saint Thecla, who was converted to Christianity by Paul, is revered as a martyr because she endured many torments in order to preserve her chastity for the sake of her devotion to God. She died as an elderly hermit. Saint Martina is supposed to have been martyred in the third century, but she was not widely venerated until Pope Urban VIII revived her cult in 1634.

The inventories made of El Greco's estate in 1614 and of his son's possessions in 1621 provide the most important evidence for the identification of the figure at the left as Martina. The inventory of 1614 includes "Una imagen con el niño y santa ines i sanª martina" (An image [of the Virgin] with the Child and Saint Agnes and Saint Martina).[10] The inventory of 1621 lists two paintings of this subject.[11] It has generally been assumed that these items refer to studies for or copies of the painting now in Washington, although no versions by El Greco or his workshop have been located. The fact that Martina is the female form of the name of the chapel's founder, Martín Ramírez, also supports this identification.[12]

The identity of this figure might now seem beyond dispute, but for several reasons it seems possible that El Greco actually represented Thecla, as Cossío suggested. It is not certain that the entries in the inventories refer to versions of the paintings now in Washington.[13] Furthermore, Saint Thecla plays a major role in the legend of Saint Martin of Tours, the primary patron saint of the founder of the chapel. Martin was frequently visited in his room by the Virgin Mary, accompanied by Saints Agnes and Thecla.[14] In the Washington painting, El Greco may have intended to depict such a visit. The original placement of the painting directly opposite *Saint Martin and the Beggar* might have helped to emphasize this meaning. Such a thematic connection between the lateral altarpieces would have reflected the tendency to relate distant images which Soehner has noted in the main retable.[15]

The representation of Saint Thecla with Saint Agnes and the Virgin Mary also would have served to commemorate the dedication of the chapel to Saint Joseph. The Church has traditionally considered these three female saints to be the principal defenders of bodily chastity, for which Joseph was revered in the late sixteenth century.[16] An image of Thecla also would have been relevant to the funerary purpose of

the chapel because the Mass for the Dead invokes God's salvation of her from the mouth of a lion as a demonstration of the grace that he extends to the souls of faithful Christians.[17]

The change that El Greco made in the position of Martina's head attests to his interest in enlivening the picture by emphasizing diagonals and by illustrating the emotional interaction among figures in the heavenly and earthly realms. The original depiction of both the virgin martyrs in profile view would have separated them from the heavenly group and would have stressed the horizontal base of the composition. The upturned head of Martina in the final painting emphasizes the diagonal that extends from her right shoulder to the Virgin's tilted head. Also, Martina's upward glance vividly expresses her pleas to the Virgin.

In the final painting, El Greco skillfully interwove glances, gestures, and drapery folds into a zigzag pattern that leads from Agnes across to her companion and finally up to the Virgin. El Greco must have determined his basic approach to the composition before he began the upper section, because no major changes are evident there. In comparison with the bold and highly charged paintings that he created for the College of Doña María de Aragón in Madrid,[18] this and the other pictures for the chapel seem tranquil. However, the paintings for both institutions reveal the same tendency to organize compositions in terms of strongly pronounced diagonals that reflect the spiritual interaction of the heavenly and earthly protagonists.

Camón Aznar considers the *Madonna and Child with Saints and Angels* (private collection, Barcelona) to be an autograph variant of the National Gallery painting.[19] However, Wethey classifies the painting in Barcelona as a twentieth-century forgery.[20] The arrangement of the Virgin and Child in the picture now in Washington closely corresponds with El Greco's presentation of these figures in the approximately contemporary *Holy Family with Mary Magdalene* (c. 1595/1600, The Cleveland Museum of Art).[21]

R.G.M.

Notes

1. Edith Standen (Widener's curator), notes, in NGA curatorial files.

2. "The Perfect Collection, as Achieved by Mr. Widener of Philadelphia," *Fortune* 6 (September 1932), 66, 69, 70.

3. Soehner 1961 is the most comprehensive study of the history and purposes of the chapel and of the series of paintings that El Greco created for it. For further discussion of the chapel and additional references, see the entry for 1942.9.25.

4. El Greco had shown a half-length figure of the saint

in the foreground of each of the lateral altarpieces at Santo Domingo el Antiguo, Toledo (1577–1579). (For illustrations, see Wethey 1962 [see Biography], 1: figs. 51, 52.) As in the present paintings, the placement and poses of the saints in the earlier altarpieces were certainly meant to express their prayers on behalf of the patron. Compare David Davies, *El Greco* (London, 1976), 13, note to pl. 13.

5. Cossío 1908 (see Biography), 588, no. 241, and all subsequent sources have identified this figure as Agnes.

6. Alban Butler, *The Lives of the Fathers, Martyrs, and Other Principal Saints*, ed. F. C. Husenbeth, 4 vols. (London, 1926), 1: 82–84.

7. Cossío 1908 (see Biography), 588, no. 241; Widener 1913–1916, vol. 3, not paginated; Widener 1923, 32; Cook, "Spanish Paintings," 66; Widener 1948, 31, no. 622; Guinard 1956, 26; Walker 1963, 1: 62, no. 622; Cairns and Walker 1966, 1: 198; Lafuente Ferrari and Pita Andrade 1975, 125, no. 57.

8. Mayer 1911, 40; Mayer 1926, 8, no. 35; Goldscheider 1938, no. 117; Camón Aznar 1950, 2: 692, 1369, no. 227; Soehner 1957, 218; Soehner 1961, 31; Wethey 1962 (see Biography), 2: 12, no. 17; Cossío 1972, 340, n. 9; William B. Jordan in exh. cat. Toledo-Madrid-Washington-Dallas, 1982–1983, 241–242, no. 31.

9. On Saint Thecla, see Louis Réau, *Iconographie de l'art chrétien*, 3 vols. (Paris, 1955–1959), vol. 3, part 3, 1250–1252; on Saint Martina, see Réau 1955–1959, vol. 3, part 2, 918.

10. San Román 1910 (see Biography), 192.

11. These references are "No. 53. Una imagen en el zielo con el niño y uños anjeles y serafines y abajo Santa ines y Santa Martina, de bara y quarta de alto y tres quartas de ancho" (No. 53. An image in the heavens with the Child and some angels and seraphim and below Saint Agnes and Saint Martina, one and one-quarter *varas* in height and three-quarters in width); and "No. 54 Otra ymagen de la misma manera en todo" (No. 54 Another image identical in every respect). Francisco de Borja de San Román y Fernández, "De la vida del Greco," *AEAA* 3 (1927), 192.

12. See, for example, Soehner 1961, 31–32.

13. Of the two or three relevant paintings inventoried, none has been discovered. But even if the relevant items refer to versions of the National Gallery painting, one of the saints may have been incorrectly identified. Both inventories seem to have been compiled hastily.

14. Granger Ryan and Helmut Ripperger, trans., *The Golden Legend of Jacobus Voraigne* (1941; reprint, New York, 1969), 668. The representation in art of the visit to Saint Martin is briefly discussed by Réau 1955–1959, vol. 3, part 2, 911. A representation of this event is included in most of the fifteenth- and sixteenth-century Spanish retables of Saint Martin's life which have been recorded in the photographic archives of The Frick Art Reference Library, New York. The fifteenth-century Retable of Saint Martin by the Master of Hix in the parish church of Hix is among the Spanish altarpieces that include this scene. Like many other artists, the Master of Hix showed Martin kneeling before his three saintly visitors. Sometimes artists included Saints Peter and Paul in representations of this subject, although Peter and Paul visited and talked with Martin on distinct occasions (compare Ryan and Ripperger 1969, 668). Jacomart's painting of this subject in the Museo Diocesano, Segorbe, exemplifies the visual conflation of these events. This panel is discussed by Chandler R. Post, *A History of Spanish Painting*, 14 vols. (Cambridge, Mass., 1930–1966), vol. 6, part 1, 33.

15. Soehner 1961, 32–33.

16. Butler 1926, 1: 82, traces back to Saint Ambrose the tradition that the Virgin Mary and Saints Agnes and Thecla were the leading guardians of chastity. For a general discussion of the development of the cult of Saint Joseph in the Counter-Reformation period, see Emile Mâle, *L'art du XVIe siècle, du XVIIe siècle et du XVIIIe siècle* (1951; reprint, Paris, 1972), 313–325.

17. Réau 1955–1959, vol. 3, part 3, 1250. The suggestion that El Greco represented Thecla can be considered only as a tentative hypothesis at this time. To avoid confusion, the official identification of the saint as Martina has been retained in the rest of the text.

18. On this commission, see Mann 1986 (see Biography), chapter 2.

19. Camón Aznar 1950, 2: 697, 1369, no. 228, fig. 533. Angels are shown in the foreground, and the two saints in the background seem to be men.

20. Wethey 1962 (see Biography), 2: 191, no. X-116.

21. Exh. cat. Toledo-Madrid-Washington-Dallas 1982–1983, 242, no. 31, pl. 46.

References

1845. Amador de los Rios, José. *Toledo pintoresco o descripción de sus más célebres monumentos.* Madrid: 186.

1857. Parro, Sisto Ramón. *Toledo en la mano o descripción histórico-artística de la magnífica catedral y de los demás célebres monumentos.* 2 vols. Toledo, 2: 320.

1890. Palazuelos, El Vizconde de. *Toledo: guía artístico-práctica.* Toledo: 958.

1906. Lafond, Paul. "La Chapelle San José de Tolède et ses peintures du Greco." *GBA* 36: 388–389, repro. 389.

1907–1950. Thieme-Becker. Vol. 33 (1939): 6.

1908. Cossío (see Biography): 303, 588, no. 241, pl. 45. (also 1972 ed.: 172, 174, 340, n. 9, fig. 50.)

1911. Mayer, August L. *El Greco.* Munich: 40.

1913–1916. Widener. Vol. 3: not paginated, repro.

1923. Widener: 32, repro. 33 (also 1931 ed.: 32, repro. 33).

1926. Mayer, August L. *Dominico Theotocopuli, El Greco.* Munich: 8, no. 35, pl. 33.

1931. Mayer, August L. *El Greco.* Berlin: 83, 99.

1938. Goldscheider, Ludwig. *El Greco.* London: pl. 116 (also 1949 rev. ed.: pl. 110).

1940. Widener, Peter A. B. *Without Drums.* New York: 59–60.

1942. Widener: 5, no. 622.

1944. Cairns and Walker: 76, color repro. 77.

1945. Cook, "Spanish Paintings:" 66, fig. 1.

1950. Camón Aznar, José. *Dominico Greco.* 2 vols. Madrid, 2: 692–697, 1369, no. 227, figs. 530–531 (also 1970 rev. ed., 2: 704–708, 1351, no. 236, figs. 582, 584–585).

1956. Guinard, Paul. *El Greco.* Translated by James Emmons. Cleveland: 26.

1956. Walker: 32, color pl. 10.

1957. Soehner, Halldor. "Ein Hauptwerk Grecos: die Kapelle San José in Toledo." *ZfK* 9: 215–222, fig. 26.

1957–1959. Soehner, Halldor. "Greco in Spanien." *MunchJb* 8 (1957): 167; *MunchJb* 9/10 (1958/1959): 190, under nos. 56–57.

1958. Gaya Nuño, *La pintura española*: 199, no. 1338, color pl. 6.

1961. Soehner, Halldor. *Una obra maestra de El Greco: la Capilla de San José de Toledo.* Translated. Madrid: 30–32, pls. 20–24.

1962. Wethey (see Biography). 1: 47, fig. 115; 2: 12–13, no. 17 (also Spanish ed. 1967, 1: 63, pl. 99; 2: 28, no. 17).

1963. Walker: 162, no. 622, color repro. 163.

1966. Cairns and Walker. 1: 198, color repro. 199.

1969. Manzini, Gianna, and Tiziana Frati. *L'opera completa del Greco*. Milan: no. 105-D, color pls. 17, 18.

1973. Gudiol y Ricart, José. *Domenikos Theotokopoulos, El Greco*. Translated by Kenneth Lyons. New York: 175–176, 348, no. 134, color fig. 160.

1975. Lafuente Ferrari, Enrique, and José Manuel Pita Andrade. *El Greco: The Expressionism of His Final Years*. Translated by Robert E. Wolf. New York: 158, no. 57, color pls. 15–17.

1943.7.6 (743)

Saint Jerome

c. 1610/1614
Oil on canvas, 168 x 110.5 (66⅛ x 43½)
Chester Dale Collection

Inscriptions:
Unidentified inventory number at upper left: "100"

Technical Notes: The support is a heavy, plain-weave fabric, probably linen, lined to a moderately heavy plain-weave fabric. In 1929 pieces added by a later artist at the top, the bottom, and the right side were removed.[1] El Greco utilized a reddish-brown imprimatura. Oil paint was applied in a moderately thick paste with brush strokes of low to moderate relief. There are significant losses of original paint on the saint's right thigh, the background to the left of the thigh, and in the sky at the upper left; smaller losses of paint are scattered throughout. The painting was cleaned and restored in 1988/1989. Discolored varnish and old repaint which concealed much of the brushwork on the torso and such details as the crucifix at the upper right were removed.

Provenance: El Greco's son, Jorge Manuel Theotocópuli, Toledo, by 1621.[2] Possibly in the Convent of San Hermengildo, Madrid, in 1786.[3] Felipe de la Rica of the Montejo family, Madrid, by 1902.[4] Doña María de Montejo, Madrid, by 1908.[5] Montejo family to a European art dealer; (Boehler and Steinmeyer, Lucerne and New York).[6] Purchased by Chester Dale, New York, before 25 February 1931.[7]

Exhibitions: *Exposición de las obras de Domenico Theotocópuli, llamado El Greco*, Prado, Madrid, 1902, 27, no. 43. *El Greco of Toledo*, The Toledo [Ohio] Museum of Art; Prado, Madrid; National Gallery of Art, Washington; Dallas Museum of Fine Arts, 1982–1983, 254–255, no. 54, pl. 67 (shown in Washington only).

THIS IS El Greco's only full-length representation of Saint Jerome in penitence. El Greco otherwise represented the saint in penitence in a half-length type which included many of Jerome's traditional symbols, such as a cardinal's hat, a Bible, a skull, and an hourglass.[8] In addition, El Greco depicted Jerome as a cardinal in a frontal, half-length format.[9] He consistently portrayed Jerome with a long, narrow head with hollowed cheeks, strongly pronounced cheek bones, deeply recessed eyes beneath heavy eyebrows, a long aquiline nose, and weathered, wrinkled skin. In the National Gallery's painting, El Greco made Jerome's beard significantly shorter and more scraggly than in his other paintings of the saint, and he omitted traditional attributes except for the stone in the saint's blood-soaked right hand, the opened book on top of the boulder, and the crucifix sketchily indicated in the upper right corner.

Saint Jerome (c. 345–420) is one of the Four Latin Fathers of the Church.[10] Jerome was educated in Rome, where he distinguished himself as a student of languages and eventually dedicated himself to a career as a priest. In 373 he made a pilgrimage to the Holy Land; from 374 to 376 he lived as a hermit in the Syrian desert. In 382 he returned to Rome where he was the secretary of Pope Damasus I until the Pope's death in December 384. The hostility provoked by his revisions of the Bible, efforts for religious reform, and satirical attacks on his opponents forced Jerome to leave Rome in 385 for the Holy Land. He spent the rest of his life in a monastery near Bethlehem, where he devoted himself to translating the Bible into Latin. In the sixteenth century devotion to Jerome was widespread in Spain, and Spanish rulers strongly supported the Hieronymite Order which had been founded in Spain in the fourteenth century in honor of the saint.[11]

The image of the penitent Jerome, which originated in Tuscany in the early fifteenth century, enjoyed great popularity throughout the sixteenth and seventeenth centuries.[12] The scene illustrates Jerome punishing himself during his stay in the desert as penance for his love of classical secular learning.[13] The popularity of the penitent Jerome may be explained at least in part by the general emphasis of the Counter-Reformation Church on the sacrament of penance. Loys Laserre, Johannes Molanus, and other sixteenth-century hagiographers recommended that the saint be represented in penance because they felt that this scene best exemplified the uprightness of his life and that it could inspire others to imitate his example.[14]

Among earlier representations, the present painting is most closely related to Titian's *Saint Jerome in Penitence* (1575) in the Escorial, as Wethey noted.[15]

Although Cossío's suggestion that the female figure is Artemis must be rejected, his proposal that the male represents Apollo is most convincing.[30] Apollo would be a logical witness to the execution that he ordered. Although this figure's arm is not clearly defined, it seems to be raised in a gesture of presentation or command, either of which would be appropriate for Apollo in this context. The representation of Apollo as a young man posed energetically yet elegantly follows classical tradition.

It seems possible that the female figure represents Venus (Aphrodite). Previous commentators have assumed that key attributes were omitted from this figure. However, a nude woman with an elaborate hairstyle and a diadem is an iconographically complete image of the goddess of love, who played an important role in the entire history of the Trojan conflict. Indeed, the war was caused by Paris' preference for Aphrodite, "who offered him the pleasures and penalties of love."[31] Both the preliminary head, which has a vivid expression of terror, and the final head, which is turned away from the scene of death, convey Aphrodite's suffering at the defeat of Troy. Her presence at Laocoön's punishment is appropriate because the priest had succumbed to the temptations of love. In one of his very few references to classical mythology, Carranza claimed that whenever a sexual transgression is condemned, Venus is also judged and punished.[32]

Although the meaning of *Laocoön* has proved elusive, the painting can be recognized immediately as a tour de force of artistic skill. In the *Laocoön*, El Greco seems to have tried to prove the validity of his strongly held convictions that modern artists could surpass their ancient predecessors and that painters were uniquely able to devise visually convincing and emotionally stirring images.[33] El Greco diverged more than any other sixteenth-century artist from the illustrious Hellenistic sculpture of this subject.[34] Such features as the bold foreshortening of the two reclining figures, the swaying pose of the figure on the left, the sense of real muscular exertion (created partly through the handling of light and shade and the lively brushwork), the representation of the snake's tongue by a flick of impasto, and the panoramic cityscape take advantage of the special properties of painting. Viewers may never agree on the meaning of this work, but all can appreciate its dramatic force and originality.

R.G.M.

Fig. 1. Photograph of painting prior to restoration of 1955

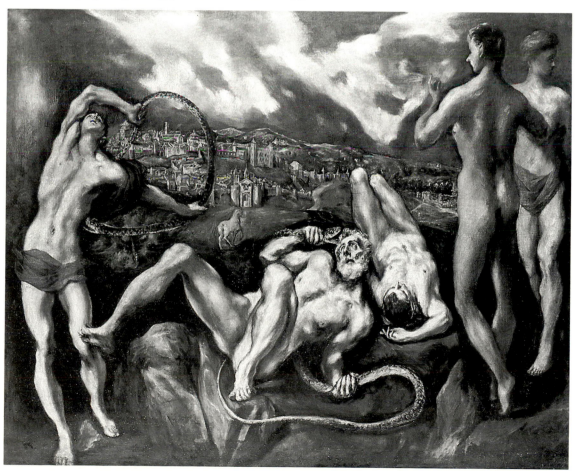

The account in the *Aeneid* is undoubtedly the best-known ancient version. According to Virgil, Lao-coön, a Trojan priest in the service of Neptune (Poseidon), incurred the wrath of Minerva (Athena) by throwing a spear at the wooden horse that she helped the Greeks to build.[14] In retaliation, Minerva sent serpents to kill Laocoön and his two sons as he offered a sacrifice to Neptune later in the day. The Trojans interpreted these deaths as an omen that the horse should be brought into the city.

In 1908, Cossío proposed that El Greco based his painting on the pre-Virgilian account of Arctinus of Miletus.[15] According to Arctinus, Laocoön was a priest of Apollo, who required chastity from those in his service. Arctinus asserted that Apollo ordained the death of Laocoön to punish him for marrying and fathering children. Cossío argued that the figure struggling with a serpent on the far left of the painting represents the son who escaped from death according to Arctinus' account. However, because the serpent's head almost touches this figure, it is difficult to believe that El Greco intended to suggest that this son will escape.

El Greco could also have been familiar with the accounts of Laocoön's death in the commentaries on the *Aeneid* by Hyginus and Servius.[16] Both authors maintained that Laocoön normally served Apollo and that he had been chosen by lot to offer a sacrifice at Neptune's altar. According to Hyginus, Apollo had been previously angered by the priest's marriage and took advantage of the ceremony at Neptune's altar to send serpents to attack him and his sons. According to Servius, Apollo was particularly angry at Laocoön because the priest had had intercourse with his wife immediately before he offered the sacrifice at Neptune's altar. Both Hyginus and Servius agreed with Virgil that the serpents killed both of Laocoön's sons.

In the left and center foreground of El Greco's painting, Laocoön and his sons are shown being attacked by serpents. The relationship to Laocoön's legend of the two figures at the right is uncertain. As Jordan has noted, the unfinished state of these figures and the seeming lack of conventional attributes have frustrated attempts to identify them.[17] In the background is a free representation of Toledo, with the wooden horse standing in front of the Puerta Nueva de Bisagra.[18]

Some scholars have argued that El Greco conceived Laocoön as a Christian martyr in classical disguise.[19] According to Waterhouse, Laocoön and his sons symbolize conservative Toledan ecclesiastics who tried to warn their contemporaries about the dangers posed by reforms in the Catholic Church.[20] More recently,

Davies interpreted the scene as a tribute to Bartolomé Carranza de Miranda, an archbishop of Toledo who was imprisoned by the Church between 1559 and 1576 while he was tried on charges of promoting heretical ideas in his writings.[21] Although the final decision in Carranza's case was ambiguous, Toledans never questioned his orthodoxy and believed he had been unjustly persecuted by misguided men.

Considering El Greco's sensitivity to fine points of iconography and doctrine, it seems very unlikely that he would have used a rebellious and unchaste priest to represent a Christian martyr.[22] More probably, El Greco intended the death of Laocoön and his sons to serve as a warning against the violation of the vow of chastity, as Cossío first suggested.[23] This interpretation follows from the commentaries of Hyginus and Servius and accords with the mood of the Church in Toledo during the Counter-Reformation. The Council of Trent maintained that the failure of priests to observe the vow of chastity discredited the Church and thereby made people susceptible to the corrupting influence of Protestant beliefs.[24] The Council's pronouncements on the vow of chastity can be related to the situation of Laocoön, who was unable to inspire the Trojans to save their city.

Carranza far exceeded the Council of Trent in condemning inchastity. In his *Comentarios sobre el Catechismo christiano*, which was greatly admired by friends and patrons of El Greco, Carranza defined a priest's failure to keep the vow of chastity as a sacrilege and strongly urged that the death penalty be used to punish sexual transgressions.[25] In accord with Carranza's writings, the death of Laocoön and his sons can be interpreted as the just and necessary punishment of an unchaste priest. Unlike other sixteenth-century representations of Troy during the final siege, El Greco's painting does not show any Trojans welcoming the horse.[26] Perhaps the almost eerie lack of any sign of life in the city was meant to affirm that Toledans ignored heretical ideas because their priests had not discredited Catholic doctrine through misconduct.[27]

Two figures standing at the right have been variously identified. Palm's identification of them as Adam and Eve and Vetter's as Paris and Helen both depend on the assumption that the male figure is holding an apple in his upraised hand.[28] However, the swirl of paint in this area does not seem to represent any object and probably resulted from the artist's efforts to define the hand and arm, which he left unfinished. Camón Aznar's suggestion that the figures represent Poseidon and Cassandra is not convincing from an iconographic point of view.[29]

1958. Gaya Nuño, *La pintura española*: 202, no. 1379.

1962. Wethey (see Biography). 1: figs. 291, 293; 2: 132, 134, no. 249 (also Spanish ed. 1967, 1: pls. 268, 270; 2: 144, 146, no. 249).

1965. National Gallery of Art. *Paintings Other than French in the Chester Dale Collection.* Washington: 11, no. 743.

1969. Manzini, Gianna, and Tiziana Frati. *L'opera completa del Greco.* Milan: no. 170, color pl. 43.

1972. Cossío, Manuel B. *El Greco.* Edited by Natalia Cossío de Jiménez. Barcelona: 384, no. 264.

1973. Gudiol y Ricart, José. *Domenikos Theotokopoulos, El Greco.* Translated by Kenneth Lyons. New York: 197–198, 350, no. 153, color fig. 179 (also 1983 ed.: 197–198, 350, no. 153, color fig. 179).

1975. Lafuente Ferrari, Enrique, and José Manuel Pita Andrade. *El Greco: The Expressionism of His Final Years.* Translated by Robert E. Wolf. New York: 137–138, 162, no. 146, color pls. 13–14.

1976. Davies, David. *El Greco.* London: 15, note to pl. 36, color pl. 36.

1980. Friedmann, Herbert. *A Bestiary for Saint Jerome.* Washington: 94, 150, 174, 257, fig. 79.

1946.18.1 (885)

Laocoön

c. 1610/1614
Oil on canvas, 137.5 x 172.5 (54⅛ x 67⅞)
Samuel H. Kress Collection

Inscriptions:
Unidentified inventory number at lower left: 104

Technical Notes: The support is a fine-weight, plain-weave fabric, lined to a similar fabric. Over the white ground El Greco applied a thin red imprimatura, which he left exposed in many parts of the composition. The paint was applied in rich, opaque layers with thin, scumbled brushwork in the areas of lighter color. Although there is no high impasto, the brushwork is lively and textured. X-radiographs reveal only a few minor revisions of the composition. The painting was cleaned and restored by Mario Modestini in 1955. Extensive areas of loss in the throat, chest, and legs of the figure at the far left and in the raised leg of Laocoön were inpainted, as were smaller scattered damages. Modestini removed loincloths which had been painted over the figures at the far left and far right and a large bouffant coiffure which had been added to the female figure at the right (fig. 1). He also exposed the middle head of the group of three now visible at the right and the fifth leg between the two standing figures at the right. The painting is in fair condition.

Provenance: Probably in El Greco's possession at his death.[1] Probably his son, Jorge Manuel Theotocópuli, Toledo, in 1621.[2] The Infante Antonio María Felipe Luis de Orléans, Duque de Montpensier [1824–1890], Seville;[3] his son, the Infante Don Antonio de Orléans, Duque de Galliera, Sanlúcar de Barremada, Cadiz.[4] (Durand-Ruel, Paris, by 1910.[5]) (Paul Cassirer, Berlin, by October 1915.[6]) The pianist Edwin Fischer [1886–1960], Basel and Berlin, by 1923.[7] Eleanora Irme von Jeszenski von Mendelssohn, Berlin, who was divorced from Fischer in 1925, by 1926.[8] T. R. H. Prince and Princess Paul of Yugoslavia, Belgrade, Johannesburg, and Paris, by May 1934;[9] consigned to (Knoedler & Co., London, Paris, and New York, 1946); purchased 1946 by the Samuel H. Kress Foundation, New York.[10]

Exhibitions: *Sonderausstellung El Greco*, Alte Pinakothek, Munich, 1910. *Werke alter Kunst aus Berliner Privatbesitzer*, Paul Cassirer, Berlin, 1915. *Domenikos Theotokopoulos (El Greco): Some Works of His Early and Mature Years*, Benaki Museum, Athens; National Pinakothek, Athens, 1979–1980, 12–16. *El Greco of Toledo*, The Toledo [Ohio] Museum of Art; Prado, Madrid; National Gallery of Art, Washington; Dallas Museum of Fine Arts, 1982–1983, 256–257, no. 56, pls. 68, 69. On loan to the State Hermitage Museum, Leningrad, 1989.

THE *Laocoön* is widely recognized as a masterpiece of the last years of El Greco's life. The free, vigorous handling of paint; the boldly twisted poses of the figures; and the intense facial expressions are typical of the powerful, emotionally charged works that El Greco created between 1610 and 1614.

The *Laocoön* is the artist's only extant painting of a classical mythological subject. Its unfinished state suggests that it was a trial piece for the larger version of the Laocoön recorded in the seventeenth century.[11] It seems probable that the middle head and leg were preliminary studies for the woman at the right.[12] If the Gallery's painting was indeed a trial piece, El Greco may have left the alternate head and leg for the female figure exposed; a later artist may have applied the paint that was removed in 1955 (see fig. 1).

No work by El Greco has aroused as much controversy among scholars as *Laocoön*. Despite numerous attempts to interpret it, no consensus has been reached about the meaning of this stunning painting. Jordan suggests that it might be a relatively straightforward depiction of the ancient legend.[13] However, because formal and iconographic inventiveness are generally linked in El Greco's work, it seems probable that the artist intended the scene to have additional layers of meaning.

The legend of Laocoön and his sons exists in several variants, and attempts to interpret the National Gallery's painting have been frustrated by the impossibility of knowing which one El Greco illustrated.

drid," *BSEE* 41 (1933), 50. According to this inventory, the painting measured "2 varas y media de alto y ancho" (2½ *varas* in height and width [approximately 210 x 210 cm]). Because the inventory was incomplete and inconsistent in many places, it is possible that the compilers omitted the width and that they intended to refer to the National Gallery's painting, which was 215 cm tall before the added pieces were removed (Peter Murray, letter, 4 May 1964; Philip Troutman, letter, 28 May 1964, both in NGA curatorial files). The unfinished state of the painting may account for the relatively low valuation of 600 *reales* assigned it in the 1786 inventory. For comparison, El Greco's finished portrait of Fray Hortensio Félix Paravicino (now in the Museum of Fine Arts, Boston) was valued at 6,000 *reales* in the same inventory.

4. *Exposición de las obras de Domenico Theotocópuli, llamado El Greco* [exh. cat., Prado] (Madrid, 1902), 27, no. 43. It is stated that Rica was a member of the Montejo family in a letter from Boehler and Steinmeyer, New York, 10 April 1931, transcribed by David Finley in a notebook in NGA curatorial files.

5. Cossío 1908 (see Biography), 571, no. 113.

6. Boehler and Steinmeyer, letter, 10 April 1931, transcribed by David Finley in a notebook in NGA curatorial files.

7. Photocopy of statement of authenticity, 25 February 1931, in NGA curatorial files.

8. Wethey 1962 (see Biography), 2: 132–133, nos. 245–248. Versions of this type exist in the National Gallery of Scotland (Wethey 1962, 1: fig. 290); Real Academia de Bellas Artes de San Fernando, Madrid (Wethey 1962, 1: figs. 289, 292); the Diputación Provincial, Madrid (Camón Aznar 1950, 2: fig. 695); and the Hispanic Society of America, New York (Camón Aznar 1950, 2: fig. 696).

9. Wethey 1962 (see Biography), 2: 130–131, no. 240–244. Versions of this type are located in the Musée Bonnat, Bayonne (Wethey 1962, 1: fig. 287); National Gallery, London (Camón Aznar 1950, 2: fig. 689); the collection of José Luis Várez-Fisa, Madrid (Camón Aznar 1950, 2: fig. 685); The Frick Collection, New York (Wethey 1962, 1: fig. 286); and the Robert Lehman collection at The Metropolitan Museum of Art, New York (Wethey 1962, 1: fig. 288).

10. The basic source on the life and cult of Jerome is now Eugene F. Rice, Jr., *Saint Jerome in the Renaissance* (Baltimore, 1985); see especially 1–22 on Jerome's life. Other sources include Mrs. [Anna Murphy] Jameson, *Sacred and Legendary Art*, 4th ed., 2 vols. (London, 1863), 1: 285–300; Karl Künstle, *Ikonographie der Christlichen Kunst*, 2 vols. (Freiburg im Breisgau, 1926), 2: 299–307; F. X. Murray, "Saint Jerome," *New Catholic Encyclopedia*, 15 vols. (Washington, 1967), 7: 872–874; Louis Réau, *Iconographie de l'art chrétien*, 3 vols. (Paris, 1955–1959), vol. 3, part 2, 740–755.

11. Alonso de Villegas, *Flos Sanctorum y historia general de la vida y hechos de Iesu Christo y todos los santos de que rezan y haze fiestas en la Yglesia Católica*, rev. ed. (Madrid, 1588), 335v–336v. For a concise but informative history of the Hieronymite Order, see J. M. Besse, "The Hieronymites," *The Catholic Encyclopedia*, 15 vols. (New York, 1907–1912), 7: 345. After his abdication in 1555, Charles V retired to the Hieronymite monastery at Yuste. Philip II made a Hieronymite monastery an essential part of the palace at the Escorial.

12. Rice 1985, 76–83, 104, 144–145, 153.

13. See Rice 1985, 3–11.

14. Rice 1985, 144–145, 153–161.

15. Wethey 1962 (see Biography), 2: 132. El Greco greatly reduced the scope of the landscape, however, and made the figure occupy most of the picture surface. For an illustration of Titian's painting, see Harold E. Wethey, *The Paintings of Titian*, 3 vols. (London, 1969–1975), 1: pl. 195.

16. Wethey 1962 (see Biography), 2: 133, no. 249. On these visions, see Jameson 1863, 1: 286–287.

17. Rice 1985, 179–188.

18. On these paintings, see Rice 1985, 189–195, with extensive bibliography. Examples include Domenichino's *Saint Jerome* (1602, National Gallery, London; Richard E. Spear, *Domenichino*, 2 vols. [New Haven, 1982], 2: pl. 3).

19. Jonathan Brown, in exh. cat. Toledo-Madrid-Washington-Dallas 1982–1983, especially 113–117.

20. Soehner 1957, 194; Wethey 1962 (see Biography), 2: 134, no. 249; Davies 1976, 15, note to pl. 36; William B. Jordan in exh. cat. Toledo-Madrid-Washington-Dallas 1982–1983, 255, no. 54. Mayer 1926, 45, no. 281, suggested that the painting was probably a late work. For a general discussion of El Greco's late technique, see Hubertus Falkner von Sonnenburg, "Zur Maltechnik Grecos," *MunchJb* 9/10 (1958/1959), 249–250. Cossío 1908, 571, no. 113, dates the painting 1584/1594. Camón Aznar 1950, 2: 1382, no. 516, assigns the painting to the years 1600–1605. Gudiol 1973, 350, no. 153, dates the painting 1597–1603.

21. Wethey 1962 (see Biography), 1: figs. 72, 154; 2: 133, no. 249; exh. cat. Toledo-Madrid-Washington-Dallas 1982–1983, 255, no. 54.

22. Rutter 1930, 90, no. 12, pl. 80. The figure in the drawing is weightless and delicate–very unlike the strong, fully three-dimensional bodies in El Greco's paintings. The elaboration of the background is also not characteristic of El Greco's technique.

23. Wethey 1962 (see Biography), 2: 242, no. X-378. For an illustration, see Legendre and Hartmann 1937, 436. Although the use of the reddish-brown ground corresponds with El Greco's technique, the conception and execution of both the figure and the setting strongly differ from El Greco's method.

References

1908. Cossío (see Biography): 366, 571, no. 113, pl. 71.

1909. Calvert, Albert F., and C. Gasquoine Hartley. *El Greco*. London: 153, pl. 58.

1924. Bénézit, E. *Dictionnaire critique et documentaire des peintres, sculpteurs, dessinateurs, et graveurs*. 3 vols. Paris, 3: 882.

1926. Mayer, August L. *Dominico Theotocopuli, El Greco*. Munich: 45, no. 281, repro. 45.

1930. Mayer, August L. "Unbekannte Werke des Greco." *Pantheon* 5: 183–184, repro. 181.

1930. Rutter, Frank. *El Greco*. New York: 90, no. 12.

1931. "Fine El Greco Added to Chester Dale Collection." *ArtN* 29 (29 April): 4.

1931. Mayer, August L. *El Greco*. Berlin: 64, fig. 46.

1937. Legendre, Maurice, and Alfred Hartmann, *Domenikos Theotokopoulos, Called El Greco*. Paris: 437, repro.

1945. Cook, "Spanish Paintings:" 75, fig. 6.

1950. Camón Aznar, José. *Dominico Greco*. 2 vols. Madrid, 2: 896–897, 1382, no. 516, fig. 698, (also 1970 ed., 2: 898, 900, 1366–1367, no. 518, figs. 759–760).

1957. Soehner, Halldor. "Greco in Spanien." *MunchJb* 8: 182, 184, 194.

One major difference between the paintings is the role of light. Titian showed light entering the mouth of the saint's cave from the upper left and illuminating the crucifix that he contemplates, but he did not represent the saint responding to it, as El Greco did. El Greco endowed the burst of white and golden light with great importance because he depicted the saint twisting the upper part of his body toward it and gazing at it with an expression of spiritual rapture. The upward striving effect created by the spiral pose and the elongated proportions give the impression that the saint is lifting himself toward the light.

El Greco may have intended to represent Jerome experiencing one of the many visions he was supposed to have received during his stay in the desert.[16] It also seems possible that the artist was trying to visualize Jerome responding to the Holy Spirit, which guided him as he translated the Bible. Post-Tridentine theologians defended the sanctity of the Vulgate by claiming that the inspiration of the Spirit enabled Jerome to translate the Bible without making any serious errors of doctrine. These theologians acknowledged that the Spirit had not suppressed Jerome's human faculties and had permitted him to make errors on such insignificant matters as points of grammar.[17] Late sixteenth- and seventeenth-century artists usually visualized the inspiration of Jerome by showing an angel dictating points to him.[18] The dictating angel clearly illustrated the intervention of the Spirit but obscured Jerome's role as an active translator. The more abstract representation of the Spirit by a band of light would express more precisely the view of the Counter-Reformation Church because it would permit Jerome greater freedom of action. This conception would accord with El Greco's usual tendency to visualize accurately complex points of doctrine.[19]

Soehner, Wethey, Davies, and Jordan have recognized the National Gallery's painting as a major work of the final years of El Greco's life. The bold, fluid handling of paint and the unfinished state support the assumption that the painting dates from the period of about 1610/1614.[20]

This unfinished painting is particularly fascinating because it reveals the stages of the artist's technique. El Greco first outlined the entire figure with black paint over the reddish-brown imprimatura which is visible in many places, especially in the lower half of the composition. He utilized thin, fluid strokes of gray and earth tones to define the figure, as can be noted in the saint's left leg, and then smoothly applied lighter flesh tones to model the anatomy, as can be noted in the right leg. The torso and arms

exemplify the next stages of his construction of the figure. He enlivened the upper part of the body with roughly applied flicks of thick, white impasto. Strong lines made by the coarse bristles of the artist's brush are visible in many places, most notably in the saint's right hand. If he had completed this section, El Greco probably would have smoothed out the jagged contours and more fully described such sketchily indicated elements as the saint's right hand. The head is virtually complete. Here, El Greco blended together the vigorously applied impasto highlights in order to create a relatively smooth, coherent effect. The ruddy flesh tones of the head are typical of his depictions of male saints. The right background is sketchily defined with the same gray and earth tones utilized in the left leg. The sky, tree, and cave mouth at the upper left are defined more fully with fluid strokes of various colors and white impasto highlights.

The pose is closely related to that which El Greco employed in the early *Saint Sebastian* in the Cathedral at Palencia and for Christ in the *Baptism of Christ* for the College of Doña María de Aragón (1596–1600, Prado, Madrid).[21] A drawing in the Gutekunst collection, London, which has been described as a preparatory study, probably has no connection with the National Gallery painting.[22] A small version (64 x 40) of the painting in the Galleria Palatina, Palazzo Pitti, Florence, may be by Luis Tristán or another Spanish artist of the seventeenth century.[23]

R.G.M.

Notes

1. The restoration is discussed briefly by Mayer 1930, 183. The additions included a trumpet at the top and landscape at the bottom and right. With the additions, the painting measured 215 x 120 (Cossío 1908 [see Biography], 571, no. 113). For an illustration of the painting before the additions were removed, see Cossío 1908, pl. 71. It is widely agreed that the added pieces were not by El Greco (see, for example, Mayer 1926, 45, no. 281; Wethey 1962 [see Biography], 2: 133, no. 249).

2. Francisco de Borja de San Román y Fernández, "De la vida del Greco," *AEAA* 3 (1927), 82, no. 145: "un San Jerónimo desnudo" (a nude Saint Jerome). According to this inventory, the painting measured 2 x 1¼ *varas* (approximately 168 x 106 cm). Exh. cat. Toledo-Madrid-Washington-Dallas 1982–1983, 255, no. 54, also identifies the Gallery's painting as the one cited as no. 145 in the 1621 inventory. It is probable that Jorge Manuel inherited this painting from his father, although it is not mentioned by name in the inventory made of El Greco's estate in 1614. The painting may have been one of the "quinze quadros bosqueados" (fifteen paintings sketched in) mentioned in the inventory of 1614; San Román 1910 (see Biography), 195.

3. The inventory made of the paintings in the convent included a Saint Jerome by El Greco. See El Conde de Polentinos, "El Convento de San Hermengildo, de Ma-

El Greco, *Saint Jerome,* 1943.7.6

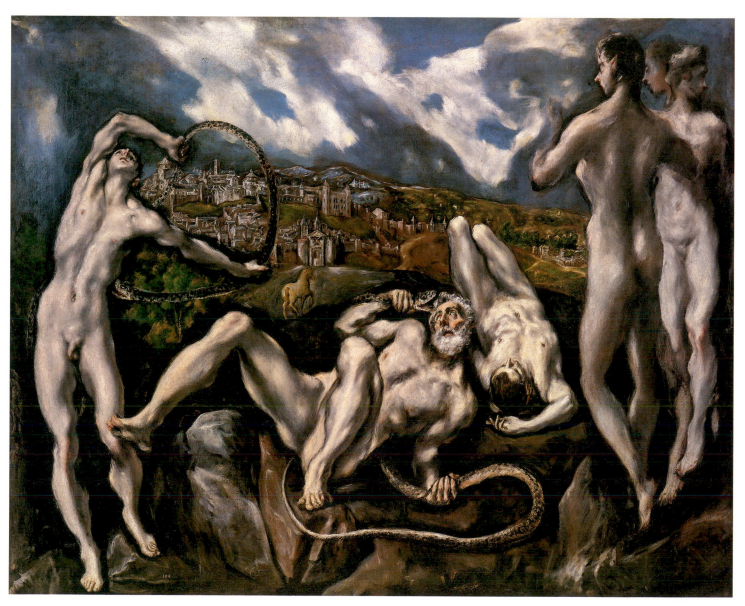

El Greco, *Laocoön*, 1946.18.1

Notes

1. The inventory of the artist's estate made in 1614 included two examples of a small Laocoön ("Un laocon pequeño") and one large painting of this subject ("Un laocon grande"); San Román (see Biography) 1910, 193. Because the measurements of the Kress painting correspond most closely to those of the smallest of the versions cited in the inventory of 1621 (see note 2), it seems likely that the Kress painting was one of the two small versions recorded in 1614.

2. The inventory of the possessions of Jorge Manuel made in 1621 includes the following items:

"41 Un laocon, de dos baras de largo y bara y dos terzias de alto" (A Laocoön of two *varas* in width and one and two-thirds of a *vara* in height).

"179 Un laocon grande, de tres baras y media en quadrado" (A large Laocoön, three and one-half *varas* square).

"180 Otro laocon, casi del mismo Tamano" (Another Laocoön, almost the same size).

Francisco de Borja de San Román y Fernández, "De la vida del Greco," *AEAA* 3 (1927), 291, 301. Because a *vara* equals approximately 84 cm, the measurements of no. 41 correspond closely to those of the Kress painting. The difference in the numbers of large and small versions of the subject mentioned in the two inventories suggest that Jorge Manuel sold one of the two smaller paintings in his father's estate and that he or another artist in the workshop produced another large copy of the composition before 1621. Alternatively, a mistake may have been made in one of the inventories.

The inventory made in 1632 of the collection of Don Pedro Laso de la Vega, Madrid, includes the following: "Una pintura grande delacon del Dominico" (A large painting of Laocoön by Domenico). See Caviro 1985, 217–219. It is possible that this refers to the National Gallery's painting. However, Laso's inventory could also refer to one of the larger versions of the subject recorded in 1621 in Jorge Manuel's possession.

Many scholars have maintained that the Kress painting was in the royal collection in the seventeenth and eighteenth centuries: Cossío 1908 (see Biography), 362; Villar 1928, 132; Cook 1944, 262, n. 1; Camón Aznar 1950, 2: 921; Wethey 1962 (see Biography), 2: 84, no. 127; Eisler 1977, 198, no. K1413; William B. Jordan, in exh. cat. Toledo-Madrid-Washington-Dallas 1982–1983, 257, no. 56; Moffit 1984, 44; Pita Andrade 1985, 329. However, López Torrijos 1981, 397, has argued that the Kress painting was not included in the royal collection. It seems most probable that the royal inventories refer not to the Kress painting but to one of the larger versions cited in the 1621 inventory. The relevant entries are the following:

Alcázar, Madrid, inventory of 1666, no. 520: "3 varas casi en quadro de Lauconte y sus hijos de mano del Greco en 300 ducados de plata" (3 *varas*, almost square, of Laocoön and his sons, by the hand of El Greco, at 300 silver *ducados*). Harold E. Wethey, letter, 22 June 1969, in NGA curatorial files.

Alcázar, Madrid, inventory of 1686, no. 310: "Un quadro de tres baras de largo casi quadrado de la Oconte y sus hijos de blanco y negro de mano del Griego, tiene Marco negro como las demas pinturas de esta pieza" (A painting, three *varas* in width, almost square, of Laocoön and his sons, in white and black by the hand of El Greco, has a black frame like the other paintings in this room). Yves Bottineau, "L'Alcázar de Madrid et l'inventaire de 1686: aspects de la cour d'Espagne au XVIIᵉ siècle," *Bulletin Hispanique* 60 (1958), 164.

Alcázar, Madrid, inventory of 1701–1703, no. 119: "Un cuadro de tres varas de largo quasi quadrado de laoconte y sus hijos de blanco y negro de mano del Griego con marco negro tasado en cien Doblons" (A painting three *varas* in width, almost square, of Laocoön and his sons, in white and black by the hand of El Greco, with a black frame valued at 100 *doblones*). Gloria Fernández Bayton, ed., *Inventarios reales: Testamentario del Rey Carlos II*, 6 vols. (Madrid, 1975–), 1:29.

The dimensions given in all these inventories correspond to the now lost larger versions of the Laocoön, but not to the Kress painting.

The Kress painting has also been related to references in the royal inventories of 1701–1703 and 1791 to an approximately square painting of Laocoön, about two *varas* across, said to be a copy of Titian. The width of this painting approximates that of the Kress painting. However, it seems most unlikely that the Kress painting would have been described as a copy of Titian, especially because an original Laocoön by El Greco and the copy after Titian were recorded in the royal collections at the same time. (Fernández Bayton 1975– , 1:29, no. 119; 2:324, no. 581.) Spanish critics of the seventeenth and eighteenth centuries carefully distinguished the styles of Titian and El Greco, and the compilers of the royal inventories probably would not have confused them. See, for example, Antonio Palomino de Castro y Velasco, *El Museo pictórico y escala óptica* (1715 and 1724; reprint, Madrid, 1947), 841; Antonio Ponz, *Viaje de España*, ed. C. María de Rivero (Madrid, 1947), 640.

3. *Catálogo Montpensier* 1866, 44, no. 155.

4. Cossío 1908 (see Biography), 579, no. 162.

5. Eisler 1977, 198, 201, no. 163, no. K1413. On loan to the Alte Pinakothek, Munich, July 1911–1913. See Mayer 1911/1912, 10–11; Mayer 1926, 50, no. 311. Mayer 1911, 11, indicates that the Alte Pinakothek hoped to obtain the painting for its collection. The ownership of the painting from 1911 to October 1915 is uncertain.

6. Burchard 1915, 525. Recorded in 1914 and again in 1916 as on loan to the Kaiser Friedrich Museum, Berlin (Kehrer 1914, 85; Mayer 1916, 57).

7. "Die Zeit und der Markt" 1923, 1156–1157; Schmid 1923, 6; Schmid 1924, 6.

8. Riggenbach 1926, 27; Fischer 1926, 6; Fischer 1929, 34. On loan to the öffentliche Kunstsammlungen, Basel, 1923–1929, from Fischer and later from von Jeszenski von Mendelssohn. Basic biographical information about Fischer and von Jeszenski von Mendelssohn is given in *Neue Deutsche Biographie* 5 (Munich, 1961), 180. Cook 1944, 262, n. 1, maintains that the *Laocoön* was purchased before 1914 by Fischer's wife, whom he misidentifies as Frau von Schwabach. Because this painting was owned by the dealer Cassirer in 1915, this supposition is unlikely. Frau von Schwabach may possibly have been an earlier owner, unrelated to Fischer.

9. Clark 1935, 7. On loan to the National Gallery, London, May 1934–December 1935. During the Second World War, Prince Paul, then resident in Johannesburg, arranged to have the painting at the National Gallery, Washington, for safekeeping (Finley 1973, 89).

10. Walker 1974, 144–146, presents a lively discussion of the negotiations involved in the sale.

11. On the larger version(s), see notes 1 and 2. On the

restoration that revealed the extra head and leg, see Technical Notes.

12. As Palm 1969, 132, noted, the additional head and leg give the group at the right a confused appearance. Hauser 1965, 1:269, supposed that they form part of a sixth figure that El Greco intended to finish. However, strokes of the other two heads appear to cross over the edges of the middle head, suggesting that the middle head was a preliminary study replaced by the head now on the right.

13. William B. Jordan, in exh. cat. Toledo-Madrid-Washington-Dallas 1982–1983, 256, no. 56.

14. Virgil, *The Aeneid*, trans. Robert Fitzgerald, 2d ed. (New York, 1985), 34–35, 40–41 (book 2, 55–80, 273–310).

15. Cossío 1908 (see Biography), 357–363. Eisler 1977, 198–199, no. K1413, n. 5, reviews what is known of Arctinus' account. A fragment of this account is transcribed and translated by Hugh G. Evelyn-White, *Hesoid: The Homeric Hymns and Homerica* (1936; reprint, New York, 1974), 520–523.

16. Hyginus' account of Laocoön is transcribed by H. J. Rose, ed., *Hygini Fabulae Recensuit* (Leiden, 1963), 98. Servius' commentary is transcribed by Rose 1963, 99–100, n. 135. Eisler 1977, 196, no. K1413, suggested that the commentaries of Hyginus and Servius could have been El Greco's literary sources.

17. Exh. cat. Toledo-Madrid-Washington-Dallas 1982–1983, 256–257, no. 56.

18. Davies 1976, 16, note to pl. 41, pointed out that El Greco's representation of Toledo as Troy is in accord with a legend that the Spanish city was founded by two descendants of the Trojans, Telemon and Brutus. The representation of Toledo in this painting can also be related to El Greco's depictions of it as the setting of the Crucifixion and other biblical events.

19. Kehrer 1939, 103–104, and Moffitt 1984, 44–60, suggest that El Greco was influenced by art theorists who recommended that the famous Hellenistic sculpture of Laocoön be used as a model for representing the sufferings of Christ and the saints. For further discussion of the critical evaluation of the Laocoön by sixteenth-century theorists, see Margarete Bieber, *Laocoön: The Influence of the Group Since Its Rediscovery* (New York, 1942), 2–7; L. D. Ettlinger, "*Exemplum Doloris*: Reflections on the Laocoön Group," in Millard Meiss, ed., *De Artibus Opuscula: Essays in Honor of Erwin Panofsky*, 2 vols. (New York, 1961), 1: 12. Camón Aznar 1950, 2: 914–919, maintained that El Greco intended the pleading expression on Laocoön's face to signify his final appeal to God and his confidence in divine mercy.

20. Waterhouse 1972, 114.

21. Davies 1976, 16, note to pl. 41. Waterhouse 1978, 32, and Rogelio Buendía 1983, 42–44, have endorsed Davies' proposal. Rogelio Buendía also argued that the salvation of martyrs is symbolized by the serpent held in an arc by the figure at the far left. Crombie 1977, 321, presented some important arguments against Davies' interpretation. On Carranza's career and the circumstances of his imprisonment, see Mann 1986 (see Biography), 3–4, 7–8, 116–117 (with bibliography).

22. It should be kept in mind that the recommendation to use the sculpture of Laocoön as a model of Christian suffering (see note 19) referred only to the work of art and did not imply approval of Laocoön's actions.

23. Cossío 1908 (see Biography), 362. Villar 1928, 133, endorsed Cossío's theory. Palm 1969, 131–132, interpreted the painting as a warning of the danger of violating any aspect of the Christian moral code.

24. *The Canons and Decrees of the Sacred and Oecumenical Council of Trent*, trans. J. Waterworth (London, 1848), 270–271 (session 25).

25. Bartolomé Carranza de Miranda, *Comentarios sobre el Catechismo christiano*, ed. José Ignacio Tellechea Idigoras, Biblioteca de Autores Christianos Maior 1–2, 2 vols. (Madrid, 1972), 2: 56–62, 87–88. On this issue, Carranza's ideas correspond with those of such Doctors of the Church as Basil. See Saint Basil, *Ascetical Works*, trans. M. Monica Wagner (New York, 1950), 208. On the estimation of Carranza by El Greco's friends and patrons, see Mann 1986, 3–4, 6–8, 30–31, 116–117, 137 (with bibliography). Cardinal Quiroga, Archbishop of Toledo (1577–1594), declared that a priest's failure to keep the vow of chastity constituted a sacrilege. Cardinal Gaspar Quiroga, *Consitutiones sinodales hechas por el illustrissimo y reverendissimo Señor d. Gaspar de Quiroga* (Madrid, 1583), 20r–20v, 29v–30r. Quiroga ordered that priests who violated the vow of chastity should be excommunicated, but he stopped short of advocating the death penalty recommended by Carranza. Appearances seem to have mattered as much as actions to Quiroga; he proposed that priests should be excommunicated if they were seen in the company of women suspected of immoral behavior even if sexual intercourse did not take place.

26. More typical in this respect is Giovanni Fontana's engraving of Laocoön. For a reproduction, see Cook 1944, fig. 11.

27. The belief that Toledans were exceptionally virtuous and devout was emphasized by many of El Greco's contemporaries. See, for example, Pedro Salazar de Mendoza, *Cronica de el gran Cardenal de España, Don Pedro Gonçalez de Mendoça* (Toledo, 1625), 1–19.

28. Palm 1969, 132; Palm 1970, 298–299; Vetter 1969, 295–297.

29. Camón Aznar 1950, 2:914. Although Laocoön was officiating at the altar of Poseidon (Neptune) when he was attacked, none of the accounts suggests that Poseidon sought to punish the priest. The male figure lacks any attributes of the god of the sea. Because Apollo punished Cassandra and thus ensured that her warnings would be ignored by the Trojans, it might seem appropriate to include her as a parallel to Laocoön. However, none of the accounts of the siege of Troy relates Laocoön and Cassandra directly to one another. Moreover, there would be no justification for representing Cassandra nude, and pairing her with a god would be very unconventional.

30. Cossío 1908 (see Biography), 361–362. It seems unlikely that El Greco would have represented Artemis (a goddess of chastity) nude.

31. Homer, *The Iliad*, trans. E. V. Rieu (Harmondsworth, 1950), 437–438 (book 24, 29–31).

32. Carranza 1972, 2:61.

33. Marías and Bustamente García 1981 (see Biography), especially 165–166, 171–172.

34. As Förster 1906, 174–175, noted. In devising the National Gallery painting, El Greco may have drawn inspiration from a large number of earlier works. Eisler 1977, 196–197, 199–200, nn. 9–27, no. K1413, and Moffitt 1984, 46–49, summarize many possible sources (with extensive bibliography). Kitaura 1986, 85–91, also discusses various possible sources and points out borrowings from the Lao-

coön sculptured group in earlier paintings by El Greco.

References

1866. *Catálogo de los cuadros y esculturas pertenecientes á la galeria de SS. AA. RR. los Seteníssimos Señores Infantes de España, Duques de Montpensier.* Seville: 44, no. 155.

1903–1904. Williamson, George, ed. *Bryan's Dictionary of Painters and Engravers.* 4th ed. 5 vols. London, 5: 168.

1906. Förster, Richard. "Laokoön im Mittelalter und in der Renaissance." *JbBerlin* 27: 174–175.

1907–1950. Thieme-Becker. Vol. 33 (1939): 7.

1908. Cossío, Manuel B. *El Greco.* Madrid, 1908: 357–363, 579, no. 162, pl. 67 (also 1972 ed.: 207–211, 397, no. 385, fig. 66).

1909. Calvert, Albert Frederick, and C. Gasquoine Hartley. *El Greco.* London: 170–171, pl. 126.

1911. Mayer, August L. *El Greco.* Munich: 56–58, 74, 82, repro. 73 (also 1916 ed.: 32–33, 57, pl. 51).

1911/1912. Mayer, August L. "Sammlungen." *Kunstchronik* 23: 10–11.

1914. Kehrer, Hugo. *Die Kunst des Greco.* Munich: 22, 85–87, 101, pl. 61.

1915. Burchard, Ludwig. "Werke alter Kunst aus Berliner Privatbesitzer." *Kunst und Künstler* 13: 523, 525, repro. 525.

1917. Henry, Norman. "Vergil in Art." *Art and Archaeology* 5: 239, repro.

1923. Schmid, H. U. "Über das Jahr 1923." *Jahresbericht der öffentlichen Kunstsammlungen, Basel* 20: 6.

1923. "Die Zeit und der Markt: Sammlungen." *Der Cicerone* 15: 1156–1157.

1924. Schmid, H. U. "Über das Jahr 1924: Gemäldegalerie." *Jahresbericht der öffentlichen Kunstsammlungen, Basel* 21: 6.

1925/1926. "Bericht über das Jahr 1925 und 1926." *Jahrbuch für Kunst und Kunstpflege in der Schweiz* 4: 60.

1926. Kehrer, Hugo. *Spanische Kunst.* Munich: 96–97, repro. 98.

1926. Mayer, August L. *Dominico Theotocopuli, El Greco.* Munich: 50, no. 311, pl. 116.

1926. Riggenbach, R. "Über das Jahr 1926: Gemäldegalerie." *Jahresbericht der öffentlichen Kunstsammlungen, Basel* 23: 27.

1927. Fischer, Otto. "Über das Jahr 1927." *Jahresbericht der öffentlichen Kunstsammlungen, Basel* 24 (1927): 6.

1927/1928. Saxl, Fritz. Review of August L. Mayer, *El Greco.* In *Kritische Berichte zur kunstgeschichtlichen Literatur*: 95–96, fig. 11.

1928. Villar, Emilio H. del. *El Greco en España.* Madrid: 132–133, pl. 28.

1928/1930. Fischer, Otto. "Bericht über das Jahr 1928: Gemäldegalerie;" "Bericht über das Jahr 1929." *Jahresbericht der öffentlichen Kunstsammlungen, Basel* 25/27: 6, 34.

1931. Mayer, August L. *El Greco.* Berlin: 138–139, 163, fig. 120.

1935. Clark, Kenneth. "Report: National Gallery, 1935." *National Gallery and Tate Gallery Directors' Reports 1935.* London: 4.

1937. Legendre, Maurice, and Alfred Hartmann. *Domenikos Theotokopoulos Called El Greco.* Paris: 482, repro.

1938. Goldscheider, Ludwig. *El Greco.* London: 8, 16, pl. 216 (also 1954 rev. ed.: pl. 193).

1939. Bourgeos, Stephen. *Byrdcliffe Afternoons.* Woodstock, N.Y.: 99–101.

1939. Kehrer, Hugo. *Greco als Gestalt des Manierismus.*
Munich: 100–108, pl. 13.

1944. Cook, Walter S. "El Greco's *Laocoön* in the National Gallery." *GBA* 26: 261–272, figs. 1–2, 4–6.

1946. Chamberlain, Betty. "Recent Additions to the Kress Collection." *BurlM* (1946): 82.

1946. "Vernissage." *ArtN* 45 (April): 17, repro.

1950. Camón Aznar, José. *Dominico Greco.* 2 vols. Madrid, 1950, 2: 805, 880, 914–921, 1390, no. 696, figs. 714–717, 719–720 (also 1970 rev. ed., 2: 815, 883, 918–924, 997, 1292, 1376, no. 684, figs. 780–783, 785–786).

1952. Cairns and Walker: 81, color repro.

1956. Guinard, Paul. *El Greco.* Translated by James Emmons. Cleveland: 104, 106, repro. 102, color repros. 103–104.

1956. Walker: 32.

1958. Gaya Nuño, *La pintura española*: 206, no. 1424.

1958/1959. Soehner, Halldor. "Greco in Spanien." *MunchJb* 9/10: 181, 194, fig. 59.

1959. Kress: 269, no. 885, repro.

1960. Kehrer, Hugo. *Greco in Toledo.* Stuttgart: 69–70, figs. 75–76.

1962. Wethey (see Biography). 1: 50–51, 61, 63, figs. 144–145; 2: 83–84, no. 127 (also Spanish ed. 1967, 1: 66–67, 76, 78, pls. 128–129; 2: 98, no. 127).

1963. Sánchez Cantón, Francisco Javier. *El Greco.* London: 43–44, pl. 44.

1963. Walker: 164, no. 885, color repro. 165.

1965. Hauser, Arnold. *Mannerism.* Translated by Eric Mosbacher in collaboration with the author. 2 vols. New York, 1: 269; 2: pl. 300.

1966. Cairns and Walker. 1: 202, color repro. 203.

1969. Manzini, Gianna, and Tiziana Frati. *L'opera completa del Greco.* Milan: no. 166, color pls. 48–51.

1969. Palm, Erwin Walter. "El Greco's *Laokoön.*" *Pantheon* 27: 129–135, figs. 1–5.

1969. Vetter, Ewald W. "El Greco's *Laokoon* 'reconsidered'." *Pantheon* 27: 295–299.

1970. Palm, Erwin Walter. "Zu zwei späten Bildern von El Greco." *Pantheon* 28: 298–299.

1972. Waterhouse, Ellis. "Some Painters and the Counter Reformation Before 1600." *Transactions of the Royal Historical Society, London* 22: 114.

1973. Finley, David Edward. *A Standard of Excellence: Andrew W. Mellon Founds the National Gallery of Art at Washington.* Washington: 89, repro. 90.

1973. Gudiol, José. *Domenikos Theotokopoulos, El Greco.* Translated by Kenneth Lyons. New York: 268–271, 356, no. 227, color fig. 250, fig. 251, (also 1983 ed.: 268–271, color fig. 250, fig. 251).

1974. Walker, John. *Self-Portrait with Donors.* Boston: 144–146, repro. 145.

1974. Winner, Matthias. "Zum Nachleben des Laokoön in der Renaissance." *JbBerlin* 16: 113, n. 90.

1975. Lafuente Ferrari, Enrique, and José Manuel Pita Andrade. *El Greco: The Expressionism of His Final Years.* Translated by Robert E. Wolf. New York: 61, 73–74, 114, 136–137, 162, no. 145, color fig. 93, color pls. 7–9.

1976. Davies, David. *El Greco.* London: 10, 16, n. to pl. 41, color pls. 41–43.

1977. Crombie, Theodore. Review of *El Greco* by David Davies. *Apollo* 106: 321.

1977. Eisler: 195–201, no. K1413, figs. 198–200.

1978. Waterhouse, Ellis. Review of *El Greco* by David Davies. *BurlM* 120: 32.

1981. López Torrijos, Rosa. "El Bimilienario de Virgilio y la pintura española del siglo XVII." *AEA* 54: 397–398.

1983. Rogelio Buendía, José. "Humanismo y simbología en El Greco: el tema de la serpiente." *StHist*: 42–45, repros. 43–44.

1984. Moffitt, John F. "A Christianization of Pagan Antiquity." *Paragone* 35 (November): 44–60, pl. 31.

1985. Caviro, Balbina M. "Los Grecos de don Pedro Laso de la Vega." *Goya* 184 (January-February): 217–219, repro. 219.

1985. López Torrijos, Rosa. *La mitología en la pintura española del Siglo de Oro.* Madrid: 220–222, 224, fig. 84.

1985. Pita Andrade, José Manuel. "Sobre la presencia del Greco en Madrid y de sus obras en las colecciones madrileñas del siglo XVII." *AEA* 58: 329.

1986. Kitaura, Yasunari. "El procedor artístico de El Greco." *Boletín del Museo de Prado.* 7: 85–91.

1957.14.4 (1482)

Christ Cleansing the Temple

Probably before 1570
Oil on panel, 65.4 x 83.2 (25 3/4 x 32 3/4)
Samuel H. Kress Collection

Inscriptions:

At lower left (to right of bird cage): (DOMÉNIKOS THEOTOK[O]POULOS KR[E]S) (Domenicos Theotocopoulos Cretan)

ΔΟΜΉΝΙΚϘ ΘΕΟΤΌΚΟΠΛ
ΚΡΗ·

Technical Notes: The support is a single piece of poplar with horizontally oriented grain. It has a modern wooden cradle. A white ground of variable thickness was applied overall somewhat roughly. Most commentators have supposed that El Greco executed this painting in tempera.[1] However, close visual examination suggests that the primary medium is oil due to the nature of the paint, its consistency, and the presence of numerous passages of resinous transparent glazes. Short, choppy strokes predominate throughout. Underdrawing for the architectural elements is partially visible through the paint film. Some of the outlines of the background architecture were incised in the white ground. The painting is in stable condition. The left edge of the panel is cut unevenly, and the adjacent composition looks chopped, suggesting that the composition has been cut down along the left edge and possibly the top edge as well. The ground and paint layers are damaged along the left edge, and there are additional small scattered areas of loss observed throughout. The blues and reds of the painting have lost their tonal balance. In contrast to the bright, stark blue drapery, the red drapery appears drab and washed out; the red pigment may have faded. The varnish is in fair condition; it is abraded along the left edge and penetrated by fine vertical fractures throughout.

Provenance: Possibly in the collection of the Marqués de Salamanca [d. 1866], Madrid.[2] John Charles Robinson, London[3] (sale, Hôtel Drouot, Paris, 7 May 1868, no. 25). Sir Francis Cook, 1st Bart. [1817–1901], Doughty House, Richmond, Surrey, by 1894;[4] his son, Sir Frederick Lucas Cook, 2d Bart. [1844–1920], Doughty House;[5] his son, Sir Herbert Frederick Cook, 3d Bart. [1868–1939], Doughty House;[6] his son Sir Francis Ferdinand Maurice Cook, 4th Bart. [b. 1907], Doughty House and Monserrate, Portugal.[7] (Rosenberg & Stiebel, New York); purchased 17 October 1955[8] by the Samuel H. Kress Foundation, New York.

Exhibitions: *Venetian Art*, The New Gallery, London, 1894–1895, 35, no. 182. *Spanish Art*, The New Gallery, London, 1895–1896, 30, no. 130. *Spanish Old Masters*, Grafton Galleries, London, 1913–1914, 113–114, no. 116. *Paintings and Sculpture from the Kress Collection*, National Gallery of Art, Washington, 1956, 92–94, no. 34. *El Greco of Toledo*, The Toledo [Ohio] Museum of Art; Prado, Madrid; National Gallery of Art, Washington; Dallas Museum of Fine Arts, 1982–1983, 78–80, 226–227, no. 2, pl. 12.

THIS IS EL GRECO'S earliest painting of Christ cleansing the temple, a theme that interested him throughout his career. El Greco here represented Christ in the midst of a throng of vendors, money changers, and beggars on the steps of an Italian Renaissance palace. A large arch, which opens onto an extensive architectural vista, helps to set off the figure of Christ; he is twisted in a dynamic spiral and holds the "whip of cords" (John 2:15) in his upraised right hand. The densely crowded figures on the left side of the painting fall back as if overwhelmed by the force of his anger. The gestures and expressions of the figures immediately to the right of Christ suggest they are reflecting and commenting upon the significance of his actions.

Further to the right, a woman moves away from Christ, leading a naked child by the hand and carrying a pole with a chicken and basket attached to it. It has generally been assumed that she is entering the temple to make a sacrifice but, because she is not headed toward the entrance and is not carrying a sacrificial animal, it seems more probable that she is a vendor fleeing from Christ's anger.[9] The two men engaged in a heated discussion in the dimly lit interior of the temple (in the background at far right) may represent the priests and scribes who protested Christ's expulsion of the merchants and plotted to destroy him (Mark 11:18).

El Greco included in this painting and in the approximately contemporary *Christ Healing the Blind* (Staatliche Kunstsammlungen, Dresden)[10] more genre details than in any of his later works. However,

in light of his future development, it is interesting that there are many fewer details of this sort in the National Gallery's painting than in other mid-sixteenth-century representations of the subject by such artists as Jan van Hemessen (1559, Musée des Beaux-Arts, Nancy), Jacopo Bassano (Prado, Madrid), and Francesco Morandi (Kunsthistorisches Museum, Vienna).[11] El Greco may have intended the genre elements both as symbols and as demonstrations of his representational skills.

Following the biblical accounts (Matthew 21:12–17; Mark 11:15–17; Luke 19:45–46; John 2:14–16), the caged doves and overturned money chest were routinely included in representations of Christ cleansing the temple.[12] However, El Greco also devised motifs not shown by other artists and not mentioned in the biblical accounts, and omitted such typical details of the scene as the oxen and bags of coins. The two rabbits and the sack and basket of oysters in the center foreground emphasize the baseness of commerce at the temple, because these foods were condemned as unclean and prohibited to the Hebrews (Leviticus 11:4–6, 9–12).[13] The partridge was cited in Jeremiah (17:11) as an image of the folly of ill-gotten wealth.[14] El Greco converted the lamb into a vivid symbol of the Eucharist by depicting it with its feet bound to a pole to which a wine cask is also attached.[15] The nude infant sprawled on the floor with his right hand raised palm upward toward Christ may represent the children who cried out in praise of Christ's efforts to reform the Temple (Matthew 21:15–16).[16] El Greco's use of such unusual but meaningful details in his painting looks forward to the iconographic originality of his mature work.

As Jordan has noted, the theme of Christ cleansing the temple was especially relevant to the situation of the Counter-Reformation Church,[17] and it was represented on the reverse of several papal medals of this period.[18] In general terms, the theme could refer to the explusion of heretics. More specifically, it commemorates the efforts of the Council of Trent to prohibit begging and trading on Church property, to ensure appropriate behavior at all religious services, and to prevent ecclesiastics from exploiting Church benefices for material gain.[19] El Greco revealed his sensitivity to the Council's decrees by showing an elderly man immediately to the right of Christ arguing with the vendor of oysters and rabbits in the foreground. The vendor is most probably being exhorted to give up his trade, in accord with the Council's pronouncements that, before punishing wrongdoers, priests should "reprove, entreat and rebuke them in all kindness and doctrine."[20] Entreaty

and expulsion signify the gentle and severe means available to the Church for combatting sin.

Before the mid-sixteenth century, Christ's purification of the temple was most commonly represented as part of a cycle of Christ's life or Passion.[21] El Greco is one of several artists active in the mid- and late sixteenth century who treated the subject as an independent scene. Other representations of the period include Michelangelo's drawings (British Museum, London, and Ashmolean Museum, Oxford) for a painting by Marcello Venusti (National Gallery, London), as well as the previously cited works by Hemessen, Morandi, Bassano, and Campi.[22] Of these, Michelangelo's drawings and the paintings by Venusti and Hemessen can be securely dated before El Greco's earliest treatment of the theme.[23] Although El Greco's paintings cannot be considered as isolated examples, as has sometimes been thought,[24] his selection of the subject for one of his earliest works attests to his exceptional awareness of contemporary developments in art and theology.[25]

In devising the painting now in Washington, El Greco seems to have tried to demonstrate his mastery of the Italian style by borrowing from a wide variety of High Renaissance sources.[26] The composition – with a dynamically posed Christ in the middle, the figures at the left leaning away from him, and a large figure seated in the foreground just to the right of him – seems to follow Michelangelo's drawings for the Purification, which El Greco may have known through copies.[27] El Greco may have derived the woman with a child on the right, as well as the statues on both sides of the arch, from Raphael.[28] Both Christ and the reclining woman with an arm raised over her head may have been borrowed from Titian.[29] The voluptuous and elegant female figures, especially the one in the left foreground, seem strongly influenced by Veronese.[30] The construction of space with receding floor tiles and an architectural vista in the background seems to have been based upon Serlio's treatise.[31] The heavy impasto suggests that El Greco was trying to imitate Venetian methods, but the shortness and hesitancy of his strokes suggest that he had still not fully mastered the techniques.[32]

El Greco's attempt to incorporate so many virtually undisguised borrowings from such a wide range of artists is one of the factors that suggest that he executed this work very early in his career, probably before he went to Rome in 1570.[33] The awkward anatomy of several figures, the disjunction between draperies and the bodies underneath, and the lack of coherent relationships between the principal figures and the complex spatial construction reflect

El Greco, *Christ Cleansing the Temple*, 1957.14.4

El Greco's relative lack of experience. Only the extensive borrowings from Michelangelo and Raphael suggest a date in El Greco's Roman period,[34] but these do not seem to provide a sufficient basis for dating it later than 1570.

In the *Christ Cleansing the Temple*, now in The Minneapolis Institute of Arts, which he probably executed in about 1570/1575 in Rome, El Greco revealed a significant advance in his artistic powers.[35] The figures are fuller and more clearly articulated; they predominate over the spatial setting and no longer seem jumbled together. The elimination of many of the still-life details also clarifies the scene. The four portrait heads of artists whom El Greco admired distinguish the Minneapolis painting from all the other versions. In the considerably later versions now in The Frick Collection, New York (c. 1595–1600), and in the National Gallery, London (c. 1600–1605), El Greco reduced the number of figures, increased their size in relation to the surrounding space, and brought them close to the picture plane.[36] The violent expressions and gestures of many of the figures, the attenuated proportions, and the high, cold tones contribute to the emotionally intense mood of these versions. The late painting in San Ginés, Madrid (c. 1610/1614), probably involved extensive collaboration by El Greco's son Jorge Manuel.[37]

R.G.M.

Notes

1. Willumsen 1927, 2: 275–281, seems to be the earliest source to claim that El Greco used tempera. This was also asserted by Camón Aznar 1950, 2: 1361, no. 82; Trapier 1958, 85; Wethey 1962 (see Biography), 2: 68, no. 104; Manzini and Frati 1972, no. 10a; Davies 1976, note to pl. 2; William B. Jordan, in exh. cat. Toledo-Madrid-Washington-Dallas 1982–1983, 226, no. 2. Eisler 1977, 191, no. K2127, described the technique as mixed.

2. Maclaren 1960, 27, n. 27 (under no. 1457). In a letter in the archives of the National Gallery, London, Sir J. C. Robinson indicated that he had bought the version of El Greco's *Christ Cleansing the Temple* now at the National Gallery, London, from the marqués de Salamanca in Madrid. However, Robinson bought the painting now in London at an anonymous sale (Samuel S. Mira, vendor) at Christie, Manson & Woods, London, 30 June 1877, no. 63. Maclaren suggests that Robinson confused the London painting with the Washington version, which he also once owned, and that he might have purchased the Washington painting from the marqués in Madrid.

3. Robinson 1868, 38–41, no. 28.

4. Exh. cat. London 1894–1895, 35, no. 182. Basic biographical information on members of the Cook family is given in *Burke's Peerage*, 105th ed. (London, 1975), 628–629.

5. *Catalogue of Doughty House* 1903, 22, no. 5; Brockwell 1915, 131, no. 495.

6. Brockwell 1932, 29, no. 495.

7. Camón Aznar 1950, 62. Kress 1956, 92–94, no. 34; Eisler 1977, 193, no. K2127.

8. Photocopy of bill of sale in NGA curatorial files.

9. For the usual interpretation of this figure, see Eisler 1977, 192, no. K2127. It is unlikely that a chicken would have been offered as a sacrifice, since the bird is not mentioned as an acceptable offering in the very detailed directions on temple rituals presented in Leviticus and Deuteronomy. Wittkower 1957, 54, and most later commentators have assumed that El Greco represented the condemned on the left side of the painting and the saved on the right. However, this work seems to lack such a clear-cut separation.

10. Wethey 1962 (see Biography), 1: fig. 4.

11. Reproduction of van Hemessen's painting: Max J. Friedlaender, *Early Netherlandish Painting*, trans. H. Norden, ed. N. Veronee-Verhaegen, G. Lemmers, H. Pauwels, and S. Herzog, 14 vols. (New York, 1967–1976), 12: pl. 102. One of the two paintings by Jacopo Bassano of the Cleansing of the Temple, now in the Prado, is illustrated by Diego Angulo Iñiguez, *Prado, Madrid: pintura italiana anterior à 1600* (Madrid, 1979), pl. 49. Morandi's painting is included in the photographic archives of The Frick Art Reference Library, New York.

12. Caged birds were included in such diverse representations of the scene as Giotto's fresco at the Arena Chapel, Padua (James H. Stubblebine, *Giotto: The Arena Chapel Frescoes* [New York, 1969], fig. 39), and Jacopo Bassano's paintings of this subject at the Prado. Overturned money chests are found in the paintings by Bassano, Hemessen, and Morandi (see note 11). For the iconography of the cleansing of the temple and a review of other representations, see Louis Réau, *Iconographie de l'art chrétien*, 3 vols. (Paris, 1955–1959), vol. 2, part 2, 401–403.

13. Eisler 1977, 192, no. K2127, proposed that the rabbits and oysters were symbols of carnal love.

14. Compare Davies 1983, 63.

15. It has been suggested (in a report, August 1980, in NGA curatorial files) that El Greco derived the image of the lamb with bound feet from a print after Titian's *Adoration of the Shepherds* (*Titian and the Venetian Woodcut* [exh. cat., National Gallery of Art] [Washington, 1976], pl. 43A). In the print, a shepherd standing to the right of the lamb has attached to his belt a wine cask very similar to the one included in El Greco's painting. Bernardino Campi included a bound lamb in a drawing of Christ driving out the money changers (A. E. Popham and Johannes Wilde, *The Italian Drawings of the XV and XVI Centuries in the Collection of His Majesty the King at Windsor Castle* [London, 1949], 205, no. 190, fig. 45). Popham and Wilde propose that this drawing was a study for a lost altarpiece. Because the drawing is undated, it is impossible to determine whether Campi or El Greco first employed the motif in the scene of the cleansing of the temple.

16. The gesture of the hand raised with the palm upward is one that El Greco used in his later work to signify the fulfillment of divine will (Wittkower 1957, 53). It is possible that such a connotation was intended here.

17. Jordan in exh. cat. Toledo-Madrid-Washington-Dallas 1982–1983, 226, no. 2.

18. Paul IV (1555–1559) issued a medal of this type. See Ludwig von Pastor, *The History of the Popes*, ed. and trans. F. I. Antrobus, R. F. Kerr, E. Graf, and E. F. Peeler, 40 vols. (St. Louis, 1938–1953), 14: 240–241. Medals showing the purification of the temple on the reverse for Pius IV (1559–

1565) and Gregory XIII (1572–1585) are recorded in *Carlos V y su ambiente* [exh. cat., Museo de Santa Cruz] (Toledo, 1958), 205, 208, nos. 447, 490, 491.

19. *The Canons and Decrees of the Sacred and Oecumenical Council of Trent*, translated by J. Waterworth (London, 1848), 14–5 (session 2), 29 (session 5), 59–62 (session 7), 84–85 (session 13), 114, (session 14), 151 (session 21), 253–271 (session 25). On the significance of the theme of the cleansing of the temple, see Waterhouse 1930, 70; Réau 1955–1959, vol. 2, part 2, 401–402; Wethey 1962 (see Biography), 2: 66; Davies 1976, 12, note to pl. 2.

20. *Trent* 1848, 84–85 (session 13).

21. Representations of the cleansing of the temple as part of a cycle include those by Giotto in the Arena Chapel, Padua (see note 11); Lorenzo Ghiberti in one of the panels on the Baptistry door, Florence (Kenneth Clark, *Florence Baptistry Doors* [New York, 1980], fig. 133); the Master of the Orsay Altar in an altarpiece now at Bob Jones University, Greenville (*The Bob Jones University Collection of Religious Paintings*, 2 vols. [Greenville, 1962], 2: 214, no. 116a); Hans Holbein the Elder in an altarpiece for the Dominican church at Frankfurt am Main, now in the Städelsches Kunstinstitut, Frankfurt (UNESCO, *An Illustrated Inventory of Dismembered Works of Art: European Painting* [Paris, 1974], 64, no. 13, repro.); Albrecht Dürer in the *Small Woodcut Passion* (Willi Kurth, ed., *The Complete Woodcuts of Albrecht Dürer* [New York, 1963], fig. 229). Additional images are recorded by Réau 1955–1959, vol. 2, part 2, 402; and in the photographic archives of The Frick Art Reference Library, New York.

22. Reproductions of Michelangelo's drawings: Charles De Tolnay, *Michelangelo*, 2d ed., 5 vols. (Princeton, 1947–1960), 5: figs. 241–247; of Venusti's painting: De Tolnay 1947–1960, 5: fig. 317. In addition, Bosch represented the cleansing of the temple as an independent scene in the sixteenth century in a painting, of which a copy is now in the Glasgow Art Gallery and Museum. Friedlaender 1967–1976, 5: pl. 55.

23. The other works mentioned here are undated. It would be particularly interesting to know the date of the painting by Jacopo Bassano catalogued as no. 27 by the Prado (see note 11). If Bassano's painting is earlier than El Greco's painting in Washington, El Greco may have been influenced by it. In the paintings by both artists, the cage of doves is located in the same place at lower left. In both works a figure with outstretched legs is seated prominently in the foreground immediately to the right of the cage; however, in Bassano's painting the figure is male. Both artists represented a dimly lit interior with smaller figures in the background, but the specific architectural forms and number of figures differ.

24. See, for example, Waterhouse 1930, 70.

25. Jordan, in exh. cat. Toledo-Madrid-Washington-Dallas 1982–1983, 226, no. 2, emphasizes that the theme was rare even during the Counter-Reformation.

26. For a fuller discussion, see Jonathan Brown in exh. cat. Toledo-Madrid-Washington-Dallas 1982–1983, 78–80; Eisler 1977, 192–194, no. K2127.

27. Maclaren 1960, 25, 26, n. 5 (under no. 1457). For an opposed point of view, see Wethey 1962 (see Biography), 2: 66–67. Michelangelo's composition for the Purification was very unusual. Among earlier artists, Giotto seems to be the only one to have placed Christ in the middle. Generally, Christ was placed to one side (usually to the left) and

shown in a profile view. The wave of figures falling back from Christ distinguishes the interpretations of Michelangelo, Venusti, and El Greco from those of other artists. Harris 1943, 7, pointed out that the two men who have raised their arms to defend themselves from Christ were derived from Michelangelo's *Last Judgement*.

28. Harris 1943, 7, pointed out that the woman and child recall figures in Raphael's tapestry cartoon for the *Healing of the Lame* (1515–1516, Victoria and Albert Museum, London; John Shearman, *Raphael's Cartoons in the Collection of Her Majesty the Queen and the Tapestries for the Sistine Chapel* [London, 1972], pl. 12). The statues in the niches on either side of the arch are derived from Raphael's *School of Athens*, as Camón Aznar 1950, 1: 66, noted, even though the placement of the niches on the arches varies from this model (Pavon 1962, 210). El Greco has reversed Raphael's arrangement and placed the male figure on the right and the female on the left. For the male figure El Greco retained the lyre, a basic attribute of Apollo. Although the female is clearly modeled on the statue of Minerva painted by Raphael, El Greco eliminated her basic attributes. Wethey 1962 (see Biography), 2: 68, no. 104, suggested that El Greco's female figure should be identified as Hera. Neither identification – as Minerva or as Hera – is entirely satisfactory.

29. Maclaren 1960, 25, under no. 1457, noted that the figure of Christ was similar to that in Titian's *Transfiguration* (San Salvatore, Venice; Harold E. Wethey, *The Paintings of Titian*, 3 vols. [London, 1969–1975], 1: pl. 124) but inverted. Waterhouse 1930, 70, proposed that the woman with the arm thrown over her head was derived from Titian's *Bacchanal* (Prado, Madrid; Wethey 1969–1975, 3: pl. 57), although Maclaren 1960, 25, under no. 1457, suggested that El Greco may have derived the figure directly from an ancient sculptural source.

30. Wethey 1962 (see Biography), 2: 68, no. 104.

31. Brown in exh. cat. Toledo-Madrid-Washington-Dallas 1982–1983, 78–80. Jordan in exh. cat. Toledo-Madrid-Washington-Dallas 1982–1983, 226, no. 2, relates the handling of the architectural setting to Tintoretto's paintings. For a full discussion of possible sources for the architecture in the National Gallery painting and other early works, see Pavon 1962, 209–215.

32. Brown in exh. cat. Toledo-Madrid-Washington-Dallas 1982–1983, 78, points out that short, unblended strokes of the sort found in this work were characteristic of Greek icon painters active in Venice.

33. Wethey 1962 (see Biography), 2: 68, no. 104; and Jordan in exh. cat. Toledo-Madrid-Washington-Dallas 1982–1983, 226, no. 2, are among the many sources that date this work prior to 1570. For a comprehensive review of the various dates proposed for this work, see Eisler 1977, 192–194, no. K2127.

34. Eisler 1977, 193, no. K2127.

35. Wethey 1962 (see Biography), 2: 68–69, no. 105; exh. cat. Toledo-Madrid-Washington-Dallas 1982–1983, 227, no. 3, color pl. 44.

36. Harris 1943, 7–10; Wethey 1962 (see Biography), 1: figs. 199, 200; 2: 67, 69–70, nos. 106, 108.

37. Wethey 1962 (see Biography), 1: fig. 198; 2: 67, 70, no. 110. In addition to these examples, a workshop replica of the Frick version is in the Harvard University Art Museums, Cambridge, Massachusetts (Legendre and Hartmann 1937, pl. 160); and a version of the San Ginés painting by El Greco and his workshop is in the collection of Don

Luciano Abrisqueta, San Sebastián (Wethey 1962, 2: 70, no. 109). Two later copies of the Minneapolis version, two of the Frick version, and one of the San Ginés version have also been recorded (Wethey 1962, 2: 193, nos. X-128 – X-132).

References

1868. Robinson, John Charles. *Memoranda on Fifty Pictures*. London: 38–41, no. 28.

1897. Justi, Carl. "Die Anfänge des Greco." *ZfbK* 8: 182–184. Reprinted in Carl Justi. *Miscellaneen aus drei Jahrhunderten spanischen Kunstlebens*. 2 vols. Berlin, 1907, 1: 217–218.

1903. *Abridged Catalogue of the Pictures at Doughty House, Richmond, Belonging to Sir Frederick Cook, Bart., M.P., Visconde de Monserrate*. London: 22, no. 5.

1903–1904. Williamson, George, ed. *Bryan's Dictionary of Painters and Engravers*. 4th ed. 5 vols. London, 5: 166.

1907–1950. Thieme-Becker. Vol. 33 (1939): 5.

1908. Cossío (see Biography): 76–81, 609. no. 349; pl. 7 bis, (also 1972 rev. ed.: 39–40, 46–47, 359, no. 44, fig. 10).

1909. Calvert, Albert F., and C. Gasquoine Hartley. *El Greco*. London: 37–38, 46.

1911. Mayer, August L. *El Greco*. Munich: 22–24, 83, repro. 23.

1914. Bertraux, Emile. "L'exposition espagnole de Londres." *GBA* 11: 254–255.

1914. Beruete y Moret, Aureliano de. "Exposition d'anciens maîtres espagnols à Londres." *La revue de l'art ancien et moderne* 35: 65.

1915. Brockwell, Maurice. *Catalogue of the Paintings at Doughty House, Richmond, and Elsewhere in the Collection of Sir Frederick Cook, Bt., Visconde de Monserrate*. 3 vols. London, 3: 131, no. 495, pl. 17.

1926. Mayer, August L. *Dominico Theotocopuli, El Greco*. Munich: 10, no. 49, pl. 3.

1927. Willumsen, Jens Ferdinand. *La jeunesse du peintre El Greco*. 2 vols. Paris, 2: 275–290, pl. 50.

1928. Villar, Emilio H. del. *El Greco en España*. Madrid: 81, pl. 1.

1930. Rutter, Frank. *El Greco*. New York: 3, 16–17, 89, no. 4, pl. 3.

1930. Waterhouse, Ellis K. "El Greco's Italian Period." *Art Studies* 8: 70, 85, no. 5.

1931. Mayer, August L. *El Greco*. Berlin: 13, 26–31, fig. 13.

1932. Brockwell, Maurice W. *Abridged Catalogue of the Pictures at Doughty House, Richmond, Surrey, in the Collection of Sir Herbert Cook*. London: 29, no. 495.

1937. Legendre, Maurice, and Alfred Hartmann. *Domenikos Theotokopoulos Called El Greco*. Paris: 158, repro.

1938. Goldscheider, Ludwig. *El Greco*. London: pl. 5. (also 1954 rev. ed.: pl. 5).

1943. Harris, Enriqueta. *El Greco: The Purification of the Temple*. The Gallery Books 2. London: 7–12, figs. 3, 8.

1943. López-Rey, José. "El Greco's Baroque Light and Form." *GBA* 24: 75–76, fig. 1.

1948. Palluchini, Rodolfo. "Some Early Works by El Greco." *BurlM* 90: 133.

1950. Camón Aznar, José. *Domenico Greco*. 2 vols. Madrid, 1: 62–66, fig. 40; 2: 1361, no. 82 (also 1970 rev. ed., 1: 80–84, 133, fig. 46; 2: 1342, no. 85).

1956. Kress: 92–95, no. 34, repros. 93, 95.

1957. Wittkower, Rudolf. "El Greco's Language of Gestures." *ArtN* 56 (March): 54, repro. 48.

1958. Gaya Nuño, *La pintura española*: 187, no. 1193.

1958. Trapier, Elizabeth du Gué. "Greco in the Farnese Palace, Rome." *GBA* 51: 78, 83–85.

1959. Kress: 268, no. 1482.

1960. Maclaren, Neil. *National Gallery Catalogues: The Spanish School*. Rev. ed. by Allan Braham. London: 24–27, under no. 1457.

1961. Sánchez de Palacios, Mariano. *El Greco*. Madrid: 112.

1962. Cairns and Walker: 42, color repro. 43.

1962. Pavon, B. "El Greco arquitecto." *AEA* 35: 209–214.

1962. Wethey (see Biography). 1: 21–23, figs. 3, 363; 2: 66–68, no. 104 (also Spanish ed. 1967, 1: 40–41, pls. 3, 363; 2: 81–83, no. 104).

1963. Walker: 160, color repro. 161.

1964. Xydis, Z. G. "El Greco's 'Healing of the Blind.'" *GBA* 64: 303–304, fig. 6 (detail).

1965. *The Italian Heritage*. Exh. cat., Wildenstein & Co. New York: under no. 43.

1966. Cairns and Walker. 1: 196, color repro. 197.

1968. *The Frick Collection: An Illustrated Catalogue*. 2 vols. Princeton, 2: 314, 316–317, under 09.1.66.

1969. Manzini, Gianna, and Tiziana Frati. *L'opera completa del Greco*. Milan: no. 10a.

1973. Gudiol y Ricart, José. *Domenikos Theotokopoulos, El Greco*. Translated by Kenneth Lyons. New York: 21, 339, no. 8, figs. 9–10, color fig. 11 (also 1983 ed.: 21, 339, no. 8, figs. 9–10, color fig. 11).

1976. Davies, David. *El Greco*. London: 6, 11, note to pl. 2, color pl. 2.

1976. Pérez Sánchez, A. E. *The Golden Age of Spanish Painting*. Exh. cat., Royal Academy of Arts. London: 30, under no. 6.

1977. Eisler: 191–194, no. K2127, figs. 194, 197.

1983. Davies, David. "El Greco and the Spiritual Reform Movement in Spain." *StHist* 13: 63, fig. 1.

1983. Puppi, Lionello. "Il soggiorno italiano del Greco." *StHist* 13: 143.

1959.9.4 (1527)

The Holy Family with Saint Anne and the Infant John the Baptist

c. 1595/1600
Oil on canvas, 53.2 x 34.4 (20⅞ x 13½)
Samuel H. Kress Collection

Technical Notes: The support is a plain-weave fabric, lined to a slightly coarser fabric of the same type. The tacking edges have been cropped, but the original format has presumably been retained. The reddish-brown imprimatura applied above the thin ground was left exposed in several places, notably in the sky and in the unfinished area at the bottom. Oil colors were applied thinly in a wet-on-wet technique and with a semitransparent layering of colors. In areas of moderate relief, oil colors with a more paste-like consistency were applied over already dried layers. X-radiographs reveal no significant pentimenti. There is a four-inch-wide tear to the left of the center of the fabric.

Another large loss is located on Saint John's stomach. Overall, the surface shows solvent abrasion and many glazes have broken through. Much of the retouching has discolored. Weave interference from the lining fabric is visible on the surface.

Provenance: Probably in El Greco's studio at the time of his death;[1] probably his son, Jorge Manuel Theotocópuli, Toledo.[2] Carlos Beistegui, Paris.[3] Michael Dreicer [1868–1921], New York;[4] bequeathed 1921 to The Metropolitan Museum of Art, New York, where it was displayed 1922–1933;[5] returned 1933 to Dreicer's heirs, who had challenged the terms of his will.[6] Private collector, London, by 1937.[7] Private collector, New York; consigned to (Paul Drey Gallery, New York, 1940s).[8] Baroness de Kerchove, New York; sold or consigned to (French & Co., New York, 24 February 1948);[9] purchased 1949 by the Samuel H. Kress Foundation, New York.[10]

Exhibitions: *Spanish Painting*, The Toledo [Ohio] Museum of Art, 1941, no. 43. *The Samuel H. Kress Collection*, Philadelphia Museum of Art, 1950, no. 17. *Paintings and Sculpture from the Samuel H. Kress Collection*, National Gallery of Art, Washington, 1956, no. 35. *El Greco of Toledo*, The Toledo [Ohio] Museum of Art; Prado, Madrid; National Gallery of Art, Washington; Dallas Museum of Fine Arts, 1982–1983, 116, 234, 239, no. 26, pl. 45.

THIS IS A SMALL VERSION of a composition known in two other authentic paintings by El Greco, now in the Museo de Santa Cruz, Toledo (fig. 1), and in the Prado, Madrid (fig. 2).[11] In contrast to the two other versions, the National Gallery's painting is unfinished; this is most evident at the bottom and at the lower right edge, which are covered by seemingly random strokes of white and gray paint.

The three versions differ only in a few respects. The National Gallery version is the only one that shows Joseph as an elderly man. In both the other examples, El Greco first painted in an elderly Joseph and then replaced the figure with a youthful one that more adequately expresses the attitude of the Counter-Reformation Church toward this saint.[12] In the version in Toledo, Joseph does not bend toward the Child as in the other example but, instead, stands erect and gazes directly out at the spectator. The version in Madrid is unique in showing the Child with his eyes open and the Baptist looking straight ahead.

In the scene of the Holy Family with Saint Anne and the Baptist, El Greco illustrated several beliefs strongly emphasized by the Counter-Reformation Church. The sleep of the Infant Jesus may symbolize his death, and the cloth on which he lies may represent his shroud.[13] In accord with the ideas of contemporary Spanish devotional writers, the bright white cloth could also signify the Host.[14] The Baptist's gesture of one finger against his lips is evidently a demand for silence, appropriate to the contemplation of the solemn mysteries of the Mass.[15] By representing Anne lifting the swaddling cloth, El Greco may have intended to depict her role as the one who initiated the earthly history of salvation through Christ.[16] In the paintings now in Washington and Madrid, the bending pose of Joseph helps to suggest the care and protection he gave to Jesus as the Child's earthly guardian.[17]

The painting in Toledo is probably the earliest of the three versions. A date of about 1580/1585 for the Toledo version is suggested by several factors, including the relatively smooth brushwork, the scant use of white impasto highlights, and the very fine modeling of Mary's face and hands and of the Baptist's body.[18] Looser brushwork, more extensive use of white impasto highlights, and stronger contrasts of light and shade indicate that the Prado version should be dated later, about 1595/1600.[19]

Debate about the connections between the versions has focused on the function of the National Gallery painting. Wethey, Gudiol, and Harris have described the National Gallery painting as a sketch for one or both of the larger versions.[20] Eisler had classified the National Gallery painting as a copy of the altarpiece now in Toledo.[21] Jordan has recognized the relation of the National Gallery painting to both the other versions and proposed that it was one of the small *originales* for El Greco's compositions seen by Francisco Pacheco during his visit to the artist's studio in 1611.[22] As Jordan has pointed out, these replicas were probably used by the artist and his assistants to repeat successful works.

Most recently, McKim-Smith, Garrido, and Fisher have convincingly demonstrated that the National Gallery painting effectively served both as a *ricordo* of the version in Toledo and a *modello* for the version in Madrid.[23] They have found that the lack of pentimenti in the National Gallery version indicates that it was to a large extent copied from the earlier altarpiece now in Toledo. However, the differences in Joseph's appearance and pose suggest that El Greco conceived the National Gallery painting as an innovative variation of the original composition and not simply as a precise record of it. The artist's evident vacillation between two different ways of representing Joseph is understandable, because the newer image of the saint as a dynamic youthful man had not yet replaced the traditional image of him as an elderly figure.

The theory that El Greco used the National Gallery painting as a *modello* for the Prado version is supported by the close resemblance between Joseph in the National Gallery painting and the first representation of the saint in the Prado painting.[24] In the final state of the Prado version, El Greco retained the pose that he formulated in the National Gallery painting, but he transformed Joseph into a youthful figure. The clouds in the National Gallery version are considerably less rounded and tumultuous than the clouds in the Toledo painting but less flat and hard than those he used to define a lozenge of blue sky directly above the Virgin's head in the Prado version. In the Prado painting, as in the National Gallery version, El Greco accented angular shapes through bold, heavy slashes of paint and made extensive use of white im-

pasto highlights. However, the Prado painting is less freely executed than the smaller version. In his large-scale altarpieces of the 1590s, El Greco tended to favor a comparatively smooth treatment of surfaces, which can also be noted in the *Madonna and Child with Saint Martina and Saint Agnes* (1942.9.26).

If the theories of McKim-Smith, Garrido, and Fisher are correct, the National Gallery painting should be dated sometime between the two larger versions. Because of its lively brushwork, it probably can be dated even more narrowly to the period c. 1595/1600, as Wethey and Jordan have proposed.[25]

Although Eisler has questioned the authenticity of the Washington painting, it seems virtually certain that it is an outstanding example of El Greco's mature style.[26] The remarkably free handling of paint reveals

Fig. 1. El Greco, *The Holy Family with Saint Anne and the Infant Baptist*, c. 1580/1585, oil on canvas, Church of Santa Leocadia, Toledo, on loan to the Museo de Santa Cruz, Toledo

Fig. 2. El Greco, *The Holy Family with Saint Anne and the Infant Baptist*, c. 1595/1600, oil on canvas, Museo del Prado, Madrid, 826

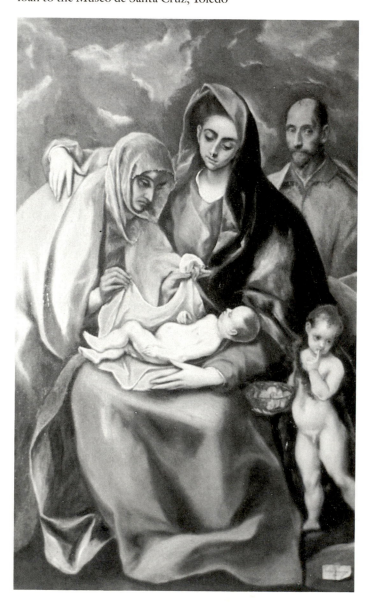

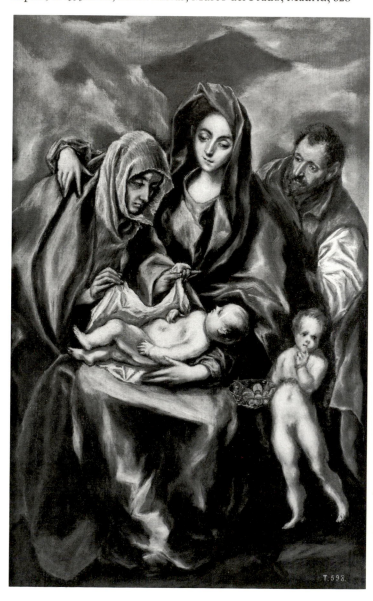

Studio of El Greco

1937.1.84 (84)

Saint Martin and the Beggar

1600/1614
Oil on canvas
 original painted surface 99.5 x 55 (39⅛ x 21⅝),
 with extensions on all four sides 104.3 x 60.3 (41 x 23¾)
Andrew W. Mellon Collection

Inscriptions:
At lower left, in cursive Greek: [Do] *ménik* [os Theoto-
 kopoulos]
Formerly, unidentified inventory number at lower right: 387[1]

Technical Notes: The original support is a single piece of
fine, plain-weave fabric. Before 1937 the original tacking
edges were flattened out, and the picture was lined to a
larger, slightly coarser fabric. Above the gypsum ground
is a reddish brown imprimatura that was left exposed in
places, particularly along the outlines of the figures. Most
of the surface is covered evenly by a moderately thick paste
of oil paint, applied primarily with short, choppy strokes.
Analysis of several cross sections by the NGA science and
painting conservation departments indicates that the
palette is virtually the same as that used for the large-scale
version of *Saint Martin and the Beggar* (1942.9.25), but the
layering of colors is considerably simpler. X-radiographs
did not reveal any pentimenti. The painting was cleaned
and conserved between 1987 and 1988. A period frame hides
the non-original extensions.[2]

Provenance: Louis Manzi, Paris, by 1908.[3] In the private
collection of Josse and Gaston Bernheim-Jeune, art dealers,
Paris, by 1919;[4] (M. Knoedler & Co., New York, 19 June
1929);[5] purchased 28 March 1930 by Andrew W. Mellon,
Pittsburgh and Washington;[6] deeded 28 December 1939 to
The A. W. Mellon Educational and Charitable Trust, Pitts-
burgh.

Exhibitions: *Exposition d'art ancien espagnol*, Hôtel Jean
Charpentier, Paris, 1925, no. 48. *A Loan Exhibition of Sixteen
Masterpieces*, M. Knoedler & Co., New York, 1930, 29, no.
13. *Paintings and Sculpture Owned in Washington*, Phillips
Memorial Gallery, Washington, 1937, no. 14.

THIS IS ONE OF FIVE small-scale replicas of the
altarpiece which El Greco made for the Chapel of
Saint Joseph, Toledo, and which is also in the Na-

tional Gallery (1942.9.25). Other versions of this sub-
ject are in The Art Institute of Chicago (fig. 1); for-
merly in the Royal Palace at Bucharest[7] and now
unlocated (fig. 2); in the Galleria Palatina, Palazzo
Pitti, Florence (fig. 3); and at the John and Mable
Ringling Museum of Art, Sarasota, Florida (fig. 4).[8]

Technical analysis of the small-scale version at the
National Gallery strongly supports the assumption
that it is a *ricordo* rather than a *modello*. The simple
layering of colors suggests that the artist was trying
to reproduce the surface of the altarpiece without
going through the entire process involved in the cre-
ation of the original work.[9]

The authorship of the Mellon version remains con-
troversial. Cossío, Mayer, Cook, and, more recently,
Pérez-Sánchez have considered this painting to be an
outstanding work by El Greco.[10] However, Camón
Aznar, Soehner, and Wethey have argued that it is by
El Greco's son Jorge Manuel or another artist in the
workshop.[11]

To this writer it seems most likely that Jorge Man-
uel or another member of the workshop executed the
Mellon replica. Only the use of the red ground as
outline corresponds with the technique that El Greco
employed in the original altarpiece for the Chapel of
Saint Joseph. A strong divergence from El Greco's
methods characterizes most of the workshop produc-
tion after 1600, because other artists were unable to
equal the boldness and freedom of his late style.[12]

The uniform short strokes in the Mellon painting
contrast with the greatly varied strokes evident in the
large altarpiece for the Toledan chapel. The choppy
application of paint creates a strongly pronounced
surface pattern that conflicts with the artist's attempt
to create plastic, three-dimensional bodies.[13] The
copyist has exaggerated several aspects of El Greco's
distinctive figure style. For instance, he has trans-
formed the muscles in the arms and calves of the
beggar into sharp, flat, triangular shapes. The hand
with which Martin grasps his sword looks like a claw
because the fingers are so sharply pointed. The saint's
serene expression has been distorted by the wavelike
curves of his mouth. Similar mannerisms occur in
works known to be by Jorge Manuel, such as his
signed copy of El Greco's *Espolio* (Prado, Madrid).[14]

The differences from authentic works by El Greco
suggest that the Mellon painting is not by him. How-
ever, because paintings by Jorge Manuel and the

to Anne was often described as the dawn of the Christian world.

17. See Mâle 1972, 313–325.

18. This dating corresponds with exh. cat. Toledo-Madrid-Washington-Dallas 1982–1983, 234–235, no. 16. Camón Aznar 1950, 1: 581, dates the Toledo version c. 1585. Wethey 1962 (see Biography), 2: 58, no. 85, dates the Toledo version somewhat later, c. 1590/1595; see Wethey for a review of other proposed dates.

19. Wethey 1962 (see Biography), 2: 59, no. 87. Compare Jordan in exh. cat. Toledo-Madrid-Washington-Dallas 1982–1983, 239, under no. 26.

20. Wethey 1962 (see Biography), 2: 59–60, no. 88, and Harris 1974, 103, consider the National Gallery painting a sketch for the Prado version. Gudiol 1973, 197, argues that the National Gallery painting was a sketch for both the other versions.

21. Eisler 1977, 202, no. K1684.

22. Jordan in exh. cat. Toledo-Madrid-Washington-Dallas 1982–1983, 239, no. 26. Compare Francisco Pacheco, *Arte de la pintura* (1649), in Francisco J. Sánchez Cantón, *Fuentes para la historia del arte español*, 5 vols. (Seville and Madrid, 1923–1941), 2: 168.

23. McKim-Smith, Garrido, and Fisher 1986, 70–75.

24. Garrido and Cabrera 1982, 98, fig. 4.

25. Wethey 1962 (see Biography), 2: 59–60, no. 88; Jordan in exh. cat. Toledo-Madrid-Washington-Dallas 1982–1983, 239, no. 26.

26. Eisler 1977, 202, no. K1684, assigned the painting to El Greco's workshop.

27. For a concise analysis of El Greco's technique, see Hubert Falkner von Sonnenberg, "Zur Maltechnik Grecos," *MunchJb* 9/10 (1958/1959), 245–250.

28. Wethey 1962 (see Biography), 2: 189, no. X-106; Camón Aznar 1950, 1: fig. 431.

29. Wethey 1962 (see Biography), 2: 189–190, nos. X-105, X-107–X-109.

References

1922. Wehle, Harry B. "The Michael Dreicer Collection." *BMMA* 17: 103–106.

1926. Mayer, August L. *Dominico Theotocopuli, El Greco*. Munich: 8, no. 31, pl. 32.

1931. Burroughs, Bryson. *Catalogue of Paintings: The Metropolitan Museum of Art*. New York: 145, no. G791–2.

1931. Mayer, August L. *El Greco*. Berlin: 83.

1937. Legendre, Maurice, and Alfred Hartmann. *Domenikos Theotokopoulos Called El Greco*. Paris: 144, repro.

1941. Gudiol y Ricart, José. "Span of Spanish Painting: 1150–1828." *ArtN* 40 (1 April): 17.

1950. Camón Aznar, José. *Dominico Greco*. 2 vols. Madrid, 1: 581; 2: 1370, no. 242, (also 1970 rev. ed., 1: 588, fig. 477; 2: 1352, no. 254).

1959. Kress: 270, repro.

1962. Wethey (see Biography). 1: 46, fig. 102; 2: 59–60, no. 88 (also Spanish ed. 1967, 1: 62–63, pl. 87; 2: 74–75, no. 88).

1969. Manzini, Gianna, and Tiziana Frati. *L'opera completa del Greco*. Milan: no. 99b.

1972. Cossío, Manuel B. *El Greco*. Edited by Natalia Cossío de Jiménez. Barcelona: 358, no. 30.

1973. Gudiol y Ricart, José. *Domenikos Theotokopoulos, El Greco*. Translated by Kenneth Lyons. New York: 197, 349, no. 147, color fig. 175 (also 1983 ed.: 197, 349, no. 147, color fig. 175).

1974. Harris Frankfort, Enriqueta. "El Greco's *Holy Family with the Sleeping Child and the Infant Baptist*: An Image of Silence and Mystery." *Hortus Imaginum, Essays in Western Art*. Ed. by Robert Enggass and Marilyn Stockard. Lawrence, Kans.: 103–111, fig. 69.

1975. Lafuente Ferrari, Enrique, and José Manuel Pita Andrade. *El Greco: The Expressionism of His Final Years*. Translated by Robert E. Wolf. New York: 156, no. 26.

1977. Eisler: 201–220, no. K1684, fig. 196.

1982. Garrido, María del Carmen, and José María Cabrera. "Estudio técnico comparativo de dos Sagradas Familias del Greco." *Boletín del Museo del Prado* 3: 98.

1986. McKim-Smith, Gridley, María del Carmen Garrido, and Sarah L. Fisher. "A Note on Reading El Greco's Revisions: A Group of Paintings of the Holy Family." *StHist* 18: 67–77, figs. 1, 5.

nothing of a copyist's laborious efforts to reproduce the forms devised by another artist. The flicks of impasto used to define Joseph's hair and beard and to create reflections on Anne's veil, the glass bowl, and the eyes are distinctive characteristics of El Greco's mature work.[27] The marks left by bristles in the impasto on the draperies and in other areas, and the exposure of the grain of the fabric in the sky attest to the artist's interest in exploiting effects of different textures.

An anonymous copy of the National Gallery painting is in the Bernhardt collection, Buenos Aires.[28] At least four copies of El Greco's other versions have been identified;[29] none seems to have any connection with El Greco or his workshop.

R.G.M.

Notes

1. This seems probable because the painting appears to have been owned by the artist's son in 1621 (see note 2). Because the inventory of El Greco's estate in 1614 does not include measurements, it is difficult to identify the National Gallery painting with a specific reference in this document. However, if the painting was given the same title in 1614 as in 1621, it can probably be identified as "Una imagen, con el niño dormido y S. Joseph y Santa Ana y S. Jnº bautista" (An image with the sleeping child and Saint Joseph and Saint Anne and Saint John the Baptist); San Román 1910 (see Biography), 192. Wethey 1962 (see Biography), 2: 59, emphasizes that it is impossible to be certain about the listing of the painting in the 1614 inventory but suggests that it might have been described as "Una imagen con el Niño y S. Joseph y S. Ana no acabada" (An unfinished painting with the Child and Saint Joseph and Saint Anne). See San Román 1910, 193. William B. Jordan in exh. cat. Toledo-Madrid-Washington-Dallas 1982–1983, 239, no. 26, also maintains that El Greco kept the National Gallery painting in his studio.

2. No. 16 in the inventory made of his possessions in 1621 reads: "Una imagen con su niño dormido santa ana y san Joseph y San Juº bautista, y quadro dorado, tiene de ancho casi media bara y de alto dos terzias" (An image [of the Virgin] with the Child sleeping, Saint Anne and Saint Joseph and Saint John the Baptist, and a gilded frame, measures in width almost half a *vara* and in height almost two-thirds). Francisco de Borja de San Román y Fernández, "De la vida del Greco," *AEAA* 3 (1927), 288. Because a *vara* (a traditional Spanish measurement) equals approximately 84 cm, no. 16 of the inventory would have been 42 cm in width and 56 cm in height. These figures are close to the measurements of the NGA painting. El Greco's other interpretations of the subject are significantly larger. Compare Wethey 1962 (see Biography), 2: 58, 59, nos. 85, 87. The copies of El Greco's other paintings of the subject are significantly larger than the NGA painting. Compare Wethey 1962, 2: 189–190, nos. X-105–X-109.

3. Wethey 1962 (see Biography), 2: 60, no. 88.

4. Michael Dreicer, *Collection of Michael Dreicer* (New York, n.d.), 4, 15. Dreicer preferred to collect exclusively small-scale paintings like the present example. See Mac-

donald Parish-Watson, "Art and the Businessman: A Note on the Michael Dreicer Collection," *Arts and Decoration* 15 (1921), 249–295, 319.

5. Wehle 1922, 100, 103; Burroughs 1931, 145, no. G791–2.

6. Eisler 1977, 202, no. 1527.

7. Legendre and Hartmann 1937, 144.

8. Robert Carlucci, Paul Drey Gallery, letter, 4 August 1988, in NGA curatorial files, states that the painting was owned during the early 1940s until at least 1947 by a European collector resident in New York, who consigned it to the Paul Drey Gallery "for some period of time." This individual and the private collector, London, recorded by Legendre and Hartmann (see note 7) may be the same as the Baroness de Kerchove, about whom little is known. See note 9.

9. French and Co. stock records at the Getty Provenance Index, stock no. 7690A. A sizeable group of paintings from the Baroness was recorded in the French and Co. stockbooks in 1948. French and Co. sent the painting to the Paul Drey Gallery in May 1948; no date of return is recorded. I am grateful to Martha Hepworth of the Getty Provenance Index and to Susan Davis of the NGA Department of Curatorial Records for assistance with this part of the painting's history.

10. French and Co. stock records at the Getty Provenance Index.

11. In devising this scene, El Greco seems to have drawn upon several earlier works. See Harris 1974, 104–111, figs. 70–73 (with previous bibliography). Michelangelo's *Holy Family* (known in several copies) may have inspired the pose and the majestic fullness of the figure of Mary. The elderly figure of Joseph bending toward the Child could have been borrowed from Lavinia Fontana's *Holy Family with the Sleeping Child and the Infant Baptist* (1589) in the Escorial. Both Michelangelo and Fontana represented the Baptist wearing an animal skin and raising a finger to his lips. For the figure of the Baptist, El Greco also seems to have studied such representations of Harpocrates (the Greek god of silence) as the woodcut in Cartari's *Le imagini de i dei antichi* (Venice, 1571). This woodcut shows the naked god offering a peach branch with one hand as he gestures for silence with the other.

12. On the preliminary state of the Madrid and Toledo versions, see Garrido and Cabrera 1982, 93–101. Analysis of the layers of paint in the Toledo version has established that a later artist was responsible for the blue paint that partially concealed the figure of Joseph before the restoration of 1982. On devotion to Joseph during the Counter-Reformation and representations of him in art, see Émile Mâle, *L'art du XVIe siècle, du XVIIe siècle et du XVIIIe siècle* (1951; reprint, Paris, 1972), 313–325. During the Counter-Reformation, Joseph was increasingly shown as a handsome and virile young man who served as a model of earthly virtue for the Christ Child. El Greco responded to this development by representing Joseph as a young man in most cases.

13. Wethey 1962 (see Biography), 2: 59 (with bibliography).

14. Contemporary devotional writers compared Christ's swaddling clothes to the Host because both served to cover the Real Presence. See Mann 1986 (see Biography), 88.

15. Harris 1974, 105.

16. On Anne's role in the history of salvation, see Mâle 1972, 346–353, especially 348. The birth of the Virgin Mary

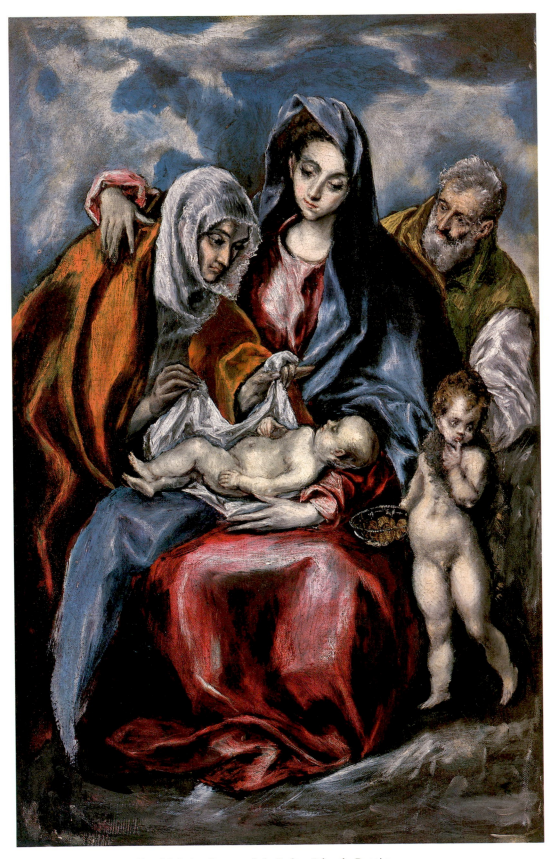

El Greco, *The Holy Family with Saint Anne and the Infant John the Baptist*, 1959.9.4

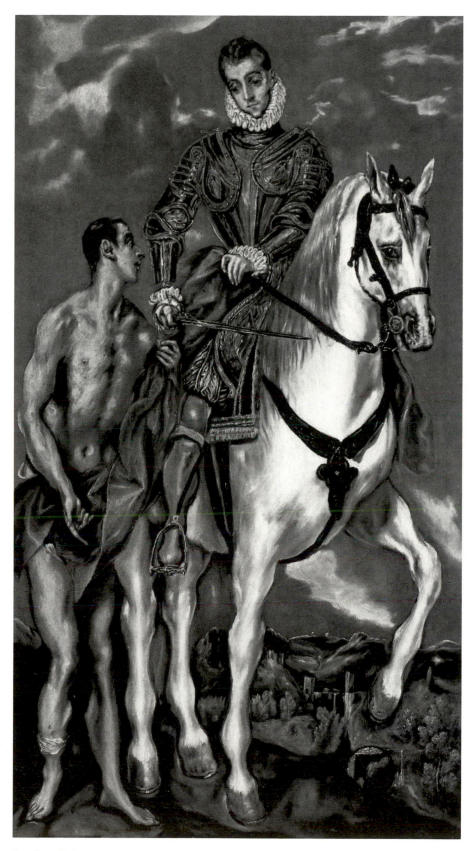

Studio of El Greco, *Saint Martin and the Beggar*, 1937.1.84

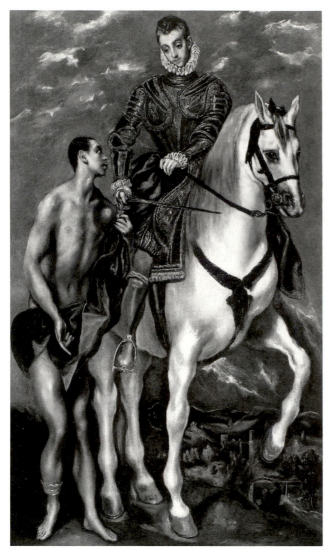

Fig. 1. Studio of El Greco, *Saint Martin and the Beggar*, 1600/1614, oil on canvas, The Art Institute of Chicago, Gift of Mr. and Mrs. Chauncey McCormick, 1949.1093 Copyright 1989 by The Art Institute of Chicago

Fig. 2. Studio of El Greco, *Saint Martin and the Beggar*, c. 1610/1614, oil on canvas, present location unknown, formerly in the Royal Palace, Bucharest [photo: Ampliaciones MAS]

workshop have many common characteristics, it is impossible to be certain whether El Greco's son or another artist created the Washington picture.[15] All scholars agree that the Mellon painting was created after completion of the altarpiece for the Chapel of Saint Joseph in 1599, and it has been assigned various dates within the general period of 1600 to 1614.[16] Until the paintings from El Greco's workshop can be more accurately dated, precise dates cannot be established with certainty.

The existence of five replicas of the altarpiece for the Chapel of Saint Joseph suggests that El Greco's interpretation of the legend of Saint Martin was popular and that several copies of it were commissioned.[17] The inventory of El Greco's estate made in 1614 includes a *Saint Martin*;[18] without additional evidence, it is impossible to know which version was in the artist's studio at the time of his death. Two paintings of this subject are listed with measurements in the inventory made in 1621 of the possessions of Jorge Manuel.[19] The measurements of one of these versions approximate those of four of the replicas known today, including the National Gallery example.

Although they differ from the master's style in

Fig. 3. Jorge Manuel Theotokopoulos, *Saint Martin and the Beggar,* c. 1615/1620, oil on canvas, Galleria Palatina, Palazzo Pitti, Florence [photo: Ampliaciones MAS]

Fig. 4. Jorge Manuel Theotokopoulos, *Saint Martin and the Beggar,* c. 1620/1631, oil on canvas, The John and Mable Ringling Museum of Art, Sarasota, Florida, State no. 656

important respects, the replicas now in the National Gallery and in The Art Institute of Chicago correspond more closely to the original altarpiece than do any of the others. Both repeat the vivid color scheme of the original. In addition, despite notable distortions, the figures in both retain at least to a limited extent the organic coherence that characterizes figures in authentic paintings.[20]

From old photographs and reports, it appears that the Bucharest example was less faithful to El Greco's original than the Washington and Chicago examples.[21] Its overall gray tonality differed from the high-

ly colored original and the replicas in Washington and Chicago. In addition, the Bucharest painting had more distortions of anatomy than the previously discussed versions. The awkward articulation of the shoulders and the narrow, pinched waist contributed to the disconcerting doll-like impression of Martin in this version. The folds of the cloak had become stiffer and more elaborate, and the clouds had been transformed into flat surfaces. All of these were characteristics typical of workshop production after 1610.[22]

The version in the Galleria Palatina, Palazzo Pitti, Florence, reveals many of the characteristics of paint-

ings produced in the workshop under Jorge Manuel's direction after El Greco's death (c. 1615–c. 1620).[23] One can note in this regard the hard contours of the metallic drapery, the exaggerated white highlights on the drapery and armor, and the greenish tonality of the beggar's body. The monumental impact of the figures has been diminished because they occupy less of the painting surface than in the original or in any of the previously discussed replicas. The expanse of sky surrounding the figures attests to Jorge Manuel's greater interest in space than in figures.

The version in Sarasota, which is nearly twice as wide as any other replica, is in the distinctive style that Jorge Manuel developed by about 1620.[24] On the left, the artist added a large, twisted tree trunk with a single branch growing from it; on the right, a large mottled yellow obelisk attests to his training as an architect.[25] Dark, murky tones like those that prevail in this painting can be noted in many late works by Jorge Manuel.[26]

Based upon these observations, it is possible to classify the replicas. The versions in Washington and Chicago are the earliest and most faithful copies. They were probably painted in the workshop under El Greco's supervision but without his participation. The Bucharest version was probably produced by the workshop still later within the artist's lifetime. The replica now in Florence is typical of the workshop production in the years immediately following El Greco's death. The painting in Sarasota, certainly the latest in the group, exemplifies Jorge Manuel's final manner.

Because all five identified versions of the Saint Martin altarpiece must be assigned to either Jorge Manuel or the workshop, it is evident that El Greco at least sometimes assigned other artists the task of making the replicas of his major paintings and that he did not feel obligated to make copies of them himself.

R.G.M.

Notes

1. The inventory number was painted out during the recent restoration of the painting.

2. The Technical Notes are based on Susanna Pauli, "Two Paintings by El Greco: *Saint Martin and the Beggar.* Analysis and Comparison" (forthcoming publication, conservation department papers, National Gallery of Art). I thank Ms. Pauli for providing me with a typescript of this article and for allowing me to discuss some of her findings here.

3. Cossío 1908 (see Biography), 600, no. 309. Wethey 1962 (see Biography), 2: 247, no. X-401, suggests that the National Gallery painting was in the sale of the Baron Isidoro de Taylor collection, Hôtel Drouot, Paris, 24–26 February 1880, no. 22. The only information provided in the sale catalogue for lot 22 is the title and artist (El Greco).

It is therefore impossible to identify which of the five small versions of *Saint Martin and the Beggar* was sold at the 1880 auction. Mayer 1929, 151, argues that the number *387* formerly inscribed at lower right indicates that the Mellon painting was once in the Spanish royal collection, but he does not provide any evidence to support this assertion. The number 387 is not used to identify a painting of Saint Martin or a work of any subject by El Greco in the published inventories of the royal collection. Compare Yves Bottineau, "L'Alcázar de Madrid et l'inventoire de 1686. Aspects de la cour d'Espagne au XVIIe siècle," *Bulletin hispanique* 60 (1958), 175; Gloria Fernández Bayton, ed., *Inventarios reales: testamentario del Rey Carlo II*, 6 vols. (Madrid, 1975–), 1: 56, 330; 2: 78, 266, 307. The unpublished inventories of the Spanish royal collection have not been checked.

4. Fénéon 1919, 1: 61–64, pl. 68. Mayer 1926, 48, no. 299, claims that the painting was included in the auctions of the Manzi collection. However, it was not mentioned in the catalogues of the auctions of paintings from the Manzi collection held at Galerie Manzi, Joyant et Cie, Paris, 13–14 March 1919 and 13 December 1919. Nor is it mentioned in contemporary articles on these auctions. See, for example, Alexandre Arsène, "Les Collections Manzi," *Les Arts* 5 (1919), 1–26. It seems possible that the brothers Bernheim-Jeune purchased the painting from Manzi, Joyant et Cie – with which Louis Manzi was affiliated – sometime before 1919.

5. Knoedler's records, as reported by Martha Hepworth of the Getty Provenance Index, letter, 9 June 1988, in NGA curatorial files.

6. Knoedler's records, as reported by Martha Hepworth, letter, 9 June 1988, in NGA curatorial files. The painting is listed in "More Masterpieces in Mellon Collection Become Known," *ArtN* 33 (2 March 1935), 4. On Mellon's purchases from Knoedler, see "List of Mellon Art Turned Over to Educational Trust," *ArtN* 33 (13 April 1935), 3. On Mellon's methods of collecting, see also William Larimar Mellon and Boyden Sparkes, *Judge Mellon's Sons* (New York, 1948), especially 425–427.

7. Busuioceanu 1934, 298.

8. On these four versions, see Wethey 1962 (see Biography), 2: 247–248, nos. X-402, X-403, X-404, X-405.

9. Pauli, forthcoming.

10. Cossío 1908 (see Biography), 330, 600, no. 309; Mayer 1926, 48, no. 299; Mayer 1929, 151; Cook, "Spanish Paintings," 71; exh. cat. Toledo-Madrid-Washington-Dallas 1982–1983, 168.

11. Camón Aznar 1950, 2: 1382, no. 522 (as by Jorge Manuel); Soehner 1957, 215, n. 88 (as probably by Jorge Manuel); (also Soehner 1961, 40, n. 88;) Wethey 1962 (see Biography), 2: 247, X-401 (as by the workshop). José Gudiol y Ricart, *Domenikos Theotokopoulos, El Greco*, trans. Kenneth Lyons (New York, 1973), does not include the NGA replica in his extensive catalogue of authentic works by El Greco.

12. Halldor Soehner, "Greco in Spanien," *MunchJb* 9/10 (1958/1959), 164. Soehner characterizes and differentiates the works of Jorge Manuel, the workshop, and later seventeenth-century artists in this important study, 147–174. Elizabeth du Gué Trapier, "The Son of El Greco," *Notes Hispanic* 3 (1943), 1–47, is still the only detailed study of all facets of Jorge Manuel's life and career.

13. According to Soehner 1958/1959, 166, choppy strokes began to appear in the paintings of Jorge Manuel and the

workshop as early as 1600 and predominated in their later production.

14. In the Prado's *Espolio* (Wethey 1962 [see Biography], 1: fig. 63), one may note flat triangles used for muscles in the arms of the executioners, Christ's sharply pointed fingers, and the curving lips of the Virgin. Wethey 1962, 2: 184, no. X-83, dates this version of the *Espolio* c. 1595. Soehner 1958/1959, 224, no. 218, assigns it to c. 1600. Both consider it to be one of the earliest certain works by El Greco's son.

15. On the possibility of the confusion between the paintings of Jorge Manuel and of the workshop, see Soehner 1958/1959, 163–164, and especially 167–168.

16. Cossío 1908 (see Biography), 600, no. 309, dates it 1604–1614. Mayer 1926, 48, no. 299, dates it 1604–1612. Wethey 1962 (see Biography), 2: 247, no. X-401, classifies it as 1600–1605.

17. Cossío 1908 (see Biography), 330.

18. San Román 1910 (see Biography), 193: "un S. Martin."

19. Francisco de Borja de San Román y Fernández, "De la vida del Greco," *AEAA* 3 (1927), 301, 303: "170 Un San Martin a caballo, de bara y terzia y tres quartas" (A Saint Martin on horseback, of a *vara* [84 cm] and a third by three-quarters [of a *vara*]). "213 Un S. Martin, de dos baras y terzia de alto y bara quarta de ancho" (A Saint Martin, of two *varas* and a third in height and one *vara* and a quarter in width). Because the smallest fraction of a *vara* mentioned in the inventory is one-sixth, all measurements must be considered approximations. Like the English yard, the *vara* was divided into feet and inches for greater precision.

The measurements of the painting listed in the inventory under number 170 approximate those of the replicas in Washington (111.9 x 63 cm), Chicago (110 x 63 cm), (formerly) Bucharest (106 x 58 cm), and Florence (106 x 64 cm). Measurements of the Chicago, Florence, and Bucharest versions are given by Wethey 1962 (see Biography), 2: 247–248, nos. X-402, X-403, X-405. The measurements of item number 213 correspond only with those of the original altarpiece (1942.9.25). It is possible that the workshop made a full-scale reproduction of the original altarpiece. However, it is tempting to speculate that Jorge Manuel recorded the height of this version incorrectly, for its width corresponds closely with that of the version now in Sarasota (138 x 107 cm).

20. On the Chicago version, see *Paintings in The Art Institute of Chicago* (Chicago, 1961), 205; Soehner 1957, 215, n. 88; Wethey 1962 (see Biography), 2: 247, X-402. The Art Institute catalogue suggests that the replica in Chicago may have been commissioned as a pair with the small version of *Saint Joseph and the Christ Child* (109 x 56 cm), now in the Museo de Santa Cruz, Toledo (Legendre and Hartmann 1937, repro. 131).

21. Busuioceanu 1934, 298, provides the fullest description.

22. Soehner 1958/1959, 167–169.

23. Wethey 1962 (see Biography), 2: 248, no. X-405. Compare Soehner 1958/1959, 168–170.

24. On this painting, see Cossío 1908 (see Biography), 607, no. 345; Trapier 1943, 24; Wethey 1962 (see Biography), 2: 247–248, no. X-404.

25. On Jorge Manuel's architectural work, see Trapier 1943, 29–34, 39–45. Trapier 1943, 24, has noted similar architectural motifs in other paintings by El Greco's son, such as the *Purification of the Temple* now in San Ginés, Madrid (Wethey 1962 [see Biography], 1: fig. 197).

26. For instance, the *Saint Louis of France* now in the Casa del Greco, Toledo (Camón Aznar 1950, 1: fig. 539). See Soehner 1958/1959, 169–170.

References

1906. Lafond, Paul. "La Chapelle San José de Tolède et ses peintures du Greco." *GBA* 36: 387, repro.

1906. Lafond, Paul. "Domenikos Theotokopuli dit Le Greco." *Les arts* 58 (October): 20–22, repro. 6.

1908. Cossío (see Biography): 330, 600, no. 309, pl. 47 (also 1972 ed.: 192, 386, no. 287).

1909. Calvert, Albert F., and C. Gasquoine Hartley. *El Greco*. London: 124.

1911. Mayer, August L. *El Greco*. Munich: 53.

1919. Fénéon, Félix, ed. *L'art moderne et quelques aspects de l'art d'autrefois d'après la collection privée de MM. J. et G. Bernheim-Jeune*. 2 vols. Paris. 1: 61–64, pl. 68.

1925. Boyer, Raymond. "La saison des 'retrospectives.'" *RArt* 48: 229.

1925. Dayot, Armand. "Une exposition d'art ancien espagnol." *L'art et les artistes* 19: 296.

1926. Mayer, August L. *Dominico Theotocopuli, El Greco*. Munich: 48, no. 299.

1928. Villar, Emilio H. del. *El Greco en España*. Madrid: 103.

1929. Mayer, August L. "*St. Martin and the Beggar* by El Greco." *Apollo* 10: 151, color repro.

1930. Bull, Henry Adsit. "Notes of the Month." *IntSt* 95: 58, repro.

1930. Rutter, Frank. *El Greco*. New York: 62, 98, no. 80, pl. 70.

1931. Mayer, August L. *El Greco*. Berlin: 107, fig. 105.

1934. Busuioceanu, Al. "Les tableaux du Greco dans la collection royale de Roumanie." *GBA* 76: 298, repro. 294.

1937. Cortissoz, Royal. *An Introduction to the Mellon Collection*. Boston: 42.

1937. Legendre, Maurice, and Alfred Hartmann. *Domenikos Theotokopoulos, Called El Greco*. Paris: 463, repro.

1945. Cook, "Spanish Paintings:" 70–72, fig. 3.

1949. Mellon: xii, repro. 43.

1950. Camón Aznar, José. *Domenico Greco*. 2 vols. Madrid, 2: 702–704, 1383, no. 528, fig. 538 (also 1970 rev. ed., 2: 712, 714, 1367, no. 528, fig. 594).

1957. Soehner, Halldor. "Ein Hauptwerk Grecos: die Kapelle San José in Toledo." *ZfK* 9: 215, n. 88.

1958. Gaya Nuño, *La pintura española*: 205, no. 1407.

1961. Soehner, Halldor. *Una obra maestra de El Greco: la Capilla de San José de Toledo*. Translated. Madrid: 40, n. 88.

1962. Wethey (see Biography). 1: fig. 119; 2: 247, no. X-401 (also Spanish ed., 1967, 2: 262, no. X-401, pl. 103).

1969. Manzini, Gianna, and Tiziana Frati. *L'opera completa del Greco*. Milan: no. 105C-1.

1982. Péréz-Sánchez, Alonso E. "On the Reconstruction of El Greco's Dispersed Altarpieces." In exh. cat. Toledo-Madrid-Washington-Dallas (see Biography): 168.

Juan van der Hamen y León

1596 – 1631

VAN DER HAMEN was baptized in Madrid, where he lived all his life. His father was a Fleming of noble ancestry, his mother was half-Spanish and half-Flemish, claiming descent from the Spanish nobility. The family was prosperous and provided its sons with a solid education; in fact, Van der Hamen's brother Lorenzo distinguished himself as a man of letters.

Nothing is known of the painter's artistic training, except that it occurred in Madrid. The earliest record of his work as a painter dates from 1619, when he received payment for a still-life painting from the crown. This was the genre for which he would become famous, although he was also an excellent portraitist. Van der Hamen's still lifes are among the finest painted in the seventeenth century and are distinguished for their exquisite naturalism and subtle compositional balance.

Van der Hamen held an appointment in the royal household as a member of the Royal Archers, an honorary corps of guards. However, his application to become a royal painter was not successful. He died in Madrid at the young age of thirty-five.

J.B.

Bibliography

Jordan, William B. *Spanish Still Life in the Golden Age.* Exh. cat., Kimbell Art Museum; Toledo [Ohio] Museum of Art. Fort Worth, 1985: 103–124.

1961.9.75 (1627)

Still Life with Sweets and Pottery

1627
Oil on canvas, 84.2 x 112.8 (33⅛ x 44⅜)
Samuel H. Kress Collection

Inscription:
At right: *Juan vanderHamen i Leon/fat 1627*

Technical Notes: The support is a medium-fine weight, plain-weave fabric which has been lined to a plain-weave, double-threaded support. A thin red ground is applied overall, over which the paint is applied in thin, opaque rich-paste layers. Although the paint is worked in a wet-in-wet technique to create smooth tonal transitions, the artist uses low striated brush strokes, giving the surface a delicately textured unity. The painting is moderately abraded overall, particularly in the dark background, and the impasto is flattened. Minute spots of retouch, applied over the abrasion in the background, have become discolored and light. The painting was relined, cleaned, and treated in 1955.

Provenance: Possibly Diego de Messía Felípez de Guzmán, Marqués de Leganés, Madrid, 1655.[1] Private collection, Florence, by 1950.[2] (Victor Spark, New York).[3] (David M. Koetser, New York, London, and Zurich).[4] Purchased 1955 by the Samuel H. Kress Foundation, New York.

Exhibitions: *La Nature morte de l'antiquité à nos jours,* Musée de l'Orangerie, Paris, 1952, 95, no. 72, pl. 28. *Spanish Still Life in the Golden Age 1600–1650,* Kimbell Art Museum, Fort Worth; The Toledo (Ohio) Museum of Art, 1985, 135, no. 17, color pl. 17.

THIS SPLENDID STILL LIFE, generally considered to be one of the artist's finest, belongs to a group of works that marks a new stage in van der Hamen's development. In earlier works, he was influenced by still-life types created by Flemish and Spanish painters of the early seventeenth century, in which inanimate objects are arranged on a single level, usually a table or the ledge of a window or other kind of framed opening. Beginning in 1626, however, the artist began to employ a more complex formula with various levels created by stepped stone plinths, as here.

The source of this motif has been much discussed and is still uncertain. Longhi hypothesized the influence of painters whom he placed in the orbit of Caravaggio, specifically Tomasso Salini, Giovanni Battista Crescenzi, and Pietro Paolo Bonzi.[5] This idea was accepted by Pérez Sánchez, who reproduced a signed painting by Bonzi, datable to around 1610, which is a kitchen still life consisting of figures with foodstuffs arranged on several levels in front of them.[6] The painting is now in the Palacio de los Aguila, Avila, but its whereabouts in the seventeenth century is unknown. Pérez Sánchez assumed that paintings of this type existed in Spanish collections in the first third of the seventeenth century.

Juan van der Hamen, *Still Life with Sweets and Pottery*, 1961.9.75

Following Longhi, Pérez Sánchez also suggested that the still lifes of Crescenzi may have played a part in the introduction of the stepped-plinth composition into van der Hamen's work. Crescenzi was an Italian nobleman who came to Spain in 1617 and remained there until his death in 1635, during which time he became an influential figure in the artistic circles of the court. Baglione mentions his practice of still-life painting, examples of which he presented to Philip III upon his arrival in Madrid.[7]

Jordan takes a broader view of the question,[8] accepting both the possible influence of contemporary Italian still life and the idea advanced by Bergström, that the source might be found in "such architectural forms [which] actually existed in the pantries of seventeenth-century houses."[9] He also notes Sterling's observation that this format was used in the still-life painting of classical antiquity.[10] Although these paintings were not discovered until the eighteenth century, they were described in antique sources. Accordingly, Jordan hypothesizes that the artist was inspired to use the motif by the famous Roman antiquarian, Cassiano dal Pozzo, who came to Madrid in 1626 with Cardinal Francesco Barberini, and who was in contact with van der Hamen. Finally, he reproduces a still life of uncertain date that he reattributes to an anonymous Italian artist,[11] and which utilizes in part the stepped-plinth composition, although the arrangement of the objects is less formal than in the works by van der Hamen. The importance of Italian sources for this development in van der Hamen's art seems undeniable, although it is difficult to accept that Crescenzi played a role in the change. He arrived in Madrid nine years before the stepped-plinth motif appears in van der Hamen's work, and, in any case, no still lifes have yet been convincingly attributed to him.[12] However, the arrangement of still-life objects on two or more levels was current in Roman painting by 1620, as seen in several canvases attributed to Tomasso Salini (c. 1575–1625) and Agostini Verrocchi (active 1619–1634).[13] Although the compositions of these paintings are more cluttered with objects and less disciplined in composition and use of light, they may have provided a starting point for van der Hamen, who then revised the concept by applying the austere, ordered format he had learned from the works of Juan Sánchez Cotán.

It has often been suggested that van der Hamen's still lifes with stepped plinths were painted in pairs and meant to be hung to produce a continuous composition, enclosed at either end by the highest plinth. While this idea has merit, it should not be taken to mean that every still life in this format originally had a pendant. It is interesting to observe that some paintings are signed in the lower corner, while others, including the National Gallery's, are signed at a higher point on the canvas, where the signature would have intruded into a continuous composition in paired pictures. Eisler correctly questioned the suggestion that the Washington work is the pendant of *Still Life with Fruit and Glassware* (The Museum of Fine Arts, Houston), because the arrangements are not complementary; nor were the pictures executed in the same year.[14] The idea that the two paintings were part of a series of the four seasons is plausible but unproved.[15]

Following a common practice of still life painters, the artist used some of the elements from this painting in other works. Thus, the circular marzipan boxes surmounted by the jar of preserved quinces appear in four other works by van der Hamen and his workshop, dating from 1620 to 1627,[16] in two of which the basket of candied fruit at the left also reappears.[17] Eisler has identified the red earthenware vessel with a circular opening as a *Loch*, made in the lower Rhineland.[18] The various confections represented in the picture were served by the upper classes in Madrid on what Lope de Vega called "honradas ocasiones."[19]

J.B.

Notes

1. Exh. cat. Fort Worth-Toledo 1985, 135, raises the possibility that this painting is identical to one owned by Leganés at his death in 1655. The marquis owned several still lifes by van der Hamen, including one described in his inventory (no. 97) as "otro banquete de la misma mano y tamaño (ie. 2 baras poco mas o menos de alto y una y media de ancho), con cajas de conserbas, un canastillo de diferentes dulces y bucaros" (another banquet of the same hand and size, with boxes of conserves, a basket of varied sweets and drinking cups). As Jordan notes, the dimensions are significantly different from those of the Gallery's painting (84.2 x 112.8 cm versus c. 167.2 x 135.4 cm). He suggests that a scribe's error may be responsible for the discrepancy. Certainly the vertical dimensions seem excessive for a still life of this type.

2. Longhi 1950, pl. 16.

3. Recorded as owner in exh. cat. Paris 1952, and in Allan Gwynne-Jones, *Introduction to Still-Life* (London, 1954), 66, no. 59.

4. David Rust to William Jordan, 6 June 1969, in NGA curatorial files.

5. Longhi 1950, 39.

6. Pérez Sánchez 1974, 83; Pérez Sánchez 1983, 49, no. 14, repro.

7. Cited by Longhi 1950, 37.

8. Exh. cat. Fort Worth-Toledo 1985, 132.

9. Bergström 1970, 36–37. This author tentatively posits a relationship between van der Hamen's still lifes and those of Frans Snyders.

10. Charles Sterling in exh. cat. Paris 1952, 66.

11. Ingvar Bergström in *La natura in prosa* (Bergamo, 1971), pl. 50, had attributed the painting to an unidentified Spanish artist of the seventeenth century.

12. Carlo Volpe, "Una proposta per Giovanni Battista Crescenzi," *Paragone* 25 (January 1973), 25–36; Mina Gregori, "Notizie su Agostino Verrocchi e un' ipotesi per Giovanni Battista Crescenzi," *Paragone* 25 (January 1973), 36–56. Luigi Spezzaferro, "Un impreditore del primo seicento: Giovanni Battista Crescenzi," *Ricerche di storia dell'arte* 26 (1985), 50–73, argues that the artist painted very few still lifes in Spain.

13. For paintings in a similar mode attributed to Verrocchi and others, see Gregori 1973.

14. Eisler 1977, 206.

15. Eisler 1977, 206.

16. They are as follows:
 1. *Basket of Sweets* (by workshop), signed and dated 1620, private collection, unspecified location; exh. cat. Fort Worth-Toledo 1985, 137, fig. VI.23.
 2. *Vase of Flowers and Dog*, Prado, Madrid; exh. cat. Fort Worth-Toledo 1985, 111, fig. VI.12.
 3. *Serving Table*, signed and dated 1621; Museo Provincial de Bellas Artes, Granada; exh. cat. Fort Worth-Toledo 1985, pl. 12.
 4. *Basket and Boxes of Sweets*, signed and dated 1627; private collection, Madrid; exh. cat. Fort Worth-Toledo 1985, pl.18

17. Numbers 1 and 4 in note 16.

18. Eisler 1977, 206.

19. Cited in exh. cat. Fort Worth-Toledo 1985, 113.

References

1950. Longhi, Roberto. "Un momento importante nella storia della 'Natura Morta'." *Paragone* 1: 34–39, pl. 16.

1956. Kress: 104, repro. 105.

1959. Kubler, George, and Martin Soria. *Art and Architecture in Spain and Portugal and Their American Dominions, 1500–1800*. Baltimore: 235, pl. 122a.

1959. Soria, Martin. "Notas sobre algunos bodegones españoles del siglo XVII." *AEA* 32: 273–280.

1964–1965. Jordan, William B. "Juan van der Hamen y León: A Madrilenian Still-Life Painter." *Marsyas* 12: 52–59, fig. 16.

1967. Jordan, William B. "Juan van der Hamen y León." Ph.D. diss., New York University: 333, no. 16, fig. 34.

1970. Bergström, Ingvar. *Maestros españoles de bodegones y floreros*. Madrid: 36.

1971. Angulo Iñiguez, Diego. *Pintura española del siglo XVII*. Ars Hispaniae, 15. Madrid: 29.

1974. Pérez Sánchez, Alfonso E. "Caravaggio y los Caravaggistas en la pintura española." In *Colloquio sul tema Caravaggio e i Caravaggeschi*. Rome: 57–85, fig. 12.

1977. Eisler: 206–207, fig. 202.

1979–1980. Held, Jutta. "Verzicht und Zeremoniell: zu Stilleben von Sánchez Cotán und van der Hamen." *Stilleben in Europa*. Westfälisches Landesmuseum für Kunst und Kulturgeschichte. Munster: 390–394, repro. 391.

1983. Pérez Sánchez, Alfonso E. *Pintura española de bodegones y floreros*. Exh. cat., Prado. Madrid: 42, repro.

Eugenio Lucas Villamil

1858 – 1918

EUGENIO LUCAS VILLAMIL was born in Madrid, the son of the painter Eugenio Lucas Velázquez (1817–1870),[1] a figure of significance in the history of nineteenth-century Spanish painting. Although the elder Lucas died when his son was only twelve, the younger Lucas modeled his style on his father's example. In particular, he continued to produce copies and imitations of the works of Goya, as his father had done. The Goyesque works of Lucas Villamil are often confused with those of Lucas Velázquez.

Lucas Villamil lived a modest life as a painter in Madrid until his death. His major patron was the collector José Lázaro Galdiano, who commissioned him to execute a fresco in his Madrid house, now the Museo Lázaro Galdiano.

J.B.

Notes
1. The correct name of the older artist, previously thought to be Lucas Padilla, and his date of birth are established by Arnaiz 1981, 9.

Bibliography
José Manuel Arnaiz. *Eugenio Lucas. Su vida y su obra.* Madrid, 1981: 190–207.

1954.10.1 (1350)

The Bullfight

c. 1890/1900
Oil on canvas, 73.9 x 109.9 (29⅛ x 43¼)
Gift of Arthur Sachs

Technical Notes: The picture is on a fabric of tight and regular weave and adhered to a fine lining material. All tacking edges have been removed. The ground consists of a rough layer of reddish brown particles over which rich oil paint has been applied with brush and palette knife. An examination of the pigments by x-ray fluorescence spectroscopy did not reveal the use of any pigments unavailable to Goya, although chrome yellow, which is present, was only introduced in the early 1800s.[1] The paint and ground layers present evidence of a history of poor adhesion. Flake losses have occurred in the thick, knife-applied layers and at cracks near the outer extremities of the picture. There are fills and retouches applied to many of the flake losses. The surface coating is somewhat dull.

Provenance: Probably Edouard Kahn, Paris (sale, Hôtel Drouot, Paris, 8 June 1895, no. 2).[2] Sigismond Bardac (sale, Paris, 1910). (Gimpel and Wildenstein, Paris, by 1924);[3] Baron Maurice de Rothschild, Paris, 1925. Arthur Sachs [1880-1975], New York and Cannes, by 1928.[4]

Exhibitions: *Exposition d'art ancien espagnol,* Hôtel J. Charpentier, Paris, 1925, 49, no. 41, repro. *Exhibition of Spanish Paintings from El Greco to Goya,* The Metropolitan Museum of Art, New York, 1928, 2, no. 6 fig. 6. *A Century of Progress Exhibition of Paintings and Sculpture,* The Art Institute of Chicago, 1933, 25, no. 162.

THE ATTRIBUTION of this painting to Goya, upheld by Lafond, von Loga, Calvert, Stokes, and Mayer,[5] was first challenged by Trapier, who identified it and a companion piece in the Reinhart collection, Winterthur, as the work of the Spanish romantic painter, Eugenio Lucas Velázquez.[6] This proposal has gained acceptance by most of those who have subsequently studied the painting.[7] However, Gassier and Wilson have advanced the name of Lucas' son, Eugenio Lucas Villamil, as the author.[8]

Trapier based the attribution to Lucas Velázquez in part on the fact that he painted numerous bullfighting scenes in a style derived from the late works of Goya. In addition, she accepted that this painting and the Reinhart picture were the two bullfighting scenes mentioned in 1863 in the Acebal y Arraitia collection in Madrid. At that date, Lucas Villamil was only five years old, obviously too young to have painted the works. However, the source of this information, Francisco Zapater y Gómez, the nephew of Goya's friend and correspondent, Martín Zapater, describes the paintings in the Acebal collection as miniatures.[9] The first documented reference does not occur until 1895, when a bullfight scene of comparable dimensions appeared in the E. Kahn sale, Paris. The entry in the catalogue is too brief to determine whether the painting in question was the one in the Gallery or the pendant in Winterthur.

Finally, Trapier noted that the composition of the foreground figures in the Winterthur painting was based on a signed gouache by Lucas Velázquez, then in the collection of Pedro Castillo Olivares, which she regarded as a preparatory study for the picture.[10]

Master of the Catholic Kings

active c. 1485 – 1500

THE Master of the Catholic Kings is the name given to the artist thought to have been responsible for *The Marriage at Cana* (1952.5.42), *Christ among the Doctors* (1952.5.43), and six other paintings. In 1922, Conway, who was among the first scholars to study the panels, suggested that they were executed by an artist active in Brussels or Louvain about 1490.[1] On the basis of heraldry in four of the panels, Van der Put proposed that an artist active in Valladolid painted them for a retable commissioned by the Catholic Kings, Ferdinand of Aragon and Isabel of Castile, who unified their kingdoms through their marriage in 1469.[2] Van der Put's hypothesis has been accepted by subsequent commentators. Mayer acknowledged the Master's indebtedness to Netherlandish artists but maintained that he was a Castilian who had been trained by Fernando Gallego.

Post was the first to recognize the Master as an independent artistic personality. Post emphasized the affinities of the Master's work with such late fifteenth-century Castilian artists as Gallego and the Master of Saint Ildefonsus and proposed that he was trained by the Pacully Master. Post also pointed out that the Master's extensive borrowings from Netherlandish art could be accounted for by the widespread influence of northern art in Castile, and that it was not necessary to suppose that he had lived outside Spain. Mayer and Post were probably correct in maintaining that the artist was Castilian. However, the highly eclectic character of the Master's style has frustrated attempts to determine his origins, and his nationality remains uncertain.

Gudiol identified the Master as Diego de la Cruz, whose only signed painting is the *Man of Sorrows with the Virgin and Saint John the Evangelist* in the Bonova collection, Barcelona.[3] Gudiol further proposed that this painter was the same Diego de la Cruz who has been documented as a collaborator of the sculptor Gil de Siloé between 1488 and 1499. Utilizing "excessive elongation of noses" and high M-shaped hairlines as hallmarks of Diego's style, Gudiol attributed a large number of paintings to him, including the panels of the Retable of the Catholic Kings. Cuttler accepted Gudiol's identification of the Master as Diego de la Cruz and suggested that he may have been trained in Cologne by the Holy Kinship Master, whose works are characterized by lavishly decorated surfaces and colored shadows.[4]

Gudiol, however, provides insufficient evidence to justify attributing the panels of the Retable of the Catholic Kings to Diego de la Cruz. The noses and the hairlines which Gudiol describes as characteristic of Diego can be noted in many later fifteenth-century Castilian works, such as the *Flagellation* and the *Resurrection* from the Rojo y Sojo collection, Cadiz.[5] None of the other paintings attributed by Gudiol to Diego de la Cruz have the deep space of the paintings from the Retable of the Catholic Kings. In addition, the exceptional angularity and stiffness of the figures in the signed *Man of Sorrows* differentiate them from the figures in the paintings of this retable.

The high quality of the paintings attributed to the Master and the likely patronage of the Catholic Kings indicate an important artist; but he remains elusive. It is not possible to identify him, although his paintings can be appreciated as "among the most significant productions of the whole Hispano-Flemish movement."[6]

R.G.M.

Notes

1. Martin Conway, typescript, 5 April 1922, in NGA curatorial files. Conway discussed only four of the panels: *The Circumcision, The Purification, Christ Among the Doctors,* and *The Marriage at Cana.*

2. Albert Van der Put, typescript, c. 1922, in NGA curatorial files. Van der Put analyzed the four panels also discussed by Conway.

3. Gudiol 1966, 208, repro.

4. Charles D. Cuttler, *Northern Painting from Pucelle to Brueghel* (New York, 1968), 254; on the Master of the Holy Kinship, 278–279. Gudiol 1966, 210, proposed that Diego was Flemish, as was Gil de Siloé. Eisler 1977, 178, recorded Gudiol's hypothesis but did not indicate whether or not he agreed with it.

5. August L. Mayer, "Pinturas castellanas procedentes

References

1902. Lafond, Paul. *Goya*. Paris: 107, no. 29.

1903. von Loga, Valerian. *Francisco de Goya*. Berlin: no. 547.

1909. Calvert, Albert F. *Goya: An Account of His Life and Works*. London: 161, no. 143.

1914. Stokes, Hugh. *Francisco Goya*. London: 352, no. 535.

1924. Mayer, August L. *Francisco de Goya*. London and Toronto: 181, no. 666.

1940. Trapier, Elizabeth du Gué. *Eugenio Lucas y Padilla*. New York: 48, pl. 24.

1947. LaFuente Ferrari, Enrique. *Antecedentes, coincidencias e influencias del arte de Goya*. Madrid: 230–231.

1948. Adhémar, Jean. *Goya*. New York: 22, pl. III.

1956. López-Rey, José. "Goya and His Pupil María del Rosario Weiss." *GBA* 47: 282.

[c. 1965]. Gudiol y Ricart, José. *Goya*. New York: 164, color repro. 165.

1970. Gassier, Pierre, and Juliet Wilson. *Vie et oeuvre de Francisco Goya*. Paris: 356–357 (also English ed. 1971: 356–357).

1975. Koella, Rudolf. *Collection Oskar Reinhart*. Neuchâtel: 346.

1977. Glendinning, Nigel. *Goya and His Critics*. New Haven: 124, 321, n. 5, fig. 36.

1981. Arnaiz (see Biography): 474, no. 342, color repro. p. 101, no. 84.

Nevertheless, the Winterthur painting is executed in a markedly different style from the gouache, and the differences help to distinguish the bullfighting scenes of the elder from those of the younger Lucas.[11] In general, Lucas Villamil is a less careful draftsman than his father, who tends to complete the contours of the principal figures in his compositions, even when painting with considerable freedom. Lucas Villamil, also a lesser craftsman, often fuses the figures into a jumbled, untidy mass, relying on broad, hasty effects of thickly impasted pigment to indicate crowds of people. While neither artist is much concerned with the detailed rendering of expression, the younger Lucas often resorts to a schematic formula of representing the eyes and mouth that borders on caricature. Another characteristic of Lucas Villamil is the lack of attention given to the spectators in the arena, whose treatment is perfunctory. Finally, the younger Lucas uses brighter, more strident colors than his father.

The touchstone for Lucas Villamil's imitations of his father's (and Goya's) bullfighting scenes, as Gassier and Wilson point out, is a painting in the Nationalgalerie, Berlin, which is documented by the famous Spanish collector, José Lázaro Galdiano, a friend and patron of the artist.[12] According to his account, Lázaro saw the painting in the office of Wilhelm Bode, the director of the Kaiser Friedrich Museum, Berlin. Bode had just acquired the painting as a work by Goya, but Lázaro assured him that it had been executed by his friend, Lucas Villamil. To prove the point, Lázaro, upon his return to Madrid, asked the painter to replicate the picture, which he was able to do, not surprisingly, in two days' time. Lázaro brought the copy with him on his next trip to Berlin and showed it to a suitably chagrined Bode.

It should be noted that the painter has misunderstood the subject of his picture by combining a bullfighting scene with the popular diversion of climbing a greasy pole, and setting them both in a formal arena.[13] The combination of events itself is not implausible and is seen in one of the small paintings presented by Goya to the Madrid Academia in 1793 (Marqués de la Torrecilla, Madrid) and also in a painting by Lucas Velázquez.[14] However, these two artists were careful to set the scene in a large village square, implying that both events were elements of a popular *fiesta*. Placing the scene in a formal bullring is contrary to practice and elementary rules of caution. This careless combination of disparate elements is nowhere to be found in the bullfighting scenes of the elder Lucas.

J.B.

Notes

1. Identified by optical microscopy.

2. The dimensions for this painting and its companion piece, now in the Museum Stiftung Oskar Reinhart, Winterthur, are almost identical. The Kahn sale catalogue (*Catalogue des tableaux par Antoine Watteau, Boucher, Goya, Gustave Moreau, Teniers…formant la collection K.*) contains only one entry for a "course de taureau" by Goya, which is described as a "belle esquisse," although it is annotated with a sale price of 2500 francs. Lafond 1902, however, not only lists both paintings as being in this sale, but without explanation identifies no. 29 (the NGA version) as the one that sold for 2500 francs.

3. Mayer 1924, 181.

4. Exh. cat. New York 1928, no. 6.

5. Lafond 1902, 107, no. 29; von Loga 1903; Calvert 1908, 161, no. 143; Stokes 1914, 352, no. 535 (who lists without references the previous ownership of M. Piot and H. Hochefort); Mayer 1924, 181, no. 666; Gudiol [c. 1965], 164. Gudiol excludes the painting from his book *Goya* (Barcelona, 1971), but for some reason accepts the authenticity of the pendant at Winterthur. Glendinning 1977, 124, considers it to be by Goya or a follower.

6. Trapier 1940, 48, pl. 34. The Winterthur painting is reproduced as pl. 33.

7. For example, Lafuente Ferrari 1947, 230–231; Koella 1975, 346; Arnaiz 1981 (see Biography), 474, no. 342; Juan J. Luna, letter, 20 August 1982, in NGA curatorial files. López-Rey 1956, 282, speculated that this painting and the one at Winterthur might be the work of Goya's pupil, María del Rosario Weiss, who is sometimes thought to be his illegitimate child. She was with Goya in Bordeaux during the final years of his life. In November 1952, Francisco J. Sánchez Cantón examined the picture and rejected the attribution to both Goya and Lucas Velázquez, proposing the name of Francisco Domingo Marqués (1842–1920); notes in NGA curatorial files. The attribution to Goya is still accepted by Adhémar 1948, 22.

8. Gassier and Wilson 1971, 356–357. Little is known of his life and art. See the reminiscences of José Lázaro, *Loan Exhibition of Paintings, Gouaches and Drawings by Lucas and His Son from the Collection of José Lázaro, Madrid* [exh. cat., Wildenstein] (New York, 1942), 3–9; Arnaiz 1981 (see Biography), 190–207.

9. Francisco Zapater y Gómez, *Apuntes histórico-biográficos acerca de la escuela aragonesa de pintura* (Madrid, 1863), 40.

10. Trapier 1940, pl. 32.

11. For reproductions of comparable scenes by Lucas Velázquez, see Arnaiz 1981 (see Biography), 315, 317, 321, 323, 325, 327, 435, figs. 54–55, 57–58, 65, 66, 67–68, 70–72, 276–277, many of which are based on prints from Goya's *Tauromaquia*.

12. Lázaro 1942, 5–6.

13. This discrepancy is noted by Trapier 1940, 48, who excuses it by supposing that the artist, in her opinion Lucas Velázquez, combined two sketches of scenes from a village bullfight and used the arena setting to "suit his fancy on popular taste."

14. For the Goya, see Gassier and Wilson 1971, 169, no. 318. Lucas Velázquez' painting is reproduced in Arnaiz 1981 (see Biography), 315, fig. 54.

Eugenio Lucas Villamil, *The Bullfight*, 1954.10.1

de la coleccíon Rojo y Sojo," *Revista española de arte* 12 (1934–1935), 209, 210, repro.

6. Post 1930–1966, vol. 4, part 2, 418.

Bibliography

Mayer, August L. *Geschichte der spanischen Malerei*. Leipzig, 1922: 144–145. Also Spanish ed. Madrid, 1942: 165–166.

Post, Chandler R. *A History of Spanish Painting*. 14 vols. Cambridge, Mass., 1930–1966, vol. 4, part 2: 418–428; vol. 5, part 1: 182, 194.

Mayer, August L. "Late XVth Century Castilian Painting." *Apollo* 29 (1939): 281.

Post, Chandler R. "The Pacully Master." *GBA* 23 (1943): 328.

Gudiol y Ricart, José. "El Pintor Diego de la Cruz." *Goya* 70 (1966): 208–217.

1952.5.42 (1121)

The Marriage at Cana

c. 1495/1497
Oil on panel
 original painted surface 137.1 x 92.7 (54 x 36½)
 with addition at bottom 153.1 x 92.7 (60¼ x 36½)
 with added border strips 155.7 x 95.8 (61¼ x 37¾)
Samuel H. Kress Collection

Inscriptions:

On border of tablecloth: *AVE * GRATIA * PLENA * DOMINUS * TECU BENEDICTATU * INMUI-LERIBUS* (Hail full of grace, the Lord is with thee: blessed art thou among women) (Luke 1:28).

On border of Christ's tunic: *QUID MIHI ET TIBI EST MULLER* (What have I to do with thee, woman?) (John 2: 4).

On towel over shoulders of attendant on right, and on border of Mary's mantle.[1]

Technical Notes: The original support is composed of two vertically oriented planks of pine. The lower 16 centimeters is constructed of four pieces of vertically oriented fir wood of unequal width, which have been attached to the bottom of the original support.[2] Narrow strips of wood have been added to the edges of the composite panel, and a modern cradle has been attached to it. The damage to the paint surface across the lower edge of the original panels suggests that the four blocks added at the bottom may have replaced a destroyed part of the original composition. The original support is covered by a thick, white ground probably composed of two layers. X-radiographs show fibrous inclusions (grass?) in the ground. The fibrous inclusions seem to be confined to the lower layer; it is supposed that there is a second, thinner ground layer without fibers above. The composition was extensively underdrawn on the original

support, in a black liquid, probably applied with a brush (fig. 1). The major figures and such details of the setting as the bed were fully cross-hatched in the underdrawing, while the background figures were only indicated with sketchy contours. Several minor changes can be noted between the drawn and painted stages, including the shape and position of the Virgin's nose, the features of the man lifting his cap, and the bride's right sleeve. In the underdrawing, two diagonal lines extend from the goblet to the groom's right hand. The straight borders of the brocade at the right were incised. Oil paint was applied in a series of carefully controlled layers, with glazes and finely applied details modifying the underlayers. The support is basically solid, although the addition of the blocks at the bottom has caused some cracks to form in the original planks. There are minor losses of paint along the left edge and elsewhere. The eyes of the dog were damaged in 1979.

Provenance: Possibly commissioned for a church or convent in Valladolid, Spain.[3] Conde de las Almenas, Madrid, before 1919;[4] (Frank Partridge, London, 28 March 1919).[5] Dr. Preston Pope Satterwhite [1867–1948], New York, by 1933;[6] purchased 1949 by the Samuel H. Kress Foundation, New York.[7]

Exhibitions: *Exhibition of Spanish Painting*, The Brooklyn Museum, 1935, no. 6. *Spanish Paintings*, Philadelphia Museum of Art, 1937, no cat. *Spanish Painting*, The Toledo [Ohio] Museum of Art, 1941, no. 27. *Paintings and Sculpture from the Samuel H. Kress Collection*, National Gallery of Art, Washington, 1951, 180, no. 79.

POST and subsequent scholars[8] have maintained that *The Marriage at Cana* and the National Gallery's *Christ among the Doctors* (1952.5.43) originally formed part of a retable that also included six other paintings: *The Annunciation* (fig. 2), *The Visitation* (fig. 3), *The Nativity* (fig. 4), *The Adoration of the Magi* (fig. 5), *The Circumcision* (fig. 6), and *The Presentation in the Temple* (fig. 7). There are only slight variations of height and width among the paintings.[9]

These paintings would have constituted only part of the decoration of a typical Spanish retable of the fifteenth century. The retables erected behind the altars of Spanish churches were often large and complicated. Paintings and reliefs depicting scenes from the lives of Christ and the saints were organized in vertical rows on both sides of a central section, where a lavishly decorated tabernacle was displayed on the lowest story. Above the tabernacle there usually was a large relief of the Assumption of the Virgin. Statues forming a tableau of the Crucifixion of Christ crowned the central attic story.[10]

The prominent display of heraldic devices of the Catholic Kings (Reyes Católicos) and Maximilian I

in *The Marriage at Cana*, *Christ among the Doctors*, and two other paintings in the group has led scholars to speculate that the Catholic Kings commissioned the retable to commemorate the marriage of their younger daughter, Juana of Castile, to Philip the Fair, Maximilian's son (September 1496), and that of their son, Juan of Castile, to Margaret of Austria, Maximilian's daughter (April 1497).[11] This theory has won general acceptance among scholars because it provides a convincing explanation for the heraldry. If the altarpieces were indeed commissioned in honor of these marriages, they probably postdate the ratification on 29 April 1495 of the treatises finalizing plans for the weddings.[12]

In *The Marriage at Cana*, the escutcheons of Maximilian I and the Catholic Kings are shown hanging from rafters. Three of the shields refer to Maximilian's territories: on the far left, the arms of the Duchy of Brabant (sable, a lion rampant or); second from the right, the arms of the Holy Roman Empire (gules, a double-headed eagle sable); and on the far right, the arms of Flanders (or, a lion sable). On the shield second from the right are shown the combined arms of Castile and Leon, the territories of the Catholic Kings (quarterly, 1 and 4: gules, a castle or; 2 and 3: argent, a lion rampant gules).[13]

The eight paintings assigned to the retable are closely related in style, distinguished by the convinc-

Fig. 1. Detail of infrared reflectogram of underdrawing of 1952.5.42

Master of the Catholic Kings, *The Marriage at Cana*, 1952.5.42

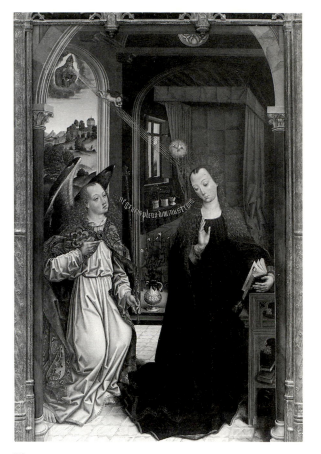

Fig. 2.

Fig. 3.

Fig. 2. Master of the Catholic Kings, *The Annunciation,* c. 1495/1497, oil on panel, The M. H. de Young Memorial Museum, San Francisco, 61.44.21

Fig. 3. Master of the Catholic Kings, *The Visitation,* c. 1495/1497, oil on panel, University of Arizona Museum of Art, Tucson, KR61,301

Fig. 4. Master of the Catholic Kings, *The Nativity,* c. 1495/1497, oil on panel, The M. H. de Young Memorial Museum, San Francisco, 61.44.22

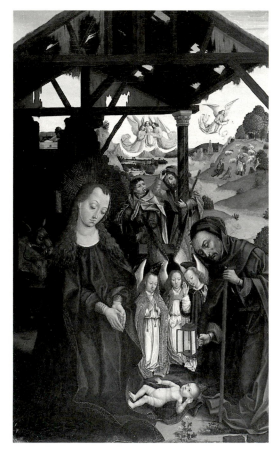

Fig. 4.

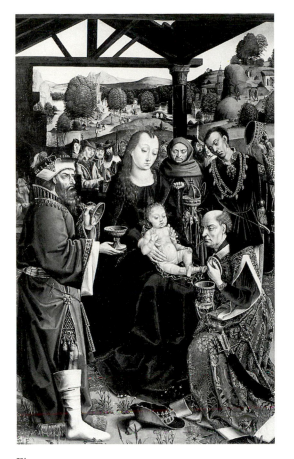

Fig. 5.

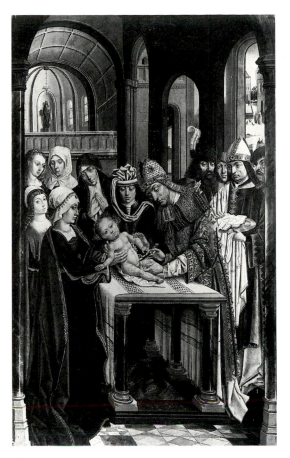

Fig. 6.

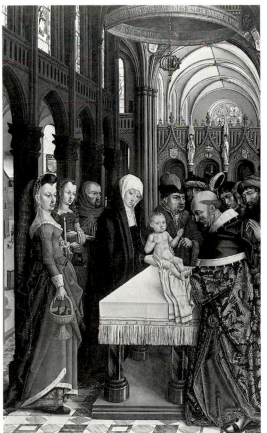

Fig. 7.

Fig. 5. Master of the Catholic Kings, *The Adoration of the Magi*, c. 1495/1497, oil on panel, Denver Art Museum, E-949

Fig. 6. Master of the Catholic Kings, *The Circumcision*, c. 1495/1497, oil on panel, private collection, England [photo: courtesy of French and Co., Inc., New York]

Fig. 7. Master of the Catholic Kings, *The Presentation in the Temple*, c. 1495/1497, oil on panel, Harvard University Art Museums, Cambridge, Massachusetts, 1933.29

ing rendering of space and the exquisite handling of details. These qualities attest to the influence of Netherlandish art. Commentators have noted specific borrowings from Rogier van der Weyden, Memling, and other northern artists.[14] The paintings of the Pacully Master are among the few other fifteenth-century Spanish works that show architectural settings as spacious and as lavishly decorated as those in the Gallery's two paintings and in *The Presentation in the Temple*.[15]

Although the panels reveal the influence of Netherlandish art, certain aspects of them attest to their Spanish origins. The powerful, somber expressions; the harsh peasant features of many of the male figures; the occasional awkwardness in the handling of anatomy; and the prevalence of rich, deep tones suggest that the paintings were created by an artist active in northern Castile.[16]

Despite the basic stylistic coherence of the paintings, there are enough differences among them to posit that more than one artist from the same workshop was involved in their production. Gudiol attempted to identify distinct contributions to the panels by separating the work of a major artist from that of his assistant. He proposed that a leading artist was solely responsible for *The Annunciation* and *The Nativity* and for the most important figures in *The Visitation*, *The Adoration of the Magi*, and *The Presentation in the Temple*. Gudiol further suggested that an assistant created the two paintings now in the National Gallery and the secondary figures in *The Visitation*, *The Adoration of the Magi*, and *The Presentation in the Temple*.[17] Gudiol's assumption that two artists executed the paintings makes sense.[18] However, the artist who created the two paintings in the National Gallery would also appear to be entirely responsible for *The Presentation in the Temple*.

The artist who painted *The Marriage at Cana*, *Christ among the Doctors*, and *The Presentation in the Temple* was unable to depict figures as skillfully as his colleague, who can be assumed to have been the head of the workshop. The figures in these three paintings are notably thinner than the fully rounded figures of *The Annunciation* and *The Nativity*, and they tend to be stiffly posed. Angular, bony faces are a hallmark of the artist responsible for the Gallery's paintings and *The Presentation in the Temple*. In modeling the faces, the artist depended heavily on line and avoided subtleties of light and shade. The treatment of the face of the Virgin typifies his approach. In the paintings now in Washington and Cambridge, the Virgin has a thin, angular face with strongly marked cheekbones, a sharply pointed nose, and a protruding chin.

She is shown wearing a white headdress with sharp folds that complement the treatment of her face. In contrast, the Virgin in *The Annunciation*, *The Visitation*, and *The Adoration of the Magi* has a full face with large, softly modeled cheeks and long, gently waved hair.

The skillful depiction of large, lavishly decorated interiors is the most impressive feature of *The Marriage at Cana*, *Christ among the Doctors*, and *The Presentation in the Temple*. The deep space is emphasized by placing the foreground figures farther back than is the case in any of the other paintings of the series. The artist used subtle shifts in the distribution of light and shade to enhance his masterful construction of space. The three paintings all include a view, through an opening, of a street with distinctly northern buildings. The architecture and furnishings of the interiors combine late Gothic and early Renaissance elements. For example, in *The Marriage at Cana*, the table and bed are distinctly Gothic and the fireplace, arches, and central column are typical of the early Renaissance style.

The Circumcision, which Gudiol did not mention, differs from all the other paintings assigned to the retable, and it seems likely that it is by a third artist. Its figures combine the stiffness of the adult figures in *Christ among the Doctors* with the fullness of the figures in *The Nativity*. The space is shallower than in any of the other scenes, and the austere, undecorated architecture contrasts with the ornate setting of *The Presentation in the Temple*, for example. In consideration of these differences, it even seems possible that *The Circumcision* originally formed part of another retable.

Christ's transformation of water into wine at the marriage at Cana (John 2: 1–12) was the first miracle of his public career, and it was frequently interpreted as a premonition of the Eucharist.[19] In accord with traditional iconography, the artist has here shown Christ in the act of blessing six pitchers of water and a servant simultaneously pointing to them in recognition of the miracle. The statue of Moses directly above Christ was probably included because the miracle of water pouring out of the rock struck by Moses (Exodus 17: 1–7) was likened to Christ's transformation of water into wine at Cana; the staff held by the figure underlines the parallel. The representation of the marriage feast in the large banqueting hall of an upper-class residence, with a view into the kitchen where additional figures can be seen celebrating, recalls earlier northern paintings of the subject, such as that by the North German artist Henrik Funhof (private collection, Germany).[20]

thin, brown imprimatura is thought to cover the ground beneath the paint layer; the tonality of the imprimatura was used as a base for the faces of the doctors, but elsewhere is covered over with thick opaque paint. Oil paint was applied in a variety of techniques, ranging from carefully built-up opaque layers with some slightly raised brush texture to thin, translucent glazes. The painting is in stable condition, although the panel is penetrated by cracks and checks. X-radiographs indicate scattered losses of paint.

Provenance: same as 1952.5.42.

Exhibitions: *Exhibition of Spanish Painting*, The Brooklyn Museum, 1935, no. 7. *Spanish Paintings*, Philadelphia Museum of Art, 1937, no cat. *Paintings and Sculpture from the Samuel H. Kress Collection*, National Gallery of Art, Washington, 1951, 178, no. 78.

LIKE *The Marriage at Cana* (1952.5.42), *Christ among the Doctors* probably formed part of a retable that included six other paintings now in American and English collections. The prominent display of heraldic devices of the Catholic Kings (*Reyes Católicos*) and Maximilian I in *Christ among the Doctors*, *The Marriage at Cana*, and two other paintings of this group supports the theory that the Catholic Kings commissioned the paintings to commemorate the double marriage of their children to those of Maximilian I.[3]

Here, escutcheons decorate the large stained-glass windows directly above Christ. In the center is the coat of arms of Castile and Leon, the combined territories of the Catholic Kings (quarterly, 1 and 4: a castle or; 2 and 3: a lion rampant gules). Enframing the shield are the arms of two of Maximilian's territories: on the left, the double-headed eagle sable of the Holy Roman Empire, and on the right, the lion rampant of Flanders.[4] Partly visible in the window at the far left is the heraldic support of the arms of Castile (a lion rampant or).[5]

Christ among the Doctors represents the dispute of the twelve-year-old Christ with the doctors (Luke 2: 41–52), the last incident of his childhood recorded in the Bible.[6] Christ is shown seated on a throne beneath a baldachin in the center of the painting. Mary and Joseph, who looked for the missing child for three days, are shown entering at the right. Like the doctor in the right foreground, Christ touches his extended forefingers together in a gesture that was probably meant to signify the enumeration of arguments.[7] The arrangement of the doctors in two groups of unequal size, the doctors' harsh expressions and ugly features, and the vaguely Oriental costumes worn by several of them correspond with the treatment of this subject by Fernando Gallego and other fifteenth-century Spanish artists.

The representation of the temple of Jerusalem as the apse of a church, with Romanesque architecture below and Gothic architecture above, follows a convention of northern painting.[8] On four of the capitals are statues of Old Testament figures. The ruler and the priest on the left are probably David and Melchisedek.[9] The figure with a purse is probably Joseph, whose ability to interpret dreams was likened to Christ's mastery of theological arguments;[10] the purse is an appropriate attribute for Joseph because his policy of storing grain during years of plenty enabled Egypt to survive the famine.[11] The long mantle and pointed hood identify the figure on the far right as a prophet.[12]

R.G.M.

Notes

1. The letters are difficult to decipher because they have been damaged and the blue pigment of Mary's mantle, which probably has darkened, has obscured them. The letters, studied by Paula De Cristofaro of the NGA conservation department with the aid of infrared reflectography, appear to be the following: *ENIHS*O IO*EEPRS I*MO [?]S*SIE*E OE O*EI*

2. The woods used for the original support and additions were analyzed by Michael Palmer, NGA scientific department.

3. See the discussion at 1952.5.42.

4. Henry Gough and James Parker, *A Glossary of Heraldry* (Oxford, 1894), 88; A. C. Fox-Davies, *A Complete Guide to Heraldry*, ed. J. R. Brooke-Little and C. A. Franklyn (London, 1985), 178, 403.

5. Eisler 1977, 181, no. K1681. On the possible significance of the white cross saltire repeated on the floor tiles, see note 13 of the entry for 1952.5.42.

6. Louis Réau, *Iconographie de l'art chrétien*, 3 vols. (Paris, 1955–1959), vol. 2, part 2, 290–292, reviews the meaning and the iconography of the scene.

7. The significance of gestures of this type is discussed by O. Chomentovskaja, "Le comput digital: histoire d'un geste dans l'art de la Renaissance italienne," *GBA* 20 (1938), 157–172. Chomentovskaja considers the gesture to be distinct to Italian art, but it also occurs in earlier Spanish paintings of Christ among the doctors, such as those by Fernando Gallego (part of the Ciudad Rodrigo retable, now in the University of Arizona Museum of Art, Tucson; Eisler 1977, fig. 155), the Master of the Encarnación (Prado, Madrid), and the Master of Astorga (part of the Cisneros retable, in San Facundo, Cisneros). Reproductions of the latter two works are available in the photographic archives of The Frick Art Reference Library, New York.

8. Eisler 1977, 181, no. K1681. The convention is analyzed by Erwin Panofsky, *Early Netherlandish Painting*, 2 vols. (Cambridge, Mass., 1953), 1: 134–140.

9. Eisler 1977, 181, no. K1681.

10. Réau 1955–1959, vol. 2, part 2, 290.

11. Joseph is represented with a purse in Hans Holbein's

don, no. 2613; Centre National de Recherches "Primitifs Flamands" [Belgium], *Corpus de la peinture des anciens pays-bas méridionaux au quinzième siècle*, 13 vols. [Antwerp and Brussels, 1951–1973], 3: pl. 20). Conrad Meit depicted her in a bronze bust (Kunsthistorisches Museum, Vienna; Jane de Iongh, *Margaret of Austria* [New York, 1957], repro. opp. 209). Portraits of Juana include paintings by Juan de Flandes (Kunsthistorisches Museum, Vienna; Hulst 1958, repro. opp. 29) and by the Master of the Legend of Saint Mary Magdalen (Wilkinson collection, Paris; Hulst 1958, repro. opp. 131), and the effigy by Bartolomé Ordoñez on her tomb in the Capilla Real, Cathedral, Granada (Francisco Javier Sánchez Cantón and José Pita Andrade, *Los retratos de los reyes de España* [Barcelona, 1948], no. 94).

28. Representations of Philip the Fair include paintings by the Master of the Abbey of Afflingen (Kunsthistorisches Museum, Vienna; Hulst 1958, repro. opp. 28); and by the Master of Saint Giles. (Reinhart collection, Switzerland). The Master of the Legend of Saint Mary Magdalen and his workshop executed several versions of a portrait of Philip (Rijksmuseum, Amsterdam; Upton House, Banbury; Ramón Serrano Suñez collection, Madrid; and Kunsthistorisches Museum, Vienna; for the version in Madrid, see Hulst 1958, repro. opp. 12). Philip was shown with his wife in Colin de Coter's *Christ and Saints with Philip the Fair and Juana of Castile* (Louvre). Prince Juan was seldom shown in portraits. This may be because he was largely secluded from public view due to his physical weakness and mental retardation. (See Fernández Armesto 1975, 59–60.) I have been able to identify only two representations of him: a portrait at the age of approximately twelve years in an altarpiece by the Master of Santa Cruz, showing the Catholic Kings and their children adoring the Virgin and Child (Prado, Madrid), and the effigy by Domenico Alessandro Fiorentino on his tomb in Santo Tomás, Avila.

29. Anderson 1979, 16.

30. This is also noted in exh. cat. Washington 1951, 180, no. 79.

31. Pierre d'Avity, *The Estates, Empires, and Principalities of the World*, trans. Edmund Grimstone (London, 1615), 318–319; Order of the Golden Fleece, *Liste nominale des chevaliers de l'ordre illustre de la toison d'or depuis la fondation de l'ordre jusqu'à nos jours* (Vienna, 1886), not paginated.

32. José Aesencio y Torres, *Tratado de heráldica y blasón* (Madrid, 1939), 153. On the collar and other devices of the order, see Costa 1856, 217; Iñigo 1863, 2: 201–202; Hummel 1943, 21; Garma 1967, 155–169.

33. Valentin Carderera y Solano, *Iconografía española*, 2 vols. (Madrid, 1855–1864), 2: 60.

34. Fernández Armesto 1975, 122.

References

1922. Mayer (see Biography): 145, fig. 113 (also Spanish ed. 1942: 166, fig. 135).

1930–1966. Post (see Biography), vol. 4, part 2: 418–419, fig. 164.

1934–1935. Mayer, August L. "Pinturas castellanas procedentes de la colección Rojo y Sojo." *Revista española de arte* 12: 205, 110.

1935. Philipps, Gerry. "Spanish Painting at Brooklyn." *MagArt* 28: 675, repro.

1937. Clifford, Henry. "Great Spanish Painters: A Timely Show." *ArtN* 25 (17 April): 9, repro. 8.

1939. Mayer (see Biography): 281.

1941. Frothingham, Alice W. *Hispanic Glass*. New York: 29, fig. 20.

1952. Brans, J. V. L. *Isabel la católica y el arte hispano-flamenco*. Madrid: 130–132.

1955. Gudiol y Ricart, José. *Pintura gótica*. Ars Hispaniae 9. Madrid: 355, fig. 311.

1956. King, Marian. *Portrait of Jesus: Paintings and Engravings from the National Gallery*. Philadelphia: 28, repro. 29.

1958. Gaya Nuño, *La pintura española*: 274, no. 2246.

1959. Kress: 262, no. 1121.

1966. Gudiol (see Biography): 214–215.

1968. Cuttler, Charles D. *Northern Painting from Pucelle to Brueghel*. New York: 254, fig. 317.

1977. Eisler: 177–178, 181–182, no. K1680, fig. 183.

1979. Anderson, Ruth Mathilda. *Hispanic Costume: 1480–1530*. New York: 35, 49, 83, 109, 169, 189, figs. 26, 84, 205, 269, color pl. 11.

1981. O'Meara, Cárra Fergusson. "In the Hearth of the Virginal Womb: The Iconography of the Holocaust in Late Medieval Art." *AB* 63: 86, n. 58.

1952.5.43 (1122)

Christ among the Doctors

c. 1495/1497
Oil on panel
 original painted surface 136.2 x 93 (53⅝ x 36⅝)
 with addition at bottom 155.2 x 93 (61⅛ x 36⅝)
Samuel H. Kress Collection

Inscriptions:
Letters in relief on Virgin Mary's mantle.[1]

Technical Notes: The original support is composed of three vertically oriented pieces of pine. An addition approximately 19 cm tall, consisting of several pieces of pine with vertical grain, is attached to the bottom of the original support.[2] The irregular line of damage along the lower edge of the original support suggests that the addition may have replaced a destroyed part of the original composition. A modern cradle is attached to the composite panel. The original support is covered by a thick white ground probably composed of two layers. There appears to be a thicker, lower layer with fibrous inclusions (grass?) and a second, thinner ground layer without fibers above. The ground on the added pieces has a markedly different composition from the ground on the original support. The composition was underdrawn on the original support in a black liquid, probably applied with a brush. Broad parallel and cross-hatched strokes define the figures and primary details of the setting in the underdrawing. A downward shift in the eyes, lips, and nose of the Christ Child is the only major change between the underdrawing and the painting. The main lines of the architecture were incised in the ground layer. A

dispersed panels belonged to the retable, but he only mentioned by name *The Purification* [*The Presentation in the Temple*], *Christ among the Doctors*, and *The Marriage at Cana*.

9. They vary in height from 153 to 157.5 cm and in width from 92 to 96.5 cm. Such small variations in size were common in Spanish retables.

10. On the form and iconography of Spanish retables, see Juan José Martín González, "Tipología e iconografía del retablo español," *Boletín del seminario de estudios de arte y arquelogía* (Valladolid), 30 (1964): 5–60.

11. Albert van der Put, typescript, c. 1922, in NGA curatorial files; Post 1930–1966 (see Biography), 420–422; Brans 1952, 130; Gudiol 1955, 360–362; Eisler 1977, 177–179, 181–182, nos. K1860, K1681, K1680. See the entry for *Christ among the Doctors* (1952.4.43) for the devices in that painting. For the devices in *The Presentation in the Temple*, see Post 1930–1966, 420; for those in *The Visitation*, see Eisler 1977, 179, no. K1860.

12. Henri d'Hulst, *Le marriage de Philippe le Beau avec Jeanne de Castille*, 2d ed. (Brussels, 1958), 9–29, reviews the treaties and ceremonies involved in the marriages. On the political significance of the marriages, see also Felipe Fernández Armesto, *Ferdinand and Isabella* (New York, 1975), 119–125.

13. Henry Gough and James Parker, *A Glossary of Heraldry* (Oxford, 1894), 88, 498; A. C. Fox-Davies, *A Complete Guide to Heraldry*, ed. J. R. Brooke-Little and C. A. Franklyn (London, 1985), 178, 403. Eisler 1977, 182, no. 1680, n. 3, points out that the cross saltire in the stained glass window in the background and on the banner suspended from the central trumpet is a device of Burgundy. Compare Servicio Historico Militar de España, *Tratado de heráldica militar*, 2 vols. (Madrid, 1949–1951), 2: 197. Eisler further suggests that the four white marks on each of the gray banners suspended from the central trumpet are "references" to the Order of the Golden Fleece. However, they do not clearly correspond to any of the devices of the order and, in fact, appear to be simply daubs of paint. On the devices of the order, see Modesto Costo y Turell, *Tratado completa de la ciencia del blasón* (Barcelona, 1856), 217; M. de Iñigo y Miera, *Historia de las ordenes de la caballería*, 2 vols. (Madrid, 1863), 2: 201–202; Luc Hummel, *Histoire du noble ordre de la toison d'or* (Brussels, 1943), 21; Francisco Xavier de Garma y Durán, *Arte heráldica* (Barcelona, 1967), 155–169. Marcus Burke, in written comments on an earlier version of this entry (1988), suggests that the white cross saltire in the stained glass window was intended to recall the blades of a windmill and to serve as the device of a Netherlandish artist with a name related to the Dutch word for mill (*molen*), such as Molenaar. Burke assigns the same significance to the white cross saltire repeated on the floor tiles of *Christ among the Doctors* (1952.5.43). He also proposes that the large "M" inscribed on a building in *The Visitation* (fig. 3) could indicate that the artist's name began with that letter. Robert Quinn, *The Samuel H. Kress Collection at the University of Arizona* (Tuscon, 1957), interprets the "M" as a reference to Maximilian I and maintains that Juana of Castile, who married Maximilian's son, is represented by the woman in the middle ground who looks up at the letter.

14. Eisler 1977, 177–182, nos. K1860–K1863, K1680–K1681, with bibliography.

15. On the Pacully Master, see Post 1943 (see Biography), 321–328. Post suggests that the Pacully Master may have been the teacher of the Master of the Catholic Kings.

16. These qualities can be noted, for example, in paintings by the important fifteenth-century Palencian artist Fernando Gallego, in his *Adoration of the Magi* (Toledo [Ohio] Museum of Art; *The Toledo Museum of Art: European Paintings* [Toledo, 1976], fig. 49). Post 1930–1966 (see Biography), 423–427, cites parallels with work of the schools of Burgos and Valladolid. See also Gudiol 1966 (see Biography), 209–217.

17. Gudiol 1966 (see Biography), 214–215. Gudiol's identification of the major artist as Diego de la Cruz, which I do not accept, is discussed in the biography of the Master.

18. Robert Quinn, who read part of Gudiol's article before its publication, endorsed the division of the paintings, in a typewritten report, 14 June 1963, in the NGA curatorial files. Eisler 1977, 178, recorded Gudiol's theory but did not indicate whether or not he agreed with it. Post 1930–1966 (see Biography), 422–423, stated that some authorities, whom he did not name, held that one artist had executed *The Annunciation*, *The Visitation*, *The Nativity*, and *The Adoration of the Magi*, and that a second artist painted the other four panels. Post, however, maintained that a single artist was responsible for all the paintings.

19. Louis Réau, *Iconographie de l'art chrétien*, 3 vols. (Paris, 1955–1959), vol. 2, part 2, 362–367, reviews the iconography and meaning of the scene. O'Meara 1981, 86, n. 58, proposes that the fireplace in the kitchen in the background of the Gallery's painting was intended to emphasize the Eucharistic meaning of the event. She argues that a fireplace in late medieval representations of scenes of Christ's life often symbolized the altar of the ancient Hebrew temple, which theologians likened to Christian altars on which Mass was offered. It seems possible, however, that the fireplace in the background of the Gallery's painting was intended simply to enhance the domestic character of the setting.

20. Eisler 1977, 182, no. K1860, argues that the Gallery's painting so closely resembles Funhof's that one can suppose that the Master studied with him. The representation of the feast in an extensive hall with musicians on a balcony and other figures in a distant kitchen accords with Funhof's painting. But the details of Funhof's setting and the articulation and compositional arrangement of his figures differ from the Master's. Moreover, Funhof's cheerily smiling countenances create a very different mood from the Master's somber faces. For a reproduction of Funhof's painting, see *Kindlers Malerei Lexikon*, 7 vols. (Zurich, 1965), 2: 505.

21. Anderson 1979, 179.

22. Anderson 1979, 109.

23. Anderson 1979, 49.

24. Frothingham 1941, 21.

25. Réau 1955–1959, vol. 2, part 2, 365.

26. Post 1930–1966 (see Biography), 420–424; exh. cat. Washington 1951, 180, no. 79.

27. Portraits of Margaret of Austria include paintings by Juan de Flandes (Kunsthistorisches Museum, Vienna; Hulst 1958, repro. opp. 29); Bernard van Orley (Wilkinson collection, Paris; Hulst 1958, repro. opp. 20); Master of the Legend of Saint Mary Magdalen (Louvre); and an anonymous fifteenth-century Flemish artist (National Gallery, Lon-

The costumes and serving vessels accurately illustrate Spanish taste of the last two decades of the fifteenth century. The bride wears a brocade gown over a chemise with pseudo-Arabic inscriptions embroidered on the neckband; Moorish influence can often be noted in such details of ladies' chemises.[21] Before 1500 the collars of men's cloaks usually lay flat, as does the groom's.[22] The two slashes decorating the tight sleeves of the jerkin of the attendant on the left accord with a popular fashion.[23] The servant on the right offers the bridal couple a clear glass goblet of a type manufactured in the fifteenth century in Cadalso de Vidrio and elsewhere in Castile but not produced in other regions of Spain.[24]

Prominent individuals were frequently portrayed as the bride and groom in paintings of the marriage at Cana.[25] Because of the probable patronage of the Catholic Kings, it is not surprising that commentators have described the bride and groom as one of the couples in the marriages of the children of the Catholic Kings and Maximilian.[26] The bride could reasonably be described as an idealized portrait of either Juana of Castile or Margaret of Austria. Portraits indicate that these two princesses closely resembled one another.[27]

The identification of the groom is also problematic. Like the princesses, Juan and Philip seem to have looked rather like one another,[28] both having high cheekbones, aquiline noses, and pouting lower lips. The red mantle worn by the groom is a garment that late fifteenth-century Spaniards regarded as characteristic of Philip and that they wore in tribute to him.[29] The costume might seem to establish the identity of the groom as Philip, but he is shown without the collar of the Order of the Golden Fleece, which Philip wears in all known portraits.[30] Philip was made a member of the order in 1482, and he headed it from 1484 until his death in 1506.[31] Members of the order were obligated to wear the collar of the order at all religious ceremonies and public events.[32] Certainly, this rule would have applied at a royal wedding.

The lack of a collar provides the most convincing evidence that the groom represents Juan rather than Philip. Also supporting this identification is the color of the groom's hair. Like the groom, Juan had light brown, almost blond hair,[33] whereas Philip had dark hair. If Prince Juan is indeed represented, the painting was probably executed before his death on 7 October 1497, less than six months after his wedding; Juan's marriage apparently exhausted his weak health.[34] Philip probably would not have been represented until after Juan's death, because Spaniards would have considered Juan, the heir to the Spanish throne, to be the more important prince.

R.G.M.

Notes

1. Biblical verses are identified by Eisler 1977, 181, no. K1680. The upper border of the towel is inscribed SA * RN * VMT; the lower border, AEN * D * VI. The lettering on the border of Mary's robe is difficult to read because it is small in scale and covered with blue of the same shade as the rest of her garment, which has probably darkened. It can be perceived only because it is raised in relief; read with the assistance of infrared reflectography, the letters appear to be OVOSONRVM.

2. The woods of the original support and the added pieces were analyzed by Michael Palmer, NGA scientific department.

3. The probable partronage of the Catholic Kings has led Van der Put and subsequent commentators to posit that the altarpiece was commissioned for a church or convent in Valladolid. Albert van der Put, typescript, c. 1922, in NGA curatorial files; Post 1930–1966 (see Biography), 418–420; Brans 1952, 130; Gudiol 1955, 360–362; Cuttler 1968, 254; Eisler 1977, 177–178. On the probable patronage of the Catholic Kings, see the discussion that follows. *The Marriage of Cana, Christ among the Doctors* (1952.5.43), and the six related panels have qualities characteristic of Spanish painting in northern Castile during the reign of the Catholic Kings. Among cities in the region, Valladolid was the one most favored by the monarchs, who occasionally held court there. The theory that the panels were intended for an institution in Valladolid is plausible, but it cannot be regarded as certain. Even if the paintings were created in northern Castile, they could have been commissioned for an institution in another part of Spain.

4. This painting is shown hanging on a wall of the Madrid residence of the conde de las Almenas in a photograph in Arthur Byne and Mildred Shapley, *Spanish Interiors and Furniture*, 2 vols. (New York, 1922), 2: pl. 109.

5. Frank Partridge, memorandum, 1924, in the files of The Frick Art Reference Library, New York.

6. Post 1930–1966 (see Biography), 418. It is uncertain whether Satterwhite purchased the painting from Partridge or from another source.

7. Exh. cat. Washington 1951, 180, no. 79. According to Eisler 1977, 178, and the NGA provenance card, French & Co., New York, purchased the painting from Satterwhite and sold it to the Kress Foundation. However, Martha Hepworth, Getty Provenance Index, letter, 26 August 1988, in NGA curatorial files, states that the panel does not appear in the French & Co. stockbooks, which are now at the Getty. Robert Samuels, Jr., of French & Co., in telephone conversations, 27 September 1988 and 18 January 1989, with Susan Davis of the NGA department of curatorial records, stated that the files of French & Co. still in New York revealed no mention of this painting. I would like to thank Susan Davis for her assistance with this aspect of the painting's provenance.

8. Post 1930–1966 (see Biography), 418–428; Brans 1952, 130–132; Gudiol 1966 (see Biography), 214–215; Cuttler 1968, 254; Eisler 1977, 177–182, nos. K1860–K1863, K1680–K1681. Mayer 1922 (see Biography), 145, stated that several

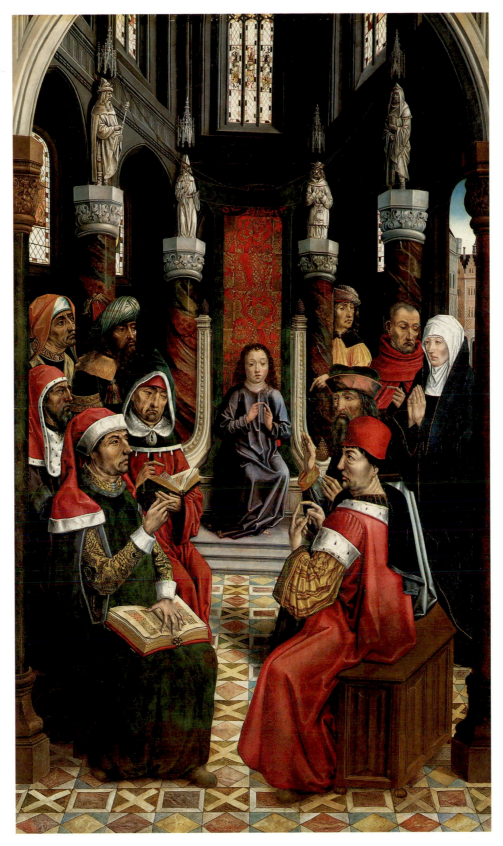

Master of the Catholic Kings, *Christ among the Doctors*, 1952.5.43

woodcut of Jacob blessing the sons of Joseph (before 1520).

12. Réau 1955–1959, vol. 2, part 1, 345.

References

1922. Mayer (see Biography): 145 (also Spanish ed. 1942: 166).

1930–1966. Post (see Biography). Vol. 4, part 2: 418–428.

1937 Clifford, Henry. "Great Spanish Painters: A Timely Show." *ArtN* 35 (17 April): 9.

1952. Brans, J. V. L. *Isabel la católica y el arte hispano-flamenco*. Madrid: 130–132.

1958. Gaya Nuño, *La pintura española*: 274, no. 2274.

1966. Gudiol (see Biography): 214–215.

1968. Cuttler, Charles D. *Northern Painting from Pucelle to Brueghel*. New York: 254.

1977. Eisler: 177–178, 181, no. 1681, fig. 182.

Bartolomé Esteban Murillo

1617 — 1682

MURILLO'S career is tied to Seville, the city where he lived and died. He was left an orphan at the age of ten and raised by his older sister and her husband. His early training seems to have occurred in the workshop of Juan del Castillo, a distant relation and well-established local painter.

In 1645, Murillo received his first known commission from one of the many local religious institutions of Seville, which were to be the mainstay of his career. This was for a series of paintings for a cloister in the monastery of San Francisco el Grande. During the 1650s Murillo's fame increased rapidly, and he was employed to make paintings for the Seville Cathedral, which established his preeminent position among the local painters. The *Vision of Saint Anthony of Padua*, painted for the cathedral baptistery in 1656, shows the influence of Francisco de Herrera the Younger, a painter from Seville who returned to that city from Madrid in 1655 and introduced an energetic baroque style which transformed the local school of painting. In 1658, Murillo made a trip to Madrid, which completed the evolution of his style to its characteristic sfumato manner.

In the succeeding decade, the artist received one important commission after another: the church of Santa Maria la Blanca (1665), the Capuchins (1665–1669), and the Brotherhood of Charity (1666–1672) all gave him large cycles of paintings to execute. In addition, he received numerous commissions from individuals, some of whom formed sizable collections of his work.

In the 1670s, Murillo found patrons in Cadiz, which was rising in importance as a center of commerce and trade. He was working on a series of paintings for the Capuchins of Cadiz when he died.

Murillo's fame rests on his work as a devotional painter, in which he had few peers in the seventeenth century. His paintings of themes such as the Virgin of the Immaculate Conception set the standard by which all other versions were judged. However, his seemingly effortless style of painting, which reduces the barriers between the sacred subjects and the viewer, is surprisingly sophisticated. He was a tireless draftsman, who carefully planned his compositions to achieve maximum effect, and a diligent student of paintings by Italian and Flemish artists, whose works he skillfully synthesized for his own purposes. A significant part of his clientele was comprised of Dutch and Flemish merchants in Seville, for whom he painted a small but highly original group of genre scenes.

J.B.

Bibliography

Angulo Iñiguez, Diego. *Murillo: Su vida, su arte, su obra*. 3 vols. Madrid, 1981.

Bartolomé Esteban Murillo, 1617–1682. Exh. cat., Prado, Madrid; Royal Academy of Arts. London, 1982.

Brown, Jonathan. *Murillo and His Drawings*. Exh. cat., The Art Museum, Princeton University. Princeton, 1986.

1942.9.46 (642)

Two Women at a Window

c. 1655/1660
Oil on canvas, 125.1 x 104.5 (49¼ x 41⅛)
Widener Collection

Technical Notes: The support is a moderately fine, single-thread, plain-weave fabric. The original tacking margin is gone and the top and sides are slightly out of square. The window ledge is painted on a separate piece of fabric, 9 cm high, of a different fabrication from the rest of the picture. Removal of the overpaint on the added piece revealed a paint layer unrelated to the technique of the rest of the picture. A line of loss, with a thin piece of fabric inserted in the right half, suggests that the top 8 cm of the painting with original ground and paint was once folded.

The paint is generally applied over a chalk ground as an opaque paste with low impasto and broad brush marking. Pentimenti on the proper left sleeve of the standing woman and on the shoulders of the dress of the young girl show the artist working out the design of the folds. There are numerous discrete losses scattered throughout, particularly along the left, top, and right edges, throughout the back-

ground, across the faces of the two women, and in the hands and proper right arm of the young girl. The painting was cleaned, stabilized, and revarnished between 1979 and 1982.

Provenance: Duque de Almodóvar del Río, Madrid;[1] his heirs; William A'Court, later 1st Baron Heytesbury [1779–1860], Heytesbury, Wiltshire, 1823;[2] his eldest son, William Henry Ashe, 2d Baron Heytesbury [1809–1891]; his grandson, William Frederick, 3d Baron Heytesbury [1862–1903]; (Stephen T. Gooden, London, 1894);[3] purchased 3 December 1894 by P. A. B. Widener, Elkins Park, Pennsylvania;[4] inheritance from the Estate of Peter A. B. Widener by gift through power of appointment of Joseph E. Widener, Elkins Park.[5]

Exhibitions: British Institution, London, 1828, no. 2. British Institution, London, 1864, no. 56. Royal Academy of Arts, London, 1887, no. 114. *Spanish Painting*, The Toledo (Ohio) Museum of Art, 1941, 118, no. 77.

Two Women at a Window is one of a small number of genre paintings by the artist. This group is exceptional in the history of Spanish art of the seventeenth century, when genre paintings were rarely executed. It has recently been suggested that some of these pictures were painted for Flemish and Dutch merchants resident in Seville, who had become familiar with genre painting in their native lands.[6] There is as yet little documentary evidence to corroborate this hypothesis. However, according to an inventory of 1690, the Flemish merchant Nicholas Omazur owned a picture that may be a copy of this work, although the description does not correspond completely to the composition.[7]

The compositional format of figures at a window is often found in Dutch painting of the period, while it is virtually nonexistent in the work of Spanish painters. Accordingly, it has been suggested that Murillo knew Northern models.[8] The hypothesis is strengthened by the artist's apparent use of other compositional types derived from Dutch and Flemish sources as the basis for certain of his genre scenes, and occasionally for portraits.[9]

The significance, if any, of the composition is uncertain. An engraved copy by Joaquín Ballester (1740–1808), made while the picture was owned by the duque de Almodóvar del Río, bears the title *Las Gallegas* (the Galician women). In the late eighteenth century, women from the province of Galicia were sometimes reputed to be prostitutes, which implies that the painting was then understood to represent an amorous solicitation.[10] This interpretation was retained by Baron Heytesbury, who exhibited the pic-

ture in 1828 under the title "Spanish Courtesan." Angulo has noted that in Spanish *refranes* or adages of the seventeenth century, the image of a woman at a window often was used to denote sexual license.[11] Sánchez Cantón has identified the picture as the source for Goya's *Maja and Celestina on a Balcony* (Bartolomé March collection, Madrid), where the amorous significance is unmistakable.[12]

Nevertheless, as Angulo observes, Murillo's painting differs from Goya's in the absence of the hag, or *celestina,* as the type is called in Spain after the famous story of a procuress.[13] Both women in the painting are young. Thus, it is possible that the picture is either an exercise in illusionism without ulterior meaning or a representation of an innocent flirtation. The smiling faces and the low-cut bodice of the central figure suggest that an amorous overture, be it innocent or illicit, is represented. In the absence of specific attributes such as invariably occur in Dutch paintings, the question has to be left unresolved.

The work has often been dated to between 1665 and 1675, but Angulo's proposal to date it just before 1660 is more consistent with the style.[14] In particular, the firm outlines of the figures, the controlled brush stroke, and the absence of sfumato effects are closer to the earlier period. Comparison of the picture to genre paintings of the later period such as *Pastry Eaters* or *Boys Playing Dice* (both Alte Pinakothek, Munich) confirms the proposal for a date in the later 1650s.[15] As Angulo noted[16] and technical examination has confirmed, the window ledge is not original and was added at a later date. If the print by Ballester records the appearance before the bottom edge was cut down, then the ledge was drawn in perspective. However, it was not unusual for reproductive engravers to make small compositional changes to correct what they perceived as defects in the originals. Angulo also questions whether the right-hand frame of the window, which is omitted from the print, is a later addition, but the canvas is completely intact in this area. By the time Ballester made the engraving, the top edge had been folded over.

Several copies are known. As already noted, Kinkead suggests that a painting owned by Matías Arteaga in 1680 and 1703 (unidentified) was an early copy. Although the vertical dimensions are approximately identical ("vara y medio de alto," or about 135.4 centimeters high), the entry mentions only a single female figure in the composition. The copy in the collection of Omazur has also been mentioned. Another version, measuring approximately 85 by 85 centimeters and listed in the 1814 inventory of the Palacio Real, Madrid, has not been traced.[17] Other

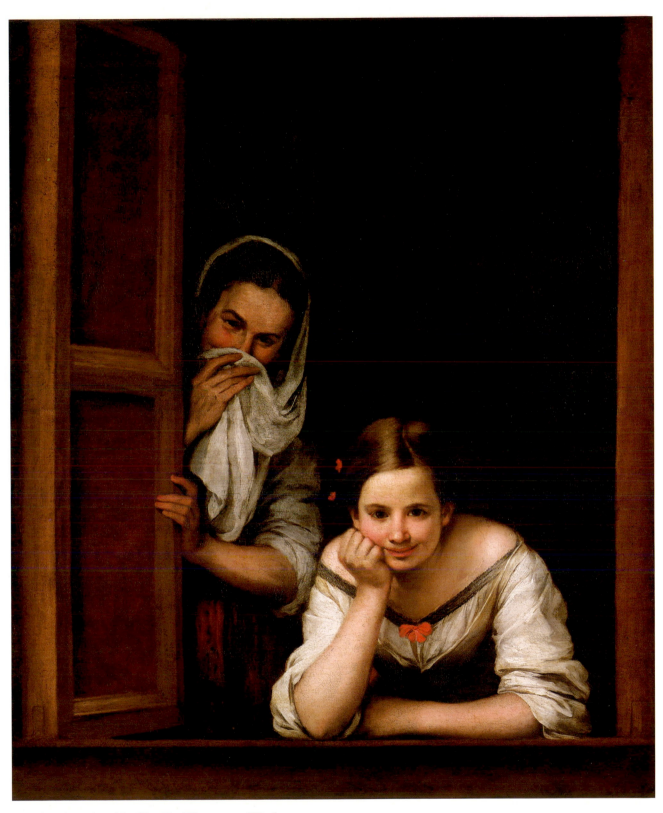

Bartolomé Esteban Murillo, *Two Women at a Window*, 1942.9.46

copies include one owned by H. A. J. Munro, measuring 48 by 40 inches, which was engraved by John Bromley;[18] another sold in the Soult sale in 1852 and, as of 1977, in the possession of Mme Cachera, Paris;[19] and a third that appeared on the art market in Madrid in 1967.[20]

<div align="right">J.B.</div>

Notes

1. For this provenance see Stirling-Maxwell 1848, 2: 920, n. 2, who presumably had the information from Baron Heytesbury (d. 30 May 1860). Heytesbury was ambassador extraordinary in Madrid from 1822 to 1823. Pedro Francisco Luján y Góngora, duque de Almodóvar del Río (1728–1794), was a Spanish diplomat and man of letters. The ownership is established by the inscription on an undated print after the painting by Joaquín Ballester, which employs the present tense: "Quadro original de Bartolomé Murillo que posee el Excmo. Sr. Duque de Almodóvar;" Angulo 1972, fig. 2. Waagen 1857, 389, mistakenly gives the provenance as the family of the count of Altamira. Kinkead 1981, 353, posits that the picture is identical to one in the 1703 inventory of the Sevillian painter Matías Arteaga. However, the entry does not give the name of the artist and mentions only one woman–"Un lienzo de vara y medio de alto de una mujer asomada a ventana" (A canvas a *vara* and a half high of a woman looking out of a window). In a letter to the author (7 September 1986), Professor Kinkead states that the same picture is mentioned in Arteaga's *capital* (possessions of husband at marriage) of 1680, where the estimated value, in his opinion, "is simply too low for it to have been an original by Murillo."

2. *Burke's Peerage* (London, 1967), 1247–1248.

3. Gooden's name is found in the manuscript copy of the Widener catalogue; see note 4.

4. Records of Edith Standen (Widener's curator), in NGA curatorial files.

5. Widener 1923, not paginated.

6. Jonathan Brown, "Murillo y los mercaderes," paper presented at symposium, *El barroco andaluz y su proyección hispanoamericana*, Córdoba, 9–16 November 1986; where evidence is cited that Murillo's genre paintings were in Flemish and Dutch collections at an early date.

7. See Kinkead 1986, 139, n. 28; see also note 11.

8. Angulo 1981 (see Biography), 1: 452.

9. See Brown 1982, 37–38, who also presents some evidence that Murillo may have been familiar with works by the *bambocciati*. Portraits using a northern compositional format include Murillo's *Self-Portrait* (National Gallery, London) and *Nicholas Omazur* (Prado, Madrid; Angulo 1981 [see Biography], 3: 464).

10. Angulo 1981 (see Biography), 1: 452–454. This interpretation is accepted by Gaya Nuño 1961, 58.

11. Angulo 1981 (see Biography), 1: 453–454. However, in Omazur's inventory (see note 7) the related painting is described simply as "Una mosa y una vieja asomandose en una ventana" (A young woman and an old woman looking out of a window). It is not clear whether the old woman referred to in this entry is a misreading of the figure with a veil or whether the entry describes a different composition.

12. Cited by Angulo 1981 (see Biography), 1: 454.

13. The hag also appears repeatedly in Dutch paintings of scenes of prostitution; see, for example, Dirck van Baburen, *The Procuress* (Museum of Fine Arts, Boston); *Masters of Seventeenth-Century Dutch Genre Painting* [exh. cat., Philadelphia Museum of Art] (Philadelphia, 1984), pl. 10.

14. Until the publication of Angulo's monograph, most writers accepted the date proposed by Mayer 1913, 211. See, for example, Gaya Nuño 1978, 103–104, no. 197, who dates it c. 1670. For Angulo 1981 (see Biography), 2: 308, the date is "algo anterior a 1600."

15. Angulo 1981 (see Biography), 3: 440, 442.

16. Angulo 1972, 781.

17. Angulo 1981 (see Biography), 2: 308.

18. Stirling-Maxwell 1848, 3: 1442, who states that it was obtained as a gift from a "Spanish grandee" while Mr. Munro's father was British consul-general in Madrid. See also Curtis 1883, 288.

19. For the entry in the Soult sale, see Ilse H. Lifschutz, *Spanish Paintings and the French Romantics* (Cambridge, 1972), 324, no. 105. A photograph is in NGA curatorial files.

20. Angulo 1972, 2: 781–782; 3: repro. 5. In this copy, a balustrade replaces the windowsill. Angulo 1981 (see Biography), 2: 308, asks if a balustrade was originally represented in place of the ledge. This seems unlikely because it lessens the impact of the composition by changing the format from nearly square to strongly vertical. Also, as Angulo later noted (1981, 2: 308), the balustrade is architecturally incompatible with the window opening. I also see no reason to believe that the figures were originally full length, as Angulo tentatively suggests.

References

1848. Stirling-Maxwell, William. *Annals of the Artists of Spain*. 3 vols. London, 2: 920–921; 3: 1442, repro. 920 (also 1891 ed., 3: 1091–1093, repro. 1092; 4: 1635).

1857. Waagen, Gustav F. *Galleries and Cabinets of Art in Great Britain*. 3 vols. and supplement. London, supplement: 388–389.

1883. Curtis, Charles B. *Velázquez and Murillo*. New York and London: 288.

1885–1900. Widener. 2: 229, repro.

1913. Mayer, August L. *Murillo*. Klassiker der Kunst, 22. Stuttgart and Berlin: 215, repro. (also 1923 ed., 215, repro.)

1913–1916. Widener. 3: not paginated, repro.

1915. Mayer, August L. "Notes on Spanish Pictures in American Collections." *AAm* 3: 315.

1923. Widener: not paginated, repro.

1935. Widener: 34, repro.

1945. Cook, "Spanish Paintings:" 65–86, fig. 11.

1961. Gaya Nuño, Juan A. "Peinture picaresque." *L'oeil* 84 (December): 58, color repro. 59.

1972. Angulo Iñiguez, Diego. "Quelques tableaux de Murillo. Les femmes à la fenêtre de Murillo, de la Galerie Nationale de Washington." In *Evolution générale et développements régionaux en histoire de l'art*. 3 vols. Budapest, 2: 781–784, pl. 533: 1.

1978. Gaya Nuño, Juan A. *L'opera completa di Murillo*. Milan: 103–104, color repro. front cover.

1979. Angulo Iñiguez, Diego. "Murillo y Goya." *Goya* 148–150: 211–213, repro. 210.

1981. Angulo (see Biography). 1: 452–455; 2: 307–308, pl. 435.

1981. Kinkead, Duncan T. "Tres documentos nuevos del pintor Matías Arteaga y Alfaro." *BSAA* 47: 345–357.

1982. Brown, Jonathan. "Murillo, pintor de temas eróticos. Una faceta inadvertida de su obra." *Goya* 169–171: 35–43, fig. 7.

1986. Kinkead, Duncan T. "The Picture Collection of Don Nicolás Omazur." *BurlM* 128: 132–146.

1948.12.1 (1027)

The Return of the Prodigal Son

1667/1670
Oil on canvas, 236.3 x 261 (93 x 102¾)
Gift of the Avalon Foundation

Technical Notes: The picture is executed on a coarse, loosely woven linen support comprised of three pieces of fabric sewn together, the seams horizontal. It is lined, with a narrow strip of tacking edge left intact. The ground is moderately thick and buff colored. The paint is of paste consistency and applied broadly to emphasize the brushwork. The ground and paint layers are largely intact, although there is some flattening of the paint texture and slight abrasion of the readily soluble colors, especially the thinly applied reds and browns and blacks. The paint surface also exhibits wide-aperture, deeply cupped crackle. The varnish is delaminating from the edges of the cracks.

Provenance: Commissioned for the church of the Hospital of Charity, Seville. Removed by government decree to Alcázar, Seville, 1810; taken to Paris by Marshal Nicolas Jean de Dieu Soult, Duke of Dalmatia [1769–1851], 1812; George Granville [1786–1861], 2d Duke of Sutherland, Stafford House, London, 1835; George Granville [1888–1963], 5th Duke of Sutherland; (Thos. Agnew & Sons, London, 1948); purchased 1948 by the Avalon Foundation, New York.

Exhibitions: British Institution, London, 1836, no. 22. *Spanish Old Masters*, Grafton Galleries, London, 1913–1914, 88–89, no. 83. *Seventeenth-Century Art in Europe*, Royal Academy of Arts, London, 1938, no. 217; *Bartolomé Esteban Murillo, 1617–1682*, Prado, Madrid; Royal Academy of Arts, London, 1982–1983, 200, no. 46, color pl. 46.

THE PAINTING formed part of a series executed by Murillo and Valdés Leal for the decoration of the chapel of the Hospital of Charity, Seville, a private foundation of the Brotherhood of Charity led at the time by Miguel Mañara.[1] In December 1663, Mañara became *hermano mayor* of the brotherhood and initiated a program of construction and decoration of the building complex, including the amplification of the church. This was completed by June 1667, although the paintings may have been commissioned

in the previous year.[2] By July 1670 the pictures were installed in the church, although the final payment to Murillo was not made until 1674.[3]

The program of decoration as devised by Mañara included eight paintings by Murillo–this being one of them–two by Valdés Leal, and the sculptural relief in the major altarpiece, and was designed to illustrate how the charities performed by the brotherhood were effective in insuring the eternal salvation of the members.[4] The two paintings by Valdés Leal, *In Ictu Oculi* and *Finis Gloriae Mundi* (both Hospital of Charity, Seville), represent a variety of worldly endeavors which are made futile for the purposes of salvation by the inevitable death of the body. Six of Murillo's paintings and the sculptured scene in the altarpiece, which represents the Entombment, established a parallel between the seven acts of mercy (Matthew 25: 34–39) and the charitable program of the brotherhood. The paintings were installed on the walls of the nave. The *Return of the Prodigal Son* (Luke 15: 22) illustrates the act of clothing the naked.[5]

Two additional paintings by the artist, *Saint Elizabeth of Hungary* and *Saint John of God* (both Hospital of Charity, Seville), were placed in lateral altarpieces in 1672 and provide examples of the efficacy of good works.

The composition reverses Murillo's earlier painting of the subject of circa 1660, which in turn utilizes a print by Pietro Testa as the point of departure.[6] It is also possible that the artist subsequently referred to a woodcut of the same scene by Martin van Heemskerck for the pose of the father and son, although the pose might be considered a conventional one.[7] In the National Gallery painting, however, the artist emphasizes the motif of the clothing held by the two figures at the right, in keeping with the programmatic significance of the picture.

Murillo's paintings for the Hospital of Charity are among his most famous works and were greatly coveted in the nineteenth century. In July 1800, Mariano Luis de Urquijo, secretary of state of Charles IV of Spain, initiated a process to remove them to Madrid for incorporation into a projected royal museum.[8] The brotherhood was able to resist their displacement until 1810, when they were seized on the order of the government of Joseph Bonaparte and deposited in the Alcázar of Seville.[9] Eventually, five were appropriated by Marshal Soult, who removed them to his house in Paris in 1812. After attempting to sell some of the group to the British government (1824) and Louis-Philippe (1835), he sold *Abraham and the Three Angels* and *The Return of the Prodigal Son* in 1835 to the second duke of Sutherland.[10]

Writers on art who saw the latter painting in Stafford House were unstinting in their praise. For Waagen, it was "in the highest rank of art."[11] Mrs. Jameson described the picture in ecstatic terms: "The execution, too, is as fine as possible: the drawing so firm; the colors so tenderly fused into each other; the shadows so soft; the effect of the whole so in harmony with the sentiment and subject, that I consider it a rare example of absolute excellence in its class."[12]

Even now, the paintings in the Hospital of Charity series are acknowledged to be among the finest painted by the artist. The warm colors, soft, hazy atmosphere, and benevolent expressions capture the spirit of heartfelt repentance and loving forgiveness implicit in this episode of the parable of the Prodigal Son. However, unlike other representations of the subject, Murillo's emphasizes the clothing of the son in accord with the intention to represent the relevant cardinal act of mercy.

A copy of the painting, made by Joaquin Cortés in 1802–1803, when arrangements were being made to remove the originals to Madrid for the royal museum, is now lost.[13] Numerous other copies exist.

J.B.

Notes

1. For a full account of the commission, see Brown 1970, 268–269.

2. Angulo 1981 (see Biography), 2: 87–88, publishes documents stating that one of Murillo's paintings, *Abraham and the Three Angels*, was installed in the church on 25 June 1667; that another, the *Liberation of Saint Peter*, was put in place on 27 August of that year; and that a third painting of an unspecified subject was installed by 1668. The fact that three paintings were finished by 1668 lends support to the suggestion by Brown 1970, 268, that the commission was started in 1666.

3. Brown 1970, 269.

4. See Brown 1970, 269–274, for an analysis of the program and reproductions of all the works. The interpretation of each painting and the altarpiece as a specific act of mercy is confirmed in a document of 1674 published by Valdivieso and Serrera 1980, 71, who provide additional details concerning the program.

5. The other acts of mercy by Murillo are: *Moses Sweetening the Waters of Mara, Feeding of the Five Thousand* (both Hospital of Charity, Seville), *Christ Healing the Paralytic* (National Gallery, London), *Liberation of Saint Peter* (Hermitage), and *Abraham and the Three Angels* (National Gallery of Canada, Ottawa).

6. *The Illustrated Bartsch*, vol. 45, *Italian Masters of the Seventeenth Century* (New York, 1982), 129, repro. The Testa source is adduced by Angulo 1981 (see Biography), 2: 25; it is closer to Murillo's composition than Callot's print from scenes of the Prodigal Son (J. Lieure, *Jacques Callot*, 5 vols. [Paris, 1924–1929], vol 3, 2d fasicule, 91–92, no. 1411), which as Dorival 1951, 96–97, figs. 11–12, showed, partly influenced Murillo's series now in the National Gallery of Ireland, Dublin.

7. F. W. H. Hollstein, *Dutch and Flemish Etchings, Engravings, and Woodcuts, ca. 1450–1700* (Amsterdam, 1949), vol. 8, 235, no. 53. The Heemskerck print was brought to my attention by Steven N. Orso, letter, 7 January 1988.

8. Gómez Imaz 1896, 37.

9. Gómez Imaz 1896, 38–41.

10. For the attempted sale of 1824, see Buchanan 1824, 43–44. The offer to Louis-Philippe is described by Lipschutz 1972, 37. The two paintings are represented on display at Stafford House in an 1848 painting by James D. Winfield (Francis Haskell, *Rediscoveries in Art* [Ithaca, N.Y., 1976], fig. 93).

11. Waagen 1854, 2: 67–68.

12. Jameson 1844, 191.

13. For this and other copies, see Angulo 1981 (see Biography), 2: 86–87.

References

1787–1794. Ponz, Antonio. *Viaje de España*. 18 vols. Madrid, 9: 148.

1800. Céan Bermúdez, Juan A. *Diccionario histórico de los más ilustres profesores de las bellas artes en España*. 6 vols. Madrid, 2: 52.

1824. Buchanan, William. *Memoirs of Painting*. London: 43–44.

1829–1834. Réveil, Etienne A. *Musée de peinture et de sculpture*. 16 vols. Paris, 5: 301.

1844. Jameson, Anna B. *Companion to the Most Celebrated Private Galleries of Art in London*. London: 191.

1848. Stirling-Maxwell, William. *Annals of the Artists of Spain*. 3 vols., London, 2: 864, 3: 1431, (also 1891 ed., 4 vols., London, 3: 1028, 4: 1622).

1854. Waagen, Gustav F. *Treasures of Art in Great Britain*. 3 vols. and supplement. London, 2: 67–68.

1883. Curtis, Charles B. *Velázquez and Murillo*. New York and London: 116, 195.

1892. Justi, Carl. *Murillo*. Leipzig: 64, fig. 20.

1896. Gómez Imaz, Manuel. *Inventario de los cuadros sustraídos por el Gobierno intruso en Sevilla año de 1810*. Seville: 38–41, 61.

1907. Calvert, Albert F. *Murillo: A Biography and Appreciation*. London: 63, 167.

1913. Mayer, August L. *Murillo*. Klassiker der Kunst, 22. Stuttgart and Berlin: 126, repro. (also 1923 ed., 12: 131 repro.)

1923. Montoto, Santiago. *Bartolomé Esteban Murillo. Estudio biográfico-crítico*. Seville: 97.

1951. Dorival, Bernard. "Callot modèle de Murillo." *Revue des Arts*, 2: 94–101.

1970. Brown, Jonathan. "Hieroglyphs of Death and Salvation: The Decoration of the Church of the Hermandad de la Caridad, Seville." *AB* 52: 265–277, fig. 5. Reprinted in *Images and Ideas in Seventeenth-Century Spanish Painting*. Princeton, 1978: 128–146.

1972. Lipschutz, Ilse H. *Spanish Painting and the French Romantics*. Cambridge, Mass.: 37.

1978. Gaya Nuño, Juan A. *L'opera completa di Murillo*. Milan: 109–110, color pl. 53, fig. 253.

1980. Valdivieso, Enrique, and Juan Miguel Serrera. *El Hospital de la Caridad de Sevilla*. Seville: pl. 38, no. 1.

1981. Angulo (see Biography). 1:396–398, 2:86–87, figs. 274–277.

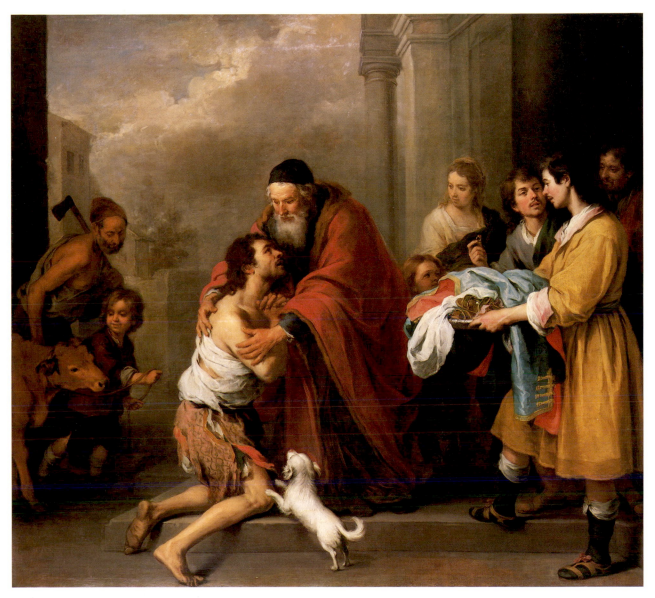

Bartolomé Esteban Murillo, *The Return of the Prodigal Son,* 1948.12.1

Juan de Nisa y Valdés Leal

1622 – 1690

VALDÉS was a native of Seville, where he probably received his artistic training, although there are no records of his early life. He is first recorded in Córdoba in 1647, the year he signed and dated a painting of *Saint Andrew* (San Francisco, Córdoba), which shows affinities with the style of the Sevillian master, Francisco de Herrera the Elder. Valdés remained in Córdoba until 1656, by which time he had developed his mature style.

From 1656 until his death, Valdés lived in Seville, where he established a reputation second only to Murillo. In 1660, the two painters participated in the founding of a drawing academy, of which Valdés was president from 1663 to 1666. They also collaborated in the decoration of the church of the Brotherhood of Charity. The two paintings by Valdés Leal, known collectively as the Hieroglyphs of Death and Salvation and still in situ, are among the most famous Spanish paintings of the seventeenth century. After about 1682, the artist was beset by ill health and increasingly relied on his son, Lucas, to direct the work of his shop. He died in Seville.

Valdés was almost exclusively a painter of religious themes and worked for local churches and private clients, receiving few commissions from monastic patrons, who favored Murillo. His style offers a striking contrast to that of his more famous contemporary. In his mature works, Valdés used a sketchlike technique and crowded and high-keyed compositions that convey an agitated quality very different from the calm, controlled style of Murillo. In his best works, he captures the emotional excitement and intensity of the Catholic faith in an entirely unique and convincing way.

J.B.

Bibliography

Trapier, Elizabeth Du Gué. *Valdés Leal: Spanish Baroque Painter.* New York, 1960.

Kinkead, Duncan T. *Juan de Valdés Leal (1622–1690): His Life and Work.* London and New York, 1978.

Valdivieso, Enrique. *Juan de Valdés Leal.* Seville, 1988.

1961.9.46 (1409)

The Assumption of the Virgin

c. 1658–1660
Oil on canvas, 215.1 x 156.3 (84⅝ x 61½)
Samuel H. Kress Collection

Inscriptions:
In lower center, beneath hand of Saint Peter: *BALDS LEA* (*BAL* in ligature)

Technical Notes: The painting is executed on a compound twill-weave canvas with a diamond pattern and is lined on a medium-weight, plain-weave fabric. The ground is a warm, off-white color over which the paint is thinly applied, with some slight impasto in the highlights. The paint layer has suffered overall abrasion and has been extensively inpainted in the abraded areas. There are larger and more serious losses in the head of the angel at the right, in the sky, in the blue robe of the figure at the bottom, and in the mouth of the putto at the right. There is also inpainting around all four edges approximately ½ in. in from the edge. The varnish is uneven and has a milky appearance. Pentimenti are found around the left sleeve of the Virgin, the right foot of the angel at the left carrying the Virgin, and at the right index finger of the male figure shading his eyes at the bottom.

Provenance: Removed to Alcázar, Seville, 1810, following French occupation of the city.[1] Marquise de Landolfo Carcano [1872–1912], Paris (sale, Galerie Georges Petit, Paris, 30 May–1 June 1912, no. 174); Dr. Carvalho,[2] Château Villandry, near Tours. (Rosenberg & Stiebel, New York, after 1950);[3] purchased 8 February 1955 by The Samuel H. Kress Foundation, New York.[4]

Exhibitions: Grafton Galleries, London, 1913–1914, no. 102, pl. 48. *Exposition d'Art Espagnol*, Hôtel Charpentier, Paris, 1925, no. 100. *Painting in Spain 1650–1700*, The Art Museum, Princeton University; The Detroit Institute of Arts, 1982, 106–108, no. 43, pl. 43.

MOST SCHOLARS AGREE that *The Assumption of the Virgin* was painted after the artist's return from Córdoba to Seville in 1656, although Mayer related it to the altarpiece for the Carmelites, Córdoba, painted around 1655 to 1656.[5] Suida and Shapley place the date as late as about 1670, Kinkead a few years earlier, between about 1667 and 1668.[6] As Benesch was the

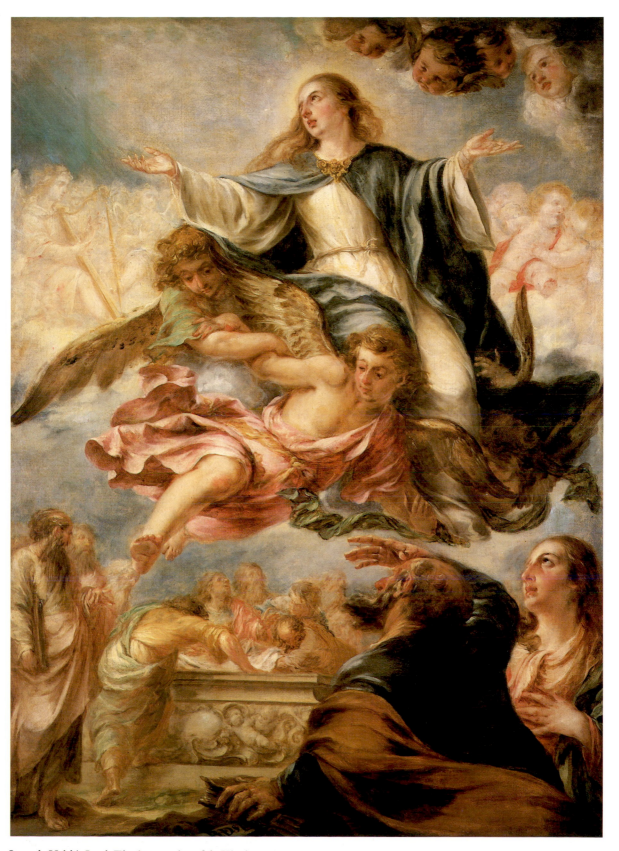

Juan de Valdés Leal, *The Assumption of the Virgin*, 1961.9.46

first to note, the composition is related to the *Ecstasy of Saint Francis* (fig. 1), a major painting by Francisco de Herrera the Younger, completed in 1657.[7] Herrera, a native of Seville, returned home from Madrid in 1655 and introduced a dramatic, highly colored style of painting that made a considerable impact on the local artists, including Valdés Leal.[8]

Evidence of the connection between the *Ecstasy of Saint Francis* and *The Assumption of the Virgin* is found in the figure of Saint Peter in the lower right corner, which is modeled on Brother Leo in the lower left of Herrera's painting. A comparable figure also is found in Herrera's *Allegory of the Eucharist*, executed in 1655 for the Confraternity of the Santísimo Sacramento del Sagrario, Seville (in situ). The high-keyed colors are another indication of Valdés' debt to Herrera, as are the lightly brushed musical angels, the open,

sketchy brushwork, and the foreshortened pose of the angel supporting the Virgin Mary. Accordingly, it is reasonable to date the *Assumption* to the years immediately following the completion of Herrera's *Ecstasy of Saint Francis*, that is to say, around 1658 to 1660.

The origins of the central group, showing the Virgin Mary raised aloft by angels, are complex. This element of the composition is related in part to the central group in Herrera's *Ecstasy of Saint Francis*, which in turn was inspired by Rubens' *Assumption of the Virgin* (Cathedral, Antwerp).[9] Rubens' painting was reproduced in an engraving by Schelte à Bolswert and was known earlier in Seville, as demonstrated by its influence on Zurbarán's *Apotheosis of Saint Jerome* (Monastery, Guadalupe),[10] executed no later than the mid-1640s. It would appear that Valdés independently consulted a version of Rubens' composition for the pose of the Virgin, although he reversed her orientation. The angels holding the Virgin aloft are not found in the Rubens, however, but derive from Herrera's *Ecstasy of Saint Francis*, which combines angels and putti as members of the supporting cast.

A preparatory oil sketch (fig. 2) was published by Benesch, who did not make the connection to the Gallery's picture.[11] Kinkead noted the relationship and described the numerous changes between the sketch and the finished work,[12] which chiefly involve the reversal of the lower part of the composition and the increase in the size of the Virgin.

The iconography follows the *Golden Legend* in that only eleven of the twelve apostles are represented.[13] The twelfth, Saint Thomas, was absent at the moment of the Assumption and doubted that it had occurred. Valdés also omits the three virgins, or holy women, who were present at the death of the Virgin and are represented in Rubens' composition.

J.B.

Fig. 1. Francisco de Herrera the Younger, *Ecstasy of Saint Francis,* Cathedral, Seville

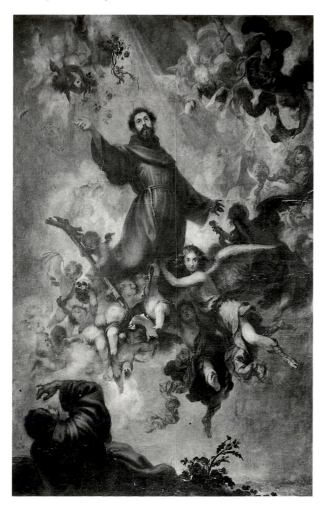

Notes

1. Manuel Gómez Imaz, *Inventario de los cuadros sustraídos por el gobierno intruso en Sevilla el año de 1810* (Seville, 1896), 72, lists a painting of this subject measuring 2½ *varas* high by 2 *varas* wide, or 210 x 168 cm. As Eisler 1977, 223, n. 11, has pointed out, these dimensions approximately correspond to those of the Gallery's painting. Lafond 1923, 92, identified the painting with one in the Aguado sale (Bonnefons and Benou, Paris, 20–28 March 1843). However, as Eisler 1977, 223, n. 12, has stated, the dimensions of this picture (164 x 111 cm) differ significantly from those of the work in Washington, although the description corresponds closely.

2. Annotated copy of Landolfo Carcano sale catalogue, in NGA library.

3. Still listed as in the Carvalho collection in Nieto 1950, 158.

4. A copy of the bill from Rosenberg & Stiebel, 8 February 1955, is in NGA curatorial files.

5. Mayer 1942, 374.

6. Suida and Shapley in Kress 1956, 188; Kinkead 1978 (see Biography), 421. Other datings include the following: Benesch 1926, 263, early 1660s; Kubler and Soria 1959, 294, c. 1659; Trapier 1960, 48, after 1669; Eisler 1977, 223, c. 1659; exh. cat. Princeton-Detroit 1982, 107, c. 1659; Valdivieso 1988, 145, c. 1665–1669.

7. Benesch 1926, 262.

8. For an analysis of Herrera's impact on painting in Seville, see Duncan T. Kinkead, "Francisco de Herrera and the Development of the High Baroque in Seville," *Record of the Art Museum, Princeton University* 2 (1982), 12–23.

9. For the origins of Herrera's composition, see Kinkead 1982, 13.

10. See José Milicua, "Observatorio de ángeles," *AEA* 31 (1958), 6–16. A painting of the Assumption of the Virgin attributed to Rubens was recorded in an inventory of the Casa de Pilatos, Seville, in 1637. See Jonathan Brown and Richard L. Kagan, "The Duke of Alcalá: His Collection and Its Evolution," *AB* 69 (1987), 248. The general similarity of the Washington picture to Juan del Castillo's *Assumption of the Virgin* (Museo de Bellas Artes, Seville), c. 1634–1636, noted by Eisler 1977, 222, is probably more typological than specific, the result of Castillo's use of a print after Rubens' *Assumption* and not of the direct influence of Castillo on Valdés Leal.

11. Benesch 1926, 259–268.

12. Kinkead 1978 (see Biography), 185. Valdivieso 1988 (see Biography) does not accept the relationship between these two works and believes that the Harrach sketch is a study for a painting still unknown.

13. Granger Ryan and Helmut Ripperger, trans., *The Golden Legend of Jacobus de Voragine* (New York, London, and Toronto, 1941), 452–454.

References

1911. Beruete y Moret, Aureliano. *Valdés Leal: Estudio crítico*. Madrid.

1914. Beruete y Moret, Aureliano. "Une Exposition d'anciens maîtres espagnols à Londres." *Revue de l'Art Ancien et Moderne* 35: 73, repro. 71.

1916. Gestoso y Pérez, José. *Biografía del pintor sevillano, Juan de Valdés Leal*. Seville: 208.

1923. Lafond, Paul. *Juan de Valdés Leal*. Paris: 92–93.

1926. Benesch, Otto. "Seicentostudien." *JbWien*, n.s., 1: 259–268. Reprinted in *Collected Writings*. 2 vols. New York, 1971, 2: 174–180.

1926. Milward, Jo. "The Carvalho Collection of Spanish Art." *IntSt* 84 (August): 13–24, 92, repro. 21.

1939. Mather, Frank J. *Western European Paintings of the Renaissance*. New York: 661.

1942. Mayer, August L. *Historia de la pintura española*. Madrid: 374.

1950. Nieto, Benedicto. *La Asunción de la Virgen en el arte*. Madrid: 158.

1956. Kress: 188.

1959. Kubler, George, and Martin Soria. *Art and Architecture in Spain and Portugal and Their American Dominions 1500–1800*. Baltimore: 294.

1960. Trapier (see Biography): 48.

1971. Angulo Iñiguez, Diego. *Pintura del siglo XVII*. Ars Hispaniae 15. Madrid: 383.

1977. Eisler: 221–223, fig. 217.

1978. Kinkead (see Biography): 185–186, 420–422, no. 101, fig. 89.

1988. Valdivieso (see Biography): 145, 252, no. 122, pl. 113.

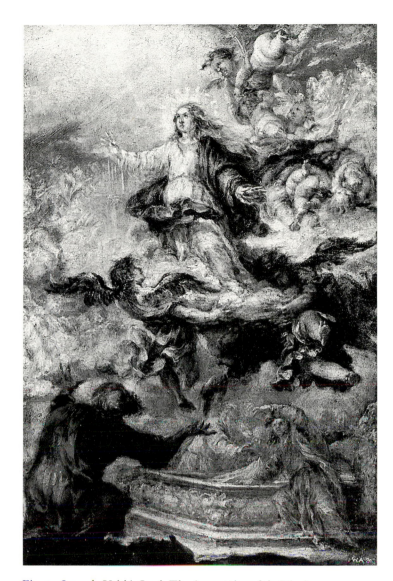

Fig. 2. Juan de Valdés Leal, *The Assumption of the Virgin*, c. 1666–1667, oil sketch, Graf Harrach'sche Familiensammlung, Schloss Rohrau

Diego Rodríguez de Silva y Velázquez

1599 – 1660

VELÁZQUEZ is recognized as the leading Spanish painter of the seventeenth century and as one of the greatest masters of the art. He was born in Seville, the son of parents of the lower nobility or gentry. His teacher was the painter-theorist Francisco Pacheco, who introduced his pupil to the techniques of painting and provided him with a grounding in artistic theory. The early works by Velázquez, painted in the years between 1615 and 1623, are entirely original within the context of Sevillian painting and display a remarkable gift for reproducing natural appearances. The genre scenes created at this time constitute the first coherent body of secular figural compositions in the history of Spanish art.

In 1623, Velázquez obtained the appointment of painter to Philip IV, whom he served at the court in Madrid for the rest of his life. During the 1620s he struggled to consolidate his position in the face of competition from the senior court painters. His painting of the *Feast of Bacchus*, or *Los Borrachos* (Prado, Madrid), shows a brilliant but still unformed artist. However, after a trip to Italy from 1629 to 1630, Velázquez was inspired to create his original style of painting, based on the notational application of pigment to create effects of light and color that approximate these natural phenomena to an extraordinary degree.

The decade of the 1630s was the artist's most productive period, as he created pictures for the newly constructed palace of the Buen Retiro and the Torre de la Parada, a hunting lodge near Madrid. The masterpiece of this period is the *Surrender of Breda* (Prado, Madrid), which was installed in the Buen Retiro.

In the 1640s, Velázquez began to curtail his activity as a painter to devote himself to the personal service of the king. The motive for this decision seems to lie in a desire to enhance his social status and thus to increase the prestige of his art. As he rose in the court hierarchy, he painted fewer and fewer pictures, yet he never ceased to develop his style. His greatest paint-ing, *Las Meninas* (Prado, Madrid), was done around 1656, at a moment when much of his time was devoted to assisting the king with the installation of the royal picture collection. Four years later he died, after returning from an exhausting trip to the Franco-Spanish border in attendance of the king and his court.

As court painter, Velázquez was mainly required to execute portraits of the royal family. He produced but few religious paintings, a handful of mythological works, and two landscapes. Yet to each of his works, whether portrait or subject painting, he brought to bear the pictorial intelligence and original technique that continue to exercise a compelling fascination over specialists and the general public alike.

J.B.

Bibliography

López-Rey, José. *Velázquez; the Artist as Maker*. Lausanne and Paris, 1979.
Harris, Enriqueta. *Velázquez*. Ithaca, 1982.
Brown, Jonathan. *Velázquez, Painter and Courtier*. New Haven and London, 1986.

1937.1.81 (81)

The Needlewoman

c. 1640/1650
Oil on canvas, 74 x 60 (29⅛ x 23⅝)
Andrew W. Mellon Collection

Technical Notes: The painting is on a relatively coarsely woven fabric and adhered to a very coarsely woven, heavyweight canvas. It has been reduced in size along all four edges and later expanded again. A ¾-inch band of the original surface was once made to serve as a tacking margin, but later returned to the picture surface. Heavy retouching covering this portion of the picture was removed during treatment in 1988. Mild cusping at the edges suggests that the present format is roughly the same as the original. The ground layer is a warm red brown, applied very thinly, leaving the tops of the threads exposed. A sketch of the composition with black paint was laid in over the ground color, and is still slightly visible at the left. In the pillow at the lower left, the ground is exposed. Some pentimenti are evident, particularly

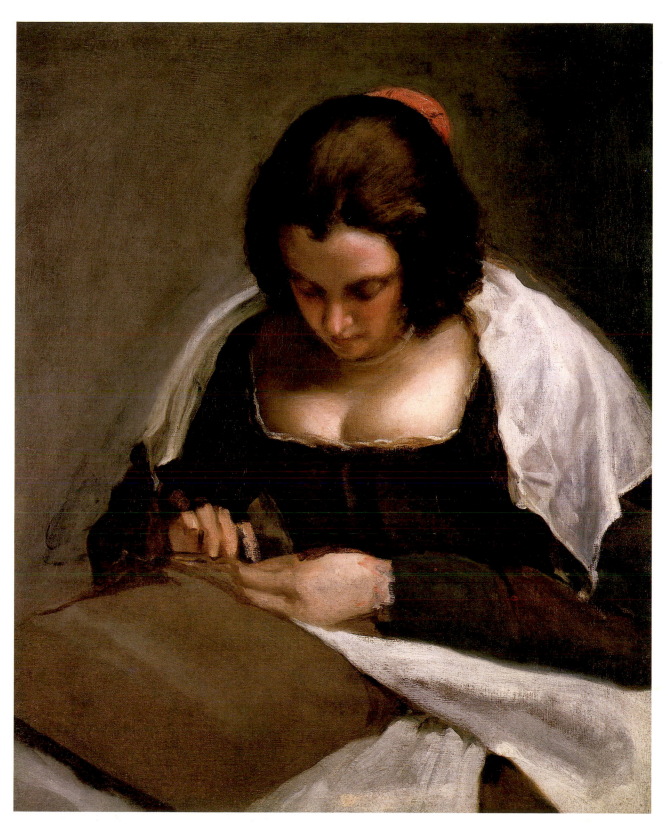

Diego de Velázquez, *The Needlewoman*, 1937.1.81

around the unfinished hands. Other pentimenti are located in the neckline of the dress and at the lower left of the sitter's hair. The painting is in good condition, although there are small, inpainted losses scattered over the painting and light abrasions, particularly in the background and pillow.

Provenance: In the artist's possession at his death, 1660. Probably Pierre-Armand-Jean-Vincent-Hippolyte, Marquis de Gouvello de Keriaval [1782–1870], Château de Kerlévénant, Sarzeau, Morbihan, Brittany.[1] Christiane de Polès, Paris; (Wildenstein, New York, 5 July 1926);[2] consigned to (M. Knoedler & Co., New York);[3] by whom purchased 9 March 1927;[4] purchased the same day by Andrew W. Mellon, Pittsburgh and Washington;[5] deeded 12 December 1934 to The A. W. Mellon Educational and Charitable Trust, Pittsburgh.

Exhibitions: *Velázquez*. The Metropolitan Museum of Art, New York; Prado, Madrid, 1989–1990, 216, no. 81, pl. 29.

THE PAINTING appears to be included in the death inventory of Velázquez, compiled between 11 and 29 August 1660 by his son-in-law, Juan Martínez del Mazo, and Gaspar de Fuensalida. Velázquez had lived in the Casa del Tesoro, a dependency of the Alcázar, Madrid. In the room called the *bovedilla*, the following painting is listed: "Otra cabeza de mujer haciendo labor" (another head of a woman sewing).[6]

Mayer, who first published the picture, identified the sitter as Velázquez' daughter Francisca (1619–before 1658), wife of the painter Juan Martínez del Mazo.[7] He believed that she resembled what he thought were two portraits of Francisca: in Mazo's *Family Portrait* (Kunsthistorisches Museum, Vienna), and in Velázquez' *Lady with a Fan* (Wallace Collection, London).[8] Sánchez Cantón challenged this identification on the grounds that Mazo, a compiler of the inventory, would have been able to identify his deceased wife.[9] However, Soria defended Mayer's hypothesis, agreeing that the sitter and the *Lady with a Fan* represented the same person. He suggested that Mazo deliberately failed to identify his wife "to protect Velázquez's estate from the accusation that the artist portrayed members of his family while in the king's pay,"[10] although there is no reason to suppose that Philip IV would have objected to the practice. López-Rey accepted that the sitters in *The Needlewoman* and the *Lady with a Fan* resemble each other and on this basis postulated that the paintings may depict a member of Velázquez' immediate circle.[11] Gudiol proposed that the sitter is Juana Pacheco, Velázquez' wife.[12]

The informal nature of the picture does suggest that the sitter might have been associated with the painter's household, but in the absence of verifiable portraits of any member of Velázquez' family, it is impossible to identify her with either of his daughters or his wife. The identification of the woman as Francisca del Mazo is obviated by the fact that Mazo's *Family Portrait* was painted around 1664, by which time she had died and her husband had remarried.[13] The resemblance between the sitters of *The Needlewoman* and the *Lady with a Fan* is not close enough to indicate that they are one and the same person; in any case, the comparison is hampered by the foreshortened pose of the head of the Washington figure. The sitter therefore must remain anonymous.

The attribution to Velázquez is now generally accepted, although doubts were sometimes expressed in the years following the appearance of the picture in the 1930s. Sánchez Cantón originally thought that Mazo had added passages to a composition initiated by Velázquez.[14] He later rejected the attribution of any part of the canvas to Velázquez,[15] but eventually reversed himself and agreed that the entire picture was the work of the master.[16] While Pantorba and Camón Aznar also rejected Velázquez' authorship, it has been accepted by Soria, López-Rey, Gudiol, and Brown.[17]

Although unfinished, the painting is characteristic of Velázquez' mature work. The soft lighting on the face, achieved by thin, translucent pigments, and the incorporation of the weave of the canvas as a means of modulating shadow are found in numerous portraits of the 1630s and 1640s (for instance, *Juan Martínez Montañés*, Prado, Madrid).[18] The outlining of the unfinished forms with broad strokes of black pigment and the nervous white highlights that define the edge of the bodice are also unmistakable indications of Velázquez' hand.

As López-Rey has noted, the unfinished state makes it difficult to determine a precise date of execution. His suggestion of the mid-1630s to the early 1640s is plausible, although it might be extended even to around 1650, given the similarities in execution to a work such as the *Rokeby Venus* (National Gallery, London). It should be noted that low-cut bodices were prohibited by a royal decree of 1639,[19] but the markedly informal nature of the picture suggests that it would be unwise to use the decree as incontrovertible evidence for a date prior to this year.

Genre scenes are very rare in Velázquez' production after his Seville period (ended 1623). The subject of a woman doing needlework appears in Dutch seventeenth-century painting, where it has been equated with the virtue of industriousness.[20] However, there is no reason to apply that interpretation to this painting or the general context in which it was created.

For another contemporary Spanish treatment of the theme, see the drawing attributed to Mazo, formerly in the Boix collection, Madrid.[21]

<div style="text-align:right">J.B.</div>

Notes

1. The ownership by the Gouvello de Keriaval is given by Mayer [1935], 4. For a few facts about the collector Hippolyte de Gouvello, see Henri Frotier de la Messalière, *Filiations Brétonnes, 1650–1912*, 5 vols. (Saint-Briem, 1913), 2:570.

2. Ay-Whang Hsia, vice-president, Wildenstein, New York, letter, 14 September 1988, in NGA curatorial files.

3. Stockbooks, M. Knoedler & Co., in the Getty Provenance Index.

4. See letter cited in note 2.

5. Entry from David Finley notebook, in NGA curatorial files.

6. For the inventory and this identification, see Sánchez Cantón 1942, 79. The definition of "hacer labor" is given in the *Diccionario de Autoridades* (Madrid, 1732), 342, as "toda obra de aguja en que se ocupan las mujeres."

7. Mayer [1935], 3.

8. *Family Portrait* and *Lady with a Fan* are reproduced in Brown 1986, figs. 256, 176.

9. Sánchez Cantón 1942, 79.

10. Kubler and Soria 1959, 264, 386, n. 48.

11. López-Rey 1963, 331–332, no. 605.

12. Gudiol 1973, 339.

13. For this painting and biographical information on Francisca Velázquez, see José López-Navió, "Matrimonio de Juan B. del Mazo con la hija de Velázquez," *AEA* 33 (1960), 387–410.

14. Sánchez Cantón 1942, 79.

15. Sánchez Cantón 1944, 136.

16. Sánchez Cantón 1965, 127.

17. Pantorba 1955, 232; Camón Aznar 1964, 924, as by Mazo; Kubler and Soria 1959, 264; López-Rey 1963, 331–332, no. 605; López-Rey 1979 (see Biography), 390, no. 81; Gudiol 1973, 339, no. 160; Brown 1986, 158.

18. Brown 1986, fig. 170.

19. See Harris 1975, 319.

20. See Wayne E. J. Franits, "'The Vertues which ought to be in a Complete Woman:' Domesticity in Seventeenth-Century Dutch Art" (Ph.D. diss., New York University, 1987), 38.

21. Reproduced in Francisco J. Sánchez Cantón, *Dibujos españoles*, 5 vols. (Madrid, 1930), 3: pl. 231.

References

[1935]. Mayer, August L. *A Portrait by Velázquez. Francisca Velázquez, Daughter of the Master (The Woman Sewing)*. New York.

1936. Mayer, August L. *Velázquez: A Catalogue Raisonné of the Pictures and Drawings*. London: 132, no. 558, pl. 189.

1942. Sánchez Cantón, Francisco J. "Como vivía Velázquez: inventario descubierto por D. F. Rodríquez Marín." *AEA* 15: 79.

1943. Lafuente Ferrari, Enrique. *Paintings and Drawings of Velázquez. Complete Edition*. London and New York: 25, no. 77, pl. 93.

1944. Sánchez Cantón, Francisco J. Review of E. Lafuente Ferrari, *Velázquez*. *AEA* 17: 136.

1945. Cook, "Spanish Paintings:" 80–82.

1945. Sánchez Cantón, Francisco J. "New Facts About Velázquez." *BurlM* 87: 293.

1945. Soria, Martin S. Review of Enrique Lafuente Ferrari, *The Paintings and Drawings of Velázquez*. *AB* 27 (September): 214.

1948. López-Rey, José. Review of *Archivo Español de Arte* (1940–1946). *GBA* 33: 60–61.

1955. Pantorba, Bernardino de [José López Jimenez]. *La vida y la obra de Velázquez: estudio biografico y crítico*. Madrid: 232, no. 164.

1959. Kubler, George, and Martin S. Soria. *Art and Architecture in Spain and Portugal and Their American Dominions 1500–1800*. Baltimore: 264, 386, n. 48.

1963. López-Rey, José. *Velázquez: A Catalogue Raisonné of His Oeuvre*. London: 331–332, pl. 114.

1964. Camón Aznar, José. *Velázquez*. 2 vols. Madrid, 2: 973 repro.

1964. Harris, Enriqueta. Review of José López-Rey, *Velázquez*. *BurlM* 106: 426.

1965. Sánchez-Cantón, Francisco J. Review of José López-Rey, *Velázquez*. *GBA* 65: 127.

1968. López-Rey, José. *Velázquez' Work and World*. London: 94–95, pl. 133.

1974. Gudiol y Ricart, José. *Velázquez: 1599–1660*. Translated by Kenneth Lyons. London: 318, 339, no. 160, fig. 236.

1975. Harris, Enriqueta. "The Cleaning of Velázquez's *Lady with a Fan*." *BurlM* 117: 319.

1979. López-Rey (see Biography): 92, 96, 99, 390, no. 81, pl. 166.

1986. Brown (see Biography): color fig. 178.

Follower of Diego de Velázquez

1937.1.82 (82)

Portrait of a Young Man

c. 1650
Oil on canvas, 59.5 x 47.8 (23⅜ x 18⅞)
Andrew W. Mellon Collection

Technical Notes: The support consists of a single piece of coarse, open, plain-weave fabric attached to a lining of comparable material. There are irregular holes and punctures in the fabric. The tacking margin has been removed. The top and sides appear to have been folded over the width of the stretcher bar, while the bottom edge may have been enlarged. The paint is very thinly applied over a rough red-brown ground. The picture is solvent abraded, especially in the thinly painted dark areas. There are scattered losses in the background, and retouching is heavily applied along the right and bottom edges. A minor loss is located in the sitter's forehead and another at the crown of his head.

Provenance: Count Ferdinand Bonaventura Harrach [1636–1706], Vienna, by 1697;[1] his son, Count Alois Thomas Raymund Harrach [1669–1742], viceroy of Naples (1728–1731); remained in the Galerie Harrach, Vienna, until 1930; sold by Count Otto Harrach to (Duveen Brothers, New York, 1930); purchased 15 December 1936 by The A. W. Mellon Educational and Charitable Trust, Pittsburgh.

THE NAME of Velázquez was first associated with this picture in 1697, in a handwritten note of Count Harrach, who had recently acquired the portrait and considered it to be a copy of a work by the artist, or possibly an autograph copy (the wording permits either interpretation).[2] In 1889, however, Pazaurek ascribed it to the Czech painter, Karel Skreta (c. 1604–1674).[3] The attribution to Velázquez was introduced into the published literature by Bredius, who also cited the verbal opinion of Justi, given in 1876, in support of this position.[4] Nevertheless, von Loga continued to uphold the attribution to Skreta, as did Allende-Salazar in 1925.[5] Five years later, Allende-Salazar changed his mind and assigned the picture to Velázquez' follower and son-in-law, Juan Martínez del Mazo.[6]

Pita Andrade tentatively identified the painting with a work listed in the 1651 inventory of Gaspar de Haro, as follows: "173—una pintura en lienço de un retrato de medio cuerpo de un mozo desbarbado sin sombrero con una balona cayda de mano de Veláz-quez de cerca de bara de cayda y tres quartas de ancho" (a painting on canvas of a half-length portrait of a beardless youth, without hat, wearing a walloon collar, by the hand of Velázquez, about a *vara* high and three quarters [of a *vara*] wide).[7]

This identification is implicitly rejected by López-Rey, who catalogues the Haro picture as lost or unknown.[8] As he notes, the fact that the sitter in the Gallery's painting has a moustache and a small beard, known as a *mosca*, seems to eliminate the identification with Gaspar de Haro's painting, which at the time was somewhat larger than the painting in Washington.

A number of writers have accepted Allende-Salazar's attribution to Mazo, although Mayer and Gudiol continued to believe that Velázquez was the author.[9] López-Rey tentatively attributed the work to the same anonymous artist who painted the copy of Velázquez' *Juan de Pareja* (original in The Metropolitan Museum of Art) now at the Hispanic Society of America, New York.[10]

It is clear that the painting was not executed by Velázquez, although the abraded condition makes it difficult to compare the brushwork with authentic pictures of the master. However, the treatment of the collar can be compared to Velázquez' *Calabazas* (Prado, Madrid), in which the design is considerably more complex and the handling more effective in evoking the illusion of lace. The left side of the collar in the Gallery's painting is weakly rendered by a few wavy strokes that flatten the foreshortening. Another weak point is the mouth, set in a rigid expression with the parting of the lips depicted by a straight, horizontal line.

Nevertheless, the picture is of good quality and was executed by an artist who was familiar with Velázquez' portraits of the 1640s, such as *Calabazas* and *Philip IV* (The Frick Collection, New York). Mazo, who was Velázquez' principal assistant at the time, is certainly a logical candidate for authorship, but neither his work nor that of other studio assistants known in name only is sufficiently well studied to permit a definite attribution.

The sitter has been identified as Mazo and as Alonso Cano, but neither hypothesis can be confirmed because there are no proven portrayals of these two artists.[11]

J.B.

Follower of Diego de Velázquez, *Portrait of a Young Man*, 1937.1.82

Notes

1. Ritschl 1926, 130. Several conflicting dates have been published regarding Count Harrach's acquisition of this painting. Cook 1945 said that the portrait was "acquired in 1677 in Madrid," while López-Rey 1963 stated that it was purchased in 1678. Gudiol 1974 suggested that Count Harrach bought the painting in 1678. In his 1926 catalogue for the Harrach collection, however, Ritschl notes that Count Harrach mentioned the painting in a 1697 document as "ein Contrefait, Bruckstück von einem Mann im grauen Wamms mit dunklen Ermeln, kleinen Uberschlag mit Spitzen, von Velasca." Count Harrach was the Austrian ambassador in Madrid in 1661, 1665, 1672–1677, and 1697–1698.

2. Ritschl 1926, 130.

3. Pazaurek 1889, 91, no. 162.

4. Bredius 1902, 110, who refers to Justi's earlier unpublished attribution to Velázquez.

5. Gensel and von Loga 1914, 238; Gensel and Allende-Salazar 1925, 288, 265n.

6. Allende-Salazar 1930, 301.

7. Pita Andrade 1952, 227.

8. López-Rey 1963, 316.

9. Mayer 1936, 389; Gudiol 1974, 332, no. 89. The work is attributed to Mazo by Soria 1945, 214; in Kubler and Soria 1959, 388, n. 10; and by Nina Ayala Malloy, letter, 12 March 1984, in NGA curatorial files. The painting is rejected by Lafuente Ferrari 1943, but included in appendix O by the publisher. Pantorba 1955, 226, and Camón Aznar 1964, 435–437, do not accept the attribution to Velázquez, and Camón believes the work to be Italian. Cook, "Spanish Painting," 79–80, was inclined to accept the authenticity, while recognizing the increasing doubt by other authorities.

10. López-Rey 1963, 316.

11. Allende-Salazar 1930, 301, identifies the sitter as Mazo, and Temboury Álvarez 1960, 433–434, as Cano.

References:

1889. Pazaurek, Gustav E. *Carl Skreta (1610–1674). Ein Beitrag zur Kunstgeschichte des XVII. Jahrhunderts.* Prague: 91, no. 162.

1902. Bredius, Abraham. "Ein vergessener Velázquez." *ZfbK* 13: 110, repro. 111.

1905. Gensel, Walther. *Velázquez. Des Meisters Gemälde.* Klassiker der Kunst. Stuttgart and Leipzig: 127, repro.

1907–1950. Thieme-Becker. 24: 301, s.v. "Mazo."

1914. Gensel, Walter, and Valerian von Loga. *Velázquez.* Klassiker der Kunst. Stuttgart and Berlin: 239, repro.

1925. Gensel, Walter, and Juan Allende-Salazar. *Velázquez. Des Meisters Gemälde.* Klassiker der Kunst. Berlin and Leipzig: 265, repro. 288.

1926. Ritschl, Hermann. *Katalog der erlaucht Gräflich Harrachschen Gemälde-Galerie in Wien.* Vienna: 129–130, no. 333.

1936. Mayer, August L. *Velázquez: A Catalogue Raisonné of the Pictures and Drawings.* London: 389, pl. 131.

1941. *Duveen Pictures in Public Collections of America.* New York: no. 228.

1943. Lafuente Ferrari, Enrique. *Paintings and Drawings of Velázquez. Complete Edition.* London and New York: appendix O, pl. 68.

1945. Cook, "Spanish Paintings:" 79–80, fig. 8.

1945. Soria, Martin S. Review of Enrique Lafuente Ferrari, *The Paintings and Drawings of Velázquez. AB* 27 (September): 214.

1952. Pita Andrade, José M. "Los cuadros de Velázquez y Mazo que poseyó el séptimo Marqués del Carpio." *AEA* 25: 227.

1955. Pantorba, Bernardino de [José López Jiménez]. *La vida y la obra de Velázquez; estudio biográfico y crítico.* Madrid: 226, no. 157.

1959. Kubler, George, and Martin Soria. *Art and Architecture in Spain and Portugal and Their American Dominions, 1500–1800.* Baltimore: 338, n. 10.

1960. Temboury Álvarez, Juan. "Alonso Cano y Velázquez." In *Varia Velázqueña.* 2 vols. Madrid, 1: 433–434, pl. 626.

1963. López-Rey, José. *Velázquez: A Catalogue Raisonné of His Oeuvre.* London: 316, pl. 386.

1964. Camón Aznar, José. *Velázquez.* 2 vols. Madrid, 1: 435–437, repro. 436.

1969. Asturias, M. A., and P. M. Bardi. *L'opera completa di Velázquez.* Milan: 111, no. 145, repro.

1974. Gudiol y Ricart, José. *Velázquez: 1599–1660.* Trans. Kenneth Lyons. London: 150, 332, no. 89.

Circle of Diego de Velázquez, *Pope Innocent X*, 1937.1.80

Circle of Diego de Velázquez

1937.1.80 (80)

Pope Innocent X

c. 1650
Oil on canvas, 49.2 x 41.3 (19⅜ x 16¼)
Andrew W. Mellon Collection

Technical Notes: The picture is on loosely woven plain-weave fabric which has had all tacking edges removed and is attached to a plain-weave lining fabric. The paint is of rather freely and broadly applied oils, ranging in consistency from rich pastes to heavy glazes of red. Under the visible image is an earlier composition of a man dressed in a fur-trimmed mozzetta, wearing a close fitting, fur-trimmed cap (fig. 1). His features are slightly lower than those of the man in the visible image. The eyes of the underlying portrait are blue, rather than black/brown as in the finished portrait. The paint used for the visible image is not noticeably more recent than the paint utilized for the underlying portrait. The paint and ground present an overall branched crackle pattern, which is shared by the upper and lower layers. There are scattered flake losses in the upper paint layer which extend only as far as the lower

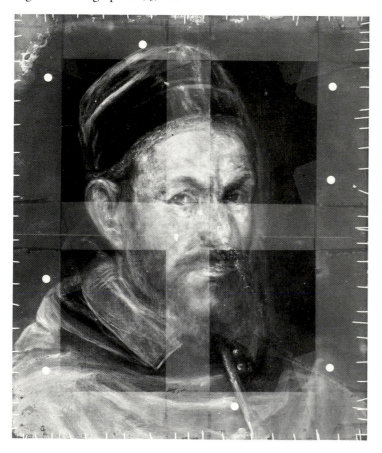

Fig. 1. X-radiograph of 1937.1.80

layer. Deeper, larger losses, which have fill or inpaint applied, are in the upper and lower left corners. It is unlikely that the portrait would present so uniform an appearance if the upper layer were added at a date much later than the original portrait. The varnish has an independent crackle pattern and is slightly opaque.

Provenance: Sir Robert Walpole [1676–1745], 1st Earl of Orford, Houghton Hall, Norfolk; his grandson, George Walpole [1730–1791], 3d Earl of Orford and 2d Baron Walpole, Houghton Hall, Norfolk; Catherine II of Russia, 1779, through Baron A. S. Moussine-Poushkin, Russian ambassador to England. Imperial Hermitage Gallery, Saint Petersburg (Leningrad), inv. no. 418; purchased 1930 (through Matthiesen Gallery, Berlin; P. & D. Colnaghi & Co., London; M. Knoedler & Co., New York) by Andrew W. Mellon, Pittsburgh and Washington; deeded 30 March 1932 to The A. W. Mellon Educational and Charitable Trust, Pittsburgh.

Exhibitions: *Spanish Painting*, The Toledo (Ohio) Museum of Art, 1941, no. 66.

INNOCENT X (Giovanni Battista Pamphili) was born in Rome on 6 May 1574,[1] was made a cardinal in 1627, and succeeded Urban VIII as pope on 15 September 1644. Innocent X supported the policies of the Spanish Hapsburgs, unlike his predecessor, who sided with Louis XIII, king of France. His reforms were directed to the revitalization of monastic discipline and the condemnation of Jansenism. He was an important patron of the arts and, among many projects, commissioned Bernini to make the Fountain of the Four Rivers in the Piazza Navona, Rome. Innocent X died on 7 January 1655 and was succeeded by Alexander VII.

The Gallery's painting is obviously related to the famous *Portrait of Innocent X* (fig. 2), painted by Velázquez either in 1649 or 1650, during his second trip to Italy.[2] The original subject is represented in three-quarter length, seated on a high-backed chair against a background of crimson drapery, whereas the Washington version shows only the head and shoulders. It has been suggested that the abbreviated representation is related to the Roman picture in one of three ways: as a preliminary study, an autograph replica, or a reduced copy by another hand.

Beginning with Stirling-Maxwell, the majority of writers have considered the painting to be a prelimi-

Fernando Yáñez de la Almedina

active 1505 – 1531

THE career of Yáñez has always been linked with that of his nearly homonymous collaborator, Fernando de Llanos, the two of whom are known in the history of Spanish art as the "dos Fernandos." Although they were natives of La Mancha, they studied in Florence in the early years of the sixteenth century, where they were strongly influenced by the art of Leonardo da Vinci. Yáñez, as is argued below, is almost certainly the person called "Ferrando spagnolo," who is documented in 1505 as assisting Leonardo in the execution of his fresco in the Sala del Consiglio, Palazzo Vecchio.

The two painters arrived in Valencia in 1506 and collaborated on various projects over the next six or seven years. Their major work was a series of twelve large panel paintings for the high altar of the Valencia Cathedral, executed between 1507 and 1510. The division of labor, and thus the character of their individual styles, has been the subject of much discussion. In the entry that follows, it is argued persuasively that Yáñez was the assistant of Leonardo and is in fact the author of the panels now usually ascribed to Llanos. As a result, Llanos emerges as the more progressive and original of the two painters, while Yáñez remained closely tied to the art of Leonardo.

The collaboration of Yáñez and Llanos lasted until about 1513, when they began to pursue independent careers. Yáñez was in Barcelona in 1515, and then apparently returned to Valencia, where he remained until approximately 1523. By that time, Llanos had moved to Murcia and worked in the region of this city for the rest of his life. (His date of death is not known.)

Around 1523, Yáñez returned to his native village of La Almedina (Ciudad Real), but on 17 March 1525 he is documented in Cuenca. Here he was employed by a canon of the cathedral, Gómez Carrillo de Albornoz, in the decoration of the family chapel, for which he produced three altarpieces. These were completed by 1536 if not before. The date of the artist's death and his whereabouts after 1531 are yet to be discovered.

Yáñez and Llanos were the first non-Italian painters to assimilate the style of the High Renaissance and to practice it in a foreign land. Their paintings for the main altar of the Valencia Cathedral are generally regarded as among the masterpieces of Spanish painting of the first half of the sixteenth century and are also an important milestone in the history of the diffusion of the Italian High Renaissance.

J.B.

Bibliography

Post, Chandler R. *A History of Spanish Painting.* 14 vols. Cambridge, 1953, II: 175–276.

Garín Ortiz de Taranco, Felipe M. *Yáñez de la Almedina.* Valencia, 1954 (also 1978 ed.).

Ibáñez Martínez, Pedro M. "Un nuevo documento sobre Fernando Yáñez de la Almedina." *Boletín del Museo e Instituto Camón Aznar* 26 (1986): 111–122.

1925. Gensel, Walter, and Juan Allende-Salazar. *Velázquez: des Meisters Gemälde*. Klassiker der Kunst. Berlin and Leipzig, 130, 282.

1926. Kehrer, Hugo. *Spanische Kunst von Greco bis Goya*. Munich: 132–133.

1930. Kehrer, Hugo. "Koepfe des Velázquez." *Estudios eruditos in memoriam de Adolfo Borilla y San Martín*. Madrid, 2: 373.

1930. Lunacharsky, A. V. *Selected Works of Art from the Fine Art Museums of the U.S.S.R: Pictures by European Masters and Russian Painters of the XVII and XIX Centuries*. Moscow: not paginated, color repro.

1936. Mayer, August L. *Velázquez: A Catalogue Raisonné of the Pictures and Drawings*. London: 96, no. 411, pl. 138.

1938. Cortissoz, Royal. *An Introduction to the Mellon Collection*. Privately printed: 9, 41–42, repro. facing 42.

1940. Mayer, August L. *Velázquez*. Paris: 20.

1941. NGA: 207, no. 80.

1942. Sánchez Cantón, Francisco J. "Como vivía Velázquez: inventario descubierto por D. F. Rodríguez Marín." *AEA* 15: 75, 81.

1943. Lafuente Ferrari, Enrique. *Paintings and Drawings of Velázquez: Complete Edition*. London and New York: 27, no. 97, pl. 122.

1944. Cairns and Walker: 78–79.

1945. Cook, "Spanish Paintings:" 76–78, fig. 7.

1945. Soria, Martin S. Review of Enrique Lafuente Ferrari, *The Paintings and Drawings of Velázquez*. AB 27 (September): 214.

1948. López-Rey, José. Review of *Archivo Español de Arte (1940–1946)*. GBA 33 (January-June): 60.

1955. Pantorba, Bernardino de [José López Jiménez]. *La vida y la obra de Velázquez: estudio biográfico crítico*. Madrid: 178–180, no. 99, fig. 99.

1956. Kapterewa, Tatjana. *Velázquez und die spanische Porträtmalerei*. Leipzig: 93, fig. 98.

1957. Gerstenberg, Kurt. *Diego Velázquez*. Würzburg: 155–156, repro. 153, no. 138.

1958. Gaya Nuño, *La pintura española*: 324–325, no. 2861.

1958. Harris, Enriqueta. "Velázquez en Roma." *AEA* 31: 187.

1960. Walker, John. "Velázquez and Visualistic Painting." In *Varia Velázqueña*. Madrid: 174.

1963. López-Rey, José. *Velázquez: A Catalogue Raisonné of His Oeuvre*. London: 274–275, no. 448, pl. 360.

1964. Camón Aznar, José. *Velázquez*. 2 vols. Madrid, 2: 730, 940, 1005, repro. 730.

1965. NGA: 134, no. 80.

1968. López-Rey, José. *Velázquez' Work and World*. London: 126.

1968. NGA: 121, no. 80.

1969. Asturias, M. A., and P. M. Bardi. *L'opera completa di Velázquez*. Milan: 107a, repro.

1973. Crombie, Theodore. "The Legacy of Victoria: Spanish Paintings at Apsley House." *Apollo* 98 (September): 213.

1974. Gudiol y Ricart, José. *Velázquez 1559–1660*. Trans. Kenneth Lyons. New York: 267, 281, 337, no. 137, fig. 207.

1974. Hendy, Philip. *European and American Paintings in the Isabella Stewart Gardner Museum*. Boston: 272–273.

1979. López-Rey (see Biography): 128.

1979. McKim-Smith, Gridley. "On Velázquez's Working Method." *AB* 61: 594–597.

1986. Brown (see Biography): 297, n. 24.

the known copies show the summer costume, a few depict the ermine trim used in the winter season.[10] Perhaps the latter versions, and the Washington picture, were based on a now-lost original preliminary sketch by Velázquez, which he never bothered to alter. Obviously the painter of the Gallery's canvas, which is one of the better copies, had access to the finished work or an accurate replica, which led him to revise the painting soon after finishing it, as is indicated by the fact that the crackle pattern and composition and granularity of the pigments of both layers are quite similar.

J.B

Notes

1. For Innocent X, see J. S. Brusher, "Innocent X," *New Catholic Encyclopedia* (Washington, 1967), 7: 528–529.

2. For a discussion of the date, see Brown 1986, 197, 297, n. 24.

3. This view is held by the following: Stirling-Maxwell 1848, 3: 1402; Stirling-Maxwell 1855, 248; Stirling-Maxwell 1891, 4: 1586; Lefort 1888, 86; Beruete 1906, 86, who accepts only the head and neck as authentic; Calvert and Hartley 1908, 114–115, who express doubt about Velázquez' authorship of the costume; Mayer 1913, 2: 173; Gensel and von Loga 1914, 264, n. 168; Mayer 1924, 144; Allende-Salazar 1925, 130; Kehrer 1926, 132–133; Mayer 1936, 96, no. 411, suggesting the costume is partly by another hand; NGA 1941, 207, no. 80; Lafuente Ferrari 1943, 27; Cook, "Spanish Paintings," 76; Pantorba 1955, 178–180, no. 89; Kapterewa 1956, 93; Gaya Nuño, *La pintura española*, 324–325, no. 2861, vestments not by Velázquez; Camón Aznar 1964, 2: 730, 940, 1005; Gudiol 1974, 267, 281, 337, no. 137; Hendy 1974, 273. McKim-Smith 1979, 595, pls. 12–13, published two sketches in pen and brown ink which are cautiously identified as Velázquez' preliminary studies for the portrait of Innocent X.

4. Antonio Palomino, *El museo pictórico y escala óptica: tomo tercero, el Parnaso español pintoresco laureado* (1724; Madrid, 1947), 912.

5. Harris 1958, 186. Writing in 1656, the court musician Lazáro Díaz del Valle mentioned a portrait by Velázquez of Innocent X, but left doubt about whether it was brought to Spain; cited by Harris 1958, 187.

6. Sánchez Cantón 1942, 75.

7. For the version in the Wellington Museum, which is now generally if somewhat unenthusiastically accepted as autograph, see C. M. Kauffmann, *Catalogue of Paintings in the Wellington Museum* (London, 1982), 142–144, no. 185. Among those who have identified the Washington picture as the autograph replica are the following: Curtis 1883, 77, no. 186; Justi 1888, 2: 191; Sánchez Cantón 1942, 75. Harris 1958, 187, is noncommittal, but omits mention of the painting in her study of 1982.

8. The attribution to Velázquez is rejected by Soria 1945, 214 (reasons given in full in letter, 3 April 1945, in NGA curatorial files); López-Rey 1963, 274–275; López-Rey 1968, 126, where it is regarded as a "copy of a copy," an opinion repeated in López-Rey 1979 (see Biography), 128; and Brown 1986 (see Biography), 297, n. 24. Mention of the painting is omitted in the studies of Elizabeth Du Gué

Trapier, *Velázquez* (New York, 1948), who on page 308 implicitly rejects the authenticity of all existing replicas, and Harris 1982 (see Biography), who accepts the version in the Wellington Museum.

9. Red velvet trimmed with white ermine was reserved exclusively for the use of the pope; thus, the underlying image can only represent a papal subject. The change from the winter to summer costume occurred at Easter, and from summer to winter, between All Saints' Day (1 November) and the Feast of Saint Catherine (25 November). See John A. Nainfa, *Costume of Prelates of the Catholic Church According to Roman Etiquette* (New York, 1909), 34; Xavier Barbier de Montault, *Le costume et les usages ecclésiastiques selon la tradition romaine*, 2 vols. (Paris, 1898–1901), 2: 55. Representations of the pope wearing his summer costume are almost unprecedented before the *Portrait of Innocent X* by Velázquez. I am grateful to Jennifer M. Kilian for bringing this information to my attention.

10. For example, see the one reproduced in López-Rey 1963, pl. 356, which is one of eleven copies in diverse formats catalogued by the author (nos. 447–457).

References

1752. Walpole, Horace. *Aedes Walpolianae: or a Description of the collection of pictures at Houghton Hall in Norfolk, the seat of Sir Robert Walpole, Earl of Orford*. London: 67 (also 1767 ed.: 67).

1848. Stirling-Maxwell, William. *Annals of the Artists of Spain*, 3: 1402 (also 1891 ed., 4: 1586).

1855. Stirling-Maxwell, William. *Velázquez and His Works*. London: 248 (also French ed. 1865: 286, no. 194).

1883. Curtis, Charles B. *Velázquez and Murillo, a Descriptive and Historical Catalogue....* London and New York: 77, no. 186.

1888. Justi, Carl. *Diego Velázquez und sein Jahrhundert*. Bonn, 2: 191 (rev. ed. 1903; 3d ed. 1933: 580; also English rev. ed. 1889: 580).

1888. Lefort, Paul. *Velázquez*. Paris: 86.

1891. Bruiningk, E., and Andrei Somoff. *Ermitage Impérial: catalogue de la galerie des tableaux, I; les écoles d'Italie et d'Espagne*. Saint Petersburg: 225–226, no. 418.

1898. Beruete y Moret, Aureliano de. *Velázquez*. Paris: 120–121, 207 (also English ed. 1906: 86, 88, 159, pl. 60).

1899. Somoff, Andrei Ivanovich. *Ermitage Impérial: catalogue de la galerie des tableaux, I; les écoles d'Italie et d'Espagne*. Saint Petersburg: 189, no. 418 (also 1909 ed.: 189–190, no. 418).

1905. Gensel, Walther. *Velázquez: des Meisters Gemälde*. Klassiker der Kunst. Stuttgart and Leipzig: repro. 74.

1906. Stevenson, R. A. M. *Velázquez*. London: 148.

1908. Calvert, Albert F., and C. Gasquoine Hartley. *Velázquez: An Account of His Life and Works*. London: 114–115, 218.

1909. Wrangell, Baron Nicolas. *Les chefs-d'oeuvre de la galerie de tableaux de l'Ermitage Impérial à St-Petersbourg*. London, Munich, and New York: x, xxxi, fig. 45.

1913. Mayer, August L. *Geschichte der spanischen Malerei*. 2 vols. Leipzig, 2: 173 (also 1922 ed.: 414).

1914. Gensel, Walter, and Valerian von Loga. *Velázquez, des Meisters Gemälde*. Klassiker der Kunst. Stuttgart and Berlin: 264, n. 168, repro. 168.

1924. Mayer, August L. *Diego Velázquez*. Berlin: 141–144, fig. 80.

nary study.[3] However, as early as 1724, Palomino noted that Velázquez had brought a copy, presumably autograph, with him when he returned to Madrid in 1651.[4] The existence of this copy is confirmed by a contemporary source, the Nuncio Giulio Rospigliosi, in a letter to Cardinal Pamphili in Rome dated 8 July 1651, in which he states that the artist had returned from Italy bringing with him "a portrait closely resembling His Holiness which has greatly pleased His Majesty."[5] In the artist's death inventory, there is listed an unattributed "Portrait of Pope Innocent X," although it is not certain that this is the same work mentioned in 1651.[6] Two paintings often have been identified with this work: the Gallery picture and a somewhat larger version in the Wellington Museum, London (fig. 3).[7] However, beginning with Soria in 1945, the Washington painting has usually been classified as a copy in reduced format made by an anonymous artist.[8]

The conspicuous weaknesses in technique and execution indicate that the painting is not the work of Velázquez. The painter of the Washington picture has faithfully reproduced the original in the placement of shadows and highlights below the lower lip, at the bridge of the nose, in the hat, and around the eyes. In comparison with the original, the brushwork is labored, lacking the sure, light touch of the master, as is especially noticeable in the flaccid treatment of the ear and forehead. The sitter's complexion is too ruddy, and the copyist has failed to reproduce the glancing effect of light on the head and the brilliant reflections on the mozzetta. The attempt to replicate the slightly parted lips is also poor, reducing this telling passage to two rigid, parallel lines and diminishing the intensity and subtlety of the expression found in the original.

As can be observed with the naked eye, and even more clearly in x-radiograph (fig. 1), the portrait has been considerably reworked. The numerous changes in design are in principle more characteristic of a preliminary study than a copy, which presumably would not require the artist to make substantial alterations in composition. However, there is another possible explanation for the changes. As the x-radiograph shows, in the original image the pope was wearing his winter costume, which is trimmed with ermine along the edge of the hood and down the front closure of the mozzetta. His cap (*camauro*) fits more closely to his head and also is trimmed in ermine. This costume does not correspond to the summer costume worn by the pope in the original, which lacks the ermine trim.[9] The reason for the discrepancy in the costume is difficult to explain. While most of

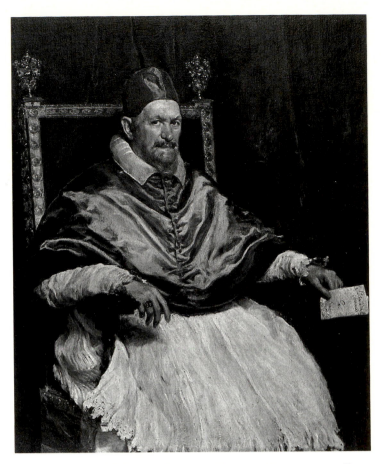

Fig. 2. Diego de Velázquez, *Portrait of Innocent X,* 1649-1650, oil on canvas, Galleria Doria-Pamphili, Rome

Fig. 3. Diego de Velázquez, *Innocent X,* 1649-1650, oil on canvas, Wellington Museum, London

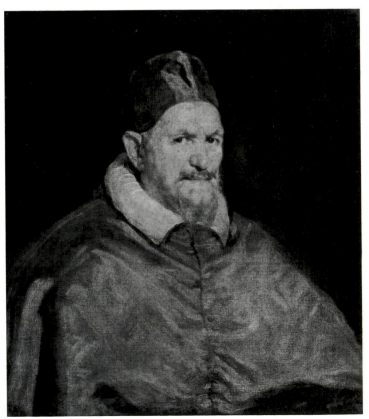

Attributed to Fernando Yáñez de la Almedina

1939.1.305 (416)

Madonna and Child with the Infant Saint John

c. 1505
Tempera and oil on wood, 78.4 x 64.1 (30⅞ x 25¼)
Samuel H. Kress Collection

Technical Notes: Reported as having been cradled, cleaned, and restored by Stephen Pichetto in 1938/1939, the picture is in very good condition, with losses confined mainly to the top and bottom edges of the original panel. A small triangular inset fills the lower right corner. Some unevenness in the paint along the left edge is due to wood knots. The red underpaint of the Madonna's blue robe was evidently meant to show through, as the surface is scored. The artist appears to have used a mixed medium, perhaps alternating tempera and oil layers.

Provenance: Sir Giles Sebright, Beechwood, Boxmoor and London (sale, Christie, Manson & Woods, London, 2 July 1937, no. 110); Bellesi. (Contini Bonacossi, Florence); purchased 1938 by the Samuel H. Kress Foundation, New York.

THIS PAINTING is so Leonardesque that when it first appeared on the art market in 1937 it was attributed to Leonardo himself. No mere pastiche, the composition effectively combines at least three different prototypes in the master's work. The most obvious debt to Leonardo involves the infant Baptist, whose kneeling figure derives from its counterpart in the *Madonna of the Rocks*.[1] The facial types and *contrapposto* of the Virgin and the Christ Child, the former seated on a rocky ledge and making a gesture of wonderment and the latter turning away from his mother, were similarly inspired by the lost *Madonna of the Yarnwinder*.[2] Leonardo's original, documented as underway in Florence in 1501, is known today mainly in the form of painted copies, including one in reverse in which the figures are oriented as in the Gallery's painting.[3] The pose of the Christ Child, moreover, on his mother's lap, recurs in Raphael's most Leonardesque painting, the *Bridgewater Madonna* of about 1507, and in a related group of drawings by the Umbrian master.[4]

The third identifiable Leonardo source for the Washington picture is also lost, a cartoon or painting

of the two holy children embracing, the existence of which can be postulated from a Leonardo sketch at Windsor Castle and from a large number of copies and variants by both central and north Italian artists.[5] Though perhaps only indirectly accessible, Leonardo's composition seems to have been especially popular north of the Alps.[6] It is worth noting that one of the derivations, a tondo attributed by Berenson to the Sienese Girolamo del Pacchia, appears particularly close to the Gallery painting in style as well as design.[7]

The general theme underlying all of these Leonardesque productions, that of the Christ Child embracing his fate in the form of a lamb or the infant Baptist, who later prophesied the Savior's self-sacrifice, was explored by Leonardo in several works – notably the London National Gallery cartoon and the Louvre *Virgin and Child with Saint Anne* – dating from around the turn of the century, which profoundly affected the course of devotional art.[8]

Unlike the figures, the bright landscape in the Washington picture has nothing to do with Leonar-

Fig. 1. Leonardesque Master (Fernando de Llanos?), *Madonna and Child with a Lamb*, Pinacoteca di Brera, Milan

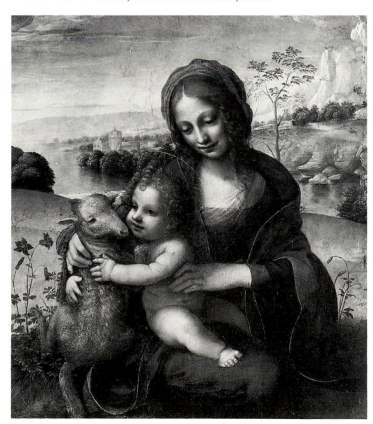

do; it employs the type of setting that artists working in Florence, like Fra Bartolomeo or Raphael, adapted from Flemish painting. The thematic relevance, if any, of the tiny background figures, one running and pointing at another seated on a rock, his head tilted back drinking from a flask, is unclear.

After the *Madonna and Child with the Infant Saint John* came to light, it was unanimously ascribed to Sodoma during the period of his activity in Florence, about 1505.[9] The attribution was based not on specific comparisons to Sodoma's work but rather on the resemblance the Washington painting bears to a better-known work (fig. 1) in the Pinacoteca di Brera, Milan, likewise ascribed to the artist, representing the Christ Child seated on his mother's lap and turning to grasp a lamb instead of the little Saint John. In recent years the Sodoma designation for the Brera panel was abandoned,[10] and the same has occurred for its analogue in Washington, with scholars tentatively suggesting Bugiardini or some other painter who could have known Leonardo's art in Florence in the first decade of the sixteenth century.[11] If none of the candidates so far proposed has proved convincing, it might be because the author of the Washington painting is not Italian.

The picture has been attributed verbally to Fernando de Llanos, the Spanish artist who is believed to have assisted Leonardo in painting the mural (subsequently destroyed) of the *Battle of Anghiari* for the council hall of the Palazzo Vecchio in Florence.[12] In support of this attribution, the Virgin and Child in the Gallery's picture were likened to their counterparts in the *Rest on the Flight into Egypt* (fig. 2), one of twelve panels making up the shutters of the *retablo* over the high altar of Valencia Cathedral, which Llanos completed, together with the second major Spanish Leonardesque painter, Fernando Yáñez, after their return to Spain, between 1507 and 1510.[13] The figures in the Washington and Valencian paintings so closely resemble each other, in fact, that there can be no question that both are by the same hand.

The *Rest on the Flight into Egypt* is linked in turn with other stylistically consonant shutter compartments, namely, the *Adoration of the Magi*, the *Resurrection*, and *Pentecost* on the exterior (fig. 3), and the *Birth of the Virgin* on the interior. These panels are closely dependent upon well-known Leonardo models and yet are highly personal.[14] The additional compartments, by contrast, are more monumental in style and reveal a wider range of Florentine influences. Their author had obviously mastered the new High Renaissance idiom being created in these very years in Florence, whereas his collaborator evidently remained faithful to his own personal notion of Leonardo.

To the group formed by the five Valencian panels cited above and the Gallery's *Madonna* may be added two further works: the tondo of the *Madonna and*

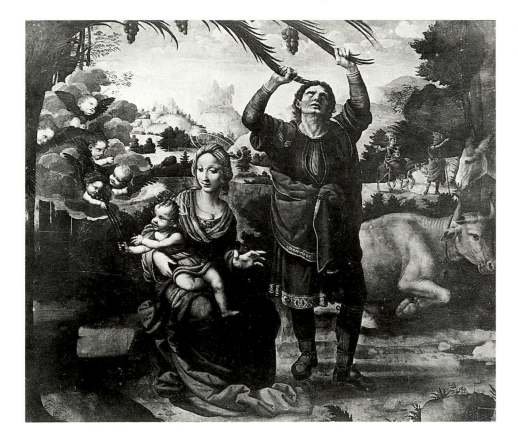

Fig. 2. Here attributed to Fernando Yáñez, *Rest on the Flight into Egypt*, Cathedral, Valencia

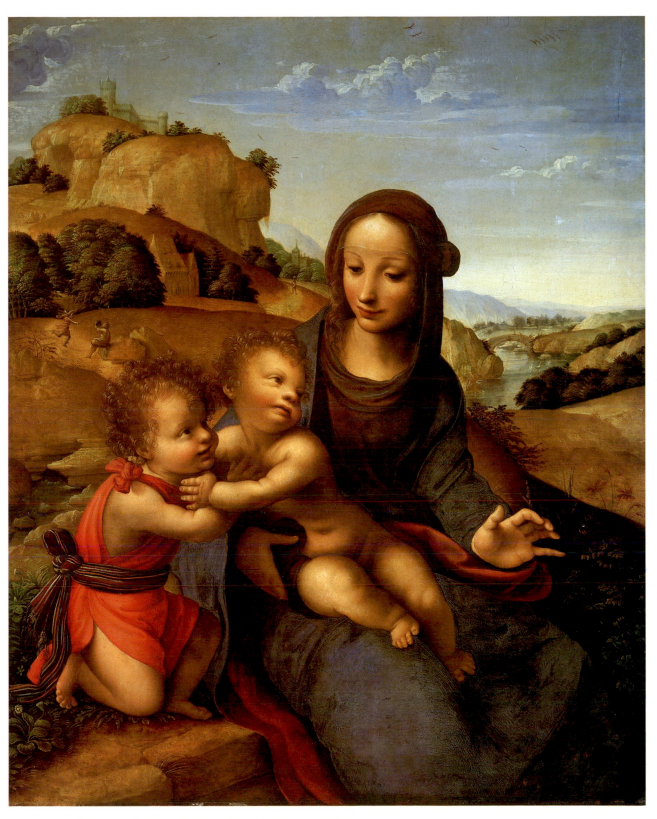

Attributed to Fernando Yáñez de la Almedina, *Madonna and Child with the Infant Saint John*, 1939.1.305

Fig. 3. Fernando Yáñez and Fernando de Llanos, High Altar, Cathedral, Valencia

Child with the Two Infant Saint Johns, already mentioned in connection with the Washington picture, and a painting of the *Two Holy Infants* identified by a photograph in the Fototeca at Villa I Tatti, Florence, as belonging to Paul Clemen in Bonn.[15] These three highly Leonardesque paintings, assuming that they were not made in Valencia, would constitute a provisional Italian oeuvre for their author before he returned to Spain, where he undertook the great altarpiece project.[16]

The master in question is usually identified as Fernando de Llanos—the name given, we have seen, to the Washington painting—as he is presumed to have been the "Ferrando Spagnolo" paid for having assisted Leonardo with the Florentine battlepiece in 1505.[17] The difficulty with this proposition is first, that the documents could refer to either of the two Spanish painters of the same name; and second, that the division of labor between Llanos and Yáñez on

the altar shutters has not yet been definitely established.[18] In fact, contrary to what is generally believed, the Washington painting and the Valencia panels most influenced by Leonardo actually appear to bear a more cogent relation to Yáñez' later independent work in Cuenca and elsewhere than they do to the later production of Llanos. In particular, the Virgin's foreshortened left hand gesture in the Washington painting became a personal mannerism of Yáñez, recurring not only in the *Pentecost*, already cited, but also in the *Lamentation* in Valencia Cathedral. Likewise, elements of the Virgin's figure—her facial type, affected smile, and twisted posture—were adopted for her counterparts in Yáñez' *Virgin and Child with Saint Anne* in the Prado, the *Annunciation* in the Colegio del Corpus Christi in Valencia, and the *Lamentation* in Cuenca. The plants growing on the ledge in the National Gallery's painting resemble those on the left in Yáñez' *Visitation* in Cuenca Cathedral, and indeed the treatment of landscape as hilly verdant terrain, articulated by walled castles and towns and bodies of water, is consistent throughout the artist's oeuvre.

These and further comparisons that could be made point to Yáñez as the author of the Washington panel, but a definite attribution to the Spanish master must await a more thorough study of his work. In the meantime, it is worth noting that the Brera *Madonna and Child with a Lamb*, repeatedly linked with the Washington panel, is, although not by the same hand, unquestionably related in style; on further investigation it may turn out to have been produced in Italy by Yáñez' partner, Fernando de Llanos, as is suggested by parallels with the less Leonardesque Valencia altar panels (the *Visitation* and the *Meeting at the Golden Gate*, for example), which appear to this author to be his work.[19]

David A. Brown

Notes

1. For another case of borrowing of Leonardo's motif, see David Alan Brown, "Raphael's *Small Cowper Madonna* and *Madonna of the Meadow*: Their Technique and Leonardo Sources," *artibus et historiae* 8 (1983), 21–22, figs. 2, 10–13.

2. As noted by Shapley 1979, 184; Trutty-Coohill 1982, 280–281.

3. William Suida, *Leonardo und sein Kreis* (Munich, 1929), figs. 132, 133. In two variants, the turning child looks back at the Virgin, as in the Washington picture (J. Byam Shaw, *Paintings by Old Masters at Christ Church Oxford* [London, 1967], 57, no. 54, pl. 55; Walter Read Hovey, *Treasures of the Frick Art Museum* [Pittsburgh, 1975], 55).

4. See, for one example, Paul Joannides, *The Drawings of Raphael* (Berkeley and Los Angeles, 1983), 70, pl. 19.

5. Kenneth Clark, with Carlo Pedretti, *The Drawings of*

Leonardo da Vinci in the Collection of Her Majesty the Queen at Windsor Castle, 3 vols., rev. ed. (London, 1968), 1: 107–108, no. 12564. Though Clark calls the sketch a studio copy, it appears to me to be autograph. Leonardo's followers often added a Madonna to the pair of children (Suida 1929, figs. 290, 291, 296, 316). Other examples, many of them close in design to the Washington painting, are by the following Tuscan artists: Filippino Lippi (Alfred Scharf, *Filippino Lippi* [Vienna, 1950], 55, fig. 81); Piero di Cosimo (Mina Bacci, *Piero di Cosimo* [Milan, 1966], 80–81, pl. 20); Signorelli (Bernard Berenson, *The Drawings of the Florentine Painters*, 3 vols. [Chicago, 1938], 2: 331, no. 2509D8, fig. 116); Fra Bartolomeo (Christie, Manson & Woods, London, 29 June 1979, no. 124); Michele di Ridolfo (Federico Zeri, *Italian Paintings in the Walters Art Gallery*, 2 vols. [Baltimore, 1976], 2: 335–336, no. 217, pl. 155); Beccafumi (Donato Sanminiateli, *Domenico Beccafumi* [Milan, 1967], 81, 98, nos. 10, 39, figs. 10, 39); Perino del Vaga? (Paola Della Pergola, *Galleria Borghese. I Dipinti*, 2 vols. [Rome, 1959], 2: 105, no. 153, fig. 153). North Italian versions are by Parmigianino (Sydney J. Freedberg, *Parmigianino: His Works in Painting* [Cambridge, Mass., 1950], 182–184, fig. 74); Luini (Angela Ottino della Chiesa, *Bernardino Luini* [Novara, 1956], 65, 89, nos. 9, 102, figs. 43, 114); Lotto (Bernard Berenson, *Lorenzo Lotto* [New York, 1956], 48, fig. 111); Caroto (Maria Teresa Fiorio, *Giovan Francesco Caroto* [Verona, 1971], 99, no. 46, fig. 52); and even the Venetian Palma Vecchio (Philip Rylands, *Palma il Vecchio* [Milan, 1988], 196, no. 6.

6. Ilse Hecht, "The Infants Christ and St. John Embracing: Notes on a Composition by Joos van Cleve," *Apollo* 230 (April 1981), 222–223.

7. Bernard Berenson, *Italian Pictures of the Renaissance: Central Italian and North Italian Schools*, 3 vols. (London and New York, 1968), 1: 307; 3: pl. 1563. The present whereabouts of the painting, formerly in the Fairfax Murray collection, London, is unknown. Dalli Regoli 1984, 10, fig. 9, identifies the third infant in the picture as Saint John the Evangelist. Comparison with similar treatments of the theme by Pacchia (*The Bob Jones University Collection of Religious Paintings* [Greenville, S. C., 1968], 10, 75, no. 219, fig. 219; Christie, Manson & Woods, London, 28 March 1969, no. 59) does not bear out Berenson's attribution to that master.

8. Dalli Regoli, 1984.

9. Unpublished MS attributions to Sodoma by Bernard Berenson, Roberto Longhi, F. M. Perkins, William Suida, and Adolfo Venturi, dating from about 1937, are in NGA curatorial files. The picture appears as Sodoma's work in Gallery publications up to 1978 and in Berenson 1968, 1: 409.

10. Marani 1987, 115–123, no. 14, who provides the fullest discussion and bibliography of the picture, tentatively ascribes it to Cesare da Sesto.

11. After the Gallery's painting was doubted as Sodoma's by Fredericksen and Zeri 1972, 646, it was denied to him by Hayum 1976, 276, who claimed it was by a Florentine close to Bugiardini. After first concurring in the Sodoma attribution (Shapley 1968, 2: 144), Shapley also opted for the designation "Florentine School, Early XVI Century" (1979, 184–185).

12. According to Trutty-Coohill 1982, 279, Giovanni Romano and Mauro Lucco suggested the attribution.

13. For the complex attributional problems regarding the altar shutters, see the fundamental study of Chandler Post, *A History of Spanish Painting, Vol. 11; The Valencian School in the Early Renaissance* (Cambridge, Mass., 1953), 175–276; and, more recently, Felipe Garin Ortiz de Taranco, *Yáñez de la Almedina Pintor español*, 2d ed. (Ciudad Real, 1978).

14. The more Leonardesque panels are related to their sources by Elizabeth Du Gué Trapier, *Luis de Morales and Leonardesque Influences in Spain* (New York, 1953), 2–11, who gives them to Llanos.

15. Reproduced in Giorgio Nicodemi, "The Life and Works of Leonardo," in *Leonardo da Vinci* (1939; New York, 1956), 44.

16. A Leonardesque *Madonna* in the Kunsthaus Zürich, which Suida 1929, 251–252, fig. 54, gave to Llanos, is now commonly ascribed to Francesco Napoletano (review by Francisco J. Sánchez Cantón in *AEAA* 5 [1929], 127).

17. Two payments (30 April and 31 August 1505) are recorded for a "Ferrando Spagnolo dipintore per dipingere con Lionardo da Vinci nella Sala del Consiglio" (Luca Beltrami, *La vita e le opere di Leonardo da Vinci* [Milan, 1919], 99–100, no. 165). He is also identified thus c. 1540 by the chronicler known as the Anonimo Gaddiano (Beltrami 1919, 162, 254).

18. Carl Justi, "Das Geheimnis der leonardesken Altargemälde in Valencia," *RfK* 16 (1893), 1–10, correctly divided the shutters between Yáñez and Llanos, though in a republication of 1908 he changed his views to conform with those of E. Bertaux, "Le Retable de la Cathédral de Valence," *GBA* 38 (April 1907), 103–130. The borrowings from the *Battle of Anghiari* in the Valencia *Resurrection* suggest that Yáñez, proposed here as the author of this work, was the "Ferrando Spagnolo" who assisted Leonardo with the mural.

19. I have already tentatively proposed that the Washington painting may be by one or the other of the two Fernandos (see Marani 1987, 120, 123), though I cited Llanos erroneously in this connection.

References

1941. NGA: 188–189.

1942. NGA: 190, repro.

1945. Kress: 115.

1959. Kress: 86.

1968. Berenson, Bernard. *Italian Pictures of the Renaissance: Central Italian and North Italian Schools*. 3 vols. London, 1: 409.

1968. Shapley: 144.

1972. Fredericksen, Burton B., and Federico Zeri. *Census of Pre-Nineteenth Century Italian Paintings in North American Public Collections*. Cambridge, Mass.: 189, 337, 646.

1976. Hayum, Andrée. *Giovanni Antonio Bazzi – "Il Sodoma."* New York and London: 276.

1979. Shapley: 184–185, pl. 128, 128a.

1982. Trutty-Coohill, Patricia. "Studies in the School of Leonardo da Vinci: Paintings in Public Collections in the United States with a Chronology of the Activity of Leonardo and His Pupils and a Catalogue of Auction Sales." Ph.D. diss., Pennsylvania State University: 279–285.

1983. *Leonardo e il Leonardismo a Napoli e a Roma*. Exh. cat., Palazzo Barberini (Rome). Florence, 1983: 65, fig. 60.

1984. Dalli Regoli, Gigetta. *La preveggenza della vergine*. Pisa: 12, 39, fig. 28.

1985. NGA: 377.

1987. Marani, Pietro C. *Leonardo e i Leonardeschi a Brera*. Florence: 120, 123.

Francisco de Zurbarán Márquez (or Salazar)

1598 – 1664

FRANCISCO DE ZURBARÁN was born in Fuentedecantos, a village in the region of Extremadura. After his apprenticeship in Seville, which lasted from 1616 to 1619, he settled in Llerena, a market town in Extremadura. In 1626 he received a commission from the Dominicans of San Pablo, Seville, and began to establish his reputation in the metropolis, to which he moved in 1630. During the next ten years, he became the leading painter of Andalusia and received many important commissions, of which the most noteworthy are those from the Cartuja of Jerez de la Frontera and the Hieronymites of Guadalupe (both in progress 1638). He also established a workshop that provided pictures to clients in southern Spain and the New World.

During the 1640s, as his work for monastic clients diminished, Zurbarán and his shop increasingly produced pictures for the Indies trade, which had a great impact on the development of painting in the Spanish colonies.

Zurbarán's popularity began to wane in the mid-1650s, as the newer styles of Murillo and Francisco de Herrera the Younger gained favor with Sevillian clients. The artist moved to Madrid in 1658, where he died in 1664 in relatively reduced circumstances.

Zurbarán is regarded as the quintessential Spanish religious painter of the first half of the seventeenth century. Through the use of brilliant colors, monumental compositions, and penetrating realism, he was able to capture as few have done the solemn and sincere spirituality of his monastic and other religious patrons.

J.B.

Bibliography

Soria, Martin S. *The Paintings of Zurbarán*. London, 1953.
Guinard, Paul. *Zurbarán et les peintres espagnols de la vie monastique*. Paris, 1960.
Brown, Jonathan. *Francisco de Zurbarán*. New York, 1974.
Baticle, Jeannine. *Zurbarán*. Exh. cat., The Metropolitan Museum of Art; Grand Palais, Paris. New York, 1987.

1943.7.11 (748)

Saint Lucy

c. 1625–1630
Oil on canvas, 105 x 77 (41⅛ x 30¼)

Inscriptions:
At upper left: *S. LVCIA*

Technical Notes: The painting is on a rather coarse, fairly open-weave fabric and is lined with an aqueous adhesive to fabric. The tacking margins have been cut off, and there is cusping of the fabric support on the right and bottom edges. There is a white ground layer over which an oil-type paint is applied wet into dry. It is relatively thinly applied with a certain amount of impasto in the flowers and some highlights. The original fabric is highly dessicated, and the condition of the paint layer suggests that there was once severe flaking overall. The existing losses are small but numerous, and many are filled with inpainting and discolored varnish. Also, the paint surface is abraded throughout and covered with a thick, discolored varnish. Discolored residues of old varnish which appear in the green drapery are particularly disfiguring.

Provenance: Art market, Paris, 1927–1928.[1] Paul Somazzi, Izmir, Turkey; through Lily Bush, Philadelphia,[2] to (Ehrich Galleries, New York, 1930 or after); purchased February 1934 by Chester Dale, New York.

SAINT LUCY was born in Syracuse c. 283 and died a martyr c. 304. Her early biographies are considered to be largely legendary and do not mention the symbol with which she is usually represented in post-medieval art—a plate holding her eyes. This motif is based on a medieval addition to her legend, an act of torture in which her eyes were torn from her head but subsequently miraculously restored.

Although the attribution of the painting is generally accepted, there is disagreement about whether it was executed in the early or middle period of the artist's career. Mayer's[3] dating to the second half of the 1630s is accepted by Guinard,[4] while a date of around 1625–1626 is proposed by Soria.[5] Gudiol extends the possible date to around 1630.[6] The date of 1625–1630 seems more compatible with the style, which is characterized by sharp divisions between areas of light and shadow and by delicate brushwork.

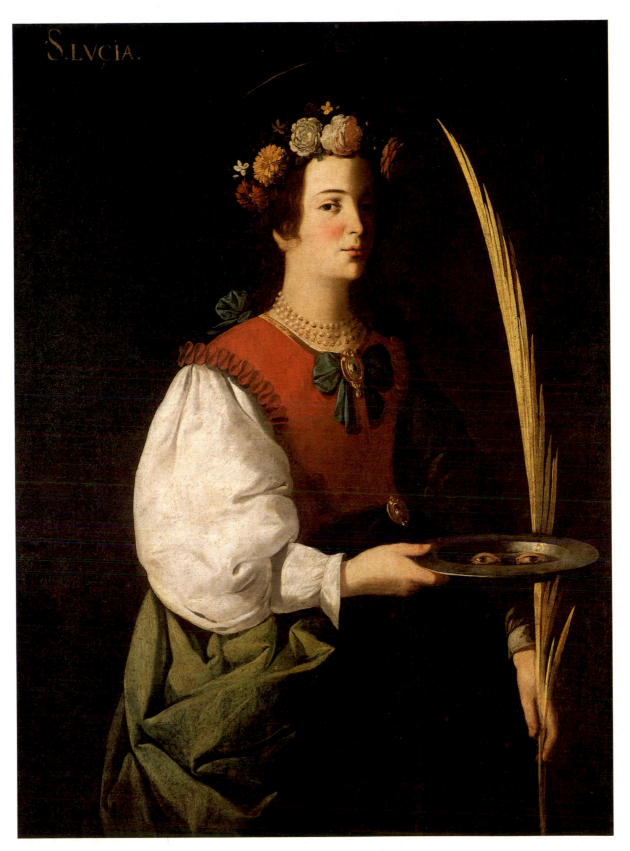

Francisco de Zurbarán, *Saint Lucy*, 1943.7.11

In particular, the play of light on the left side of the figure and the superb, taut handling of the palm frond set against the dark background are typical of the later 1620s. The same effects are used in the famous *Christ on the Cross* (The Art Institute of Chicago) of 1627, where the treatment of the face is especially close to *Saint Lucy*.

This appears to be the earliest example of the theme of the female martyr produced by the artist, although later, particularly after 1640, the subject was frequently painted by Zurbarán and his workshop.[7] Although attempts have been made to explain these pictures by reference to literary texts of the period, or to understand them as examples of disguised portraiture,[8] they do not seem to offer difficult problems of interpretation. Female saints clad in colorful costumes are to be found throughout the history of Christian art.[9] In Seville, the subject was often treated in paintings of the sixteenth and early seventeenth century. Some of these could have provided Zurbarán with models for this and later versions of the theme.[10]

Two other versions of Saint Lucy attributable to Zurbarán are known (Musée des Beaux-Arts, Chartres; Hispanic Society of America, New York), both showing the figure in full length. The pose in the Chartres version, but not the costume, is generally similar to the Washington picture. There is no reason to believe that the National Gallery's canvas has been reduced from a full-length format.

J.B.

Notes

1. Mayer 1928, 291–292.
2. Paul Somazzi, letter, 11 August 1930, in NGA curatorial files.
3. Mayer 1928, 291–292.
4. Guinard 1960 (see Biography), 240, no. 272.
5. Soria 1953 (see Biography), 7, 9. Soria 1944, 167, rejected the attribution to the master, but he reversed his opinion in Soria 1951, 256.
6. Gudiol 1977, 78, no. 51.
7. See Guinard 1960 (see Biography), 235–242, for numerous versions of the theme by Zurbarán and his workshop. Such paintings could be included in altarpieces (see, for example, Guinard 1960 [see Biography], 236, no. 240)

or installed in processional groups in churches, as discussed by Elizabeth du Gué Trapier, "Zurbarán's Processions of Virgin Martyrs," *Apollo* 85 (1967), 414–419. There is no indication of the purpose for which the Gallery's painting was intended.

8. The idea that the paintings are portraits of specific individuals seems to have originated in Théophile Gautier's poem of 1841, "En passant à Vergara," *Poésies complètes de Théophile Gautier*, ed. René Jasinski, 2d ed. (Paris, 1970), 2: 264. For a restatement, supported by literary texts, see Emilio Orozco Díaz, *Temas del barroco* (Granada, 1947), 31–35.

9. The point is made by Trapier 1967, 414. Nevertheless, numerous proposals of specific sources have appeared in the literature. Martin S. Soria, "Some Flemish Sources of Baroque Painting in Spain," *AB* 30 (1948), 256, believes that the elaborate costumes in some of the pictures are based on prints by Flemish artists such as Peter de Bailliu (1613–1660). María L. Caturla, *Francisco de Zurbarán* [exh. cat., Museo Provincial de Bellas Artes] (Granada, 1953), 42–43, suggests that the artist was inspired by religious processions and celebrations. Soria 1948, 256–257, doubts that the costumes reflect contemporary Spanish fashion; an opposite point of view is offered by the historian of costume, María J. Sáez Piñuela, "Las modas femininas del siglo XVII a través de los cuadros de Zurbarán," *Goya* 64–65 (1965), 288–289.

10. For examples, see the following: Hernando de Esturmio, *Saint Catherine and Saint Barbara*, Cathedral, Seville, 1555; Francisco Pacheco, *Saint Catherine*, Museo de Bellas Artes, Seville, 1605; Miguel de Esquivel, *Saint Justa and Saint Rufina*, Cathedral, Seville, c. 1615–1620, which has several points in common with *Saint Lucy*.

References

1927–1928. Mayer, August S. "Unbekannte Werke Zurbarans." *ZfbK* 56: 289–292, repro. 292.
1944. Soria, Martin S. "Francisco de Zurbarán: A Study of His Style." *GBA* 86: 33–48, 153–174, especially 167.
1945. Cook, "Spanish Paintings:" 82–83, fig. 10.
1951. Soria, Martin S. "Two Early Paintings by Zurbarán." *AQ* 14: 256–260, figs. 1, 3.
1953. Soria (see Biography): 9, 23, 133, no. 2, pl. 2.
1960. Guinard (see Biography): 240, no. 272, repro.
1965. National Gallery of Art. *Paintings Other than French in the Chester Dale Collection*. Washington: 10, repro.
1973. Gregori, Mina, and Tiziana Frati. *L'opera completa di Zurbarán*. Milan: 99, no. 168, pl. 26.
1977. Gudiol y Ricart, José, and Julián Gállego. *Zurbarán 1598–1664*. London: 78, no. 51, fig. 58.

Francisco de Zurbarán and Workshop

1952.5.88 (1167)

Saint Jerome with Saint Paula and Saint Eustochium

c. 1640/1650
Oil on fabric, 245.7 x 173.5 (96¾ x 68¼)
Samuel H. Kress Collection

Technical Notes: The picture is on a single piece of coarse, plain-weave fabric, lined with a modern plain-weave linen. In the treatment of 1951, the canvas additions squaring off the curved top were removed and the picture was returned to its original shape. A gray ground is visible through the paint film. There are numerous changes in the outer contours of figures and objects. The left side of Saint Jerome's mozzetta has been reduced by 2.5 cm; the right contour of the portion of his habit that falls beside the chair is moved 3 cm to the left; the head coverings of the female saints have a white under-layer at the outer perimeter and show many slight alterations at the bottom edges, including thin added layers of black which change the shape of the shoulder openings. There are losses through the paint and ground at various locations, especially across the knees of Saint Eustochium; in the right shoulder and elbow of the mozzetta; in the lower portion of Saint Paula's and Saint Jerome's habits; and under Saint Jerome's chair. The glazes modifying the folds of the habits are lightly abraded. The perimeters are heavily retouched, especially the left edge, which has a zone of retouch approximately 3 cm wide. The glazing of the architectural features behind Saint Jerome is badly abraded and rather broadly reglazed. Other small flake losses can be seen throughout, the result of the badly cupped paint film. A rather thick, glossy synthetic resin varnish is applied over the picture surface.

Provenance: Frank Hall Standish [1799–1840], Seville;[1] bequeathed to King Louis Philippe of France; his heirs (sale, Christie, Manson & Woods, London, 27–28 May 1853, no. 112);[2] Alphonse Oudry (sale, Hôtel Drouot, Paris, 16–17 April 1867, no. 157);[3] (sale, Hôtel Drouot, Paris, 10 April 1876, no. 60, for 715 francs).[4] Maximo Scioletti, Paris [d. 1951]; (M. Knoedler & Co., New York, and Pinakos, Inc. [Rudolf Heinemann], 1951);[5] purchased February 1952 (from M. Knoedler & Co., London) by the Samuel H. Kress Foundation, New York.[6]

Exhibitions: Galerie Espagnole du Musée Royal du Louvre, Paris, 1842–1848. *Zurbarán*, The Metropolitan Museum of Art, New York; Grand Palais, Paris, 1987–1988, 280–282, no. 57, repro. 281.

THE SUBJECT, which is rare in Christian art, shows Saint Paula (died c. 404) and her daughter, Saint Eustochium (died c. 419), in the company of Saint Jerome.[7] Saint Paula was a wealthy Roman who devoted herself to the service of Christ after the death of her husband at a young age. With her daughter she moved to Bethlehem, and together they placed themselves under the direction of Saint Jerome. They also founded a hospice and convent, which were regarded as the initial establishments of the Hieronymite Order (not founded, however, until the fourteenth century in Spain). Saint Paula became the abbess of the convent and, at her death, was succeeded by her daughter.

In this painting, the three figures wear the white and brown habit of the Hieronymite Order. Saint Jerome also wears a mozzetta, and behind him on the wall is a cardinal's hat. Although Saint Jerome (born c. 340–345) was traditionally represented as a cardinal, the dignity was not established until the end of the eleventh century. He and Saint Paula hold a book, presumably the Vulgate, Saint Jerome's Latin translation of the Bible, in which he was assisted by the two female saints.

After being exhibited in the famous Galerie Espagnole of the Louvre and at the two sales of the Oudry collection, the picture disappeared from view until it was acquired by the Kress Foundation. In 1953 it was published by Soria as an authentic work by Zurbarán.[8] Since then, opinions on the attribution have been divided. López-Rey believed that "two hands at least are noticeable in this canvas," presumably those of Zurbarán and an assistant.[9] Guinard classified the painting among those that might plausibly be attributed to Zurbarán, although in the catalogue entry he found the execution to be "fairly uneven," particularly the painting of the female saints' heads, and suggested the assistance of a pupil.[10] In the introductory text, he expressed even greater doubts and raised the possibility that it might be a workshop copy.[11]

In 1977 Eisler attributed the work to Zurbarán and assistants, assigning to the master the design and certain passages, notably Saint Jerome's extended hand.[12] Like López-Rey, he was troubled by the treatment of the drapery and, following Guinard, observed weaknesses in the painting of the female figures. This opinion was challenged by Young, who downgraded the painting to the status of a studio

work, believing that it might have been done by the same follower or assistant who painted the *Return from Egypt* (Toledo [Ohio] Museum of Art), which is in Zurbarán's manner.[13] Both Gudiol[14] and Baticle,[15] the most recent writers to consider the question, accept the picture as an autograph work by Zurbarán.

The attribution to Zurbarán alone seems difficult to sustain because of the many passages that are conspicuously weak. Especially notable in this respect is the handling of the drapery, which employs Zurbarán's formula without his skill. Saint Jerome's mozzetta exemplifies the point; the folds on the left arm are spongy and overelaborate, while the lower edge of Saint Paula's habit loses its sense of volume and is brushed with a broad, monotonous technique. Other passages, such as the stony expression of Saint Paula and the stiff, unarticulated drawing of the thumb resting against the book, are not paralleled in authentic works of the master.

Finally, the treatment of the background is indecisive and confused. It would appear that the artist was attempting to introduce some kind of architectural configuration behind Saint Jerome. Within the large gray area a rhomboidal section of darker gray is set at an angle, perhaps to indicate the presence of a door. But the drawing is inconclusive, leaving the viewer in doubt about the definition and intent of this area of the composition. Also, the transition from the wall to the cityscape is too abrupt. The absence of an intervening architectural element, such as a door frame, is entirely uncharacteristic of Zurbarán.

Nevertheless, the painting is an effective imitation of Zurbarán's style, which suggests that it was executed in his workshop. The numerous changes in the outer contours of the figures may indicate that the composition was established by Zurbarán and executed by an assistant.

Although the subject is often considered to be unique,[16] it was also painted by Zurbarán's contemporary, Francisco de Herrera the Elder, in the 1630s in a work for the Convent of Santa Paula, Seville.[17] This convent has been proposed as the original destination for the National Gallery's painting, on the grounds that the dedication of the convent explains the choice of the unusual subject. The existence of Herrera's version, which is still in situ, weakens this circumstantial link. It is possible, of course, that the convent possessed more than one version of the subject. Or perhaps the painting was done for another Hieronymite establishment, such as San Jerónimo de Buenavista, also in Seville.

Soria noted what he took to be a lion under Saint Jerome's chair, but this is simply an imaginative re-construction of the patches of surface damage in this area.[18]

J.B.

Notes

1. For Standish, see *Dictionary of National Biography* (London, 1898), 53: 472. Standish bequeathed his important collection of Spanish pictures and drawings to Louis-Philippe, who added them to the Galerie Espagnole of the Louvre, where they were displayed until 1848. See *Catalogue des tableaux, dessins et gravures de la collection Standish légués au roi par M. Franck [sic] Hall Standish* (Paris, 1842), 33, no. 161, where it is mistakenly identified as "Saint Dominique et deux religieuses."

2. *Catalogue des tableaux formant la célèbre collection Standish léguée à S. M. feu le Roi Louis Philippe par Mr. Frank Hall Standish*, 16, no. 112, as "Légende de Saint Dominique."

3. *Catalogue des tableaux anciens des écoles italienne, espagnole, hollandaise et flamande*, 57, no. 157, as "Évêque instruisant deux religieuses." The picture was apparently unsold because it was offered again by the same vendor in 1876.

4. *Catalogue des tableaux anciens et d'une fresque de Raphael dépendent des successions Oudry*, 25, no. 60, as "Évêque instruisant deux saintes religieuses."

5. This information, from the files of M. Knoedler & Co., is cited by Eisler 1977, 217.

6. A copy of the sale document dated 6 February 1952 is in NGA curatorial files.

7. For the subject and references to the sources, see Eisler 1977, 216.

8. Soria 1953 (see Biography), 182.

9. López-Rey 1954, 53.

10. Guinard 1960 (see Biography), 267.

11. Guinard 1960 (see Biography), 115.

12. Eisler 1977, 217.

13. Young, *Connoisseur* 195 (1977), 154; Young, *Connoisseur* 196 (1977), 69.

14. Gudiol and Gállego 1977, 105.

15. Exh. cat. New York-Paris 1987–1988, 282.

16. So characterized by Eisler 1977, 217.

17. See Antonio Martínez Ripoll, *Francisco de Herrera "El Viejo"* (Seville, 1978), 158, no. P71, fig. 62.

18. Soria 1953, 182.

References

1953. Soria (see Biography): 182, no. 198, color repro. opp. 6.

1954. López-Rey, José. "The Real Zurbarán?" Review of Martin S. Soria, *The Paintings of Zurbarán*. *ArtN* (May): 53.

1956. Kress: 208.

1960. Guinard (see Biography): 115, 267, no. 485, repro.

1963. Torres Martín, Ramón. *Zurbarán, el pintor gótico del siglo XVII*. Seville: 231, no. 252.

1973. Gregori, Mina, and Tiziana Frati. *L'opera completa di Zurbarán*. Milan: no. 310, color pl. 48.

1977. Gudiol y Ricart, José, and Julián Gállego. *Zurbarán 1598–1664*. London: 105, no. 324, fig. 314.

1977. Young, Eric. Review of Colin Eisler, *Paintings from the Samuel H. Kress Collection: European Schools excluding Italian*. *Conn* 195: 154.

1977. Young, Eric. Review of *European Paintings in the Toledo Museum of Art*. *Conn* 196: 69.

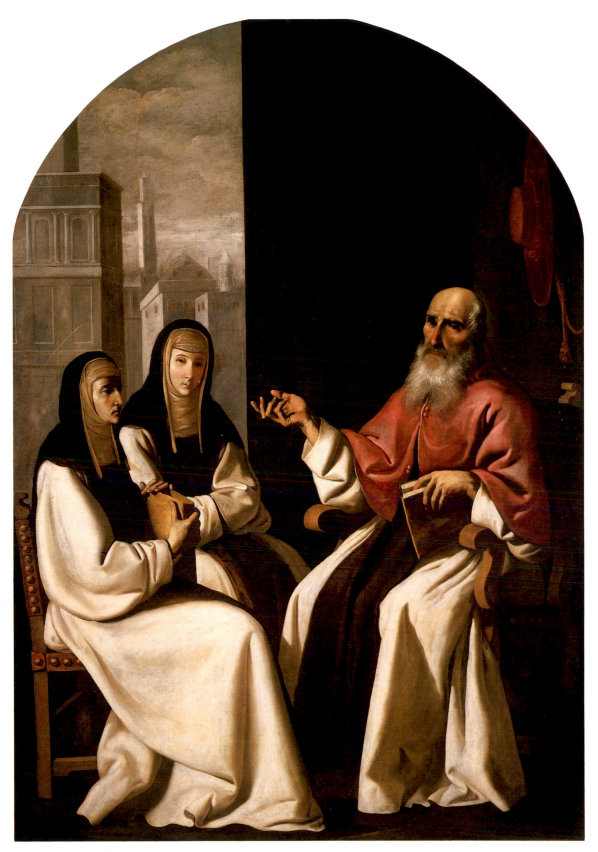

Francisco de Zurbarán and Workshop, *Saint Jerome with Saint Paula and Saint Eustochium*, 1952.5.88

Portuguese Artist

1960.6.30 (1582)

Four-Panel Screen

c. 1475/1500
Oil on four panels, 222 x 286.6 (87⅜ x 112⅗)
Saint Dionysius
 painted surface 151.5 x 54.5 (59⅝ x 21½)
 painted surface and frame 221 x 71.1 (87 x 28)
Saint Sebastian
 painted surface 151.3 x 54.7 (59½ x 21½)
 painted surface and frame 222 x 71.3 (87⅜ x 28⅛)
Saint Barbara
 painted surface 150 x 54.7 (59 x 21½)
 painted surface and frame 222 x 71.3 (87⅜ x 28⅛)
Saint Lawrence
 painted surface 151.5 x 54.5 (59⅝ x 21½)
 painted surface and frame 221 x 71.1 (87 x 28)
Timken Collection

Inscriptions:
On the moldings above the painting, probably from the early 1900s: *S. Dionisus, S. Sebastianus, S. Barba[r]a, S. Laurentius*

Technical Notes: The original supports are vertically oriented wood panels, composed of two to three members. These panels have been set into inner and outer carved, gilt, and painted frames. Only the arches, spandrels, and inscribed moldings of the inner frames are original. All other parts of the frames probably date from the early twentieth century. The outer frames have been hinged to form a screen. The panels have a thick white gesso ground. Red bole was applied under the gilded areas. The paint appears to be oil but may be tempera. Thick paint can be noted in the lighter tones and in the glazed designs on the gold borders of the mantles. Thin, curvilinear strokes predominate in all other areas. The curtains, halos, and borders of the mantles are gold leaf, decorated in places with punchwork. The paintings are in very poor condition. The panel supports are warped and are traversed by vertical checks. Vertical cleavage riddles the paint, and the ground and paint layers have suffered many small losses. The fills are extensive and disfiguring, and the overpaint and surface coatings are discolored. The original elements of the frames are badly worm eaten.

Provenance: William Salomon [d. 1919], New York (sale, American Art Gallery, New York, 4–7 April 1923, no. 358, as Spanish school, seventeenth century); T. R. Williams, New York;[1] sold to William R. Timken [d. 1949], New York; his widow, Lillian S. Timken [d. 1959], New York.[2]

THE FOUR SAINTS depicted on the screen are among the earliest and most important martyrs of the Church. It seems likely that the panels originally were organized in a retable on both sides of a large central image such as a Madonna and Child. Folding screens were seldom used in Portuguese churches. The panels were probably assembled into a screen in the early twentieth century to make them suitable for household decoration.

Saint Dionysius (d. 272) went to France as a missionary and became the first bishop of that country.[3] The Roman authorities in Paris imprisoned and beheaded Dionysius because his preaching had inspired so many conversions. After the execution he rose up, picked up his severed head, and walked to a consecrated cemetery. The usual representation of Dionysius holding a severed head refers to this miracle and not simply to the means of his martyrdom.

Saint Sebastian (d. 288) was a captain of the guards in the Roman army; he is, therefore, sometimes shown holding a sword, as here.[4] After learning of his adherence to the Church, the emperor ordered that Sebastian be executed by archers. The arrows did not pierce any of his vital organs, and Saint Irene was able to bring him back to life. Sebastian was subsequently beaten to death by soldiers after encountering the emperor and denouncing him for persecuting Christians. The representation of the saint as a clean-shaven young man was an innovation of the fifteenth century; before this time he was depicted as an elderly bearded figure. Until the sixteenth century artists outside Italy represented Sebastian clothed, in either a toga or contemporary costume.

Saint Barbara (d. 303) was tortured and martyred in Heliopolis (Egypt) by the Roman authorities to whom her father turned her over after learning of her conversion.[5] The tower, Barbara's most distinctive attribute, symbolizes the tower in which her father imprisoned her in order to conceal her from other men. The depiction of the tower with only one window in this painting is unusual; it is almost always represented with the three windows that she ordered workmen to make in honor of the Trinity. Her book, another common attribute, refers to the study of the faith to which she devoted herself during her confinement in the tower.

Born in Huesca (Aragon), Saint Lawrence (d. 258) has long been widely venerated throughout the Ibe-

rian peninsula.[6] Lawrence served Pope Sixtus II as archdeacon. Three days after Sixtus was martyred, Lawrence was imprisoned by Roman authorities, who tried to force him to reveal the location of the treasures of the Church. He remained steadfast in his loyalty even when he was burned alive on a huge, specially constructed gridiron. The instrument of his martyrdom is his most common attribute. In the National Gallery's painting he also holds a book, which refers to his responsibility as archdeacon to care for sacred texts.

The very poor condition of the panels makes a definitive judgment on their origins difficult. In 1923 the paintings were sold as works of the seventeenth-century Spanish school; in the Timken collection, they were assigned to the Portuguese school without a date.[7] The figures lack the organic coherence and plasticity that distinguish both Spanish and Portuguese paintings of the seventeenth century. The format, with isolated standing figures, is characteristic of Portuguese paintings throughout the fifteenth century.[8] Unlike their Spanish contemporaries, Portuguese painters of the period seldom represented narrative scenes from the lives of the saints. They tended to avoid outwardly dramatic displays of emotion and preferred restrained, rather bland facial expressions and gestures.

It seems most probable that the paintings were executed by a Portuguese artist during the last quarter of the fifteenth century. Compare, for example, other Portuguese works of this period, such as the panels of *Saint Ursula* and *Saint Lawrence,* now in the Santos collection, Lisbon,[9] which share such qualities as flat, wooden handling of figures without a sense of logical, organic unity; minimal use of light and shade; illogical proportions, particularly notable in the elongated arms; and harsh, linear drapery folds that obscure anatomy. In contrast, Portuguese paintings of the third quarter of the fifteenth century are characterized by full, plastic figures modeled with chiaroscuro.

Scholars generally agree that the last quarter of the fifteenth century was the least distinguished period of Portuguese painting. The reasons for the temporary decline of technical competence are unclear, but a disregard for the fine arts may have resulted from civil unrest provoked by efforts to consolidate royal authority, and from the concentration of the country's resources on the exploration and conquest of Africa, Asia, and South America. The theme of martyred saints might have had special relevance to the conquest of overseas territories, where Portugal intended to establish the Catholic faith.[10] Although the quality of the panels is not high, they constitute an interesting visual record of the situation of Portugal in the last quarter of the fifteenth century.

R.G.M

Notes

1. "Salomon sale" 1923, 4.

2. Provenance card in NGA curatorial files.

3. On the history and iconography of Saint Dionysius, see Mrs. [Anna Murphy] Jameson, *Sacred and Legendary Art,* 4th ed., 2 vols. (London, 1863), 2: 713–718; Alban Butler, *The Lives of the Fathers, Martyrs, and other Principal Saints,* ed. R. C. Husenbeth, 4 vols. (London, 1926–1929), 4: 12–13; Louis Réau, *Iconographie de l'art chrétien,* 3 vols. (Paris, 1955–1959), vol. 3, part 1, 374–379. The legend of Saint Dionysius, martyr and the first bishop of France, mistakenly identifies him as Dionysius the Areopagite, an Athenian philosopher converted to Christianity by Saint Paul.

4. On the history and iconography of Saint Sebastian, see Jameson 1863, 2: 412–424; Butler 1926–1929, 1: 80–82; and Réau 1955–1959, vol. 3, part 3, 1190–1199.

5. On the history and iconography of Saint Barbara, see Jameson 1863, 2: 494–500; Réau 1955–1959, vol. 3, part 1, 170–177.

6. On the history and iconography of Saint Lawrence, see Jameson 1863, 2: 538–547; Butler 1926–1929, 3: 160–163; Réau 1955–1959, vol. 3, part 2, 787–792.

7. See Salomon sale catalogue, American Art Gallery, New York, 4–7 April 1923, no. 358; Canaday 1960, 77.

8. On Portuguese painting of the fifteenth century, see José de Figueiredo, ed., *L'art portugais de l'époque des grands découverts au XV siècle* [exh. cat., Musée du Jeu de Paume] (Paris, 1931), 9–26; Reynaldo dos Santos, ed., *Os primitivos portugueses, 1450–1550* [exh. cat., Museu Nacional de Bellas Artes] (Lisbon, 1940), 43–46; José de Almeida e Silva, *Quinze dias de estudo na exposiçao dos primitivos portugueses* (Viseu, 1941), 8–13; Reynaldo dos Santos, *Nuno Gonçales: The Great Portuguese Painter and the Altarpiece for the Convent of Saint Vincent,* trans. Lucy Norton (London, 1955), 5–15; Reynaldo dos Santos, *Historia del arte portugés,* trans. (Barcelona, 1960), 181–196.

9. Santos 1960, repro. 195.

10. For a good survey of Portuguese history of this period, see H. V. Livermore, *A New History of Portugal,* 2d ed. (Cambridge, 1976), 121–140. On the association of the faith with the early conquests, see C. R. Boxer, *The Portuguese Seaborne Empire, 1415–1825* (London, 1969), 228–232.

References

1923. "Salomon Sale, totaling $1,292,847, Third Largest in America." *ArtN* 21 (14 April): 4.

1960. Canaday, John. "Flip of Coin Helps Divide Fortune in Art." *New York Times,* 15 May: 77.

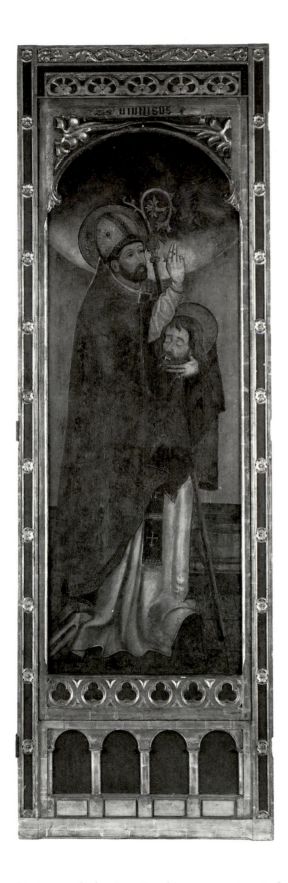
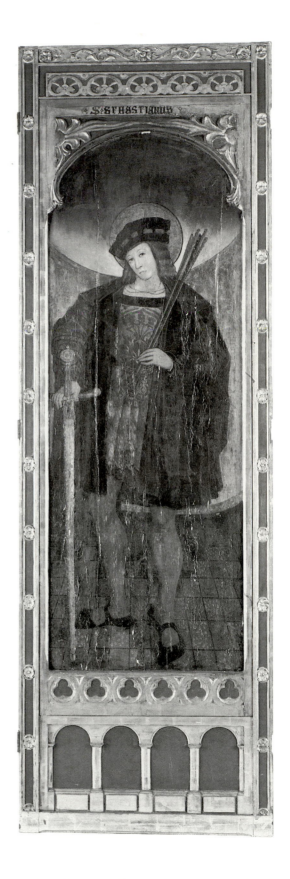

Portuguese Artist, *Four-Panel Screen*, 1960.6.30. Left to right: *Saint Dionysius, Saint Sebastian, Saint Barbara, Saint Lawrence*

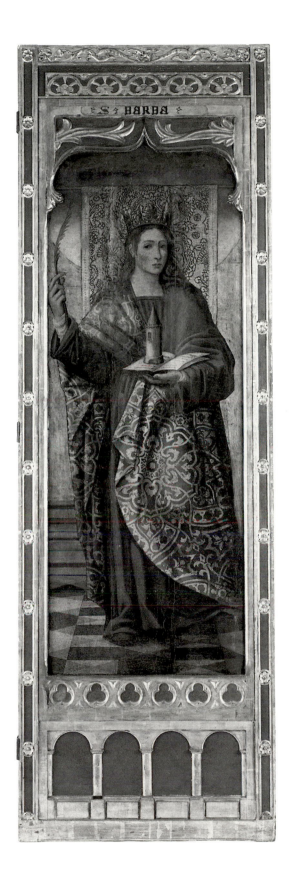
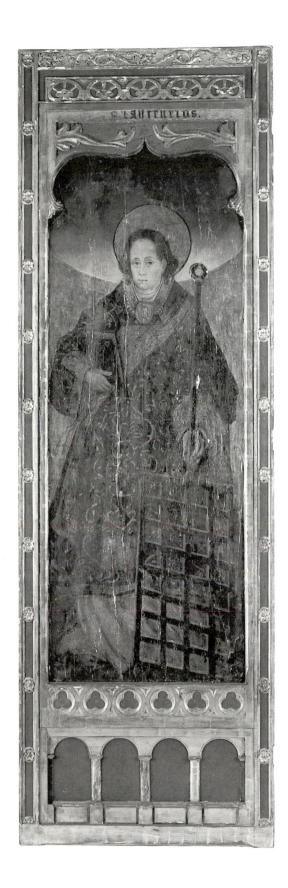

Index of Titles

The Assumption of the Virgin
Juan de Valdés Leal 1961.9.46 (1409)
Bartolomé Sureda y Miserol
Francisco de Goya 1941.10.1 (548)
The Bullfight
Eugenio Lucas Villamil 1954.10.1 (1350)
Charles IV of Spain as Huntsman
Workshop of Francisco de Goya 1937.1.86 (86)
Christ among the Doctors
Master of the Catholic Kings 1952.5.43 (1122)
Christ Cleansing the Temple
El Greco 1957.14.4 (1482)
Don Antonio Noriega
Francisco de Goya 1961.9.74 (1626)
The Duke of Wellington
Workshop of Francisco de Goya 1963.4.1 (1902)
Four-Panel Screen
Portuguese artist, 15th century 1960.6.30 (1582)
*The Holy Family with Saint Anne
and the Infant John the Baptist*
El Greco 1959.9.4 (1527)
Laocoön
El Greco 1946.18.1 (885)
Madonna and Child with the Infant Saint John
Attributed to Fernando Yáñez de la Almedina
1939.1.305 (416)
Madonna and Child with Saint Martina and Saint Agnes
El Greco 1942.9.26 (622)
María Luisa of Spain Wearing a Mantilla
Workshop of Francisco de Goya 1937.1.87 (87)
*María Teresa de Borbón y Vallabriga, later Condesa
de Chinchón*
Francisco de Goya 1970.17.123 (2495)
The Marquesa de Pontejos
Francisco de Goya 1937.1.85 (85)

The Marriage at Cana
Master of the Catholic Kings 1952.5.42 (1121)
The Needlewoman
Diego de Velázquez 1937.1.81 (81)
Pope Innocent X
After Diego de Velázquez 1937.1.80 (80)
Portrait of a Young Man
Follower of Diego de Velázquez 1937.1.82 (82)
The Return of the Prodigal Son
Bartolomé Esteban Murillo 1948.12.1 (1027)
Saint Ildefonso
El Greco 1937.1.83 (83)
Saint Jerome
El Greco 1943.7.6 (743)
Saint Jerome with Saint Paula and Saint Eustochium
Francisco de Zurbarán and Workshop 1952.5.88 (1167)
Saint Lucy
Francisco de Zurbarán 1943.7.11 (748)
Saint Martin and the Beggar
El Greco 1942.9.25 (621)
Saint Martin and the Beggar
Studio of El Greco 1937.1.84 (84)
Señora Sabasa García
Francisco de Goya 1937.1.88 (88)
Still Life with Sweets and Pottery
Juan van der Hamen y León 1961.9.75 (1627)
Thérèse Louise de Sureda
Francisco de Goya 1942.3.1 (549)
Two Women at a Window
Bartolomé Esteban Murillo 1942.9.46 (642)
Victor Guye
Francisco de Goya 1956.11.1 (1471)
Young Lady Wearing a Mantilla and a Basquiña
Francisco de Goya 1963.4.2 (1903)

Index of Subjects

Index of Previous Owners

A'Court, William, 1st Baron Heytesbury: 1942.9.46
Agnew, Thomas, & Sons: 1948.12.1
Alava, Miguel de: 1963.4.1
Alava, Ricardo: 1963.4.1
Alcudía y de Sueca, Duque de: see Ruspoli y Caro, Camilo Carlos Adolfo
Alcudía y de Sueca, Duquesa de: see Godoy y Borbón, Carlota Luisa de
Almenas, Conde de las: see Palacio, José María de
Almodóvar del Rio, Duque de: 1942.9.46
Álvarez de Toledo, Manuel, Marqués de Miraflores y de Pontejos: 1937.1.85
Art market: 1943.7.11
Ashe, William Frederick, 3d Baron Heytesbury: 1942.9.46
Ashe, William Henry, 2d Baron Heytesbury: 1942.9.46
Avalon Foundation: 1948.12.1
Bardac, Sigismond: 1954.10.1
Beistegui, Carlos: 1959.9.4
Bermejillo del Rey, Marquesa de: 1937.1.86, 1937.1.87
Bernheim-Jeune, Josse and Gaston: 1937.1.84
Böhler (Boehler) and Steinmeyer, Inc.: 1943.7.6
Bond, Hugh Lennox, Jr.: 1963.10.235
Borbón, Infante Don Luis de: 1970.17.123
Borbón y Vallabriga, María Teresa de, 14th Condesa de Chinchón: 1970.17.123
Boussod Valadon: 1942.9.25, 1942.9.26
Bruce, Ailsa Mellon: 1970.17.123
Capilla de San José (Chapel of Saint Joseph): 1942.9.25, 1942.9.26
Carlos II, king of Spain: 1937.1.83
Carvalho, Dr.: 1961.9.46
Cassirer, Paul: 1946.18.1
Catherine II, empress of Russia: 1937.1.80
Charles, W. E.: 1963.10.235
Chinchón, Conde de: see Ruspoli, Adolfo; Ruspoli y Caro, Camilo Carlos Adolfo
Chinchón, 15th Condesa de: see Godoy y Borbón, Carlota Luisa de
Chinchón, 14th Condesa de: see Borbón y Vallabriga, María Teresa de
Colima, Juan Varela: 1937.1.83
Colnaghi, P. & D., & Co.: 1937.1.80
Cook, Sir Francis, 1st Bart.: 1957.14.4
Cook, Sir Francis Ferdinand Maurice, 4th Bart.: 1957.14.4
Cook, Sir Frederick Lucas, 2d Bart.: 1957.14.4
Cook, Sir Herbert Frederick, 3d Bart.: 1957.14.4
Dale, Chester: 1943.7.6, 1943.7.11, 1963.10.231, 1963.10.232, 1963.10.233, 1963.10.234, 1963.10.235
Dalmatia, Duke of: see Soult, Marshal Nicolas Jean de Dieu
Debrousse, Hubert: 1963.4.2
Degas, Edgar: 1937.1.83
Dreicer, Michael: 1959.9.4

Dreicer, Michael, heirs: 1959.9.4
Durand Ruel : 1946.18.1, 1963.4.2
Duveen Brothers: 1937.1.82, 1937.1.88
Ehrich Galleries: 1943.7.11
Eliche, 7th Marqués de: see Haro, Gaspar de
Escat, Pedro: 1941.10.1, 1942.3.1
European art dealer: 1943.7.6
Fischer, Edwin: 1946.18.1
Frelinghuysen, Mrs. Peter H. B. (Adaline Havemeyer): 1941.10.1, 1942.3.1, 1963.4.1, 1963.4.2
French & Co.: 1952.5.42, 1952.5.43, 1959.9.4
Galliera, Duque de: see Orleáns, Infante Don Antonio de
García, Sabasa: see García Pérez de Castro, María
García de la Huerta, Serafín: 1963.4.2
García Pérez de Castro, María (called Sabasa García): 1937.1.88
García Soler, Mariana: 1937.1.88
Garriga, Benito: 1963.4.2
Gimpel and Wildenstein: 1954.10.1
Godoy y Borbón, Carlota Luisa de, Condesa de Chinchón, Duquesa de Alcudía y de Sueca: 1970.17.123
Gooden, Stephen T.: 1942.9.46
Gouvello de Keriaval, Pierre-Armand-Jean-Vincent-Hippolyte, Marquis de: 1937.1.81
Granville, George, 5th Duke of Sutherland: 1948.12.1
Granville, George, 2d Duke of Sutherland: 1948.12.1
Guye, Vincent: 1956.11.1
Guye family: 1956.11.1
Guzmán, Diego de Messía Felípez de, Marqués de Leganés: 1961.9.75
Harding, Charles B.: 1956.11.1
Harding, J. Horace: 1956.11.1
Harding, Laura: 1956.11.1
Haro, Gaspar de, 7th Marqués de Eliche: 1937.1.82
Harrach, Count Alois Thomas Raymund: 1937.1.82
Harrach, Count Ferdinand Bonaventura: 1937.1.82
Harrach, Count Otto: 1937.1.82
Harrach, Galerie: 1937.1.82
Havemeyer, Henry Osborne: 1963.4.1, 1963.4.2
Havemeyer, Louisine Waldron: 1941.10.1, 1942.3.1, 1963.4.1, 1963.4.2
Heredia, Marqués de: 1963.4.2
Herrero, José Joaquin: 1937.1.88
Heytesbury, 1st Baron: see A'Court, William
Heytesbury, 2d Baron: see Ashe, William Henry
Heytesbury, 3d Baron: see Ashe, William Frederick
Hospital of Charity: 1948.12.1
Imperial Hermitage Gallery: 1937.1.80
Jeszenski von Mendelssohn, Eleanora Irme von: 1946.18.1
Kahn, Édouard: 1954.10.1
Kerchove, Baroness de: 1959.9.4
Knoedler, M., & Co.: 1937.1.80, 1937.1.81, 1937.1.83, 1937.1.84, 1937.1.86, 1937.1.87, 1952.5.88, 1956.11.1

General Index

Concordance of Old-New Titles

Artist and Acc. No.	Old Title	New Title
Francisco de Goya 1941.10.1	Don Bartolomé Sureda	Bartolomé Sureda y Miserol
Francisco de Goya 1942.3.1	Doña Teresa Sureda	Thérèse Louise de Sureda
Francisco de Goya 1963.4.2	The Bookseller's Wife	Young Lady Wearing a Mantilla and a Basquiña
Francisco de Goya 1970.17.123	Condesa de Chinchón	María Teresa de Borbón y Vallabriga, later Condesa de Chinchón
Workshop of Francisco de Goya 1937.1.87	Maria Luisa, Queen of Spain	Maria Luisa of Spain Wearing a Mantilla
El Greco 1959.9.4	The Holy Family	The Holy Family with Saint Anne and the Infant John the Baptist
Juan van der Hamen y León 1961.9.75	Still Life	Still Life with Sweets and Pottery
Bartolomé Esteban Murillo 1942.9.46	A Girl and Her Duenna	Two Women at a Window
Francisco de Zurbarán 1943.7.11	Santa Lucia	Saint Lucy

Concordance of Old-New Attributions/Appellations

Old Attribution	Acc. No.	New Attribution
Francisco de Goya	1937.1.86	Workshop of Francisco de Goya
Francisco de Goya	1937.1.87	Workshop of Francisco de Goya
Francisco de Goya	1963.4.1	Workshop of Francisco de Goya
Attributed to Francisco de Goya	1954.10.1	Eugenio Lucas Villamil
El Greco	1937.1.84	Studio of El Greco
Master of the Retable of the Reyes Católicos	1952.5.42	Master of the Catholic Kings
Master of the Retable of the Reyes Católicos	1952.5.43	Master of the Catholic Kings
Anonymous Portuguese, 17th century	1960.6.30	Portuguese artist, 15th century
Sodoma	1939.1.305	Attributed to Fernando Yáñez de la Almedina
Diego Velázquez	1937.1.80	After Diego de Velázquez
Francisco de Zurbarán	1952.5.88	Francisco de Zurbarán and Workshop

1937.1.80	(80)	After Diego de Velázquez, *Pope Innocent X*
1937.1.81	(81)	Diego de Velázquez, *The Needlewoman*
1937.1.82	(82)	Follower of Diego de Velázquez, *Portrait of a Young Man*
1937.1.83	(83)	El Greco, *Saint Ildefonso*
1937.1.84	(84)	Studio of El Greco, *Saint Martin and the Beggar*
1937.1.85	(85)	Francisco de Goya, *The Marquesa de Pontejos*
1937.1.86	(86)	Workshop of Francisco de Goya, *Charles IV of Spain as Huntsman*
1937.1.87	(87)	Workshop of Francisco de Goya, *María Luisa of Spain Wearing a Mantilla*
1937.1.88	(88)	Francisco de Goya, *Señora Sabasa García*
1939.1.305	(416)	Attributed to Fernando Yáñez de la Almedina, *Madonna and Child with the Infant Saint John*
1941.10.1	(548)	Francisco de Goya, *Bartolomé Sureda y Miserol*
1942.3.1	(549)	Francisco de Goya, *Thérèse Louise de Sureda*
1942.9.25	(621)	El Greco, *Saint Martin and the Beggar*
1942.9.26	(622)	El Greco, *Madonna and Child with Saint Martina and Saint Agnes*
1942.9.46	(642)	Bartolomé Esteban Murillo, *Two Women at a Window*
1943.7.6	(743)	El Greco, *Saint Jerome*
1943.7.11	(748)	Francisco de Zurbarán, *Saint Lucy*
1946.18.1	(885)	El Greco, *Laocoön*
1948.12.1	(1027)	Bartolomé Esteban Murillo, *The Return of the Prodigal Son*
1952.5.42	(1121)	Master of the Catholic Kings, *The Marriage at Cana*
1952.5.43	(1122)	Master of the Catholic Kings, *Christ among the Doctors*
1952.5.88	(1167)	Francisco de Zurbarán and Workshop, *Saint Jerome with Saint Paula and Saint Eustochium*
1954.10.1	(1350)	Eugenio Lucas Villamil, *The Bullfight*
1956.11.1	(1471)	Francisco de Goya, *Victor Guye*
1957.14.4	(1482)	El Greco, *Christ Cleansing the Temple*
1959.9.4	(1527)	El Greco, *The Holy Family with Saint Anne and the Infant John the Baptist*
1960.6.30	(1582)	Portuguese artist, 15th century, *Four-Panel Screen*
1961.9.46	(1409)	Juan de Valdés Leal, *The Assumption of the Virgin*
1961.9.74	(1626)	Francisco de Goya, *Don Antonio Noriega*
1961.9.75	(1627)	Juan van der Hamen y León, *Still Life with Sweets and Pottery*
1963.4.1	(1902)	Workshop of Francisco de Goya, *The Duke of Wellington*
1963.4.2	(1903)	Francisco de Goya, *Young Lady Wearing a Mantilla and a Basquiña*
1970.17.123	(2495)	Francisco de Goya, *María Teresa de Borbón y Vallabriga, later Condesa de Chinchón*

List of Artists

Goya y Lucientes, Francisco José de
Goya, Francisco de, Workshop of
Greco, El (Domenikos Theotokopoulos)
Greco, El, Studio of
Hamen y León, Juan van der
Lucas Villamil, Eugenio
Master of the Catholic Kings
Murillo, Bartolomé Esteban
Valdés Leal, Juan de Nisa y
Velázquez, Diego Rodríguez de Silva y
Velázquez, Diego de, Follower of
Velázquez, Diego de, Circle of
Yáñez de la Almedina, Fernando, Attributed to
Zurbarán Márquez (or Salazar), Francisco de
Zurbarán, Francisco de, and Workshop
Portuguese Artist